making movies: from script to screen

making movies:
from script to screen

LEE R. BOBKER NEW YORK UNIVERSITY and VISION ASSOCIATES, INC.

with LOUISE MARINIS

HARCOURT BRACE JOVANOVICH, INC.

NEW YORK CHICAGO SAN FRANCISCO ATLANTA

B. E.

ISBN: 0-15-554630-9/paperbound
0-15-155950-3/hardbound

Library of Congress Catalog Card Number: 72-93333

Printed in the United States of America

Picture acknowledgments appear on page 303.

Cover photo from Stanley Kubrick's film *2001: A Space Odyssey*.
© 1968, Metro-Goldwyn-Mayer Inc.

preface

Just as painting and sculpture were the central art forms of the Renaissance, and the novel was the major art form of the early twentieth century, so film is without question the central art form of our time. Interest in film has grown accordingly. Moviemaking is no longer limited to those fortunate few working "in the industry." Young, independent, highly creative filmmakers are active all over the world. Filmmaking courses are burgeoning not only in universities and colleges, but in high schools everywhere. Although mass audiences are somewhat smaller than they were in the halcyon days of the 1940s when there was no television and everyone went to the movies, today's audiences are far more serious—and far more demanding—in their attitudes toward film.

This book explains the filmmaking process from script to screen, examining both the artistic and technical aspects of each step. It is designed not only for the aspiring filmmaker, but for anyone who likes movies and is interested in how they are made. I hope it will serve to clarify and simplify some of the "mystery" surrounding filmmaking.

The emphasis throughout the book is on the process of *making* movies, regardless of size or type. The technical procedures and creative principles are the same whether the filmmaker works with 8mm, 16mm, 35mm, or 70mm film. Although many beginning filmmakers start out using 8mm film and equipment, they will find that the terms and techniques explored in this book are equally valid for any other film size they choose to employ. Filmmaking always involves scripts, cameras, lights, sound recorders, and editing tools. It will not be difficult for the reader to make an easy application from any of the specific equipment I describe to the equipment he has available. There is nothing in this text that does not apply to the making of movies under the widest range of conditions.

Beginning where all films begin, the book opens with an exploration of the methods used to translate ideas into scripts. This initial section examines the possibilities for thematic texture and effective dialogue and narrative writing, and presents some of the varieties of script format available to the screenwriter. The emphasis is on helping the reader to think visually and to recognize themes and structures within the complexities of modern moviemaking.

The next major segment of the text deals with the problems of preparing a film for production—script breakdown, budgeting, scheduling, and all the organizational steps that must precede the start of filming. To help the reader gain

a concrete understanding of effective preproduction planning, a detailed guide to the mechanics of these critical procedures is provided.

The esthetics and technology of the actual production—including cinematography, sound recording, and editing—are the central focus of the book. Film is a comparatively "young" art, yet the recent growth of its technology has been phenomenal. New techniques and equipment are devised every year, and the physical possibilities of filmmaking are therefore constantly expanding. The esthetics of film must keep pace with this technological explosion, for without esthetic judgment to guide their use of the new technology, filmmakers can never realize the art's full potential. Much of the material contained in the central chapters of this book is new in concept and represents an attempt to communicate an understanding of the *specific* esthetic forces at work with relationship to visual images, aural elements, and film editing. The equipment and techniques referred to in these chapters are current and even manage to project a reasonable technical vision of the next few years, insofar as that can be done. Unless the esthetics and technology of filmmaking—in combination—are understood, filmmaking, film viewing, and film criticism remain lifeless, mechanical exercises.

The final section of the book deals in detail with pragmatic and useful subjects, including film distribution and careers in filmmaking. It provides answers to the questions I most often receive when I am lecturing at professional workshops and universities.

No book of this kind could be attempted without the help of many thoughtful and talented people. Among those who assisted me in preparing my material and who made substantive contributions to my thinking and writing were Paddy Chayefsky, who probably knows more about screenwriting than anyone else I know; my friend the distinguished American artist Everett Raymond Kinstler, who has communicated to me so much of value concerning the artistic spirit; Jonathan Rinehart, one of the truly creative people I know; Ann Eisner, a gifted assistant director and executive producer who has lent her talent and intelligence to so many of my films; my partner, Irving Oshman, one of New York's best creative editors; Herbert Raditschnig, one of the world's finest cameramen; Hilary James, of Warner Brothers, who helped me obtain the stills from *McCabe & Mrs. Miller;* my collaborator, Louise Marinis, who added so much of her own talent to the original editing of the book; and Nona Bleetstein, without whom the book would never have been written.

LEE R. BOBKER

consultants

Though my own experience in making movies has been extensive, I chose to consult some of the most knowledgeable and creative filmmakers in the country as I strove to compress a vast body of highly technical information into a statement of manageable length. These are the people who shared their experience with me as I planned and wrote what I hope will prove an accurate account of what filmmaking is today and what it is likely to become in the years ahead:

David Blumgart is one of the film industry's leading sound men. A specialist in documentary and location sound, Mr. Blumgart worked for eleven years with "CBS Reports" and Edward R. Murrow's "See It Now" and was among the first to employ many of the techniques and much of the equipment now widely used in feature films. Among his credits are *D-Day—Twenty Years After*, several Bell Telephone Hour shows, and a number of feature films, including Milos Forman's *Taking Off*.

Mel London is a gifted and innovative director who has received over two hundred awards for his films. His television credits include *Night of the Auk*, *Mornings at Seven*, and *Celebration*. His documentary *To Live Again* was nominated for an Academy Award in 1963.

Irving L. Oshman, winner of thirty-five awards at the Venice, Cannes, San Francisco, Edinburgh, and American film festivals, has been editing films for more than twenty years. He edited the highly praised *David and Lisa* and received an Academy Award nomination for his work on the film *Point of View*.

A native of Austria, **Herbert Raditschnig** is known throughout Europe and the United States as an outstanding creative cameraman. He has been director of photography on more than forty award-winning films, including *The Price of a Life, Arthur—A Portrait,* and *No Simple Thing.* Mr. Raditschnig, also well known for his sports photography, was awarded a Silver Medal for his work at the 1972 Olympics.

Ann Eisner has, over the past seven years, been assistant director and executive producer on more than sixty-five award-winning films. Among her best-known

productions are *The Revolving Door,* which was nominated for an Academy Award in 1969, and *Julie . . . and Tomorrow.*

Don Matthews has distinguished himself as a sound man in every category of production, from network news to theatrical features to industrial training films. Mr. Matthews' credits include the feature film *Paper Lion;* the documentaries *Monument to the Dream* and *Children Without,* both of which were nominated for Academy Awards; and the television documentary *What Manner of Man?,* which was nominated for five Emmy Awards in 1968. He has also done the location sound for more than half of the episodes of the television series "American Adventure" and will soon be working on a feature film to be directed by Robert Altman.

contents

illustrations

making movies: from script to screen

introduction

One of the most significant developments in motion pictures over the past decade has been the revolution in the technology of filmmaking. For almost forty years the equipment with which films were made remained essentially the same. Although the art of film made slow but steady progress, the equipment and techniques of motion picture production did not keep pace—with the exception of some minor streamlining of bulky equipment and, of course, the advent of sound. From the Hollywood production of a Cecil B. DeMille epic in the 1920s to the production of a John Huston classic in the 1950s or even a Doris Day film in the early 1960s, the basic procedures by which films were made remained unchanged: the production was rooted to the studio, the equipment was heavy and relatively immobile, and hordes of technicians stood about doing very little.

These conditions made it very difficult for new talent to break into filmmaking. The expense and rigidity of the equipment, the viselike hold of the craft guilds on the filmmaking organizations, and the mystique with which those in film guarded their secrets all served to discourage the aspiring filmmaker. To be sure, some dedicated and committed filmmakers like Stanley Kubrick surmounted these difficulties, but they were the exception rather than the rule.

Fortunately, dramatic changes began to take place in the 1960s, and they continue into the 1970s. The technology of film has begun to catch up. Technological advances have led to the development of lighter, more mobile, and considerably less expensive equipment. Production has broken free of the studios and has moved outward onto locations. Films like *Knife in the Water, David and Lisa,* and *Easy Rider* heralded the era of the small production unit. Filmmaking is no longer rooted in Hollywood and New York. Editing equipment has become more flexible and easier to use. The iron grip of the industry's unions has been broken by a variety of factors, not the least of which has been the demonstration by small groups of unknown and relatively inexperienced artists that one could make a film and make it well, even without the advantages of an established name and impressive financial resources. All these changes have combined to encourage many young men and women to move into filmmaking as a life's career.

It follows that the way filmmaking is learned has also changed. Since the art of film is more complex now than it was twenty-five years ago, there is much more to be learned. It is no longer simply a matter of learning technique and acquiring technical information and skills; in addition to examining the methods by which images and sound communicate ideas, most film courses now delve into such areas as philosophy, visual art, and the esthetics of sound and sound recording.

Film scripts are beginning to be viewed as viable literature and are studied seriously from that viewpoint. Thus the practical, technical aspects of filmmaking are juxtaposed with the esthetic facets during four, six, or even eight years of intensive study.

Because filmmaking is an art, it places tremendous demands on the filmmaker in terms of learning and mastering the many technical elements involved. It is no longer sufficient to examine film from a purely theoretical viewpoint—from the safe vantage points of the classroom and textbook. Instead of spending long years in academic study of theory and history, many film students are encouraged to begin making films as soon as possible. Today high school students are turning out high-quality, technically excellent motion pictures. This trend should certainly continue, for the need is to begin making films early—to plunge in and get your hands dirty with the raw materials of filmmaking.

Recognizing, then, that most film students are interested in actual filmmaking, this book is designed to provide the beginning filmmaker with a brief yet thorough examination of all the technical matters related to making films. Beginning even before the beginning, with the initial concept of the script, the book offers a comprehensive examination of everything the reader needs to know in order to make a film. Omitted are highly technical discussions or explanations that can be found in technical manuals such as *American Cinematographer's Handbook*.[1] The goal is to provide direct, useful information that will enable the reader to make a motion picture and make it well. This involves some slashing away at the sense of mystery that has long surrounded filmmaking—particularly at the notion that the art of film is the product of free-form genius rather than of perfect and total control of every aspect of the filmmaking process.

Film must be a delicately balanced blend of art and science, and these two elements are intimately related. It is the premise of this book that mastery of the technical elements of filmmaking is the wellspring from which the art flows and the way the filmmaker frees himself to create the art of filmmaking; that is, the greater the filmmaker's knowledge of technique, the greater his chance of creating a work of art. For example, the physical form of the script is important only insofar as it helps communication, but the artistic elements that constitute a good script are the key to a successful film. Efficient and effective preproduction planning frees the filmmaker to create. A well-run production is essential to any well-made film. Likewise, the greater the skills of the editor, the greater the creative contribution he can make to the film. Finally, an understanding of the ways in which films are distributed is essential if the film is to reach its intended audience—if it is to succeed as a work of art.

This book covers all the elements essential to creative filmmaking. To this presentation the reader is asked to bring two things: continued viewing of the works of contemporary filmmakers, as well as the great works of the past, and a persistence and willingness to learn by doing—to create and experiment by actually making films. There is no better way to become a creative filmmaker.

[1] Arthur C. Miller and Walter Strenge, eds., *American Cinematographer's Handbook* (Hollywood: American Society of Cinematographers, 1966).

part 1 before the filming

THE work involved in the art of filmmaking can be divided into three distinct segments, each of equal importance. They are the work that takes place prior to filming, the filming itself, and the work that is done after filming.

The first of these, the preproduction phase of filmmaking, can determine the success or failure of the entire enterprise. The goal is to so prepare the various elements of the production as to completely free the director to put all his creative efforts into the actual filming. This involves a great many factors, each of which must be handled creatively and carefully.

The beginning is, of course, the translation of an idea or concept for a film into a script or storyboard.

one script and storyboard

. . . the script is a very imperfect *technical* basis for a film. And there is another important point in this connection which I should like to mention. Film has nothing to do with literature; the character and substance of the two art forms are usually in conflict. This probably has something to do with the receptive process of the mind. The written word is read and assimilated by a conscious act of the will in alliance with the intellect; little by little it affects the imagination and the emotions. The process is different with a motion picture. When we experience a film, we consciously prime ourselves for illusion. Putting aside will and intellect, we make way for it in our imagination. The sequence of pictures plays directly on our feelings. . . .

Thus the writing of the script is a difficult period but a useful one, for it compels me to prove logically the validity of my ideas. In doing this, I am caught in a conflict—a conflict between my need to transmit a complicated situation through visual images, and my desire for absolute clarity.

INGMAR BERGMAN, in
Four Screenplays of Ingmar Bergman,
translated by Lars Malmstrom
and David Kushner, pp. xvii, xviii.
Copyright © 1960 by Ingmar Bergman.
Reprinted by permission
of Simon and Schuster and Lorrimer
Publishers, Ltd.

The art of the motion picture is in a state of rapid and revolutionary change. After its somewhat slow and orderly evolution over the past fifty or sixty years, the motion picture is undergoing a kind of artistic explosion. For the beginning filmmaker the question is: where to begin?

A film always begins with an idea. This is true whether the film is a theatrical feature, a social documentary, a television show, an industrial training film, or a TV commercial. Before any work is begun, the filmmaker must conceive in his mind the basic idea for a motion picture. And, although contemporary films no longer conform to a single, rigid line of development (indeed, many of them seem almost formless in style), the script—the translation into words of the filmmaker's initial idea—is still the fundamental point of departure for most films.

The script may be called by other names (treatment, story, storyboard), but few if any successful films do not evolve from such a plan, an initial design that is clearly conceived in the mind of the filmmaker.

There are both esthetic and practical reasons to think through the film in advance. On the artistic side, it is considerably easier for the filmmaker to create a unified and successful work of art if he has a definite, preconceived idea of what he wants to communicate. A film is made up of so many bits and pieces that it is essential to exert artistic control throughout all phases of production. On the practical side, far less time, money, and energy are expended during production when the filmmaker knows what he is doing and why he is doing it. Much has been written and spoken in defense of spontaneity, of "winging it" in the name of artistic freedom, but the films most successful (artistically as well as financially) in recent years—such as *Easy Rider, Woodstock, Z, Five Easy Pieces, The Conformist, The French Connection, A Clockwork Orange,* and *The Godfather*—all began as clearly formed ideas in the minds of the filmmakers. Many excellent contemporary films that *appear* to be formless, to have been made up as the director went along—for example, *Faces, M.A.S.H., Woodstock, Gimme Shelter,* and *Husbands*—are deliberately chaotic in style, so that the viewer tends to praise their verisimilitude, their closeness to reality and sense of naturalness. Yet these are the very qualities that are most difficult to obtain in a finished film and that require the most careful advance planning. Good filmmaking is never simply a matter of shooting a lot of footage and then creating a film on the editing table. Rarely does this approach result in a successful film.

A seemingly loose, improvisational style is one of the hallmarks of the work of John Cassavetes. In all his films it appears as if the actors made up the dialogue and action as they went along, and that the footage was simply edited and released. Nothing could be further from the truth. Cassavetes carefully structures and designs his films in advance with the skill and precision of a craftsman. The story line is clearly established and the characters are developed in great detail before production begins. Neither *Faces* nor *Husbands* would have been the film it was without such prefilming preparation. The greater the appearance of formlessness, spontaneity, and realism, the more rigorous the demands on the filmmaker to design his film in advance.

This is not to suggest a return to the didactic Hollywood dialogue script, which actors memorized and directors slavishly followed. In such scripts every detail was indicated and every action prescribed with utter precision, as if the screenwriter expected the director and actors to follow his instructions like automatons. Nothing was left open or flexible. The contemporary film script, though it may take a wide variety of forms depending on how structured or free the filmmaker wishes to be, is a far less rigid instrument. No film should be a slave to a piece of paper. The script as it will be examined in this chapter is simply a name for the design of the film—a design that must exist clearly and completely in the mind of the filmmaker well in advance of production. This does not mean that throughout production the film should not take wide detours, change directions, and continue to grow. What is essential, however, is a beginning point from which the end result can be achieved. From this beginning point, the filmmaker can

proceed to translate his idea into a form in which it can be seen, understood, discussed, and evaluated. The three basic elements in this transformation process are research, the screen treatment or rough storyboard, and the shooting script or complete storyboard.

research

Whatever the type of film to be made, it is essential that the filmmaker understand his material. Whether the film is a complex "story" production like *Five Easy Pieces*, a historical pageant like *A Man for All Seasons*, a social documentary like *Gimme Shelter*, or a TV commercial for Alka Seltzer, the more the filmmaker knows about the subject of the film, the more successful the film will be. The research process in filmmaking is not simply a tour through the dusty archives of the local library; it is a highly disciplined procedure that often leads to total involvement in source material. Often it is necessary for the filmmaker to acquire in a relatively short period of time a great deal of expert knowledge on the subject with which the film deals.

EXAMINATION AND EVALUATION OF SOURCE MATERIAL

The first step in an effective research program is to compile a selective collection of existing material in the subject area. Since it is obviously impossible for a filmmaker to read everything written about a subject in the time available to him, it is important that the material compiled be representative of a wide variety of opinion. One way to do this is to ask four or five "experts" to recommend a selected list of research material that will give the filmmaker an accurate and honest overview of the subject. At this stage nothing should be accepted as truth, no fact should go unchallenged, and diverse and contradicting viewpoints should be actively sought. This reading and study process is, in effect, a total immersion in the material on the part of the filmmaker. The important thing at this stage is that the filmmaker begin to *understand* the subject of the film.

INTERVIEWS AND DIRECT EXPERIENCE

The second step in the research process is to interview and converse with people who are knowledgeable in the subject area. This stage begins before the first stage is completed. As the filmmaker acquires a broader and deeper understanding of his material, he is able to engage in more productive discussions with experts in the field. For example, if the basic film idea is a history of a mental breakdown, the filmmaker should seek out psychiatrists, group therapists, lay advisers, and patients. He will know about some of these people as a result of the first stage of his research; others will be recommended by the first group of individuals he has chosen to see.

Whatever the type of film to be made, the filmmaker can understand his material only if he first conducts productive dialogues with those who have spent their lives with the subject at hand. For example, in preparing his script for *2001, A Space Odyssey,* Stanley Kubrick immersed himself in the subject of space not only through his association with the eminent science-fiction writer Arthur C. Clarke (who later became Kubrick's collaborator), but through interviews with scientists and leaders in the space program.

I was immediately impressed by Kubrick's immense intellectual curiosity. When he is working on a subject, he becomes completely immersed in it and appears to absorb information from all sides, like a sponge. In addition to writing a novel with Clarke, which was to be the basis of the script for *2001,* he was reading every popular and semi-popular book on science that he could get hold of. . . .

I next saw Kubrick at the end of the summer in London, where I had gone to a physicists' meeting and where he was in the process of organizing the actual filming of *2001.* I dropped in at his office in the M-G-M studio in Boreham Wood, outside London, one afternoon, and again was confronted by an incredible disarray—papers, swatches of materials to be used for costumes, photographs of actors who might be used to play astronauts, models of spaceships, drawings by his daughters, and the usual battery of cameras, radios, and tape recorders. Kubrick likes to keep track of things in small notebooks, and he had just ordered a sample sheet of every type of notebook paper made by a prominent paper firm—about a hundred varieties—which were spread out on a large table. We talked for a while amid the usual interruptions of messengers and telephone calls. . . .

Clarke and Kubrick spent two years transforming ["The Sentinel"] into a novel and then into a script for *2001,* which is concerned with the discovery of the sentinel and a search for traces of the civilization that put it there—a quest that takes the searchers out into the far reaches of the solar system. Extraterrestrial life may seem an odd subject for a motion picture, but at this stage in his career Kubrick is convinced that any idea he is really interested in, however unlikely it may sound, can be transferred to film. "One of the English science-fiction writers once said, 'Sometimes I think we're alone, and sometimes I think we're not. In either case, the idea is quite staggering,'" Kubrick once told me. "I must say I agree with him."

By the time the film appears, according to Kubrick's estimate, he and Clarke will have put in an average of four hours a day, six days a week, on the writing of the script. (This works out to about twenty-four hundred hours of writing for two hours and forty minutes of film.)[1]

Since this second stage of research is in effect a continuation of the learning process begun in the first stage, the information gained in stage 1 of the research process becomes the building material for stage 2, and those being interviewed will recommend more material to be read as well as other people to be seen. The filmmaker must keep an open mind during these dialogues, for the danger of being unduly influenced by an "expert" in the field is very great. The filmmaker must encourage controversy, seek out dissension, repeat the statements of one expert

[1] Jeremy Bernstein, "How About a Little Game? Stanley Kubrick," in *Comprehensible World: On Modern Science and Its Origins* (New York: Random House, 1967), pp. 225–30. Reprinted by permission of the author and Random House, Inc.

to another in order to generate passion and argument, and always *listen*. Most important, he must beware of too much agreement. If all the people he interviews are in complete agreement on a given subject, only one side of the story is being presented.

On occasion, of course, when he is dealing with a subject and people that he knows or knew well during some phase of his life, the filmmaker will operate directly from personal experience. In this case, he may by-pass these early phases of research, substituting his own attitudes, knowledge, and direct experience. For example, the personal experiences of Bob Rafelson as he wandered across the United States, picking up hitchhikers along the highways, working in the oil fields of Texas, and living in the gray, damp loneliness of an island in Puget Sound, form the basis for many of the finest scenes in *Five Easy Pieces*. In particular, the strong sense of reality in the oil field sequences at the beginning of the picture and the authenticity of the dialogue in the episode in which Bobby Dupea picks up the lesbian couple have their genesis in the actual life experience of the director, who really knew what situations like these looked and sounded like.

In the documentary and industrial film field the need to know and understand the subject of the film is of primary importance, for these films are produced to inform, convince, educate, and motivate. If the filmmaker's treatment is shallow and superficial, if he fails to probe his material beyond the obvious, the film cannot succeed and will be open to serious criticism.

In the making of TV commercials, the "experts" are those who know their product and have a marketing program clearly in mind. Before an effective storyboard can be developed, the filmmaker must learn as much as possible about the marketing strategy and objectives of his client. The following are two cases in point:

Alka Seltzer. Here, a general strategy was based on the concept that in order to widen and upgrade the total market the TV spots would have to appeal to a higher level and broader segment of the audience. Consistent with these goals, the advertising agency used a sophisticated, humorous approach in designing their spots, almost in the manner of a *New Yorker* cartoon or a Peter Sellers comedy. Compressed into one minute, these spots enjoyed such a wide appeal that the product was accepted by consumers who transferred their good will (enjoyment of the spots) to hard sales for the product.

Eastern Airlines. In this case, the sponsor felt it was imperative to transmit to the audience a more accurate image of the airline. A survey had shown that too many people still conceived of Eastern Airlines as a regional carrier, despite the fact that they were the second largest passenger carrier in the world. The agency designed a series of very "rich" and highly produced spots built around a grandiose theme—"The Wings of Man." The sound track—the rich, sensuous images, the music of Strauss played by the London Philharmonic, and, most important, the voice of Orson Welles combined to create successfully the image of a major enterprise. The public apparently reasoned that the awe-inspiring, almost biblical language and the exhilarating sense of flight could only represent a major company, and within a year Eastern Airlines' image completely changed.

DOYLE DANE BERNBACH INC.

CLIENT MILES LABORATORIES **TITLE** "MAGADINI'S MEATBALLS"

PRODUCT ALKA SELTZER **CODE** MALKA-70-6-6C

1. (SILENT)

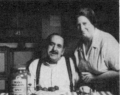

2. PAPA: Mama Mia, thatsa some speecie. . . .

3. DIRECTOR: Spicey meatballs, Jack.

4. PAPA: Sorry (SFX) ASST. CAM: Take 28.

5. DIRECTOR: Out Tony, and action.

6. PAPA: Mama Mia, that's a spicey meatball. DIRECTOR: Cut.

7. PAPA:What was the matter with that? DIRECTOR:The accent. (SFX)

8. PAPA: Huh, huh. DIRECTOR: Cut. (SFX)

9. DIRECTOR: Cut (SFX)

10. PAPA: Meeci, micey, balsy, balsy. DIRECTOR: Cut. (SFX)

11. ASST. CAM: Take 59. (SFX)

12. DIRECTOR: And action.

13. ANNCR:(VO)Sometimes you eat more than you should... DIRECTOR: Jack...

14. ANNCR: (VO) . . . and when it's spicey besides, (SFX UNDER)

15. Mama Mia, do you need Alka Seltzer.

16. Alka Seltzer can help unstuff you. . . .

17. (SFX) . . . relieve the acid indigestion

18. and help make you your old self again.

19. PAPA: Mama Mia thatsa spicey meatball.

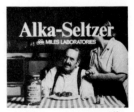

20. (SFX) DIRECTOR: Cut. OK, let's break for lunch.

FIGURE 1 ▲

DOYLE DANE BERNBACH INC.

CLIENT MILES LABORATORIES **TITLE** "GROOM'S FIRST MEAL"

PRODUCT ALKA SELTZER **CODE** MALKA-107-6C

1. (SILENT)

2. SHE: Our first homecooked meal.

3. I'm glad you liked it dear.

4. HE: I'll say. Honey. . .I've never seen a dumpling that big.

5. SHE: Well, I considered making a lot of little ones,

6. but I wanted to impress you with something

7. that would really stick to your ribs

8. HE: Right about where it's stuck dear.

9. SHE: Hmm. . . .? (SFX) I said I'm sorry I couldn't finish the whole dumpling

10. it's a shame to throw it out.

11. SHE: I froze it. The meal wasn't on the heavy side, was it honey?

12. HE: I told you my darling it was perfect, just perfect. (SFX: PLOP, PLOP)

13. SHE: Let's see what would you like for tomorrow, a. . . .

14. Stuffed Crab Surprise. Cream Duck Delight.

15. Is it beginning to rain dear?

16. HE: No, no, no.

17. SHE: Marshmallowed Meatballs.

18. Sweet'N Sour Snails, yum. . . Poached Oysters.

19. ANNCR: (VO) What love doesn't conquer,

20. Alka Seltzer will.

FIGURE 2 ▲

1. ANNCR:(VO) No matter what shape your stomach's in...

2. (MUSIC)

3. (MUSIC)

4. (MUSIC)

5. (MUSIC)

6. (MUSIC)

7. (MUSIC)

8. (MUSIC)

9. (MUSIC)

10. (MUSIC)

11. No matter what shape...

12. your stomach's in...

13. when it gets out of shape,...

14. take Alka-Seltzer.

15. Alka-Seltzer relieves the flutters...

16. calms the nervous feeling...

17. ...relieves heartburn...

18. ...relieves the stuffy feeling...and relieves a headache.

19. Fact is, today, in 1967, nothing works better than good Old Alka-Seltzer.

20. Nothing.

FIGURE 3 ▲

RADIO TV REPORTS, INC.

CLIENT: **EASTERN AIRLINES**
PRODUCT: **EASTERN**
AS FILMED TV COMM'L NO: **322-60**
TITLE: **"DAEDALUS"**

DATE: **4/5/72**
LENGTH: **60 SECONDS**

1. (MUSIC)

2. ORSON WELLS: From the beginning

3. man has dreamed of flying.

4. (MUSIC)

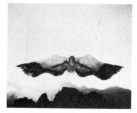

5. of breaking the chains

6. that kept him earthbound,

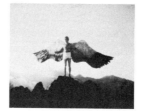

7. of being free to go anytime

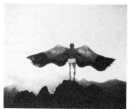

8. his heart said "Fly".

9. (MUSIC)

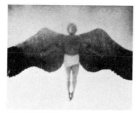

10. (MUSIC)

11. (MUSIC)

12. (MUSIC)

13. At Eastern Airlines we never forget the challenge

14. of that ancient dream,

15. to make flying natural and comfortable,

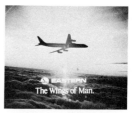

16. to make man as at home in the sky

17. as he is on land,

18. to be the wings of man.

19. Eastern Airlines,

20. the wings of man.

FIGURE 4 ▲

DIRECT INVOLVEMENT IN THE SUBJECT AREA

The third step in an effective research program is direct involvement in the subject area. Once again, this stage begins before the preceding stage has been completed. By now the filmmaker should have begun to form ideas and opinions of his own. He should have evaluated his sources of information, discarding some, selecting material from others, and isolating those aspects of the material that will form the focal point of the script.

At this point he moves away from the printed work, the library, and the interview and becomes directly involved with his subject. If he is making a feature film about a drug addict, for example, he should begin to live in and know the world of drugs. He should establish direct lines of communication with those who inhabit this world and should spend time out "on the street." During this period the filmmaker should concentrate on the reality of his subject material—the physical appearance of things, the way people actually talk, the events and incidents that really occur. This is no simple task. It is difficult to go beneath the surface and it is too easy and too tempting to be satisfied with superficial, easily obtained information. In addition, there are often barriers interposed between the filmmaker and the reality he is trying to experience and understand.

One of the most important elements in the tremendous artistic and financial success of *The French Connection* is the feeling of absolute authenticity transmitted to the audience. The dark, underground world of narcotics traffic seems as real as it would if the film were a documentary. The filmmakers, Phillip D'Antoni and William Friedkin, as well as the writer of the original book, Robin Moore, had all struggled through that dangerous world to understand the sound and the physical appearance of the material. Of course, their guide, policeman Ed Egan, about whom the book was written, provided a great deal of instant expertise. Similarly, Mike Wadleigh (*Woodstock*), the Maysles brothers (*Gimme Shelter*), and Costa-Gavras (*Z* and *The Confession*) all lived with their subjects for a period of time, during which they considered and finally conceived their films.

Unless the personal experience of the filmmaker has already made him particularly familiar with the material, there is no substitute for this third phase of research. The filmmaker must ultimately re-create on screen the material he is in the process of shaping. To do this accurately, with depth and sensitivity, he must know his subject thoroughly—and to know it he must get into it.

screen treatment and rough storyboard

A screen treatment or rough storyboard is usually required by the producer, the producing studio, or the client or agency, but this document also has great value for the filmmaker himself. It is an exercise in structuring material and, if properly done, helps the filmmaker to clarify the "line" of his film.

The screen treatment for the theatrical film can often be used to elicit interest from potential investors or large production companies. For other types of films, however, large studios and potential investors will usually not be interested in

reading screen treatments, but will insist on seeing the fully developed shooting script. For the documentary film, the TV commercial, and the animation film, the screen treatment and rough storyboard simply serve as the first stage of production *after* the work has been commissioned.

If the writer does not plan to make his own film or needs authorization to proceed, "approval" of the screen treatment and rough storyboard is a complex process that varies from case to case. The writer usually attends a "story conference," during which every element of his treatment is carefully scrutinized. Vague sections are called to question, and the writer's intent is minutely examined. The writer's chances of getting his screen treatment approved during such a session depend not only on how imaginative and creative he is, but on how well he has done his homework. If the writer is at all unclear on key elements of the film he has designed, or if he is unable to effectively articulate in words the finished film, he may find it difficult to obtain the necessary approval to proceed to the next stage, the shooting script and complete storyboard.

FORMAT

The choice of format for the screen treatment is not critical, but the goal is readability. Since the writer's main objective is to communicate to the reader his vision of the finished film, the format should make it as easy as possible for the reader to envision the film the writer has in mind. Formats in general vary depending on the type of film.

THE THEATRICAL OR "STORY" FILM

The screen treatment for the theatrical or "story" film is essentially a prose document. In effect it "tells" the film without any screenwriting jargon. Usually it describes the characters and situation, relates the plot, and briefly outlines the major dramatic sequences so that the structure of the film is apparent.

There is no single "correct" way to write a screen treatment and no ideal length for presentation. The following is a general form in common use:

1. Description of major characters
2. Plot outline (no embellishments, just a telling of the story)
3. Description of the major sequences (in order)
4. Statement of proposed photographic and editing styles
5. Filmmaker's comments on the theme

The screen treatment for the theatrical or "story" film can be as long as 100 or more typewritten pages or as brief as 12 pages, as long as it conveys concisely a clear image of the finished film. The single most important function of the screen treatment is to get the film "down on paper" so that it can be discussed, examined, and evaluated by those interested in the production as well as by the filmmaker himself. In this form it can be analyzed for strengths and weaknesses, and the filmmaker can begin to deal with it as a projected film.

THE DOCUMENTARY FILM

Today the term "documentary film" encompasses such forms as sponsored industrial films, educational films, and advertising and public relations films. Thus a documentary may take any of a variety of forms, ranging from dramatic story films identical with the theatrical film, to films containing combinations of dialogue and narration, to films consisting only of real people in real situations photographed and recorded as they happen (*cinéma vérité*). The screen treatment for a documentary film usually must contain a wider variety of elements. In addition, since the documentary film often must convey a specific "message" or a particular body of information, the screen treatment must clearly indicate where and how this material will appear. It is not enough in this type of film simply to describe characters, relate the plot, and outline the sequential order. The following is a common and effective form for the screen treatment of a documentary film.

STATEMENT OF PURPOSE

This should be a brief statement of the film's purposes and objectives as understood by the filmmaker. Since many documentary films are paid for by a sponsor or sponsoring organization, it is essential that from the beginning there be agreement about the film's goals.

STATEMENT OF THEME

The filmmaker should be able, in a few well-chosen words, to state the primary theme of the film. If sponsor and filmmaker differ about what the theme is, it is far better to discuss it at this stage of production than after the film has been made.

IDENTIFICATION OF PRIME AUDIENCES

As part of his screen treatment, the filmmaker should define the prime audience for whom the film is intended. Then everything he does can be discussed and evaluated in relation to its effect on this audience. It is essential that sponsor and filmmaker agree on the audience they are trying to reach.

DESCRIPTION OF THE FILM

This should be a prose "telling" of the film, indicating its visual structure and clearly showing when and how the film's informational material will appear.

DESCRIPTION OF THE AUDIO AND VISUAL STYLE

This indicates what kind of narration will be written (poetic or didactic, for example) and what type of images will be used (oblique, soft focus, or hard reality). In addition to describing the proposed style of the film, the filmmaker should indicate the editing techniques he plans to use (flash-cutting, long superimpositions, sound and picture overlaps, etc.).

The screen treatment for the documentary film must communicate not only the cinematic elements involved, but, more important, it must convey the content of its "hard" information and state the methods by which this material will be worked into the film. In the following screen treatment for a thirty-minute documentary film dealing with a sixteen-year-old black youth growing up in an urban ghetto, the major emphasis is on description of the content and story line. This material is continually interrupted by indented description of the informational material to be carried by the film. This format gives the reader a clear idea of the visual form of the finished film and at the same time lets him know how and where the informational material will appear. He can thus sense the balance between the two elements and evaluate whether the treatment successfully achieves its stated goals, and whether or not the information is comfortably and clearly communicated.

ARTHUR . . . A PORTRAIT

Prepared for The American Foundation Institute of Corrections
By Vision Associates, Inc.
Written by Stan Anton

I. SUBJECT

This film is designed to deal with the subject of juvenile delinquency. Six months of preliminary research have uncovered the following facts.

1. An overwhelming percentage of hard-core delinquency leading to overt criminal behavior is concentrated in the inner city.

2. The progression of social interaction among delinquents has, over the past decade, proceeded along the following lines:

　a. The gang—a horizontally structured group divided along ethnic and color lines.
　b. The gang—a vertically structured group divided along geographical and color lines.
　c. Drugs—small groups, usually in high school, brought together by the use of a variety of drugs.
　d. The individual and boy-girl amalgam, divided along color lines.
　e. Small social groups divided along color lines, giving rise to and eventually becoming involved with racist and extremist activity (e.g., militant Black Power groups).
　f. Drugs—the return to drugs in small groups, but now involving elementary school children.

3. A disproportionate percentage of our problem is centered within the black population.

4. "Message" films from *any* segment of the Establishment are "turned off" before they get started. The "Establishment" is defined by this group as anyone who "tells" them what they should do.

5. There are *no* films that delineate for kids the real nature of the life of the inner-city poor with all its strengths and weaknesses. It is the opinion of those working in the field that *no* progress can be made in the area of youth crime unless everyone puts aside old myths and begins to understand what forces are at work impelling the individual toward crime and violence.

In response to the above findings, we have, in close cooperation with those working in the field, designed a film that will reach a broad audience segment and will serve as an effective antidelinquency tool for a wide variety of groups.

II. THE AUDIENCE

1. Hard-core inner-city youth—the delinquents or borderline delinquents themselves.

2. Adolescents everywhere who need to understand those with whom they will share the adult world.

3. Adults who have not the slightest understanding of who these young adults are and what kind of world they live in.

4. Professionals who are desperate for a visual tool that reaches below the surface and dispels clichés and myths that inhibit the efforts of society to come to grips with the problem.

III. THE FILM

Title Arthur . . . A Portrait

Technique This is a pure documentary film with *no* third-person or external narration, *no* teaching, *no* telling. It reveals in shattering detail the past, present, and future life of a borderline delinquent. It probes *all* the forces—good, bad, and indifferent—present in his life. It exposes to the glare of daylight every facet, every relationship that makes up the tapestry of his world. It is an all-dialogue film with the voice-over commentary provided by Artie and his friends. In the end, the film makes its own point and provides a superb open-end tool for discussion. It should be one of the most useful films made this year.

Structure Introduction (Pretitle); Environment (Physical)

Artie's physical world The ghetto in the early morning, predawn. The dark red blindness of walls—iron and brick. Splashes of sunlight invading the shadows of night, illuminating the crevices of dirt and despair. The ghetto awakens, men

and women leave the houses. Finally we journey within the interior of Artie's home, and we see him. We arrest the action on his face and superimpose a single title:

> *Arthur . . . A Portrait*
> Artie is 16
> And goes to Franklin High School.
> He has a long mobile face,
> and soft, slanted eyes,
> and a lonely walk
> that is halfway
> between a stride
> and
> a
> lope.
> And when you watch him
> walk, he walks alone.

sequence 1 *Artie at home* He rises, has breakfast, such as it is. This is his home. We meet his father. We get a good, long, tough look at what it's like to be Artie at 7 o'clock on a weekday morning. Artie and his father both provide narration for this sequence.

> He lives in West Harlem.
> The mean part.
> Where all the bad action is.
> Where eyeballs flog
> the white man when he walks
> those streets.
> And his mother died when
> he was 11,
> and his father's
> a
> short man
> with
> a
> whine
> in
> his
> voice,
> and the look of defeat.
> And he had a construction
> job, but hurt his hand,
> and his fingers on the right
> hand won't close or straighten
> out.

And he's waiting for
THEM to tell him what
to do about it.

They live on the fourth floor
of a tenement, it's clean,
and mean,
and it smells,
and it's crowded
with three kids
and the short man,
and two of the kids
(Artie and his 11-year-old brother)
sleep on a double decker
army surplus bunk
in a room that could pass
for a green foyer;
and the 8-year-old sleeps
with the old man in the
double bed
in the next room (doorless) but
with a
TV set at the foot of it.

Artie and his father can't
communicate, and pop really
doesn't know how to handle
the kid
(for Christ sake he can't handle
life),
but Artie listens to him
if pop talks that it's too
late to go out on a date,
but Artie withdraws, and
then pop relents, and
Artie says it's too late now.
These are the games they play.

And Artie makes breakfast for
his brothers before they go
to school.

sequence 2 *Artie at school* We go with him. We meet his teachers, good and bad, his
school friends and enemies. We get a feeling of what it's like to be Artie in school.
Artie's own comments become the narration intercut with his teacher's evaluation
of the boy.

sequence 3 *Artie from 2:30 to 6:00* His world—and it's not nice. It's split almost schizo-
phrenically between the gang on the West Side—the dope peddlers, the pushers
and users, the hoods and thieves, and the little kids who tag along—and the more
hopeful world of Artie's East Side involvement with the Youth Center. He is a
janitor and assistant teacher, and here are the beginnings of something. The camera
forces us into the center of both worlds, and we really get to know them. The
narration here is divided among Artie, his hood friends already afoul of the law,
and the tough black youth worker who is trying to pry Artie loose from disaster.

sequence 4 *Artie into the night* All the elements of Artie's life come together here, where
the world turns black. We join him at home for supper, then running in the
streets—East Side, West Side.

> Dad makes dinner at
> 6:30. And on Saturday nights,
> dad does the traditional drinking
> dance of Harlem in the local bars.
>
> Artie hangs out in East Harlem
> (it's cleaner, opener, and nicer)
> and becomes up tight the minute
> he hits the West Side.
> He feels "freed" when he leaves pop
> and the West Side.
>
> You ask Artie what he
> wants to do, and he
> shrugs, and says
> I don't know, man.
> And when you say
> he's got to make bread,
> he says, I know, man,
> and I'm going to get myself
> one of those nice desk jobs,
> and make lots of money
> with no work.
>
> Once Artie bought
> himself a leather coat,
> he got the money with
> some "hustling"
> (pushing the carts outside
> the supermarket)
> and some purse
> snatching.

Clothes are important
to Artie,
and this coat was
really something to him.
And one day
a couple of junkies came
to the community center
where Artie hangs out and
works, and took some
stuff and his coat,
and ran away.
And another poor junkie came
in, and they thought he was
one of them, and they grabbed him,
and Artie and another kid who
had lost his coat
grabbed some pipes and things
and tried to kill him.
And it turned out it wasn't one
of the thieves.
When asked how he felt,
Artie said, good, man.
And maybe that old junkie
learned a lesson.
And Artie got his leather
coat back, because the
caretaker of the building
found it.

This sequence is a kind of free-form fugue, a progression of his days and hours. Narration is provided by Artie himself, and through what he says we can begin to understand the pressures that forge his life. In this sequence, we get an ear on his views on everything from "pot" to "horse" to girls and the fuzz. In this sequence we join Artie and his friends "in the act" against society.

sequence 5 *Finale* Here is the door-opener, the discussion-starter: a brief but intensive look at the delinquents, white and black, a few excerpts of their own words, and a question—what is needed to give Artie and all the others a crack at a good life? What is Artie's role . . . our role? What needs doing and who should do it? Out of this, the film can make something happen.

Arthur . . . A Portrait is a civil rights film, a corrections film, a human relations film, a training film, a teaching film. *Arthur: A Portrait* is more than a film—it is an emotional and intellectual experience that should be seen everywhere in this world.

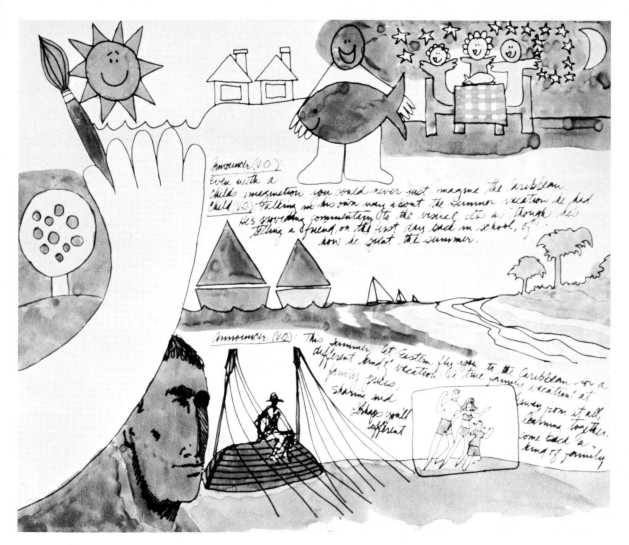

FIGURE 5 ▲

THE TV COMMERCIAL

For this form the storyboard—a pictorial version of a screen treatment—is used almost exclusively. Although it is often accompanied by a prose treatment, the rough storyboard is the essential vehicle for projecting the finished TV commercial in the early stages of production.

Figure 5 is a complete rough storyboard for a 60-second Eastern Airlines TV commercial. At this stage the visual sequences are simply approximated in very sketchy fashion, and the spoken narrative is indicated. This form permits both the client and the agency to evaluate the finished spot and discuss its possible effectiveness in achieving a stated marketing goal.

THE ANIMATION FILM

This is one of the most difficult types of films to project in its early stages of development. At this stage the visual elements of the finished film exist only in the mind of the animator, and it is extremely difficult to communicate his vision. Since most animated films use abstract designs and fantasy characters and situations, and since they depend largely on a kind of unreal movement for their effectiveness, it is not easy to communicate a sense of how the finished film will look. The equivalent of the screen treatment in this form is usually a combination of three elements: a prose description of the film, containing the story line and a description of the animation style; a series of very rough pencil sketches showing key visual elements; and a rough, partial storyboard showing both the relation of the audio and visual elements and the sequential development of the visual line.

The storyboard in Figure 6 has been excerpted from a design for *Coffee Break,* a short film prepared for IBM. The complete presentation consisted of about fifty rough sketches, a storyboard containing twenty visual frames, and a twelve-page typewritten treatment.

shooting script and complete storyboard

Once the screen treatment has been approved and, more important, has satisfied the filmmaker's conceived image, a shooting script is prepared. Again, the script can take many forms, depending on the kind of film being produced.

FORMAT

The main purpose of script and storyboard is to provide all those who will work on the film with a single, unified guide. No matter how carefully they have been prepared, the script and storyboard will certainly undergo many substantive changes as the film proceeds toward completion, but they are essential as a starting point. The format, then, must include every element that the filmmaker wants to be present in the finished film. Again, as with the screen treatment and rough storyboard, the type of film determines the format.

▲ FIGURE 6 ▼

THE THEATRICAL OR "STORY" FILM

The story film requires a shooting script in which the key visual elements of each scene are described in detail and all the dialogue is written out. The writer's instructions regarding other essential audio and visual elements appear throughout the script. Two basic forms are in common use. In the first and probably most familiar format, the scene descriptions and the dialogue alternate vertically on the page.

236 EXT: STREET—DAY[2]

Follow Annie as she walks through various parts of the city . . . she seems listless and disinterested now. The image of loneliness is stronger than ever . . . as she moves against the moving, purposeful CROWDS *of people.*

237 ANOTHER ANGLE

She is seen entering a record store near her home.

238 INT: RECORD STORE—DAY
MS: ANNIE

Annie browses through racks of records . . . she looks around and spots a YOUNG CLERK *setting records in one of the racks. Annie takes a record from the bin and moves to where he is working . . . it is obvious that this is not the first question she is asking.*

> ANNIE
Excuse me . . . I'm sorry to bother you again . . .

She holds the album out for his inspection.

> ANNIE (*cont.*)
Do they use flutes or recorders in this recording of the Brandenburg?

239 CS: CLERK

Clerk takes the album . . . looks at it briefly . . . hands it back to Annie.

> CLERK
Flutes . . . the Vienna Opera Orchestra on Vox uses recorders . . .

240 *Annie takes the album and starts back to the proper rack.*

> ANNIE
Oh . . . on Vox . . . thanks.

She sets the record back and continues browsing.

In the second script form in general use, the visual descriptions appear on the left side of the page and the dialogue appears on the right.

VISUAL AUDIO

236 EXT: STREET—DAY

Follow Annie as she walks through various parts of the city . . . she seems listless and disinterested now. The

[2] From Emanuel Frachtenberg, *The 29th Summer* (adapted from the novel by Dr. Theodore I. Rubin).

image of loneliness is stronger than ever . . . as she moves against the moving, purposeful CROWDS *of people.*

237 ANOTHER ANGLE

She is seen entering a record store near her home.

238 INT: RECORD STORE—DAY
 MS: ANNIE

Annie browses through racks of records . . . she looks around and spots a YOUNG CLERK *setting records in one of the racks. Annie takes a record from the bin and moves to where he is working . . . it is obvious that this is not the first question she is asking.*

ANNIE:

Excuse me . . . I'm sorry to bother you again . . .

She holds the album out for his inspection.

Do they use flutes or recorders in this recording of the Brandenburg?

239 CS: CLERK

Clerk takes the album . . . looks at it briefly . . . hands it back to Annie.

CLERK:

Flutes . . . the Vienna Opera Orchestra on Vox uses recorders . . .

240 *Annie takes the album and starts back to the proper rack.*

ANNIE:

Oh . . . on Vox . . . thanks.

She sets the record back and continues browsing.

The advantage of this format is that the dialogue can be read without interruption. Although this format puts a greater burden on the actor by forcing his eyes to move back and forth between scene description and dialogue, it has the advantage of keeping the actor constantly aware of the visual concepts that accompany specific pieces of dialogue.

THE DOCUMENTARY FILM

As noted earlier, many documentary films are produced as story films—they have distinct plots, and professional actors are used. In these cases, the formats just illustrated for theatrical films are employed.

Often, however, documentary films are structured around dialogue sequences that either are spontaneous and involve no staging, or are re-creations using real people improvising their own dialogue. The final script for such films sometimes

intersperses narration with dialogue to emphasize the film's theme. These scripts cannot of course be "written out" in the manner of a theatrical story film. They usually take the following form:

VISUAL[3]	AUDIO
	(*As freeze frame is released*) *Sound of siren over continuing drums.*
	NARRATOR:
Titles fade off screen, and we release the arrested action. The prisoner is put into the police car, and we speed through the city, impressionistically capturing the lights, the darkness, and so on.	This is both an end and a beginning . . . for John Cox Mitchell it is a logical conclusion following a difficult and complex childhood.
Freeze frame: a flash frame montage revealing 100 possible causes and something of the personal history of this young man, all suggested, giving us a picture of John Cox Mitchell—who he is when he first comes into contact with our system of correction.	It is never easy to say why . . . twenty-one years of life have brought him to this . . . And who can say with certainty why?
	The fact of the matter is that now he is no longer a child . . . and so, in the words of our Bible, "he must put away childish things."
*In dramatic, candid, documentary fashion, our camera (*via long lenses*) follows the prisoner through the procedure of booking and detention. (*This should not be staged, but should follow, in minute detail, the actual process.*)*	He is no longer a "youth offender" . . . he is an adult.
	In this instant, in this arrested moment of time, he closes one chapter in his life . . . and embarks on another . . . he is here involved as an adult in criminal behavior. He stands before society . . . a product of his past, as all of us are . . . facing a difficult present . . . an uncertain future.

[3]From *The Odds Against.* Prepared for the American Foundation Institute of Corrections by Vision Associates, Inc. Written by Lee R. Bobker.

VISUAL	AUDIO
	NARRATOR:
	Whatever the cause . . . however numerous the reasons . . . Johnny Mitchell here embarks on a difficult and perilous journey!
	(*We hear actual dialogue in background*)
	"Caught in the act"—this . . . in the words of the profession.
	Apprehended during the commission of a felony . . .
	Burglary . . . resisting arrest . . . assault on a police officer . . . carrying a dangerous weapon . . .
The camera is always intent on observing the impact of procedure on the prisoner. In a hundred small ways, we sense that beneath the cold, arrogant façade, there is a very disturbed, frightened human being.	All these making stronger the already strong case against Johnny Mitchell. He is booked . . . He is permitted a single telephone call . . . which he does not make. There is no one to call.
	Detention . . . pending arraignment and trial. Provision is made for Johnny Mitchell to have legal counsel. This is not the first time in his young life that Johnny Mitchell has felt the cold touch of iron . . . But it is his most serious to date.
Divested of his small belongings and of some of his protective armor, we see him placed in a cell with a variety of others. The drunk, the disorderly, the mean and the mad. The door closes. We view Mitchell through the bars.	If there is any accuracy at all in our developing science of statistics . . . it will not be the last.
We pan the faces of his fellow detainees and finally freeze frame on Mitchell, still defiant, isolated, separated, awaiting what?	(*The snare drum, which is our leitmotif and probably the only music we will use, begins again its slow, low-level rhythm as the frame arrests.*)
A long dissolve into a series of shots showing detention as it is in various parts of the country, from its worst to its best. And a succession of pan shots over faces of prisoners in detention.	According to *Uniform Crime Reports*, there were, in 1964, over 2,600,000 serious crimes reported to the police.

55,600 men, women, and youths are placed into detention awaiting trial each year. The term of this detention may vary from a few hours to months . . . even years.
The place of detention may vary from a county jail to a large city prison.

Dissolve to:

ECU: EDWARD HENDRICK
Superintendent of Prisons
City of Philadelphia

We illustrate the comments being made by our interviewee by giving, in brief screen time, a good, hard look at detention U.S.A. circa 1966.

(*Now the narrative is taken over by a leading, outspoken figure in the corrections field—one in charge of, or associated with, houses of detention. He will discuss in honest, "no holds barred" style the wide variance within places of detention throughout the country. This is not a dull, on-camera talk, but rather a dramatic, hard-hitting revelation of the wide divergence within our system in this crucial first period of correction.*)

From the last ECU of the face of a prisoner in a house of detention, we dissolve back to our arrested frame where Johnny Mitchell is. And, again, dissolve to a succession of impressionistic details concerned with arraignment and trial. These are photographed as seen from the emotional and psychological viewpoint of the prisoner.

NARRATOR:
The prisoner is arraigned . . .
(*Dialogue from arraignment*)
Returned to his place of detention to await trial . . .

(*Dialogue*)

CU: *A well known and well respected jurist,* JUDGE JOHN BIGGS, JR., *Former Chief Justice, U.S. Court of Appeals, Third Circuit, Philadelphia*

Dissolve to:

A visualization of the Judge's comments

JUDGE BIGGS:
(*Our Judge discusses the question of sentence and its relationship to the crime. He views the tremendous range throughout the nation and quotes other judges' statements on how they arrive at term of sentence. He touches on the great need for information on the background of the offender—so sorely lacking in most cases—and the nature of that information. He projects what may lie ahead for Johnny Mitchell if he is sentenced to state prison. He makes the key point that Johnny's*

As Johnny's trial proceeds, we center on those elements that underscore the Judge's comments.

future depends almost entirely on what happens to him from here on in, thus making ironic the loss of public interest at the point it should be highest.)

Note that the content of the dialogue sequences is indicated, giving the director an idea of what the dialogue should cover. The screenwriter must be very specific here in order to avoid a lot of wasted time and effort. It is generally very difficult to elicit realistic dialogue, and the director has a chance to succeed only if the screenwriter has been explicit in his description of the dialogue content of each sequence.

THE TV COMMERCIAL

The relationship between the rough storyboard and the final storyboard for a TV commercial is similar to that between the screen treatment and the shooting script for the theatrical film. The final storyboard works out in complete detail what the rough storyboard only indicated. Figure 7 shows the storyboard in its finished form. The key elements of each major scene are depicted, with the copy that accompanies the scene printed below the picture. The complete storyboard is usually rendered in color. It serves the director, cameraman, and editor in the same manner as does the shooting script for the theatrical or documentary film, but it is less likely to be changed during production. Often a full written script accompanies the storyboard, providing additional instructions regarding visual detail, music and sound effects, and other specifics involved in making the TV spot.

THE ANIMATION FILM

Since the animation film ultimately consists of thousands of frames, each of which must be rendered individually, its "script" must be the most specific of all film types. The rough storyboard, which depicts only key sequences, must now be developed into a fully rendered color storyboard providing individual frames for each scene in the film. This storyboard will also be accompanied by a fully written shooting script similar to that of a live film. In addition, as part of the script stage the animation artist must create rough drawings of *every* frame in the film. These sketches are discussed with the writer and chief animator and revised before moving into actual production.

VISUAL AND DRAMATIC INSTRUCTION

The form in which the script is written is, of course, far less important than the content. For the screenwriter, the most important goal is that the shooting script fully realize his initial concept of the film. The simplest and most effective way to write visual and dramatic instructions is first to describe the scene, covering

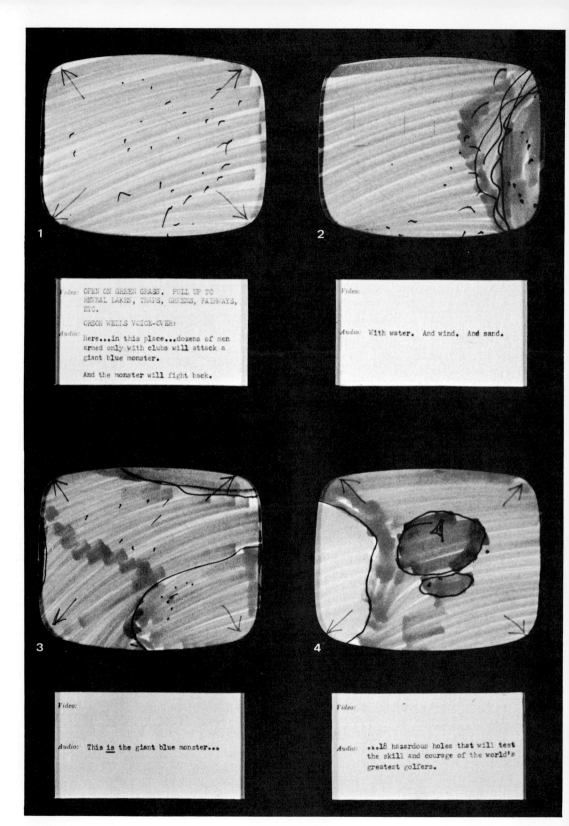

▲ FIGURE 7 ▶

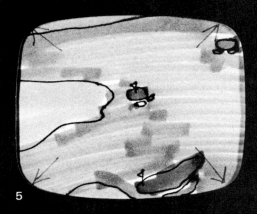

5

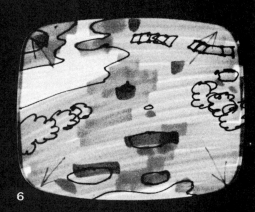

6

Video:

Audio: Be here when they attack.

Video:

Audio: March first through March fifth
at the Doral-Eastern Open.

7

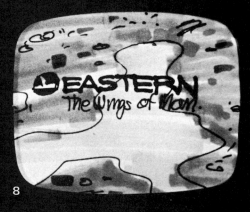

8

Video:

Audio: Sponsored by Eastern Airlines...
The Wings of Man.

Video: (SUPER)

Audio:

only those observed elements that have a significant relationship to the theme of the film or the point of the sequence, and to add action instructions only when they are relevant to the development of the film or necessary for the director's and actor's understanding of the character.

Many beginning screenwriters tend to waste time and space with descriptive jargon like *fade-out, diss,* and *segue to,* or with excessively detailed camera instructions, such as: "The camera now begins a slow dolly in toward the group, moving slightly to the right and finally centering on an ECU of Marie. On her final words, it rises almost imperceptibly on a crane, returning to an extreme close-up shot of the group."

Here the writer is taking over the director's job and making the reading of the script very tedious. In dealing with the visual elements of the script, it is quite sufficient for the writer to communicate his overall concept of each scene, leaving the specific camera moves to the director. The overwritten script segment above could easily be reduced to: "Long shot: Marie (as dialogue proceeds camera moves in). Return to wide shot of group." In short, visual instruction should be sufficiently detailed to indicate clearly the major elements to be seen, but it should never get bogged down in technical language or excessive description.

The same principle applies to the writer's dramatic instructions. Key elements that reveal character or that are significant in terms of story development should be indicated by the writer. But, again, there is nothing to be gained by filling a script with a thousand irrelevant "action" instructions. The following excerpt from *The 29th Summer* contains many essential dramatic instructions that give the filmmaker insight into the writer's intention, but it also contains far too many extraneous details. The underlined segments tend to preempt the directorial function and clutter the script without adding anything of value. The tinted segments are important.

79 INT: ANNIE'S MOTHER'S APARTMENT—SEVERAL DAYS LATER: MS[4]

It is late morning and Annie is in the kitchen with her mother, MRS. GREENSEN. *The atmosphere is tense and Annie seems ready to flare up each time her mother speaks. Her mother putters around the kitchen while Annie sits at the table smoking a cigarette. Mrs. Greensen seems to have an unfailing instinct for saying the wrong thing.*

 MOTHER
Annie, you smoke too much . . .

80 ANNIE

Closes her eyes and throws her head angrily

 ANNIE
Ma, for the love of heaven . . .

[4] From Emanuel Frachtenberg, *The 29th Summer* (adapted from the novel by Dr. Theodore I. Rubin).

81 CS: MRS. GREENSEN

> MOTHER
>
> (*mimics in sing-song chant*)
> For the love of heaven . . . for the love of heaven . . . whenever I look you're with the cigarette . . . a regular chimney.

82 *Annie crushes her cigarette in the ashtray angrily . . . she seems determined to avoid a fight with her mother.*

> ANNIE
>
> All right . . . it's out . . . you happy now?

83 MS:

But Annie's mother can't be turned aside that easily . . . she moves to the table to face Annie and to continue the discussion . . . she finds a way to relate the point to larger and more important things.

> MOTHER
>
> (*her voice trembles with self-pity*)
> Annie, I know in your eyes I'm nothing . . .

Annie makes small, protesting gestures, but her mother rides right through her objections.

> MOTHER
>
> . . . an old woman . . . stupid . . . ignorant . . .

> ANNIE
>
> You're not old and you're not . . .

> MOTHER
>
> (*continues through Annie's protest*)
> . . . but there are some things I know . . .

She puts her hands on her chest and continues beseechingly.

> MOTHER
>
> Believe me, Annie . . . I know. Boys don't like a girl should smell from tobacco . . . smoke . . . a girl has to smell sweet . . . fresh . . .

84 *Annie turns on her mother fiercely.*

> ANNIE
>
> Cut it out, Mom . . . I want you to stop it . . .

(*her voice rises threateningly*)

I want you to stop picking on me.

85 *Mrs. Greensen is injured and somewhat taken aback by the vigor of Annie's response.*

MOTHER

I'm not picking, Annie . . . if I open my mouth to say one word you get excited . . . I don't know what it is these days . . . the young people are so nervous . . . all right, I'll keep my mouth shut and you won't be nervous.

86 MCS: ANNIE

Annie is annoyed with herself for losing her temper.

ANNIE

Oh Ma . . . what's the use?

Mrs. Greensen busies herself in the kitchen, maintaining an injured silence. After a long, uncomfortable silence Annie changes the subject.

It should also be noted that although contemporary editing styles vary greatly, the script should indicate the kind of editing the writer envisions. Even the most convoluted and seemingly formless editing should be indicated in the script. To be sure, the editor may ultimately do something entirely different from what the writer suggests, but the basic concept must be present in the script so that from the outset there will be a unified plan from which others can work. If the final script is muddy and confused, everyone who works with it will be free to "do his own thing"—to distort it or change it beyond recognition. The result can only be chaos—and an unsuccessful film.

A good example of such confusion is the film version of D. H. Lawrence's novel *Women in Love*. The initial film script contained so many extraneous and unresolved ideas that it left the director, cameraman, and actors free to interpret the material according to their own views. As a result, although the film contains many excellent scenes and interesting ideas, it never comes off. To someone who has not read Lawrence's book, the film seems pointless and made up of several different stories. It is filled with half-starts, with scenes that lead nowhere; the director and actors seem to be working at cross-purposes. Individual performances shift with every major sequence, and the camera style often seems inappropriate to the content of the scene. All these shortcomings can be directly attributed to inadequacies in the initial script.

For example, the drowning of the two young lovers, coming as it does at the height of a festive lawn party, serves the cause of melodrama, but its significance in the overall design of the film is totally obscured because it comes so suddenly and is directed for its own sensational, dramatic value. Lawrence's view of the destructiveness of male-female relationships is never really developed with regard to the young victims, so their tragic deaths seem meaningless in the larger scheme of the film.

The naked wrestling sequence has a similar lack of effect. Beautifully photographed, with much attention paid to homosexual overtones, the sequence begins and ends within itself. The events that lead up to it and the impact of the physical contact on the two men are never developed or woven into the action of the film, so the sequence, although sensational, remains unrelated to the rest of the film.

The entire film is filled with an attractive but inappropriate camera style that changes with each sequence. The firelit wrestling is photographed in an overstated romantic manner; the drowning in an overlit, artificial style of the 1930s; and the final scenes in Switzerland seem garish and overlit, much in the manner of a musical. The performances too are inconsistent. Each actor seems to have a different approach to the film. For example, Oliver Reed plays his role with a strange theatrical pretentiousness, while Glenda Jackson underplays hers in almost documentary or improvisational style. It is almost as if the film had several directors, or as if Russell were making his directorial decisions as he went along, with no prior thought or planning. The original failure of the script to clarify intent and style, coupled with the director's normal lack of discipline, accounts for much of the film's problem.

It is important to remember that the script is *not* the film—it is no more and no less than a guide for the filmmaker and for all those involved with the film's production (director, actors, cameraman, editor). The script serves only to communicate a unified concept of the motion picture to be created. Too much detail can turn a blueprint into a straitjacket. The best scripts contain just enough material to clearly communicate the writer's vision while leaving the filmmaker free to expand, change, and enrich the film.

DIALOGUE

Writing film dialogue is even more complex than writing visual description. It is a game totally devoid of rules. The screenwriter must analyze and understand his characters so thoroughly that the dialogue seems always to come from them. Too often a "great line" or a "witty riposte" is delivered by a character who would never have said it, and the illusion of reality is destroyed.

Film dialogue has changed significantly over the past decade. The polished, calculated lines of the old Hollywood films are being replaced by dialogue that is often fragmented, incomplete, interrupted. Dialogue in contemporary films is highly intuitive, revealing a character's inner self, and it is written and delivered much more in the manner of real speech. Note the dialogue in the following scene from Paddy Chayefsky's film *The Hospital.*

75 INT. BOCK'S OFFICE—OUTER OFFICE[5]

as Barbara Drummond, carrying her coat and purse, comes in. Bock has apparently turned the lights on for her, but Bock himself is not immediately visible. She looks through the half-open door to Bock's private office, and there he is, seated soddenly at his desk, staring blankly at the bottle of booze on the desk. Barbara starts to say something, thinks better of it, lays her coat down, and, looking around Miss Lebow's desk, spots a Manhattan classified directory which she hauls up from its shelf and sets on Miss Lebow's desk. She sits, quickly flips through the pages.

[5] From Paddy Chayefsky, *The Hospital;* used by permission.

ACROSS *Barbara at Miss Lebow's desk, flipping through the directory looking through the half-opened doorway to a partially visible Bock in b.g. at his desk, sitting soddenly. Barbara finds what she wants, opens her purse and takes out two airplane tickets. She dials. The* CLICKING *of the dial catches Bock's ear. He looks up for a moment and then returns to his sodden state.*

> BARBARA
> (*on phone*)
> Hello, Keefe and Keefe? . . . No, it's not an emergency. I'd like to arrange an ambulance for tomorrow afternoon . . . Thank you . . .

REVERSE ACROSS *Bock at his desk with Barbara partially visible at Miss Lebow's desk in the outer office. All he can see of her are her great long tanned legs.*

> BARBARA
> (*in b.g. on phone*)
> How do you do? . . . I would like to arrange for an ambulance at half-past one tomorrow afternoon . . . Drummond, first name, Barbara. I'll pay cash . . .

Bock stands a little unsteadily and moves around his desk to get a better look at those legs.

> BARBARA (*Contd.*)
> (*on phone*)
> No, you're to pick up my father, Drummond, Edward, at the New York Medical Center, Holly Pavilion, Room Four-oh-six. It's a stretcher case. I presume you provide the stretcher.

Senses Bock looking at her, turns to him, smiles. She's a very beautiful girl. She returns to the phone.

> BARBARA (*Contd.*)
> He's to be taken to American Airlines at Kennedy Airport, Flight Seven-Two-Nine to Yuma, Arizona. I'll accompany the patient. I don't suppose you provide intravenous equipment . . . No, I'll take care of all that here . . . Yes, very good, thank you.

She returns the receiver to its cradle. When she looks up again to the doorway, Bock is no longer there. She returns the flight tickets to her purse, snaps it shut, stands and moves to the doorway, enters a step into—

76 INT. BOCK'S OFFICE

Bock, back at his desk, looks up.

> BOCK
> Do you believe in witchcraft, Miss Drummond?

> BARBARA
> I believe in everything, Doctor.

BOCK

Like a drink?

BARBARA

Yes.

Bock drains his glass and pours the girl a hefty shot of bourbon.

BARBARA

(*from the doorway, suddenly*)

My father, you should know, was a very successful doctor in Boston, a member of the Harvard Medical faculty. He was a widower, and I was his only child. He was not an especially religious man, a sober Methodist. One evening, seven years ago, he attended a Pentecostal meeting in the commons rooms at Harvard and suddenly found himself speaking in tongues.

(*she takes her drink and crosses to the sofa*)

That is to say, he suddenly sank to his knees at the back of the room and began to talk fluently in a language which no one had ever heard before. This sort of thing happens frequently at Pentecostal meetings, and they began to happen regularly to my father.

(*she sits*)

It was not unusual to walk into our home and find my father sitting in his office, utterly serene and happily speaking to the air in this strange foreign tongue. I was, at that time, twenty years old and having my obligatory affair with a minority group, in my case a Hopi Indian, a post-graduate fellow at Harvard doing his doctorate in aboriginal languages of the Southwest. One day, I brought the Indian boy home just as my father was sinking to his knees in the entrance foyer in one of his trances. The Indian wheeled in his tracks and said: "Well, I'll be a sonofabitch." You see, my father was speaking an Apache dialect, an obscure dialect at that, spoken only by a ragged band of unreconstructed Apaches who had rejected the reservation and were living in total isolation in the Sierra Madre Mountains of northern Mexico. Well! What do you say to that, Doctor Bock?

BOCK

(*who has been staring at the girl as if she were insane*)

What the hell am I supposed to say to that?

Barbara throws back her head and roars with laughter.

BOCK (*Contd.*)

I'm sitting here boozing and, all of a sudden, you start telling me some demented story about your father's religious conversion.

BARBARA

No, no, you miss the point, Doctor. Not my father's conversion—mine. You see, I had been hitting the acid pretty good at that time. I had achieved some minor sensory deformities, a few suicidal despairs, but nothing as wild as flu-

ency in an obscure Apache dialect. I mean, like wow, man! I mean, here was living afflatus right before my eyes! Within a week, my father had closed his Beacon Hill practice and set out to start a mission in the Mexican mountains. And I turned in my S.D.S. card and my crash helmet and followed him. It was a disaster, at least for me. My father had received the revelation, not I. He stood gaunt on a mountain slope and preached the apocalypse to solemnly amused Indians. I masturbated a great deal. We lived in a grass wickiup and ate raw rabbit and crushed piñon nuts. It was hideous. Within two months, I was back in Boston, a hollow shell and dizzy with dengue, disenchanted with everything. I turned to austerity, combed my hair tight and entered nursing school. I became haggard, driven and had shamelessly incestuous dreams about my father. I took up with some of the senior staff at the hospital. One of them, a portly psychiatrist, explained I was generated by an unresolved lust for my father. I apparently cracked up. One day, they found me walking to work naked and screaming obscenities. There was talk of institutionalizing me, so I packed a bag and went back to my father in the Sierra Madre Mountains. I've been there ever since, that's three years. My father is, of course, as mad as a hatter. I watch over him and have been curiously content. You see, Doctor, I believe in everything.

She pauses, her story over. Throughout all this, Bock has been trying to keep his glowering eye on the desktop. Once, during her long narration, he seized the bottle of bourbon and swigged from it. But, mostly, he is finding the whole experience murkily sensual. His glance keeps darting out from under his lowering brows to catch quick, surreptitious looks at the beautiful long tanned legs; or, when the girl bends for the drink she set on the floor between sips, to peer down the flapping open scalloped neck of her dress; she is obviously bra-less. The girl has been crossing and uncrossing her legs, bending, once or twice stretching, so that her brief dress has ridden up almost to her waist and is saved from utter exhibitionism only by the darkness of the shadows she is sitting in. She seems unaffected by Bock's voyeuristic interest in her, but she surely is not unaware of it. It is hard to believe she is not courting his attention.

> BOCK
> (*after a long moment*)
> Now, what was that all about, Miss Drummond?

> BARBARA
> I thought I was obvious as hell. I'm trying to tell you I have a thing for middle-aged men.

> BOCK
> I admire your candor.

> BARBARA
> You've been admiring a lot more than that.

Bock looks up, and the two of them suddenly find their eyes locked. The dark, dense air in the room fairly steams with incipient sexuality.

BOCK

(*looks down again*)

You're wasting your time. I've been impotent for years.

BARBARA

Rubbish.

With a crash of his fist on the desktop, Bock stands; he is in a drunken rage.

BOCK

(*lurches about*)

What the hell's wrong with being impotent? My God, you kids are more hung up on sex than the Victorians! I have a son, twenty-three. I threw him out of the house last year. Pietistic little humbug. He preached universal love and despised everyone. He had a blanket contempt for the middle class, even its decencies. He detested my mother because she took such petit bourgeois pride in her son the doctor. I cannot tell you how brutishly he ignored that rather good old lady. When she died, he refused to go to the funeral. He thought the chapel service a hypocrisy. His generation didn't live with lies, he told me. Everybody lives with lies, I said. I grabbed him by his poncho, dragged him the full length of our seven-room despicably affluent middle-class apartment and flung him out. I haven't seen him since. But do you know what he said to me as he stood there on that landing on the verge of tears. He shrieked at me: "You old fink! You can't even get it up anymore!" That was it, you see. That was his real revolution. It wasn't racism and the oppressed poor and the war in Vietnam. The ultimate American societal sickness was a limp dingus. Hah!

(*he lurches about laughing rustily*)

By God, if there is a despised and misunderstood minority in this country, it's us poor impotent bastards. Well, I'm impotent and proud of it! Impotence is beautiful, baby!

(*he raises his hand in the clenched fist of militancy*)

Power to the Impotent! Right on, baby!

BARBARA

(*smiling*)

Right on.

BOCK

(*stares drunkenly at the girl*)

When I say impotent, I don't mean merely limp. Disagreeable as it may be for a woman, a man may sometimes lust for other things, something less transient than an erection, some sense of permanent worth. That's what medicine was for me, a raison d'être. When I was thirty-four, Miss Drummond, I presented a paper before the annual convention of the Society of Clinical Investigation that pioneered the whole goddam field of immunology. A breakthrough!

I'm in all the textbooks. I happen to be an eminent man, Miss Drummond. And you want to know something, Miss Drummond? I don't give a damn. When I say I'm impotent, I mean I've lost even my desire for work, which is a hell of a lot more primal a passion than sex. I've lost my raison d'être, my purpose, the only thing I ever truly loved. It's all rubbish anyway. Transplants, antibodies, we manufacture genes, we can produce birth ectogenetically, we can practically clone people like carrots, and half the kids in this ghetto haven't even been inoculated for polio! We have assembled the most enormous medical establishment ever conceived, and people are sicker than ever! We cure nothing! We heal nothing! The whole goddam wretched world is strangulating in front of our eyes! That's what I mean when I say impotent! You don't know what the hell I'm talking about, do you?

BARBARA
Of course, I do.

BOCK
I'm tired, I'm terribly tired, Miss Drummond. And I hurt, and I've got nothing going for me anymore. Can you understand that?

BARBARA
Yes, of course.

BOCK
Then can you understand that the only admissible matter left is death?

He suspects he is going to cry, and he turns quickly away and shuffles back to his seat behind the desk. He sits heavily and fights his tears.

BARBARA
(*after a moment*)
Sounds to me like a familiar case of morbid menopause.

BOCK
(*mutters*)
Oh, Christ.

BARBARA
Well, it's hard for me to take your despair very seriously, Doctor. You obviously enjoy it so much.

BOCK
Oh, bugger off. That's all I need now, clinical insights. Some cockamamie twenty-five-year old—

BARBARA
Twenty-seven—

BOCK
—acidhead's going to reassure me about menopause now. Look, I'd like to be alone, so why don't you beat it. Close the door and turn off the lights on your way out.

They are both suddenly conscious of a third presence in the room. They each look to the door where Mr. Blacktree, the old Indian, fully clothed again and carrying his coat, is standing in the doorway. Barbara uncrosses her long legs and stands.

BARBARA
(crossing to the door)
Mr. Blacktree disapproves of my miniskirt, but it was the only thing I had to come to the city with. Back at the tribe, I wear ankle-length buckskin.

BOCK
(stares at his hands twisting on the desktop; mutters)
Swell. Just close the door and turn off the lights.

For a moment, Barbara regards his hunched form from the doorway and then, murmuring in Apache to the Indian, she exits, closing the door after her. In the moment of hush that follows, a very near clap of thunder suddenly RUMBLES and CRASHES. A whirl of wind sweeps the rain outside SLASHING against the dark window panes. The sounds go unheeded by Bock, who sits as still as marble. After a moment he slowly raises his head and sighs and then fishes about in his jacket pockets to bring out the bottle of potassium and paper-wrapped hypodermic syringe. He stands, takes off his jacket, rolls up his shirtsleeve, pokes about for the vein. He removes his trouser belt, which he ties tightly about his upper arm for a tourniquet, the tail of the belt dangling like a phylactery. Now, he tears the wrapping off the syringe and fits the needle to it. He goes back to his jacket again, fiddles about in the pockets and finally finds a crumpled pack of cigarettes. He lights one up and returns to the business of killing himself, puffing away expressionlessly as he does. The thunder RUMBLES o.s., and the rain SLASHES. He carefully draws just the right amount of potassium from the bottle to the syringe, peering at the procedure against the light of his desk lamp. He sets the cigarette on the ashtray, switches the hypodermic to his right hand, holds his left arm rigidly out under the light of the lamp—

BARBARA'S VOICE (off screen)
What're you shooting, Doc?

He turns slowly to the doorway, his bare left arm still rigidly extended, the belt dangling, the hypodermic clenched in his other hand. The tall, handsome girl is standing framed in the doorway, her overcoat over her arm. He stares at her, slowly suffusing with the numb, total, blind rage of the aborted suicide. The thunder CRASHES o.s.

BOCK
(grunts, can barely get the words out)
Leave me alone—

She comes affably in on the long, tanned legs, approaches the desk, turns the bottle of potassium around so she can read the label.

BARBARA

Potassium. You take enough of this stuff, it'll kill you, Doc.

(*moves off towards the couch*)

It occurred to me that I might have read you wrong, that you really were sui-cidal. So I came back.

The rage erupts. Bock crashes the hypodermic syringe down on his desk, shatter-ing it, the potassium puddling on the wood.

BOCK
(*hysterical rage*)
Who the hell asked you!

He moves around the desk, a shambling bear of a man, one shirtsleeve rolled up, a leather belt dangling dementedly from that arm, tears coursing down his cheeks, for he has begun to cry. He advances slowly on her in a sort of stuperous shuffle.

BOCK
(*roaring*)
Who the hell asked you!

She regards his lumbering approach with a faint, grotesquely sensual smile of anticipation. He reaches with his naked left arm to the neck of her dress and, with one savage wrench, rips her stark naked, shouting, sobbing through hysteri-cal tears:

BOCK
Leave me alone! Why the hell don't you leave me alone!

He is on her, crushing her back down into the shadows of the couch, ravening at neck and shoulders in a heavy, brutish assault, sobbing out:

BOCK
Why didn't you let me do it? Who the hell asked you!—

Throughout the above, CAMERA MOVES SLOWLY IN *through the flesh and fury to an* INTENSE TWO-SHOT *of the two participants in this terrified act of love. Then slowly to C.U. of the girl over Bock's plunging shoulder. She suddenly gasps at the moment of penetration, and then her lovely face slowly shapes into smiling se-renity. Bock sobs; even in the shadows we can see the glistening path of the tears on his cheek.*

ABRUPT SILENCE.

Successful dialogue reveals the internal lives of the characters. In order to write such dialogue, the filmmaker must possess an ear for real speech patterns *consistent* with the character, an ability to communicate through a character's speech subconscious or hidden aspects of his personality, and an ability to clearly delineate the differences between characters. This last point is not so simple as it may seem. In many films, all the characters tend to talk alike. Many of the

film scripts of the literate English writer Robert Bolt (*Lawrence of Arabia, Dr. Zhivago, A Man for All Seasons*) suffer from this fault. Whether Bolt's characters are witty, romantic, or daring, they all sound exactly the same. Thus many of the conversations between, for example, Lawrence and the Arab Prince Feisal sound like dialogues between Lawrence and himself.

It is important for the filmmaker to remember, however, that dialogue alone cannot carry a film. Film has grown into a tremendously expressive and communicative medium primarily because of its visual elements. Thus the writer should reserve for the dialogue only those things that people communicate through speech. It is not necessary to "tell" the entire story through long speeches. The didactic "explanation" given in the dénouement of an Agatha Christie novel or in the first scene of an old-fashioned play in which the maid, in answering the telephone, reviews the events of the past twenty years, is neither useful nor relevant in modern films.

It is also important to note that dialogue can be used to conceal as well as to communicate. In film what is unsaid is often as important as what is said. For example, the leading character in *Five Easy Pieces*, Bobby Dupea, talks a great deal throughout the film but says very little directly about himself and his problems. He uses language not only to communicate with others but to hide from them. Yet the very fact that Bobby engages in so much seemingly pointless dialogue tells us a great deal about him. Even when Bobby does talk directly and specifically about his fears and his inner self, as in the moving scene with his father, who cannot respond because of a stroke, his dialogue is fragmentary, haunting, unformed, and oblique.

NARRATION

Writing narration is one of the most difficult tasks for a screenwriter. Narration is rarely used in dramatic "story" films; it is generally used today only in documentary or educational films. Because modern documentary films are relying increasingly on visual and editing techniques to convey the story line, the old-fashioned "telling" narrative is almost obsolete. Currently, the real function of film narrative is to add a dimension to the film that the visual elements and dialogue sequences alone cannot convey. For example, the use of first-person narrative to provide a point of view that is otherwise unavailable is a valid use of narration. Here, however, the narrative must be consistent with the identity of the speaker. This restricts the writer, for he must remain within the confines of what the narrator could possibly know or would possibly say. The following is an excerpt from the narrative of a short educational film, written from the viewpoint of a ten-year-old Thai girl. Note that her narration, which adds a refreshing quality to the film, gives only information appropriate to the speaker's age and experience.

RAZI (*ten-year-old child*)[6]
My country is called Thailand . . . we say Prä ted′ Thai.

[6] From *The River, My Home: Family of the River.* Prepared for McGraw-Hill Book Company by Vision Associates, Inc. Written by Lee R. Bobker.

The rivers of my country are very important. They are like roads and all the things people need travel by boats over the water. It is the river that joins all the people and all the parts of my country.

I live on a large boat that my father owns, but sometimes I think that this river, called Chao Phraya, is really my home.

I am called Razi . . . and always I am on the river in this wonderful boat.

My father gets his cargo at the docks in Bangkok.

Today, we are loading salt—we buy the salt from a merchant of the city . . . he will have it loaded onto our boat and we will carry it many miles up the river and sell it at many small villages in the north.

My job is to count each bucket of salt so we do not pay for more than we get.

It is a very important job.

Each time I see a bucket of salt emptied into our boat, I put a stick into the unloaded salt. We will pay only the number of sticks I have put up.

Everyone in my family has a job to do.

My mother helps spread the salt evenly in the boat so it will ride more smoothly on the water.

We do not like it when it rains before we have loaded our boat. This means we must hurry our work so the salt will not get wet. Once the salt is in our boat, it is our responsibility.

As soon as we are fully loaded, we hire a tugboat to carry us up the river.

Sometimes, I just like to sit in the front of my boat with my brother and watch the river go by.

I help my mother take care of my little brother and my baby sister.

The baby has a rash so we put little mittens on her hands so she won't scratch herself and we put powder and oil on her.

Other effective forms of narration in documentary films include the use of excerpts from documents related to the subject of the film (as in NBC's fine film on Van Gogh, in which the letters between Vincent and his brother Theo provided the narrative), use of related poetry or prose quotations that provide insight into the subject or give it added scope (as in the ABC show on Africa that employed works of Hemingway, Isak Dinesen, and other writers on Africa), and use of the narrator to add emotional force to the film (for example, Orson Welles's compassionate narrative for Al Wasserman's classic documentary on mental illness, *Out of Darkness*). The narration for *Out of Darkness* was excerpted from an eighteenth-century book written by a former patient in a Glasgow mental hospital. This narrative device provided rich dramatic value when used in conjunction with the on-screen action. Other narration was provided by a physician, but it was the Welles narrative that gave the film its special quality.

SCENE 1 (PROLOGUE)[7]

Medium long shot of Orson Welles seated at lectern with an open book in front of him. He is spotlighted against a black background. Camera dollies in to medium closeup. Welles begins to read from the book.

WELLES

A tree, as it stands isolated on the plain or companioned by thousands in the forest, bears within its bark all the material for rapid combustion. For all so cool and green as it looks, the elements of its destruction are circling through it—through branch and trunk, leaf and root. Between the tree and the fire, and man and madness, a close analogy exists—and then they part. The fire must come to the tree; man can go and seek madness—can toil, and pray, and suffer, and as it were go a-courting of this fearful bride. And numberless are the paths . . .

Lights fade out and Welles finishes reading in darkness.

. . . which lead to the region of darkness in which she dwells.

Fade out:
Fade in:

SCENE 2—MAIN TITLES

A. *Out of Darkness*

 Fade out:
 Fade in:

Woman's voice singing "Greensleeves" with orchestra building underneath.

B. *Pan Title:*

 1. The Reader: Orson Welles
 2. Medical Narrator: Dr. William C. Menninger
 3. A CBS Public Affairs Program
 4. Produced in Consultation with The American Psychiatric Association and The National Association for Mental Health

[7] From Al Wasserman, *Out of Darkness* (CBS, 1956). Reprinted by permission of the author and Columbia Broadcasting System, Inc.

5. Out of Darkness *is an actual filmed record, largely photographed through one-way glass, of three months in the life of Doris L., a patient in a mental hospital. It is a story of new hope and promise for the mentally ill.*

Orchestra out, and woman's voice finishes alone.

Fade out:
Fade in:

SCENE 3

Medium close shot side angle of Orson Welles.

WELLES

During the next hour and a half we're going to journey through the world of mental disorder—a world unknown and feared by most of us, but not nearly so desolate of hope as we might imagine. One of our guides will be this book.

He points to book on lectern.

SCENE 4

Cut to book on lectern. The cover reads, The Philosophy of Insanity 1860.

It's a remarkable book, written almost a hundred years ago by a former patient in a mental hospital in Glasgow, Scotland.

DISSOLVE TO:

SCENE 5

A bookshelf in Dr. Menninger's study. Pan across books, revealing Dr. Menninger seated on an easy chair as he finishes replacing a book on the shelf. He turns to camera, acknowledging Welles' introduction.

Our other guide will be a doctor. Dr. William C. Menninger, one of our most eminent psychiatrists.

SCENE 6

Welles continues.

Through these two voices, one from the present, one from the past,

perhaps we will be able to gain some measure of insight into one of the most urgent health problems of our time, and into that vast and greatly misunderstood portion of humanity, the mentally ill.

And now from the book . . .

He gestures toward the book.

Camera dollies back obliquely to long-shot, front angle of Welles. He begins to read from the book.

SCENE 7

Medium closeup— Welles

I am not a medical man. My claim to be heard is founded not upon education or position but solely upon what I have seen and what I have suffered. For seventeen years I have been in communication with insanity, and for a long time I have been impressed with the idea that could this disease be rendered more familiar, and of course less repulsive to the public mind, its chance of being checked and subdued in the first stage would be much greater. In the hope of dissipating this dread and freeing the bright spirit of hope from the talons of despair, I have written this little book; and, while keeping truth in view, I have endeavored to strip lunatic asylums of all imaginary terrors and to render them familiar to the public view.

Fade out:
Fade in:

SCENE 8

EXTERIOR, DAY.
Extreme long shot, high angle, of bus entering hospital grounds.

SCENE 9

Medium long shot; bus enters hospital grounds and approaches sign in foreground reading Metropolitan State Hospital.

SCENE 10

Close shot of sign as bus passes in background.

SCENE 11

Full shot—interior of bus, containing a group of new patients arriving at the hospital. A row of women seated on the left side of the bus with the nurse front; a row of men on the left side.

SCENE 12

Medium closeup—Doris, the patient whose progress will be followed during the course of the film.

WELLES (*voice over*)
Lunacy, like rain, falls alike . . .

SCENE 13

2 shot, two of the new male patients.

. . . upon the evil and the good, and although . . .
. . . it must forever be a fearful misfortune . . .

SCENE 14

Medium closeup—another male patient.

. . . yet there is no more sin or shame in it than there is . . .

SCENE 15

Long shot—hospital grounds seen from window of bus.

SCENE 16

Medium closeup—Doris in bus

. . . in rheumatism or a fever.

SCENE 17

Extreme long shot high angle of bus turning corner and slowing down, seen through barred window.

Dissolve to:

SCENE 18

Low angle ward building seen through fence in foreground with sign reading WARD 29.

Dissolve to:

SCENE 19

INTERIOR, WARD 29.

WELLES (*voice over*)

Long shot—ward corridor. A row of patients seated along the right wall of the corridor. Doris at the far end of the corridor. She walks slowly up along the left side toward camera.

Doris stops at the end of the corridor and stands looking out at the Day Room.

Had I the certainty of an attack of insanity before me, and the power to prescribe for myself, I would say, "Put me in a place where I can do no harm to myself or any other person; and let that place not be a prison in which punishment must be suffered and penance undergone, but let it be a place of refuge . . .

SCENE 20

Long shot of one end of the Day Room. Pan across to Day Room, revealing patients sitting on chairs in various attitudes or walking up and down aimlessly. We hold as the corridor at the far end of the Day Room comes into view.

. . . an asylum."

SCENE 21

Full shot—Doris seated on chair at far end of Day Room near corridor.

Among the pitfalls to avoid in writing narrative are lush, overwritten, pseudo-poetic narration; didactic or "telling" narration, which tends to become tedious and boring; and narration loaded with inappropriate jargon or heavy descriptions that slow the pace of the film and destroy its effect.

The following script excerpts illustrate effective use of narration. Note the simplicity and naturalness of language and the fact that in each case the narrative does not function in *direct* relationship to what is being seen and heard on screen.

From as far West as Idaho,[8]
Down from the glacier peaks of the Rockies—
From as far East as New York,
Down from the turkey ridges of the Alleghenies
Down from Minnesota, twenty five hundred miles,
The Mississippi River runs to the Gulf.
Carrying every drop of water, that flows down two-thirds the continent,
Carrying every brook and rill, rivulet and creek,

[8] From Pare Lorentz, *The River*, 1937; used by permission.

Carrying all the rivers that run down two-thirds the continent,
The Mississippi runs to the Gulf of Mexico.
Down the Yellowstone, the Milk, the White and Cheyenne;
The Cannonball, the Musselshell, the James and the Sioux;
Down the Judith, the Grand, the Osage, and the Platte,
The Skunk, the Salt, the Black, and Minnesota;
Down the Rock, the Illinois, and the Kankakee
The Allegheny, the Monongahela, Kanawha, and Muskingum;
Down the Miami, the Wabash, the Licking and the Green
The Cumberland, the Kentucky, and the Tennessee;
Down the Ouchita, the Wichita, the Red, and Yazoo—
Down the Missouri three thousand miles from the Rockies;
Down the Ohio a thousand miles from the Alleghenies;
Down the Arkansas fifteen hundred miles from the Great Divide;
Down the Red, a thousand miles from Texas;
Down the great Valley, twenty-five hundred miles from Minnesota,
Carrying every rivulet and brook, creek and rill,
Carrying all the rivers that run down two-thirds the continent—
The Mississippi runs to the Gulf.
New Orleans to Baton Rouge,
Baton Rouge to Natchez.
Natchez to Vicksburg,
Vicksburg to Memphis,
Memphis to Cairo—
We built a dyke a thousand miles long.
Men and mules, mules and mud;
Mules and mud a thousand miles up the Mississippi.
A century before we bought the great Western River,
 the Spanish and the French built dykes to keep the Mississippi
 out of New Orleans at flood stage.
In forty years we continued the levee the entire length
 of the great alluvial Delta,
That mud plain that extends from the Gulf of Mexico
 clear to the mouth of the Ohio.
The ancient valley built up for centuries by the old river
 spilling her floods across the bottom of the continent—
A mud delta of forty thousand square miles.
Men and mules, mules and mud—
New Orleans to Baton Rouge,
Natchez to Vicksburg,
Memphis to Cairo—
A thousand miles up the river.
And we made cotton king!
We rolled a million bales down the river for Liverpool and Leeds . . .
1860: we rolled four million bales down the river;
Rolled them off Alabama,

Rolled them off Mississippi,
Rolled them off Louisiana,
Rolled them down the river!
We fought a war.
We fought a war and kept the west bank
 of the river free of slavery forever.
But we left the old South impoverished and stricken.
Doubly stricken, because, beyond the tragedy of war,
 already the frenzied century had taken toll of the land.
We mined the soil for cotton until it would yield no more,
 and then moved west.
We fought a war, but there was a double tragedy—
 the tragedy of land twice impoverished.
Black spruce and Norway pine,
Douglas fir and Red cedar,
Scarlet oak and Shagbark hickory,
Hemlock and aspen—
There was lumber in the North.
The war impoverished the old South, the railroads killed the steamboats,
But there was lumber in the North.
Heads up!
Lumber on the upper river.
Heads up!
Lumber enough to cover all Europe.
Down from Minnesota and Wisconsin,
Down to St. Paul;
Down to St. Louis and St. Joe—
Lumber for the new continent of the West.
Lumber for the new mills.
There was lumber in the North and coal in the hills.
Iron and coal down the Monongahela.
Iron and coal down the Allegheny.
Iron and coal down the Ohio.
Down to Pittsburgh,
Down to Wheeling,
Iron and coal for the steel mills, for the railroads driving
West and South, for the new cities of the Great Valley—
We built new machinery and cleared new land in the West.
Ten million bales down to the Gulf—
Cotton for the spools of England and France.
Fifteen million bales down to the Gulf—
Cotton for the spools of Italy and Germany.
We built a hundred cities and a thousand towns:
St. Paul and Minneapolis,
Davenport and Keokuk,
Moline and Quincy,

Cincinnati and St. Louis,
Omaha and Kansas City . . .
Across to the Rockies and down from Minnesota,
Twenty-five hundred miles to New Orleans,
We built a new continent.
Black spruce and Norway pine,
Douglas fir and Red cedar,
Scarlet oak and Shagbark hickory.
We built a hundred cities and a thousand towns—
But at what a cost!
We cut the top off the Alleghenies and sent it down the river.
We cut the top off Minnesota and sent it down the river.
We cut the top off Wisconsin and sent it down the river.
We left the mountains and the hills slashed and burned,
And moved on.
The water comes downhill, spring and fall;
Down from the cut-over mountains,
Down from the plowed-off slopes,
Down every brook and rill, rivulet and creek,
Carrying every drop of water that flows down two-thirds the continent.

NARRATOR [9]
As the population of the world continues to grow, the burden on the fertile earth increases.

In the rural areas of less developed countries, it has become harder and harder to sustain life. Increasing numbers of people leave the land for the cities looking for work.

In the already crowded urban centers, they will find only more hunger, more poverty . . . for there are not enough jobs for those already here.

Under the impact of this endless flow of migrants, transportation systems break down.

The future of the next generation is being lost in overcrowded classrooms.

The aspirations of parents are being defeated because it is impossible to provide the educational needs of their children under the pressure of a continuously rising population.

Health services are unable to cope with the growing tide of human need.

In these less developed nations live three-quarters of the world's population. More than one-half a billion people in India alone . . . one million more being added every month.

[9] From *The Day Before Tomorrow*. Prepared for Planned Parenthood—World Population by Vision Associates, Inc. Written by Lee R. Bobker.

Each day, thousands of men, women, and children come to the city of Calcutta looking for work . . . and the number of unemployed people is already beyond counting.

Latin America has the highest growth rate in the world. If its current rate of growth continues, by the end of this century, Latin America will have to support three-quarters of a billion people.

Unable to provide themselves with an income, these migrants who have come to the city in hope are unable to find a decent place to live. Around many of the cities of the world have grown up whole communities of makeshift, temporary homes . . . called by a variety of names: *favela* . . . bidonville . . . mushroom village . . . shanty-town.

Here, in sub-human squalor, are wasted the lives of countless millions of human beings and here are washed away the hopes . . . the dreams . . . the achievements of governments and men.

Finally, there are the children.
Too many children for the resources available . . .
too many to be cared for . . .
too many to be fed and clothed . . .
too many to be housed and kept warm . . .
too many to be kept healthy . . .
too many to be loved.

This is their world . . . the world into which they have come . . . the world in which they must live.

How long will they wait?

How long will they live in perpetual darkness without hope?

How long before their cries of protest set in motion currents that will be felt everywhere?

How long will the privileged nations live as islands of plenty in this sea of human misery?

VISUAL[10]	AUDIO
	NARRATOR
CUT TO CU: ENGINE *Zoom back to long shot—engine on factory floor*	Now the long road from the safety of sketches and specifications to the reality of flight must be traveled.
As the camera pulls back the entire image recedes to corner of frame followed by multiscreen optical . . .	The calculations . . . the tests . . . all say it can be done.

[10] From *No Simple Thing*. Prepared for Eastern Airlines, Inc., by Vision Associates, Inc. Written by Lee R. Bobker.

capsulizing the work on all parts of the airplane in all parts of the country.

Now the building of an airplane begins.

From England came the engines . . . from Ireland—the engine pods . . . from Tennessee—the wings . . . from California—the flight control system . . . from Texas—the underwing pylons . . . from Canada—the fuselage sub-assemblies . . . from Japan—the fuselage doors . . . from Illinois—the hydraulic systems . . . from Ohio—wheels, tires, brakes . . . from Arizona—gyroscopes.

From the hands and hearts and minds of hundreds of thousands of human beings . . . separated by the seas, and the prairies, and the mountains . . . joined now in common cause.

Multiscreen optical ends with long view of Palmdale hangar to which the camera zooms in.

This becomes a new multiscreen optical which compresses the assembly of the first airplane with shots of the plane emerging from the hangar.

It is over four years since actual work on the L1011 began.

The hours are beyond counting . . . the time spent in the pursuit of excellence, beyond measurement.

The final frame of the multiscreen optical is a circular dolly around the finished airplane zooming up to full frame and we cut sharply to extreme long shot of the desert—the plane standing at the end of the runway off in the distance.

Finally. A great aircraft assumes shape, and form. The first plane—prototype of the many that will follow—is made ready for flight.

*Cut to
plane taking off*

(*Sound of drummers*)

*Cut to succession
of in-flight beauty shots of the
Lockheed prototype plane*

(*Music segues to Handel fugue*)

The plane lands and we dissolve to a succession of beauty impressions around it as the camera circles it.

(*Sound of drummers*)

NARRATOR

In 1903, two men stood in a field in North Carolina.

For twelve seconds, they kept their flying machine ten feet above the ground.

In those twelve seconds, they wrote the preface to an age.

This plane is longer than the entire distance covered by the Wright Brothers' first flight . . .

. . . it is as high as a five-story building.

When carrying fuel, baggage, and passengers it will weigh over 200 tons.

Each engine provides 42,000 pounds of thrust.

The plane itself contains over 250,000 working parts.

It will carry in comfort and safety over 250 passengers.

It will range the heavens, cross a thousand suns in the course of its life.

The final plane shot cuts to overhead shot of worker walking on floor of hangar. Camera zooms back to reveal full hangar with planes under construction.

It is the reflection of the power of the mind of man, another great step forward in the journey that began some seventy years ago on that field in North Carolina.

In summary, narration must be used sparingly and with a purpose other than simply to tell the audience what is happening on screen. The film should be designed to communicate without direct telling, so that narration, if used at all, can be used as a truly creative element rather than as compensation for the film's inadequacies.

AUDIO-VISUAL STIMULI

The entire subject of the effect of combinations of sounds and images on the intellect and the emotions is a very complex one. The total impact of a film on an audience is the result of many individual effects, and the filmmaker should try to keep in mind that every single element is important. Visual elements include the content of each scene; the effects of the preceding and following scenes; the pace of action within the scene; and the pace of the progression from scene to scene, place to place, and time to time. Audio elements include music, dialogue, narration, incidental sounds, and silence. The joining together of these two basic factors creates the totality of audio-visual stimuli that is the essence of cinema. The best filmmakers can use all of these elements to achieve a clearly envisioned result.

One of the best recent sequences for examination is the "chase" scene in the detective film *Bullitt*. Conceived by the filmmaker Peter Yates, it seems on the surface a conventional car chase through San Francisco. However, the skillful blending of visual impact (the rising and falling motion achieved as the camera moved through San Francisco's hilly streets) coupled with the masterful use of audio effects (car sounds, bumps as the bottom or top of a hill was reached, tire squeals, etc.) combine to demonstrate the ability of audio-visual stimuli to involve the audience. Many people had to leave the theater during this sequence because the impact was so real and intense that it became too upsetting.

case history of a film script (*the odds against*)

The following is a step-by-step case history of the writing of a film according to the procedures discussed in this chapter. This account should give the reader a clearer understanding of these procedures and assist him in adapting them to his own needs.

THE IDEA

The original film idea was to produce a thirty-minute documentary on the subject of the failure of our system of corrections. This idea was developed through six months of intensive research, consisting of:

1. Reading and annotating a substantial amount of literature on the subject—recent articles from *Time, Newsweek, Christian Science Monitor, New York Times,* and *St. Louis Post Dispatch;* federal, state, and local government studies; and legislative records of hearings and investigations relating to the subject.
2. Interviews with about 120 individuals involved in all aspects of the correctional field—judges, local, state, and federal legislators, academic leaders, teachers, lawyers, sociologists and criminologists, ex-convicts, parole and probation officials, prison personnel and inmates, psychiatrists and psy-

chologists who have worked in prisons, and writers and authors with a record of work in the area.

3. Extended visits to precinct houses, jails, penitentiaries, halfway houses, and courtrooms, and informal conversations with offenders and correctional personnel.

The original story idea was to follow an individual case from first arrest as an adult offender through all key steps encountered in the penal system. These key steps were (1) arrest, (2) detention in jail, (3) trial, (4) possibility of probation, (5) imprisonment, and (6) possibility of parole. However, because the film had to convey a tremendous amount of information within a limited time span, it was decided to show these key steps through very short dialogue sequences and to use narrative, accompanied by visuals, between these dramatic vignettes to communicate the facts about the system.

SCREEN TREATMENT

This basic idea for a film, prepared in schematic outline, provided the structure from which the screen treatment was developed. The following outline was, in effect, the first attempt to put the film on paper prior to writing out the first draft of the screen treatment.

A. Introduction to the main character
 1. Background (who he is). (Note: He must be a "bad guy"—hostile, negative, surly, and unpleasant, so that the audience will not be tempted to feel sympathy for a nice guy gone astray. He must be an individual who is hard to like.)
 2. Titles
B. Arrest, arraignment, and detention
C. A narrative sequence dealing with jails and the lower courts
D. Trial and possibility of probation
E. A narrative sequence dealing with probation
F. Sentence and imprisonment (three to five years in the state penitentiary)
G. A narrative sequence dealing with the prison
H. Possibility of parole
I. A narrative sequence on parole
J. A projection of his future
K. Open-end finale ("It's up to us")

The following is the screen treatment that formed the basis for the shooting script.

PRELIMINARY TREATMENT—FILM #1

Technique Documentary—narration—lip synchronous dialogue—music—black and white photography—real people and places—in the style of Ed Murrow's "Harvest of Shame."

Purpose A look at American crime and punishment circa 1965. A hard, straight, honest presentation of where we are and where we are not, and a glimpse of what lies ahead.

Sequence 1 A teaser prologue, "The Past is Prologue"—via art work, stills, old pictures, and paintings, we trace in about a minute and a half or two minutes the development of our attitudes toward "punishment." This would be a highly stylized sequence, setting into historical perspective the body of our film. Titles follow and—

Sequence 2 A cinematic statement of the problem. The gavel falls and we hear a variety of sentences in a variety of regional accents from the mouths of judges in places all over the country, and we ask on film what lies ahead. Our camera takes us into all kinds of institutions in all parts of the country. These are glimpses in rapid-fire, dramatic-impact cinematic form. What we see varies tremendously as to conditions and attitudes. In this sequence we are not anxious to transmit any material in depth, but to give our audience a feeling for our subject. Throughout this sequence, the narrative asks questions and the dialogue we hear gives answers—some pleasant, most of them unpleasant.

Sequence 3 A more detailed look into some of the answers. A setting of terms and definitions. A documentary examination of the nature of our correctional institutions—large and small, good and bad, overcrowded, understaffed, whatever the case may be—from Georgia to California, from Maine to Wisconsin, rural and urban, and county, state, and federal. We get a good look at the walls, the buildings, the places, the people. We are talking, in this sequence, about the prisons themselves. We examine attitudes and procedures, we get a look at the range of the problems, we look into the faces of prisoners, and we get an idea of the huge variety of men and women crowded into each institution.

In this sequence we explode the myth that the criminal is a strange, abortive mutation of society, and we begin to apply basic psychological and psychiatric terminology that clearly indicates that crime is, in effect, human behavior. It can not be considered anything other than that, and we begin to realize this. Nowhere in this film do we preach or lecture. What we see and hear in terms of dialogue and actual events tells the story—that these people whom we see behind bars are human beings even as you and I. We sense the wide range of problems they represent—problems of environment, problems of health—and we begin to understand something of the nature of the problems that *we* face. This is not an appeal for understanding—it is a presentation of the facts.

Sequence 4 A long, hard, documentary look at the mechanisms of imprisonment, parole, and probation. Not in detail, superficially to be sure, but enough to give us a notion of where they fit in the overall picture. We hear an actual parole proceeding and a probation report. We sit in on examinations and discussions that take place all over our country, in our cities, in small towns, in state capitals. From this sequence we should understand some of the mechanisms we have developed to meet the growing problem of prison populations.

Sequence 5 Progress—forward or backward? An examination of some of the things we have tried—again, not in detail (that comes later, in another film), but a superficial look into the wide variety of techniques being applied to prisons, to probation, to parole, to rehabilitation, and to social work. We sense some of the fragmentation within the field, and we hear directly from the people themselves some of the attitudes and opinions of the leaders in the field—where they diverge and where they agree. From this kaleidoscope, from this collage of words and pictures, we begin to sense some of the problems we face.

The basic screen technique in this film is the mobile, inquiring, hard, dramatic use of words and pictures. Our camera goes everywhere and sees everything. Through the editing, we make our comments—sometimes ironic, sometimes terribly sad, sometimes hopeful in small ways. The important thing is that we catch the moments of truth—we use our camera and our sound recorders to reveal, to make their own comments, so as to minimize the necessity for any narrative support. Through this film, we will get a look at our prisons, at the people who are running them, at the people who are living within their walls. We will get a look at the nature of probation and parole; we will see judges in courtroom action; and we will draw from the film material the conclusions that will lead to more questions and attract the interest we hope for.

Epilogue Through the device of the freeze frame—the scene arrested on film and then released mechanically—we raise questions at the end of this film. We will, in this film, provide no answers, only information, but we will ask many questions. In the epilogue we will review and repeat many of the scenes, but they will be frozen in action on screen until we finish our commentary, and then they will be released. We will raise questions about the nature of our prison population, questions about the quality and efficacy of prison personnel, questions about the attitudes and philosophies that motivate our actions and thoughts in this field. By this dramatic form of review, we clarify and pinpoint the purpose of the film. When the film is over, there are no end titles, for it is, in effect, a beginning. It is a point of departure at which any or all of the points raised in the film can be discussed, argued, and debated.

SHOOTING SCRIPT

The following is the actual shooting script for a sequence of the film. The development of this sequence from the initial idea through a full screen treatment and on to a final shooting script demonstrates how a film is conceived in the script stage.

VISUAL	AUDIO
	NARRATOR
Johnny being returned to his cell.	The denial of parole is but one more fact of life for Johnny Mitchell. It is no more or less important than all the facts of his young life to date.

Based on current statistics, a profile of his future looks like this . . .

We watch him blending inexorably into the prison routine.

He will spend fourteen more months in prison . . .
He will . . . upon his release from prison . . . commit another serious crime . . . and will be returned to serve a long term in prison.
It is estimated that more than half of those now in prison will return again.

We follow him again through the same routine, day after day after day.

Again, he will be apprehended . . . detained . . . tried and sentenced . . . and imprisoned.

ECU: JOHN MITCHELL

we stay focused on him with our long lens.

He will be over thirty-five years old when he is released from his second term.
He will be doubly damaged.
He will be unable to do useful, productive work.
He will be scarred within himself . . . so as to make impossible the establishment of rich and rewarding personal relationships.

Like so many others, he will probably waste his life in the shadow world of the criminal . . .

FINAL CU: NIGHT

Johnny asleep.

He will contribute nothing to our world . . . and worse, he will have nothing of value from all the days of his life.

At 22 . . . he is defeated and lost.

RICHARD MCGEE
Administrator
Youth and Adult Corrections Agency
California

We see reprise shots from our on-location material and these continue after we have returned to the material.

(He provides us with a summation and gives the film its broad intellectual and philosophical thrust. He talks

about the system of corrections and what we have seen in the film, and tells us something of the high cost of crime. He points up the failures of the system and the desperate need for something better. He translates hard, dull statistics into high-impact human terms. He explodes myths and tries to put the entire film into meaningful perspective.)

Note that the visual elements are all specifically and carefully laid out, giving the director a clear idea of what the writer has in mind.

DIALOGUE AND NARRATION

In the final script, the dialogue sequences were indicated for content and the narrative was written out in full. (The narrative was later rewritten for the edited film, but in order to give the director a full view of the film it was written out in full at the beginning.)

AUDIO-VISUAL STIMULI

Only *key* peripheral sound and picture elements that affected the basic concept of the film were indicated in the initial script. Such elements as the character of the music, the silence of the street, the shattering of that silence by the police sirens, the din of the precinct house, and the sound of Mitchell's belongings clattering down on the desktop, when added to the dialogue and narration, produced a highly dramatic introduction to the film and arrested the audience's attention immediately. The total effect of the audio-visual stimuli was to plunge the audience into the protagonist's world not only by what was viewed but by what was *felt*.

summary

The script (or storyboard) is the first major step in the production of any motion picture. The more completely the script is realized at the beginning, the easier the entire production process will be. The major elements of a successful script are a clear, concise *screen treatment,* describing major characters, outlining the film's dramatic structure, and discussing the style of the film; and a fully detailed *shooting script,* containing complete descriptions of every important scene and sequence, of the dialogue and of the narration, and of all other key sound elements—such as type of music, sound effects (when significant), and relationships between picture and sound—and descriptions of any special optical or animation effects.

Although the script may be changed by the director and the editor during production, it is an important guide to the writer's initial concept; and even if used only as a point of departure, it is the central focus that holds the film together.

suggested reading

BERGMAN, INGMAR, *Four Screenplays of Ingmar Bergman,* trans. by Lars Malmstrom and David Kushner. New York: Simon and Schuster, 1960.

BUÑUEL, LUIS, *Viridiana,* in Ado Kyrou, *Luis Buñuel.* New York: Simon and Schuster, 1963.

CLARKE, ARTHUR C., and STANLEY KUBRICK, *2001, A Space Odyssey.* New York: Signet, 1971.

DURAS, MARGUERITE, *Hiroshima, Mon Amour,* text for the film by Alain Resnais, trans. by Richard Seaver. New York: Grove Press, 1961.

KUROSAWA, AKIRA, *The Seven Samurai,* trans. by Donald Richie. New York: Simon and Schuster, 1970.

SEMPRUN, JORGE, *La Guerre Est Finie.* New York: Grove Press, 1968.

suggested viewing

Alka Seltzer commercials, Miles Laboratories
A Clockwork Orange (1971), Stanley Kubrick
The Day before Tomorrow (1971), Vision Associates for Planned Parenthood-World Population
Five Easy Pieces (1971), Bob Rafelson
The Garden of the Finzi-Continis (1971), Vittorio De Sica
Gimme Shelter (1970), Maysles brothers and Charlotte Zwerin
The Hospital (1972), Paddy Chayefsky and Arthur Hiller
Husbands (1970), John Cassavetes
No Simple Thing (1971), Vision Associates for Eastern Airlines, Inc.
The Odds Against (1966), Vision Associates for The American Foundation Institute of Corrections
Out of Darkness (1956), Al Wasserman for CBS
The River (1937), Pare Lorentz
Women in Love (1970), Ken Russell
Woodstock (1969), Michael Wadleigh

two preparing the film for production

I am deeply involved in the administration, because it is in this area that many creative and artistic battles are lost. You've got to have what you want, where you want it, and at the right time, and you have got to use your resources (money and people) in the most effective way possible because they are limited, and when they are seriously stretched it always shows on the screen. Because I have to be, I am very interested in organizational problems, and the conclusion that I have come to is that the making of a film is one of the most difficult organizational and administrative problems to exist outside of a military operation. Running a business is unfortunately never a useful analogy, because the key to the successful operation of all businesses is the establishment of routine and the breaking down of jobs into simple, definable, understandable functions which can be performed by normally adequate people.

Whereas in films almost everything is a "one-of" problem, it is almost impossible to establish a routine, and the work done is so diversified that if it were to be broken down as in a manufacturing process, you would need ten times as many people, which you could not afford.

Filmmaking violates the old adage that what is wanted is a system designed by geniuses which can be run by idiots. It has always been the other way round with films. However, I keep trying and keep coming up with new systems, new means of displaying information, remembering, reminding, following up. I risk my popularity with some of my department heads by continually pressing home the point that merely giving an order to somebody is only a fraction of their job, that their principal responsibility is to see that the order is carried out accurately, on time, and within the budget.

STANLEY KUBRICK, in
Stanley Kubrick Directs,
by Alexander Walker.
New York:
Harcourt Brace Jovanovich, Inc.,
and Davis-Poynter, Ltd.,
1971, pp. 45, 46.

The script or storyboard has been approved. The filmmaker is completely satisfied with every aspect and detail of the film as it appears on paper. The next important step in the filmmaking process is to plan and organize the actual production of the film in the most effective and economical manner. The main purpose of all preproduction preparation is to *make the most efficient use of time and money.* The work done at this stage of filmmaking can often make the difference between success and failure. A poorly planned production will make it difficult to transfer the film as conceived to the screen, resulting in much wasted time and money. A shortage of time and money places the director, cast, and crew under additional pressures that are certain to detract from the quality of the finished film.

Contrary to popular belief, all films should have the benefit of a detailed and thoughtful preparation. This is true whether the film is a modest five-minute student production or a lavish million-dollar Hollywood epic. The more care and attention given to preparation, the more time can be allotted to actual filmmaking. If the production schedule is poorly prepared, unexpected crises, often unrelated to the filmmaking itself, are almost certain to occur, forcing those working on the film to devote their energies to solving these problems rather than to making the film.

The following are the major steps in preparing a film for photography:

1. script breakdown
2. preparation of a production schedule
3. budgeting
4. casting
5. selection of sets and studios
6. selection of locations for nonstudio photography
7. selection of foreign locations
8. selection of the crew
9. selection of equipment

script breakdown

The first step in all preproduction planning is to analyze the script in order to identify and isolate all those elements that will affect the scheduling and cost of the film. The script must first be separated into its component parts—shots, scenes, and sequences. (A *shot* is a single camera take from the time the camera is started until it is turned off. A *scene* can be a single shot or a group of shots; the action contained in a scene is usually unified by time and place. A *sequence* is a group of scenes that together make up a logical, unified segment of the total story. A sequence usually has a recognizable beginning and end.) Once this preliminary breakdown is done, each shot, scene, and sequence must be examined for specific information such as location, costumes and props needed, cast, special technical elements such as unusual lenses or special-effects devices, and of course the crew needed. The following is an excerpt from a script breakdown for *The Price of a Life,* a dramatic documentary dealing with probation that uses actors and dialogue.

Production 320 **SCRIPT BREAKDOWN**[1] *THE PRICE OF A LIFE*

SCENE	LOCATION COSTUMES PROPS	CAST	TECHNICAL ELEMENTS	CREW
1 Fight	Bar	Eddie Layton Bartender 2 customers	Fisheye lens Silent	Director Asst. Dir. Camera Electric Prop Grip
1a Arrest	Bar	Eddie Layton Bartender 2 customers 2 policemen (in uniform)	Fisheye lens Silent	Director Asst. Dir. Camera Electric Prop Grip
2 First interview	Room in jail Prison outfit Folder with arrest information	Eddie Layton Investigating probation officer	Sound	Director Asst. Dir. Camera Sound Electric Prop Grip
2a Eddie in jail	Cell block Prison outfit	Eddie Layton Prison guard (in uniform)	Silent Wheelchair for dolly	Director Asst. Dir. Camera Electric Prop Grip
3 Second interview	Eddie's mother's home	Investigating probation officer Eddie's mother	Sound	Director Asst. Dir. Camera Sound Electric Prop Grip
4 Third interview	Park	Investigating probation officer Eddie's wife	Sound Wireless mikes	Director Asst. Dir. Camera Sound Electric Prop Grip
5 Fourth interview	Employer's office	Investigating probation officer Past employer	Sound	Director Asst. Dir. Camera Sound Electric Prop Grip

[1] From Lee R. Bobker, *The Price of a Life*.

SCENE	LOCATION COSTUMES PROPS	CAST	TECHNICAL ELEMENTS	CREW
6 Fifth interview	Psychiatrist's office	Eddie Layton Psychiatrist	Sound	Same as above
7 Pre-sentence meeting	Judge's chambers Folder with arrest information	Judge Investigating probation officer Prosecuting attorney Defense attorney	Sound	Same as above
8 Sentence delivered	Courtroom Flag Gavel Judge's robe	Judge	Sound	Same as above
9 First meeting between case worker and Eddie	Office of probation officer (case worker) Arrest info All information from investigating probation officer	Eddie Layton Case worker	Sound	Same as above
10 Meeting between case worker and prospective employer	Job location (packing facility)	Case worker Prospective employer	Sound	Same as above
11 Interview between Eddie and prospective employer	Employer's office	Eddie Layton Prospective employer	Sound	Director Asst. Dir. Camera Sound Electric Prop Grip
12 Eddie at work at packing job	Shipping room	Eddie Layton	Silent	Director Asst. Dir. Camera Electric Prop Grip
13 Case worker meeting with employer	Employer's office	Case worker Employer	Sound	Director Asst. Dir. Camera Sound Electric Prop Grip

SCENE	LOCATION COSTUMES PROPS	CAST	TECHNICAL ELEMENTS	CREW
14 Second meeting between case worker and Eddie	Case worker's office	Case worker Eddie Layton	Sound	Director Asst. Dir. Camera Sound Electric Prop Grip
15 Eddie meets his wife and child	Zoo	Eddie Layton Wife Child	Sound Wireless mikes	Same as above
16 Eddie laid off from packing job	Shipping room	Eddie Layton Employer	Sound	Director Asst. Dir. Camera Sound Electric Prop Grip
17 Eddie breaks bar mirror	Bar Mirror	Eddie Layton Bartender	Silent	Director Asst. Dir. Camera Electric Prop Grip
18 Eddie running through city	City streets	Eddie Layton	Silent	Director Asst. Dir. Camera Grip
19 Third meeting between case worker and Eddie	Park by river	Eddie Layton Case worker	Sound Wireless mikes	Director Asst. Dir. Camera Sound Grip
20 Eddie and job counselor	Office of job counselor	Eddie Layton Job counselor	Sound	Director Asst. Dir. Camera Sound Electric Prop Grip
21 Eddie at new job	Knitting mill	Eddie Layton Three workers on line	Sound (wild only)	Director Asst. Dir. Camera Sound Electric Prop Grip

SCENE	LOCATION COSTUMES PROPS	CAST	TECHNICAL ELEMENTS	CREW
22 Eddie in night school	Classroom	Eddie Layton Ten other students	Sound	Director Asst. Dir. Camera Sound Electric Prop Grip
23 Eddie at home—daily life, series of shots	Eddie's kitchen— breakfast food Eddie's living room—television Eddie shopping for newspaper Eddie walking in streets	Eddie Layton	Silent	Director Asst. Dir. Camera Electric Prop Grip
24 Fourth meeting between case worker and Eddie	Office of case worker	Eddie Layton Case worker	Sound	Director Asst. Dir. Camera Sound Electric Prop Grip

There are, of course, many valid variations of script breakdown procedures, and every film will have its own unique requirements—a modest one-minute TV commercial consisting of three scenes will scarcely require the detailed script breakdown of a full-length feature. But the basic information needed remains essentially the same, regardless of the type of production. It is important to remember that the basic purpose of the script breakdown is to provide a clear, intelligent analysis of the requirements of *your* film and to assist you in costing and scheduling the film.

In the breakdown, each scene in the script should be numbered in sequence for reference purposes. The following information should then be listed for each scene.

CAST

For each scene, the script breakdown lists everyone who appears in the scene and, when dealing with background extras, indicates their ages, sex, and character types according to the script's requirements. This is done whether the cast consists of professional actors, extras, nonprofessionals (as in a documentary film), or even

animals. If the script calls for a crowd scene, the breakdown should specify the number of people in the crowd. If the script indicates a scene played out within a small dinner party, the number of actors needed, their ages, and the male-female ratio should all be specified. None of this information should be omitted. Even if the film is a documentary being shot in a classroom, the script breakdown should indicate the desired size of the class and any other pertinent particulars relating to the script.

SETTINGS, COSTUMES, AND PROPS

The physical setting for each scene must be described in the script breakdown. This description should specify whether the setting is to be an interior or an exterior and whether the scene will be photographed in the studio or on location. The script breakdown must identify the *exact* location for the photography of the scene. It is not sufficient simply to write *studio:* the exact address of the studio should be noted, so that accurate and efficient transportation schedules can be arranged. If the script calls for a particular time of day (e.g., dawn) or specific visual effects related to the environment (e.g., blizzard), these elements too must be included in the breakdown, since they are an essential part of the visual setting and an important factor in scheduling the production. If, as is often the case, the script itself does not specify the setting, the director and those doing the pre-production preparation must make all decisions regarding location at this time.

In addition, all key visual elements of the setting must be specified in the script breakdown. This does not mean that every item of furniture and every costume must be fully described. If the film is a theatrical feature, the set designer and costume designer will usually provide their own detailed lists. What is needed in the breakdown is simply a list of all the props and articles of clothing that will play a *significant* role in the scene.

TECHNICAL ELEMENTS

Each scene must be examined for factors that affect the choice of equipment for photography. Once again, every item of equipment need not be listed, nor must basic items be repeated with every scene. In most films the production manager will assign a basic equipment list for the entire production. The breakdown, however, must include any equipment necessary to achieve any special effects called for in the script. This equipment is usually ordered by the chief prop or the director. In addition, each scene must be identified as a silent or a sound scene, since this directly affects the scheduling of equipment (i.e., the assigning of all equipment to specific scenes on the particular days when they will be needed).

CREW

In most films a basic production crew consisting of the director, assistant director, cameraman, assistant cameraman, and a complement of technicians (electrician, grips, props, and sound men) will be assigned to the entire production. However, each scene will have its own crew requirements, and the script breakdown should indicate the exact crew members needed for each scene. The crew requirements are determined by the experience of the individual doing the breakdown (usually the assistant director), union regulations, and the requirements set forth by the script itself. For example, an assistant director who has a great deal of documentary experience, because he knows what can be done with three- or four-man units, will usually choose small crews for location work. As far as union regulations are concerned, there are specific requirements for crew size set down in all basic union agreements, and these must be considered. For example, the

Production 320 PRODUCTION SCHEDULE[2] *THE PRICE OF A LIFE*

DATE/TIME	LOCATION	CREW	CAST	TRANSPORTATION
Monday, Aug. 21 8:30 A.M.	Jimmy Ray's Bar, 772 Eighth Ave., N.Y.C.	Director Asst. Dir. Camera Electric Prop Grip	Eddie Layton Jimmy Ray 2 customers 2 policemen	Three teamsters pick up three equipment-loaded wagons and drive to location. Crew and cast to arrive on own.
1:00 P.M.	LUNCH			Crew and cast on own—regroup at 2:00 P.M. Take three wagons and as many taxis as necessary to next location.
2:30 P.M.	Office of Probations, 2 Lafayette St., N.Y.C. Office of case worker	Director Asst. Dir. Camera Sound Electric Prop Grip	Eddie Layton Case worker	Crew remains here until end of day. Three wagons with equipment are parked in garages by teamsters at end of day. Case worker is not actor and will be at location which is his actual office. Crew transportation home on their own.
Tuesday, Aug. 22 8:30 A.M.	Rosinoff Knitting Mills, 24 East 18th Street, N.Y.C. In factory area	Director Asst. Dir. Camera Sound Electric Prop Grip	Eddie Layton One actor to play worker Two actual employees of knitting mill	Three teamsters pick up three equipment-loaded wagons and drive to location. Crew and cast to arrive on own. Asst. Dir. picks up Eddie Layton in taxi and brings to location.

[2] From Lee R. Bobker, *The Price of a Life.*

Cameraman's Union in New York, Local 644, requires that a three-man camera crew (director of photography, operating cameraman, and assistant cameraman) be used on all theatrical feature sequences shot in the studio, and the requirement is rarely waived. On the other hand, if a scene calls for a long shot of New York City, a two-man camera crew would be quite sufficient.

production schedule

Once the script breakdown is complete, the next step in preparing for production is to schedule the order in which the scenes will be photographed. This is one of the most complex tasks facing the filmmaker and one of the most important to the success of the film. The following is an excerpt from the production schedule of *The Price of a Life.*

SCENE	COSTUMES, PROPS	TECHNICAL ELEMENTS
1 Eddie Layton drinking at bar gets into fight with customer		Silent
1a Eddie Layton arrested	Two police uniforms	Silent
17 Eddie Layton smashes mirror in bar	Large convex mirror	Silent
9 Eddie and case worker have first meeting in office	Have two shirts for Eddie Layton and change of tie for case worker	Sound Need fishpole
14 Eddie and case worker have second meeting in office		
19 Eddie and case worker have third meeting in office		
24 Eddie and case worker have fourth meeting in office		
21 Eddie at work in knitting mill	Working clothes for Eddie	Silent
42 Eddie fights with other employee while at work		Sound

DATE/TIME	LOCATION	CREW	CAST	TRANSPORTATION
11:30 A.M.	In shipping room		Eddie Layton Employer A	Actor playing Employer A to arrive on own for 10:30 A.M. call.
1:00 P.M.	LUNCH			
2:00 P.M.	In factory office		Eddie Layton Employer A Case worker	Case worker to arrive on own at location for 1:30 P.M. call.
6:00 P.M.	Shepard House, 243 West 22nd St., N.Y.C.		Eddie Layton Eight men living in Shepard House to be in scene (arranged by Dick Rachen)	Leave Rosinoff Knitting Mills at 5:30 P.M. Three teamsters drive three wagons with equipment and take six crew members to location. Director, Asst. Dir., Eddie Layton, and other crew members take two taxis.

EFFICIENCY OF MOVEMENT

The most influential factor in the preparation of a shooting schedule is *movement*. Each time the location of a sequence changes, each time a lighting set-up has to be revised, each time there is a change in the background of a scene, cast, crew, sets, and scenery must be moved. It is essential, then, that the schedule be prepared with the aim of achieving the most efficient movement possible. For example, if scene 1 takes place in a living room interior, scenes 2 and 3 take place just outside the house, and scene 4 is to be shot in the living room, it obviously makes no sense to shoot the scenes in sequential order. It is far more efficient to shoot scenes 1 and 4 and *then* move outside for scenes 2 and 3, thereby eliminating wasted movement.

Thus the first step in preparing the production schedule is to group all scenes according to specific location, since every change in location involves a major movement on the part of the crew and cast.

After this simplified organization is completed, each group should be subdivided into interior and exterior settings, since this will again involve extensive movements of crew, cast, and equipment. A look at the arrangement of basic locations now tells the filmmaker exactly what must be moved where, and he can begin to work out the smoothest and most efficient method of accomplishing the necessary movement.

Once the basic shooting units have been determined, they should be arranged in the best possible order for filming. Although films are usually shot out of

SCENE	COSTUMES, PROPS	TECHNICAL ELEMENTS
12 Eddie at work at packing job	Second set of working clothes for Eddie	Silent
16 Eddie is laid off from job		Sound
11 Interview between Eddie Layton and Employer A		Sound
10 First meeting between case worker and Employer A		Sound
13 Second meeting between case worker and Employer A		Sound
30 Eddie entering Shepard House to live	Suitcase for Eddie Layton	Silent Exterior
31 Eddie in group therapy session at halfway house		Sound

sequence to accommodate various economic factors, economic efficiency should never be the sole determining factor in scheduling. At this point in planning the production, several new important factors arise, and only if they are coordinated can an optimum shooting schedule be created. Each factor must be considered in relation to the other factors involved (they often conflict with one another) as well as to the artistic demands made by the script.

CONTINUITY OF PERFORMANCE

Continuity of performance is an important factor in the success of any film. The goal is to make the best and most effective use of the actors' time. For example, if the final production schedule calls for twenty shooting days and a supporting player is needed on only two shooting days, it is obviously wasteful to schedule his scenes for the first and the twentieth days, since under union regulations he must be paid for *all* the interim time. If it is impossible to schedule the actor for two consecutive days, the director should try to schedule his scenes as close together as possible.

Other considerations arise when the lead players are involved. For example, if a climactic scene involving the lead actor takes place in part in a studio interior and in part on location, it may place a great strain on the actor's performance to separate the shooting by several days simply to attain the optimum efficiency of movement. The more free time an actor has between his shooting days, the

greater the danger that he will "lose" his role. Although most film actors of necessity learn to adapt to out-of-sequence acting and to the fragmentary nature of the medium, the less burden put on the actor to sustain his role over a long and fragmented schedule the better.

Thus, insofar as the actor is concerned, two elements must be weighed against each other—the most economical use of the actor's time, and the best possible schedule in relation to the actor's needs in working out his role. Of course, the larger the cast, the more complicated these problems become.

KEEPING "WAITING" TIME TO A MINIMUM

The schedule should be adjusted so that the actor is not kept waiting while lighting, set dressing, costume changes, and other technical matters are arranged. For example, in the final complex "shoot-out" sequence at the end of *Butch Cassidy and the Sundance Kid,* the director and crew spent five days preparing *all* the technical elements. The lead actors, Paul Newman and Robert Redford, were not brought on set until the sixth day, so that their performances immediately followed two days of rehearsal and they were not kept sitting around on location unnecessarily while technical matters were being worked out.

CONSIDERATION OF THE INTENSITY OF A SCENE

In determining the optimum order for shooting, it is important to give careful attention to the demands each scene makes on the actor. No matter how economically profitable it might be, it is a poor idea to begin shooting with the actor's most difficult scene or to schedule two or three climactic scenes in succession. Although most actors have learned to adapt their art to the demands of the motion picture medium, there is much to be said for adjusting a schedule to give the actor every chance to be at his best throughout the entire shooting schedule. Thus it is a matter of common sense to give the actor time to "work up to" a major scene rather than go into it "cold."

PROVIDING AN OPPORTUNITY FOR THE CAST TO WORK TOGETHER

Finally, the production schedule should be arranged to give the cast as many chances as possible to work together as a unit. Whenever possible, the shooting of minor scenes should be scheduled directly prior to major ensemble scenes, so that the entire cast (principals and extras) will have an opportunity to work together. This helps create the kind of interaction between actors that is common on the stage but is often difficult to achieve in film. There is much more to screen acting than simply reading lines. The relationship of the entire cast of *The Godfather,* carefully fostered by the director, Francis Ford Coppola, enabled the actors to relate to one another instinctively and contributed greatly to the film's success.

CONTINUITY OF SCRIPT

There are elements, of course, within each script that directly affect the schedule and that in some ways limit its flexibility. As a general rule it is a good idea to *try* to plan the production schedule to follow the continuity of the script as closely as possible. The "time line" of the script is a good guide for planning a schedule and should be distorted only when financial consequences are too great to be borne. It is easy to understand that the more damage done to the logical dramatic continuity of the script, the more difficult its execution. Usually, the fewer times the actors are required to move forward and backward within the script, the greater the continuity of their performance. Of course, in many documentary films and television commercials, there is no "plot" or "story line." In these cases, the schedule can be planned for maximum efficiency with no consideration given to continuity.

EFFECTIVE USE OF CREW

As noted earlier, different sequences in a film will call for different size crews. Since one of the prime functions of the production schedule is to provide the most efficient and effective use of manpower, it is essential that the schedule be organized to keep the number of technicians left standing idle to a minimum. Most productions, small or large, usually rely on a nucleus of personnel to which other crew members are added as needed. Thus scenes and sequences calling for a larger crew should be shot together, if possible, so that continuity of employment can be maintained. Generally, it is most efficient to organize the schedule around the most technically complex sequences and to use sequences requiring a smaller crew to fill in gaps at the beginning and the end of the schedule. Occasionally the filmmaker may find it more efficient to hire secondary units to handle minor exterior photography or to divide the crew into "work shifts"—for example, to have part of the crew (electricians, grips, props, etc.) prepare an interior scene while the camera crew shoots exterior scenes not involving the main cast. There are many ways to insure the most effective use of the crew, but in preparing the schedule the filmmaker should always bear in mind that the greatest single waste item in a production is *idle manpower*.

SETS AND SETTING

As the shooting schedule is prepared, careful attention must be paid to physical settings. On major feature productions, one of the largest cost items in a budget is the rental of sets and studio. Since studio space is limited and expensive, the schedule must make the most economical use of studio space and of the time spent within it. Thus, for example, if ten basic interior sets are required, it may be more economical to rent space for only five. If the schedule is properly organized, the first five interiors can be shot, the production can move outside on location for exterior shooting while the other five sets are being built in the studio, and

the production can then be completed inside on the finished sets. Sometimes building and re-dressing of sets can be scheduled at night, but this may not always be economically advantageous—the time gained must be weighed against the extra cost of night work. On the average, night work is twice as expensive as work performed between the hours of 8 A.M. and 5 P.M.

Here, in simplified form, is the script for a one-minute TV commercial using five basic settings. The problems involved in setting up a production schedule for this very short film are a microcosm of those encountered on longer, more complicated productions.

VISUAL	AUDIO
1 INT. LIVING ROOM *Middle Americana—party is in progress—about a dozen people—camera zooms in suddenly to ECU as elbow hits glass and knocks it onto the rug— a moment of horrified silence—a sharp pan to the "spot" that seemingly mars forever the beauty of the room* CU: *spot—slow dissolve.*	NARRATOR (*Voice over*) At the most unexpected moments accidents can happen.
2 INT. STUDIO *Narrator-Host standing in studio set— with a single piece of carpet on the floor—he deliberately pours a dark liquid on the rug, staining it* CU: *as liquid stains carpet.* *Dissolve to: stain after several hours.*	NARRATOR (*Live*) . . . I am now deliberately pouring a mixture of ink and coffee onto this brand new carpet. Unfortunately it is not always possible to act immediately—and the stain gets worse . . . and worse.
3 CU: *Narrator holding* Olympia *detergent—camera pulls back as he applies detergent.* *Dissolve*	. . . but now, thanks to the miracle of science, an entirely new detergent— gentle, yet fully effective, will clean that carpet of the most stubborn stains.
4 EXT. A SUMMER RAINSTORM IN A FOREST *A couple running through the woods— CU as the rain runs down her face.* *Dissolve to:*	NARRATOR (*Voice over*) Just as the summer rain gently cleans the air—so does *Olympia* work on carpet stains.
5 EXT. POOLSIDE AT A COUNTRY CLUB *A perfect summer day—camera reveals sparkling cleanliness of area.*	Because of its special formula, the result of over ten years of research,

Olympia is equally effective in outdoor settings for cleaning tiles or asphalt.

Wipe to:

6 SAME SETTING BUT NOW EMPTY.
A pool attendant scrubs the area with Olympia.

Dissolve to:

7 INT. LABORATORY
Impressionistic shot through glassware.

Olympia high-powered detergent is a scientific blend of 30 separate chemicals newly formulated to clean quickly and safely.

Dissolve to:

8 ORIGINAL INTERIOR
Party over—hostess cleaning stain with Olympia—zoom in to bottle.

Remember the name *Olympia*—in the red and blue bottle.

Superimpose logo.

Note that three of the settings are interior locations and two are exterior on-location scenes. Two alternatives are open to the filmmaker. He can rent space large enough for three sets, shoot these, and make one move outside to complete the production. This would probably require a three- to four-day shooting schedule, with three additional days for set building and dressing prior to photography. Or the filmmaker may decide to rent space for a single set and follow a five-day schedule. The first two days are spent building and dressing the first set, shooting the scene, and then moving outside to shoot the first exterior while the set is rebuilt and re-dressed for the second interior. On the third day the crew returns indoors for the second interior. On the fourth shooting day the production moves outside again to complete the exterior shooting while set number three is prepared. On the fifth day the job is completed in the studio. Of course, many other elements must be considered before the filmmaker can determine which of the above schedules would be the most efficient and economical.

EFFECTIVE UTILIZATION OF EQUIPMENT

Since equipment rental is a major cost item in any production, the production schedule should be prepared to ensure maximum utilization of all equipment. For example, if an expensive crab dolly is needed on four days of a twenty-day schedule, it is inefficient to schedule it for days 2, 5, 9, and 16. This means either that the equipment item will sit idle for eleven days—at a cost of about $125

a day—or that it will have to be picked up and returned four times, a total of eight trucking trips that also must be paid for. Sound sequences should be scheduled as close together as possible to make the most effective use of sound equipment and personnel. If five sound scenes are scheduled to be shot over five days when they could have been shot in two consecutive days, three men and a lot of expensive equipment will be used for only a fraction of each day, and the waste will be significant. It is, of course, not always possible to arrange a schedule that will provide for completely efficient use of all equipment, but since the script breakdown lists the equipment required for each scene, it is quite possible to make utilization of equipment a factor in preparing the final shooting schedule.

TRANSPORTATION

Since most films require the movement of people and equipment from place to place, transportation is another major factor in scheduling. If a feature production requires twelve vehicles to move from studio to location, the producer obviously will want to make this move as few times as possible. Movement is not only expensive; more important, it takes time. If you spend four hours of an eight-hour day in movement, you are obviously losing 50 percent of actual filming time. But if the schedule can be arranged to cut travel time in half, you have not only saved money but have increased your filming time and shortened your schedule. If it is feasible to complete all shooting at a single setting before leaving it, making it unnecessary to return to that setting, significant savings in time and money can be achieved. The production schedule should always be arranged to minimize major movements and transportation needs.

Schedules should also be organized to provide for the optimum time of transportation. If the production is moving from Hong Kong to Djakarta, for example, it would not be wise to schedule the move at night, when flights are limited and cancellation of a single flight could result in a two-day delay. However, if the production is moving from New York to Philadelphia by chartered bus and car, a nighttime move, when traffic is light, might be most efficient. The schedule must consider transportation costs and availability of transportation so that decisions can be made accordingly.

OVERTIME

We have established the necessity for financial efficiency. The more production money that finds its way to the screen, the lighter the burden on the filmmaker. One of the chief factors that can escalate the cost of a production is overtime. Filmmaking on any level is expensive. In a theatrical feature or a television film or commercial, the filmmaker is often required to work with union crews, and all craft unions have complex rules concerning overtime. For example, most unions provide for an 8-hour day beginning at eight or eight-thirty in the morning. A lunch hour *must* be taken between twelve and one-thirty. All work done outside of these hours requires overtime pay ranging from one and one-half to three times

the hourly base rate. If a production is forced into night work and the crew works more than 14 or 16 hours in a 24-hour period, even more stringent stipulations apply, including triple time after 10 P.M. and a 10-hour break between the end of work on one day and the beginning of work the next day.

These rules are clearly an important factor in the scheduling of production. On a major production the overtime pay alone, if not planned for, can often destroy the budget for the entire film. As a general rule overtime is wasteful, since it provides premium pay for work performed when efficiency and productivity are usually at their lowest. *The less overtime on a production, the better.*

CONTINGENCIES

In scheduling a film, it is a serious mistake not to allow for errors and catastrophes. To assume that all will go as scheduled is the worst kind of folly. Filmmaking is by nature subject to human error and acts of God. For example, actors may become ill, which can result in a delay in production. Can any film afford to keep thirty-five technicians sitting around in the hills of Mexico waiting for the star to recover from laryngitis? A child star may get the measles halfway into production—too late to change actors and too late to cancel the filming without severe financial loss. Weather changes affect outdoor shooting. Airplane flights may be cancelled. A scene may take twice as long to shoot as anyone anticipated. These and a thousand other potential disasters hover very close to every film production. The schedule must take such contingencies into account. An alternate schedule must be prepared providing for back-up transportation, for having an interior setting ready when the weather turns foul, and so on. Every item on the schedule should have a substitute item so that the production can keep moving despite all calamities. *The best schedule is the one that assumes the worst.*

TIME OF PHOTOGRAPHY

The mood and quality of exterior photography is strongly influenced by the time of day. Morning light tends to be cool in color and blue in tone and, when photographed, suggests a harsh atmosphere. At midday the light is flat and nondescript. In the evening the atmosphere takes on a more romantic warmth. The schedule must consider the intentions of the script and try wherever possible to plan exterior photography during that part of the day that will enable the cameraman to achieve the effect called for in the script.

The above elements are some of the major factors to be considered when scheduling the production of a film. The following is the schedule of the feature film *Little Murders*. The order in which the production was scheduled reflects the assistant director's and unit manager's views of the most effective and orderly method of photographing the film. This schedule provides for a wide range of contingencies and is structured around the actors' needs and the basic dramatic continuity of the script.

LITTLE MURDERS[3]

Revised Shooting Schedule (April 29, 1970) Thursday 4/30/70 through Wednesday 5/20/70

WEEK/DAY/DATE	LOCATION	SCENES	ACTORS/ # EXTRAS	ACTION	PROPS/FX	PGS.
14th day Thurs. 4/30 2 pgs.	INT. Patsy's apt. & bath (D)	1, 2, 3, 6–9	Patsy, Alfred (VO), 2 Hoods (VO), Sgt. Kirshner (VO), Breather (VO), Lester (VO)	Patsy awakens, hears scuffling, gets call, calls police.	Phone, coffee, etc., Patsy's handbag *Morning sounds, phone ring, fight sounds, phone breathing* *Shower water— brown to clear*	2
15th day Fri. 5/1 1⅜ pgs.	INT. subway car (N)	130–131	Alfred (bloody mess), *4 Passengers*	Alfred on subway —bloody—hardly noticed.	Bus, newspapers, school books, change	1⅛
	INT. subway station (N)	132	Alfred (bloody mess), *Man (bloody mess)*	Alfred & Man confront each other.		⅔
FOURTH WEEK 16th day Mon. 5/4 1⅜ pgs.	INT. Patsy's apt. (elevator & hallway) (D)	36–39	Alfred, Patsy, Breather (VO)	Leave elevator, walk to apt., find door & apt. smashed— Breather calls.	NOTE: Apt. is wrecked.	1
	INT. Patsy's bedroom (N)	40	Alfred, Patsy	They lie on floor. Patsy refuses to be discouraged.	NOTE: Apt. is wrecked. Coats	⅜
17th, 18th days Tues. 5/5 Wed. 5/6 7⅔ pgs.	INT. Chamberlain hall & stairs (N)	119	Alfred, Father	Father tells Mother that Alfred is home.	Tape recorder, briefcase	⅝
	INT. Chamberlain living room (N)	120	Alfred, Mother, Father	Alfred's parents remember nothing of his childhood.	Drinks, tape recorder, briefcase, book	6⅝
19th day Thurs. 5/7 3⅜ pgs.	INT. Patsy's apt. (redecorated) (N)	109, 111	Alfred, Patsy (VO)	Alfred talks to Patsy on phone.	NOTE: Apt. is redecorated.	⅜
	INT. Patsy's apt. (N)	113	Alfred, Patsy	She prevents him from leaving & tells him that she wants to mold him. She leaves.	Cameras, suitcases	2⅛
	INT. Patsy's apt. (bathroom) (D)	115, 114	Alfred, Patsy	As he develops film, she hands him questionnaire and tape recorder.	Tape recorder, questionnaire	1⅜

[3]Shooting script courtesy of Little Murders Company, Brodsky/Gould Productions, 221 West 26th Street, New York, New York 10001, and Twentieth Century-Fox Film Corporation. Abbreviations used in script are: N (Night); D (Day); VO (Voice-over).

LITTLE MURDERS

Revised Shooting Schedule (*Continued*)

WEEK/DAY/DATE	LOCATION	SCENES	ACTORS/# EXTRAS	ACTION	PROPS/FX	PGS.
20th day Fri. 5/8 3⅛ pgs.	INT. Patsy's apt. (N)	116	Alfred, Patsy, Breather (VO)	Patsy gives up on Alfred. She freezes.	*Telephone ring, distant siren* NOTE: Lights are out.	3⅛
FIFTH WEEK 21st, 22nd days Mon. 5/11 Tues. 5/12 5⅝ pgs.	INT. Patsy's apt. (dusk)	121–124, 126–128	Alfred, Patsy, Mother (VO), Father (VO)	Alfred's speech unfreezes Patsy. Go to make love, Patsy blasted by rifle through window.	Tape recorder *Rifle shot, sirens* NOTE: Window must shatter. Alfred's blood spattered for sc. 126–128.	5⅝
	INT. Patsy's apt. (across street)	125	Alfred, Patsy, *Rifleman*	As they embrace, we zoom out to see Rifleman fire.	Rifle NOTE: Window shatters.	⅞
23rd day Wed. 5/13 2⅜ pgs.	INT. Newquist hallway & apt. (D)	146–147	Carol, Marjorie, Kenny	Exit elevator. Kenny unbolts locks, lets them in.	Bag of leaking groceries *Doors unlocking, bolts unbolting*	⅞
	INT. Newquist hallway & apt. (N)	133, 134	Alfred (bloody mess), Carol, Marjorie	Carol & Marjorie recoil at Alfred's appearance. He walks into Patsy's old bedroom.		⅜
	INT. Newquist living room (N)	41–43	Carol, Marjorie	Carol thinks Alfred will be a fag.	Briefcase (Carol's), bag, booze, dining setups, air conditioners	1
24th day Thurs. 5/14 1⅛ pgs.	INT. Newquist living room (N)	45–48	Carol, Marjorie, Kenny	Await Alfred's arrival.	Paperback *Lesbians of Venus*, candles, matches, drink ingredients *Doorbell sound*	1⅛
SIXTH WEEK 25th, 26th days Fri. 5/15 Mon. 5/18 6 pgs.	INT. Newquist living room (N)	49–64	Alfred (face bruised, etc.), Patsy, Carol, Marjorie, Kenny	Trying to know and understand Alfred.	Paperback, candles, matches *Sirens* NOTE: Lights go out & come back on. Interim lit by candles.	6
27th, 28th days Tues. 5/19 Wed. 5/20 6⅜ pgs.	INT. Newquist living room (N)	65–71	Alfred (face bruised, etc.), Patsy, Carol, Marjorie, Kenny, Breather (VO)	Still trying to understand Alfred.	Paperback, candles, matches, drinks *Telephone ring*	6⅜

budget

Once the production schedule has been established, a precise budget should be prepared. An experienced filmmaker can usually estimate a budget that is within 5 percent of actual expenditures; because enormous sums of money are often involved it is dangerous to allow for any greater margin of error. The basic elements in a budget are similar for all types of film production. The following are some sample production budget forms.

	QUANTITY	UNIT PRICE	SUBTOTAL	
1. PRODUCTION PERSONNEL	NO. DAYS/WEEKS			
A. Producer/Director		$	$	
B. Other				
			Total	$
2. TALENT	NO. REELS			
A. Writer		$	$	
B. Narrator				
			Total	$
3. RAW STOCK	NO. FEET/ROLLS			
A. Picture Negative		$	$	
B. Magnetic Film				
C. Optical Negative				
D. ¼″ Magnetic Tape				
			Total	$

	STRAIGHT TIME			OVERTIME (MON.–FRI.)			OVERTIME (SAT. & SUN.)			TOTAL
4. PHOTOGRAPHIC CREWS	NO. DAYS/ WEEKS	@	SUB-TOTAL	NO. HOURS	@	SUB-TOTAL	NO. HOURS	@	SUB-TOTAL	
#1 CREW A. Cameraman		$	$		$	$		$	$	$
B. Asst. Cameraman										

	STRAIGHT TIME			OVERTIME (MON.–FRI.)			OVERTIME (SAT. & SUN.)			TOTAL
	NO. DAYS/WEEKS	@	SUB-TOTAL	NO. HOURS	@	SUB-TOTAL	NO. HOURS	@	SUB-TOTAL	
C. Electrician										
D. Grip										
E. Soundman										
#2 CREW F. Cameraman										
G. Asst. Cameraman										
H. Electrician										
I. Grip										
J. Soundman										
#3 CREW K. Cameraman										
L. Asst. Cameraman										
M. Electrician										
N. Grip										
O. Soundman										
P. Still Cameraman										
Q. Pension/Welfare										

Grand Total $

	NO. FEET	@	SUBTOTAL
5. LABORATORY		$	$
DEVELOPING: A. Picture Negative			
B. Sound			
PRINTING: C. Picture Work Print			
D. Sound Print			
ANSWER PRINTS: E. 1st			
F. 2nd			

	NO. FEET	@	SUBTOTAL
G. Coding			
H. Stills	QUANTITY	SIZE	$ PRICE
			Total $

	QUANTITY	UNIT PRICE	SUBTOTAL
6. TITLES, OPTICALS, ANIMATION		$	$
A. Titles			
B. Opticals			
C. Fades			
D. Dissolves			
E. Wipes			
F. Art Work			
G. Animation			
			Total $

	NO. HOURS	@	SUBTOTAL
7. SOUND SERVICES			
RECORDING:			
A. Narration			
B. Music			
C. Effects			
D. Mix			
TRANSFER:			
E. ¼″ tape to 35mm magnetic			
F. ¼″ tape to 16mm magnetic			
G. 16mm magnetic to 35mm magnetic			
H. 16mm magnetic to 35mm optical			
I. 16mm magnetic to 16mm optical			
J. 35mm magnetic to 35mm optical			

	NO. HOURS	@	SUBTOTAL	
K. 35mm magnetic to 16mm optical				
			Total	$

8. MUSIC	NO. REELS	@	SUBTOTAL
A. Stock Music			
ORIGINAL SCORE			
B. Composer	Flat Fee		
C. Arranger	Flat Fee		
D. Copyist	Flat Fee		
E. Conductor	Flat Fee		
F. Instruments			
G. Other			

H. Music Rights (in accordance with specifications) _____

I. Musicians: _____ _____
 (quantity) (sessions)

Total $

9. EDITING	NO. WEEKS	@		
A. Editor				
B. Asst. Editor				
C. Cutting Room, with Moviola & all required equipment				
D. Projection	NO. HOURS	@		
E. Negative Cutter	NO. REELS			
F. Pension & Welfare				
			Total	$

10. STOCK FOOTAGE	NO. FEET	@	
A. Blow-up 16mm to 35mm or reduction from 35mm to 16mm			

	NO. FEET	@	
B. Fine Grain (35mm)			
C. 35mm b/w composite print			
D. Dupe negative 35mm			

E. Royalty: Total $

11. GENERAL PRODUCTIONS COSTS

INSURANCE

A. Negative

B. Equipment

C. Liability or other insurance

PAYROLL TAXES

D. FICA _____%

E. State Unemployment Ins. _____%

F. Federal Unemployment Ins. _____%

OTHER EXPENSES

G. Reel, Cans, Shipping Cases

H.

I.

J.

 Total $

12. TRANSPORTATION

_____ round trips to Washington, D.C. @

Location Travel (Itemize): Subtotal

_____ trips _____ to _____ @ $ _____

_____ trips _____ to _____ @ _____

_____ trips _____ to _____ @ _____

_____ trips _____ to _____ @ _____

_____ trips _____ to _____ @ _____

_____ trips _____ to _____ @ _____

Equipment transportation _____

Film Shipping _____

Truck rental
and mileage days/weeks @ _____ _____

Station Wagon/
car rental & mileage days/weeks @ _____ _____

Mileage miles @ _____ _____

 Total $

13. PER DIEM Subtotal

 Washington, D.C. _____ days @ _____ $ _____

 Location: _____ men × _____ days @ _____ _____

 Total $

	NO. WEEKS	@	SUBTOTAL
14. EQUIPMENT (Itemize): A. OWNED		$	$
			$_____
B. RENTED		$	$
			$_____

Less _____ % Discount Total: $_____

COST SUMMARY SHEET

Working Title _____ Production Number _____

Contractor _____ Contract Price _____

MONTHS							TOTAL COST	ESTIMATED COST
Film & Laboratory								
Optical Work								
Script Costs								
Storyboard								
Production Staff								
Animation								
Sound Recording								
Talent								
Camera & Sound Crew								
Sets								
Cutting & Editing								
Music								
Equipment Rental								
Purchases & Services								
Miscellaneous								
Travel & Subsistence								
Monthly Totals								
Total Direct Costs								
4% General Supplies								
Payroll & Ins. Taxes 10%								
Union Funds								
Total Costs								
Overhead								
Final Costs								

FILM AND LABORATORY

All costs relating to the purchase of raw stock and to laboratory work—the developing and printing of that raw stock and the eventual printing and reprinting of the finished film—must be indicated in the budget. For example, 16mm color film (Eastman Kodak Commercial Ektachrome #7252) costs (A) .0710¢ per foot of raw stock, (B) .0609¢ per foot to develop, and (C) .1143¢ per foot to make a one-lite work print. Thus if it is estimated that for a particular film 20,000 feet will be shot and developed and 15,000 feet printed, the cost estimate for this item would be (A + B × 20,000) + (C × 15,000). Most filmmakers, in estimating how much film they will need, assume a shooting ratio of ten or twelve to one—that is, ten or twelve feet shot for every foot that appears in the finished film. Thus a thirty-minute 16mm film (1080 feet) will, on the average, require an exposure of 10,000 to 12,000 feet of film.

The laboratory costs of the *finished* film are determined by the length of the film and the kind of printing work involved. For example, a half-hour film will run 1080 feet in 16mm. A 16mm answer print costs 18¢ per foot. One print would cost $194. (An "answer" print is the first print of the finished film received from the laboratory. The term comes from the fact that the lab awaits the filmmaker's answer as to color corrections and other changes before making "release" prints.)

The following is a sample laboratory price list giving typical prices for various kinds of laboratory work.

FILM OPTICALS INC.[4] **(partial price list, 1972)**

35MM COLOR FOOTAGES	FOOTAGE	MINIMUM CHARGE
Intermediate Neg.	.60	40.00
Intermediate Positive	.50	30.00
Color Reversal Inter. Neg.	.80	50.00
Optical Color Print	.50	25.00
Color Check Print	.17	17.00
16mm to 35mm Blow-up	.60	40.00
16MM COLOR FOOTAGES		
Optical Dupe (Ekta)	.60	35.00
Intermediate Neg.	.60	35.00
Color Rev. Inter. Neg.	.80	50.00
Red, 35mm to 16mm	.50	35.00
Check Print	.15	15.00
35MM BLACK AND WHITE FOOTAGES		
Optical Dupe	.25	25.00
Precision Fine Grain	.22	20.00
Precision High Contrast	.20	20.00
Pan Master	.22	20.00
Black and White Check Print	.10	8.00
16mm to 35mm Blow-up	.35	30.00
16MM BLACK AND WHITE FOOTAGES		
Optical Dupe	.40	30.00
Reversal	.50	35.00
Red, 35mm to 16mm	.50	35.00
Fine Grain Master	.40	30.00
Check Print	.10	10.00

[4]Courtesy of Film Opticals, Inc., 421 West 54th Street, New York, New York.

OPTICAL WORK

During the course of production, many different kinds of optical work may be required, including optical reprinting of scenes, special effects (dissolves, wipes, fades, superimpositions, freeze frames, multiscreen images), color distortions, enlargements of frames, and optical photography of titles. Although the experienced filmmaker can usually make a pretty sound guess from the script as to the optical work that will be required and the costs involved, it is difficult to anticipate accurately *all* the optical effects that will be needed. Often decisions involving optical effects are not made until editing is in its full stage. For example, the much-acclaimed multiscreen opticals in *Woodstock* were not considered until the editing stages, when the filmmaker decided that these effects would substantially contribute to the impact of the film. He was right, but because the cost of adding the optical effects had not been anticipated, the film went over its budget.

It is wise, then, when estimating this budget item to make allowances for unexpected costs. (A good rule of thumb is to add 2 to 3 percent of the total budget for optical work.)

SCRIPT AND STORYBOARD COSTS

All costs relating directly to researching and writing the script should be indicated in the budget. This includes writers' fees, expenses for travel, research, typing, and paper, and all other costs incurred up to and including the time when the script is approved. In addition, if a storyboard is required, all costs incurred during its preparation—including artists' fees, travel and research expenses, and costs of materials—must be shown in the budget.

PRODUCTION STAFF

This item usually includes the direct labor costs of the management group—producer, executive producer and/or assistant producers, director, assistant director, unit manager—and of all other nontechnical production personnel, such as production secretaries, script clerks, traffic and transportation supervisors, and public relations people. Here the budget must estimate as accurately as possible the total number of hours or days these people will be involved with the film, including preproduction and postproduction time. Since it is all too easy to *underestimate* the time involved before and after actual photography, it is advisable to add 20 percent more time to your most generous estimate.

ANIMATION

Many films, particularly TV commercials and educational films, include portions that are to be fully animated. Since animation is complex and costly, it is essential that this item be estimated with particular care. The estimate should include all costs, including those for labor and materials, for the animation sketches and storyboards (all animation must be based on a scene-by-scene storyboard),

for rough and final artwork, for inking of all scenes onto cells (individual celluloid frames), for animation photography, and for any other costs related to full animation. This estimated figure should also include the cost of animated film titles.

SOUND RECORDING

This figure includes all costs directly related to sound recording, with the exception of labor costs incurred during production, which are covered under the Camera and Sound Crew column. The sound recording costs to be estimated here include the purchase of raw materials (magnetic tapes); the rental of studio time for narration recording, dubbing, music recording, and any other sound recording; and the cost of transfer time from the original recording on quarter-inch or 35mm tape to either 16mm or 35mm tape for the work (editing) tracks. All sound recording studios charge a flat hourly fee for transferring sound from tape to tape or from tape to optical film. The following is an excerpt from the price list of a sound recording studio supplying these services.

NATIONAL RECORDING STUDIOS[5] **(partial price list, 1972)**

STUDIO FACILITIES per hour (½ hour min.)

	9 A.M.-6 P.M.	6 P.M.-12 MID.	AFTER MID. SAT., SUN., & HOL. (4 HR. MIN.)
EDISON HALL (2 hr. min.)	$ 95.00	$110.00	$130.00
EDISON HALL (2 hr. min.) 16-trk.	125.00	140.00	160.00
Studio A	75.00	90.00	110.00
Studio A8-trk	85.00	100.00	120.00
Studio B or E	55.00	70.00	90.00
Studio C or F	50.00	65.00	85.00
Studio D	45.00	60.00	80.00
Post Mixing/Editing Mono—2-trk	40.00	55.00	75.00
4-trk	50.00	65.00	85.00
8-trk	60.00	75.00	95.00
16-trk	80.00	95.00	110.00
Dubbing Time	25.00	40.00	60.00
On Location Recording (Portal to Portal)	55.00	70.00	90.00
Engineering Overtime	—	20.00	30.00

RECORDED TAPE STOCK

¼″ 600′	$ 5.00	½″ 2400′ (min.)	$25.00
¼″ 1200 (studio min.)	10.00	1″ 2400′ (min.)	35.00
¼″ 2400′	20.00	2″ 2400′ (min.)	75.00

(Plus Dubbing Time)

FILM FACILITIES per hour (½ hour min.)
Direct Projection/Closed Circuit TV/Videotape Playback

	9 A.M. 6 P.M.
EDISON HALL (2 hr. min.)	$110.00
EDISON HALL (2 hr. min.) 16-trk.	140.00
Studio A	95.00
Studio A 8-trk.	105.00
Studio B or E	80.00
Studio C or F	75.00
Studio D	70.00
FILM MIXING	100.00
Film Transfer (½ Hr. Min.)	55.00
Transfer Multi-Track (½ Hr. Min.)	65.00
Film Editing/Preparation	50.00

OVERTIME

Time and one half after 6 P.M.
Double time after midnight, Sat., Sun., and Holidays. (4 hr. min. on Sat., Sun., and Holidays.)

Films and tracks must be received one hour before session. Film facilities include single transfer of selected takes to any one medium, plus stock charges as listed.

[5] Courtesy of National Recording Studios, Inc., 730 Fifth Avenue, New York, New York.

MULTIPLE TAPE DUPLICATION For Broadcast

Duplication Masters: 300'-600' . $10.00 1200' . $15.00

Quantity	300'	600'	1200'
11-25	$2.30	$2.80	$4.25
26-50	2.00	2.50	3.25
51-100	1.75	2.25	2.50
101-250	1.50	2.00	2.25
251-500	1.25	1.75	2.00
501 & over	1.00	1.50	1.85

Duplication Set up $15.00 Labels additional
Volume quantity rates upon request.

PROCESSED MASTERS

One Step 7″, 10″, 12″ $50.00
Three Step 7″, 10″, 12″ $60.00
(Plus Dubbing Time)

FILM STOCK

16mm Negative (Min. 400') Per 400' Reel $ 9.00
35mm Negative (Min. 250') Per 1000' Reel . . . 30.00
16mm Magnetic Full Coat (Min. 400') 10.00
35mm Magnetic Stripe (Min. 250')
 Per 1000' Reel 35.00
35mm Magnetic Full Coat (Min. 500')
 Per 1000' Reel 50.00

SHIPPING AND DELIVERY

Packaging, Mailing, Air Freight Shipments and Messenger Service available at additional cost.

NATIONAL RECORDING STUDIOS, Inc. includes ten studios equipped for Interlock Film Projection and Multi-Track Recording. Re-recording facilities feature complete reversing interlock system with 3-Track Pick-up 16/35 Magnetic Recorder.

TALENT

The cost of all talent (actors and narrators) used in the film should be included in the budget. (Agreements regarding residual payments for commercials or for television use of a film should be noted as a separate item attached to the budget.) Although costs vary greatly depending on the reputation of the talent, day players' (actors who work on a day-to-day basis) salaries are generally based on the $138-per-day basic fee established by the Screen Actors Guild. "Name" actors, of course, are not paid on a per diem basis, but receive either a flat fee for the film, a percentage of the profits, or both, depending on the contract.

CAMERA, SOUND, AND PRODUCTION CREW

This item includes all labor costs incurred during actual production. Among the personnel involved are the director of photography, the operating cameraman (not used on most documentary films), the assistant cameraman, the still cameraman, the sound mixer, the recordist, and the boom (microphone) man. (All other costs of sound recording are usually included as sound studio costs and are covered in the Sound Recording column.) This figure also covers labor costs of all technicians (production crew) working on the film—electricians, grips, prop men, drivers of vehicles, costume designers, wardrobe supervisor, make-up artists, and so on. It does *not* include labor costs of those people involved in designing and constructing sets—these are covered in the Sets column. Representative wages for production personnel are provided in the following charts.

WAGE SCALE CHARTS

MOTION PICTURE PHOTOGRAPHERS--LOCAL 644
(Effective 1/1/73-6/30/73

| | 1/1/73-6/30/73 | | | |
	DAILY	OVTM	WKLY	OVTM
First Cameraman	$113.27	$28.32	$435.81	$21.79
Operative and				
Addl. Cameraman	87.88	21.97	390.96	19.54
Asst. Cameraman	75.29	18.82	298.15	14.90
2nd Asst. Cameraman	60.55	15.14	244.50	12.25
Still Cameraman	85.04	21.26	340.61	17.02
Annual 1st Cameraman			425.00	15.97
Annual Asst. Cameraman			280.00	10.50

PENSION FUND: $5.50/day eff. 8/1/71-6/30/73. Annual Cameramen
 receive $23.75/week as of 8/1/72.

WELFARE FUND: $5.50/day contribution by employer as of 10/1/71.
 Annual Cameramen receive $18.25/week as of 10/1/71.
ANNUAL CAMERAMEN: Receive time and one-half overtime Monday to
 Friday and Saturday work.
OVERTIME: Computed in 1/2-hour units with 10 minutes leeway.

GUARANTEED HOURS: 8 ANNUAL CAMERAMEN: 40

GOVERNMENT WORK: 15% less than the applicable wage scales above.
 When engaged for one week or more out-of-town,
 no pay for Saturdays or Sundays when no work or
 travel is done.
STARTING TIME: First Cameraman and Asst. Cameraman must begin work at
 same time or receive overtime for difference in starting
 times. Otherwise, flexible starting time between 7 & 10 A.M.

TV COMMERCIALS--NON-THEATRICAL FILMS

WAGE SCALE CHART

MOTION PICTURE PHOTOGRAPHERS--LOCAL 666
(effective 5/1/72-4/30/73)

	DAILY	OVERTIME	WEEKLY	PENSION	WELFARE
First Cameraman	$130.00	$24.37	$445.00	$4.50 per day or $15.00 per calendar week (which- ever is lower)	$3.00 per day or $15.00 per week
Assistant Cameraman	78.00	14.62	275.00		
Still Cameraman	90.00	16.87	325.00		

OVERTIME: Time and one-half shall be paid for work performed after 8 hours in one day; work performed on Saturday as such; work performed after the regular quitting time. Double time shall be paid for work performed on Sundays and Holidays; work performed between midnight and 7:00 A.M. (shall continue until employee receives at least 10 hours rest).

GUARANTEED HOURS: 8

MEAL PERIODS: A meal period shall be called after five (5) hours of work. One (1) hour dining time shall be allowed. Food supplied by the Producer without taking dining time out shall not be considered a meal period.

SETS

All costs related to the design and construction of sets should be indicated in the budget. These include the costs of studio rental plus the fees and direct labor costs of the set designer, the scenic artists (painters), the construction grips and carpenters, and the property men who are involved in dressing the set. The following is a representative wage scale.

TV COMMERCIALS--NON-THEATRICAL FILMS

WAGE SCALE CHARTS

UNITED SCENIC ARTISTS--LOCAL 829
(effective 3/28/72-3/27/74

| | 3/28/72-3/27/74 | | PENSION-- |
	WEEKLY	DAILY	WELFARE
Art Director*	$464.89	$116.52	8% of
Chargemen S.A.		83.62	gross
Journeyman S.A.		67.24	earnings
Costume Designer	329.20	90.87	
*Unlimited Hours	651.90		

GUARANTEED HOURS: 7

STARTING TIME: Chargeman and Journeyman S.A. only may work 7 hours between 7:30 AM and 7:00 PM where there is a continuous and consecutive daily engagement of three or more guaranteed working days of employment.

CUTTING AND EDITING

All costs related to the editing of the film should be indicated in the budget. They include the rental of editing rooms and equipment (a fully equipped editing room usually rents for about $150 per week), the direct labor cost of editors and assistant editors, and the cost of all material used in editing (splicing tape, film leader, acetone, etc.).

TV COMMERCIALS--NON-THEATRICAL FILMS

WAGE SCALE CHARTS

FILM EDITORS--LOCAL 771 *NOTE: NEGOTIATIONS FOR A NEW AGREEMENT ARE CURRENTLY IN PROGRESS
 (Effective 1/1/69-12/31/71)

| | WEEKLY WAGE SCALES | | | EFFECTIVE 1/1/69 | |
	1/1/71	7/1/71	10/1/71	PENSION	WELFARE
Chief Film Editor	$348.00		$354.00	$0.30	$0.30
Film/Music & Effects Editor	290.00		295.00	PER EACH HOUR WORKED	
Assistant Film Editor		$205.00		(Not to exceed 40 hours	
Editing Room Assistant	125.00			per week)	
Film Librarian	230.00				
Assistant Film Librarian	180.00			EFF. 1/1/71	
Freelance				Pension contribution is	
Film Editor	406.00		411.00	$0.35/hr	
Music & Effects Editor	381.00		386.00	————————————	
Assistant Film Editor		237.50		Rate of pay is for all	
Editing Room Assistant	132.25			hours worked each week	

OVERTIME: All work before 12:00 M. in excess of 8 hours is at time and one-half. After 12:00 M., double time. Computed in 15 minute segments.

GUARANTEED HOURS: 8 per day for freelance, 40 per week for all others.

HOLIDAYS: A holiday falling on Saturday will be given on the preceding Friday or in lieu thereof employer may elect to grant the day off consecutive with any other holiday.

MUSIC

This item includes all costs related to film music, with the exception of the rental fees for recording studios, which are covered in the Sound Recording column. Included are composers' fees, arranging and copying fees, musicians' fees, and library music fees and royalties. A 30-minute film can usually be scored for about $1200 if library or stock music is used.

EQUIPMENT RENTAL

The cost of all equipment rented for use during the production of the film (cameras, sound recorders, dollies, special-effects units such as wind and fog machines, etc.) should be indicated in the budget. This estimate should include all equipment related to the actual filmmaking (photography). Vehicles, props, costumes, and so on are all included elsewhere.

CAMERA MART, INC.[6] (partial price list, 1972)

ARRIFLEX 16mm CAMERAS		DAILY
ARRIFLEX "BL" CAMERA WITH 12/120 ZOOM LENS		
Professional self-blimped 16mm camera. Sound convertible for single/double system recording. With Angenieux 12/120 zoom lens, 12V DC Governor Controlled (Universal) motor, battery and charger, special matte box, one 400-ft. magazine and body brace		$ 65.00
ARRIFLEX "BL" CAMERA WITH 9.5/95 ZOOM LENS		
Same as above, but with Angenieux 9.5/95 zoom lens and special matte box		70.00
ARRIFLEX "BL" SOUND CAMERA WITH 12/120 ZOOM LENS		
Single system sound camera. Complete with Angenieux 12/120 zoom lens, 12V DC Governor Controlled (Universal) motor, battery and charger, matte box, one 400-ft. magazine and body brace. Magnetic sound recording module, amplifier, microphone, headset and cables		95.00
ARRIFLEX "BL" SOUND CAMERA WITH 9.5/95 ZOOM LENS		
Single system camera as above but with 9.5/95 Angenieux zoom lens and special matte box		100.00
ARRIFLEX "BL" ACCESSORIES		
MAGAZINES	400-ft.	6.00
	1200-ft. (converted 16-M magazine)	10.00
MOTORS	12V DC governor-controlled motor	6.00
	12V DC variable speed motor	6.00
	110V AC synchronous motor	12.00
	Universal Motor with electronics unit	15.00
POWER	12V pack battery with built-in charger	6.00
SUPPLIES	12V belt battery with built-in charger	6.00
	12V pack battery, small, to mount onto back of BL body brace	6.00
FINDER ACCESSORIES		
	BL Offset Finder	5.00
	Arri Periscope Finder	6.00
BODY	BL Body Brace with pistol grip	2.50
BRACES	BL concentric brace for use with offset finder	2.50
LENSES	8mm Zeiss Distagon with BL Universal Lens Housing, engraved scales	20.00
	10mm Schneider Cinegon with BL Universal Lens Housing, engraved scales	20.00
	BL Polarizer, special rotating mount, for use on 12/120 zoom lens	2.50
MISCELLANEOUS		
	Magazine barney (400-ft.)	1.25
	BL carrying handle	1.25
	NOTE: When air-shipping the Arri BL please inquire about special packing procedures to avoid damage in transit.	

Note: Weekly rates are five times daily rates.

[6]Courtesy of the Camera Mart, Inc., 456 West 55th Street, New York, New York.

PURCHASES AND SERVICES

This is a catch-all category—it includes everything bought, hired, or rented during production that is not covered in previous items. Every film production requires countless items that do not fall comfortably into specific categories—drivers, theatrical moving services, pads and pencils, make-up, and so on. The cost of these items should be estimated here.

TRAVEL AND SUBSISTENCE

All travel and transportation costs, including the purchase and rental of vehicles, should be covered in this category. In addition, according to union regulations and generally accepted procedure, the producer is responsible for all living costs of cast and crew while on location. Therefore, either a fixed daily subsistence allowance (generally about $30 per day) is allocated to each actor and crew member, or, in some cases, the producer may elect simply to pay for everything out of the general production budget. In either case, the figure must be estimated, taking into account current prices in the area in which the filming is to be done.

The total amount budgeted for the first sixteen items estimated on the Cost Summary Sheet is referred to as the *total direct cost* of the film. This is the most significant single figure in a production budget. The following items cannot be estimated accurately and so are based on a percentage of the total direct cost.

GENERAL SUPPLIES

This category includes stationery, pencils, and other small but very necessary items. A good formula for estimating the cost of general supplies is to add 4 percent of the total direct cost.

PAYROLL TAXES AND INSURANCE

Ten percent of the total direct cost is usually a good amount to allow when estimating the cost of payroll taxes (required by law) and production insurance. Production insurance covers both liability—the producer must be protected against lawsuits in case of accidental injury or death to crew, cast, or bystanders—and invasion of privacy, particularly important in documentary films, where inadvertent invasion of privacy is quite possible. For example, a prison documentary may include several long dolly shots past cells to reveal and expose poor conditions. The producer will, of course, have obtained releases from all those who will be in the film. However, if on a day of photography a person who did not sign a release accidentally (and recognizably) appears in the scene, the possibility of a lawsuit is very real. In addition, the producer should carry an insurance policy

to cover the health of the major stars, workman's compensation (as required by local, state, and federal laws), and "negative insurance," which protects the producer against most equipment failure. "Negative insurance" is the term for insurance covering the film as it is being shot, insuring that negative against damage or loss throughout production.

The filmmaker is best advised to consult an insurance broker highly experienced in film work. Such a broker, often working with an experienced lawyer, will examine the script and the production schedule and recommend not only the types of insurance needed, but the best insurance companies from whom to purchase the insurance.

UNION FUNDS

All unions require the payment of a certain fixed amount, based on salary, to their pension and welfare funds. This item can be estimated from the figures in the four columns which cover union labor: Production Staff, Camera and Sound Crew, Sets, and Cutting and Editing. For example, to the cameraman's base minimum salary of $113.27 per day for TV commercials and industrial films, a figure of $12 per day for pension and welfare must be added and paid directly to the union.

The sum of all of the above items represents the *total cost* of the production. To this must be added the following:

OVERHEAD

Usually 10 to 20 percent of the total cost is added to cover overhead, which includes rental of office space, stenographic and secretarial salaries, telephone costs, and all other costs incurred during production that cannot be itemized as part of the filmmaking process.

MISCELLANEOUS

This category includes *minor* costs (contingency items, coffee on set, small repairs, tips, etc.) and a general cost figure to accommodate errors and acts of God. A good formula to apply in estimating this item is to add 5 percent of the entire production budget. Thus in a film budgeted at $100,000, this item should be estimated at $5,000. The figure may sound high, but it is quite realistic.

The total of all of the above items comprises the *final cost* figure for the production. The following is the final cost sheet on the production of a one-hour documentary film dealing with the population problem. A careful examination of these costs will indicate the balance of each item within the entire cost structure.

COST SUMMARY SHEET

Working Title _____ Production Number _____

Contractor _____ Contract Price ___$90,000___

MONTHS	FORWARD	AUG. '71	SEPT. '71	DEC. '71			TOTAL COST	ESTIMATED COST
Film & Laboratory	5000.78	149.91						
Optical Work	1187.50	1382.75						
Script Costs	268.70							
Stills				36.25				
Research	2.00							
Production Staff	15884.71							
Animation	685.00							
Sound Recording	2212.27	121.40						
Talent	882.00							
Camera & Sound Crew	8392.00							
Sets	343.90							
Cutting & Editing	9023.24	279.37	46.87					
Music	589.25							
Equipment Rental	100.00							
Studio Rental	50.00							
Purchases & Services	194.50							
Miscellaneous	1854.75							
Travel & Subsistence	9449.56							
Monthly Totals	56120.16	1933.43	46.87	36.25				
Cumulative Totals		58053.59	58100.46	58136.71				
Total Direct Costs	56120.16	58053.59	58100.46	58136.71				
4% General Supplies	883.05	949.20	949.20	949.20				
Payroll & Ins. Taxes 10%	3034.80	3062.80	3067.50	3067.50				
Union Funds	954.70	975.50	978.75	978.75				
Total Costs	60992.71	63041.09	63095.91	63132.16				
Overhead	36132.00	36626.00	36729.00	36729.00				
Final Costs	97124.71	99667.09	99824.91	99861.16				

The importance of preparing an accurate budget before filming begins cannot be overstressed. A high percentage of theatrical feature films are never completed because the producer runs out of money. Many TV commercials and educational and documentary films lose money and plunge the filmmaker into bankruptcy because of an inaccurate or poorly prepared budget. The *art* of filmmaking can be pursued only if the *business* of filmmaking is given thoughtful and professional attention. A good accountant, a good lawyer, and a good insurance agent are as important to the filmmaking process as are the director, cameraman, and editor.

casting

In theatrical feature films, some documentary, industrial, and educational films, and most TV commercials, casting is tremendously important. How does the filmmaker identify and select the actors or nonprofessionals who will give the film the best possible chance for success?

The easiest and most direct method of casting a film is to deal with the large companies that handle professional acting talent, such as William Morris, International Famous, CMA, and so on. This method has the virtue of allowing the filmmaker to select his cast from a large number of applicants—in fact, a telephone call to any one of these agencies will result in a mob scene at the filmmaker's home or office. Unfortunately there is a great deal of wasted time and effort inherent in this method. The traditional theatrical casting method of having hordes of aspirants read sections from a play simply does not work with film. "Readings" are probably the worst way to cast, for they indicate nothing about how the actor will communicate his inner self once the cameras begin to roll. If the filmmaker is forced to select from hundreds of actors who have chosen to attend the casting session, he most likely will be buried in an avalanche of nontalent and end up more confused than when he began. The filmmaker eventually must accept the fact that over 95 percent of the acting community are not particularly talented, and perhaps fewer than 1 percent have that very special talent that propels ideas and emotions across the celluloid barrier.

It is possible, of course, for the filmmaker to do his own casting "in the field"—that is, to move about in the theater, in off-Broadway, community, and student productions, and anywhere else acting is going on. Using this method, the filmmaker can at least get some idea of the actor's ability to act, which no "reading" can give. However, it is too time-consuming and often leads to confusion by presenting the filmmaker with too many possible candidates.

Another possible casting method is to hire one or more casting agents, who for a fee will preselect a small group of actors and send them to the filmmaker for consideration. This approach has the advantage of narrowing the field in advance, but like all the above methods of casting it has its limitations. The casting agent may not share the filmmaker's vision of the film; he may be severely limited to a "standard" approach, dealing only with familiar actors; or he may simply lack the creative judgment to cast an off-beat or interesting new actor in an important role. The filmmaker who relies too heavily on the casting agent's

judgment and limits his final selection to those suggested by the casting agent is taking a great risk, for he is leaving the critical matter of casting to a non-filmmaker.

There are no simple and failure-proof guidelines for evaluating and selecting the cast, but one rule of thumb might prove helpful. Casting essentially involves a visceral or "gut" reaction to the talent on the part of the filmmaker. The "feeling" the filmmaker gets when he meets and talks with the actor is often a better standard to use than credentials, prior performances, or readings.

THEATRICAL FEATURE FILMS

In a theatrical feature film where the final choice lies with the director, the simplest and most promising method of casting is probably to operate on the basis of your own experience. Most scripts will probably call to mind well-known actors who would be suited to the major parts. For example, a filmmaker might envision "someone like Jack Nicholson in *Five Easy Pieces*" or "someone who can underplay the way Jean-Louis Trintignant did in *The Conformist*." With these cues the filmmaker can narrow down the field and can, through talent agencies, acting schools, and current film and theater productions, locate the kind of actors for whom he is looking.

Since the "box-office star" is no longer essential to the success of a film, the director should not be overly concerned if the actor doesn't have a string of "great" films to his credit. There are no guarantees against failure, even with a famous star. Dustin Hoffman put together five superb performances in the theater and film and then failed totally in *John and Mary*. Arthur Penn's "gut" feeling about Hoffman, however, led him to overlook the poor, mannered performance in *John and Mary* and cast him in *Little Big Man*—one of Hoffman's finest efforts.

Actually, in today's film world, the film creates the star rather than the star making the film, so a totally unknown face can often better serve the film. Jack Nicholson, for example, had done little of note before Peter Fonda and Dennis Hopper cast him as the Southern lawyer in *Easy Rider*. That part led to his role in *Five Easy Pieces*—and a star was born.

Casting, then, is a process of identification and communication. The filmmaker identifies the individual who best fits his concept of the role. He does this by trying to communicate with the actor in order to see something of the actor's self and of his ability to project that self. Superficial "performance" is a thing of the past. What is important today is the actor's ability to "get inside" the material, to digest it and then to project it as authentically as he can within the confines of the art. Although physically Jack Nicholson fit the director's image of what the leading character in *Five Easy Pieces* should look like, this was far less important than Nicholson's ability to communicate his understanding of the character and to reveal and project that character throughout the film.

TV COMMERCIALS

In the TV commercial, the filmmaker usually casts with an eye to credibility, honesty, and sincerity. He may also look for such additional qualities as strength (Orson Welles for Eastern Airlines) or the ability to dramatize a message (Rod Serling for Anacin). Established actors such as David Janssen (Excedrin), Paul Richards (Pontiac, American Express), and Robert Lansing (Ford) are examples of excellent casting choices who project precisely the qualities needed to sell the idea or the product. Just as in films they have always projected a kind of rugged honesty free from the "Hollywood" image, they now can transfer that quality to the selling of the product. Another important quality necessary for effective TV commercials is the ability to narrate off-camera lines. Most commercials are a combination of on-camera dialogue and off-camera voice-over narration. The voice, then, divorced from its visual accompaniment, must have a high degree of impact. Current commercials also make use of the "regular guy" or obviously ethnic character, as seen in the much-acclaimed Alka-Seltzer series ("I can't believe I ate the whole thing" and "Try it, you'll like it").

EDUCATIONAL AND DOCUMENTARY FILMS

Some educational and documentary films employ professional actors. Here the goal is not to seek out "name" performers who will attract attention to themselves, but rather to find talented actors who will seem totally real. Other educational and documentary films employ nonactors in real-life situations. Casting here takes on an entirely different quality. The search is for people who can carry out their normal activities without being affected by cameras, microphones, and lights. The filmmaker generally lives with his potential cast for a period of time and eventually selects those who can not only be "real," but who can project that reality as well.

Casting a film is a little like searching for a friend. The filmmaker must make his final decision based on his emotional reaction to the individual.

selection of studios

There are a variety of motion picture sound stages available for rental in most major cities of the world. Rental fees vary according to size and equipment included. Cost should not be the only consideration, however, and the inexperienced filmmaker can make major mistakes when selecting a studio if he doesn't know what to look for. The following section is a simplified guide to studio rental, listing some of the elements that should be considered in selecting sets and studios.

SIZE

Since the cost of most studios is based primarily on size, the filmmaker should select a studio that is only as large as is necessary. If the film calls for a small kitchen setting, there is no need to rent a studio large enough to stage a Viennese ball. The reverse is also true. If a ballroom is needed and the studio is too small, the filmmaker, forced to work in cramped quarters, will be in real difficulty.

CONVENIENCE OF LOCATION

If the film's schedule demands a great deal of studio-to-location movement and the exterior locations are in the city, it is not wise to select a studio located at the outskirts of the city or isolated in the suburbs, where traffic delays and transportation time can subtract valuable hours from filming time. Generally, it is best to choose a studio that is as convenient as possible to the other areas in which filming is to be done.

SOUNDPROOFING

All sound stages (studios) rented for the filming of sound motion pictures are presented as 100 percent free of external noise. However, it is the better part of valor (particularly in New York, Chicago, and Detroit) to examine the studio for leakages of outside sounds as well as for such extraneous sounds as creaking floors, rattling heating or air-conditioning units, and noisy pipes or ducts. A production can easily lose 10 to 20 percent of its expensive studio shooting time while a sensitive sound man frantically tries to track down and eliminate an extraneous noise. In addition, many feature films and TV commercials require rear projection of film or slides—indeed, this is often the sole reason for studio rental. The projection machines must be inspected for quality and noise-free operation.

EXITS AND ENTRANCES

The building that houses the studio should be carefully examined for the ease with which people and equipment can enter and leave. If an automobile or a complex crane is needed on the set and the studio is on the third floor, the filmmaker must make sure the equipment can be delivered without having to be dismantled. The arrangement of the entrances to the studio itself should also be examined. If the entrances are not separated from the studio itself, production must stop each time someone arrives or a piece of scenery or equipment is delivered.

On the opposite page is a layout of the Camera Mart Studio in New York. Studios like this rent for about $395 a day, with slightly lower weekly and monthly rates available. These prices cover only the studio space itself. The filmmaker usually provides all equipment and crew, although most studios can be

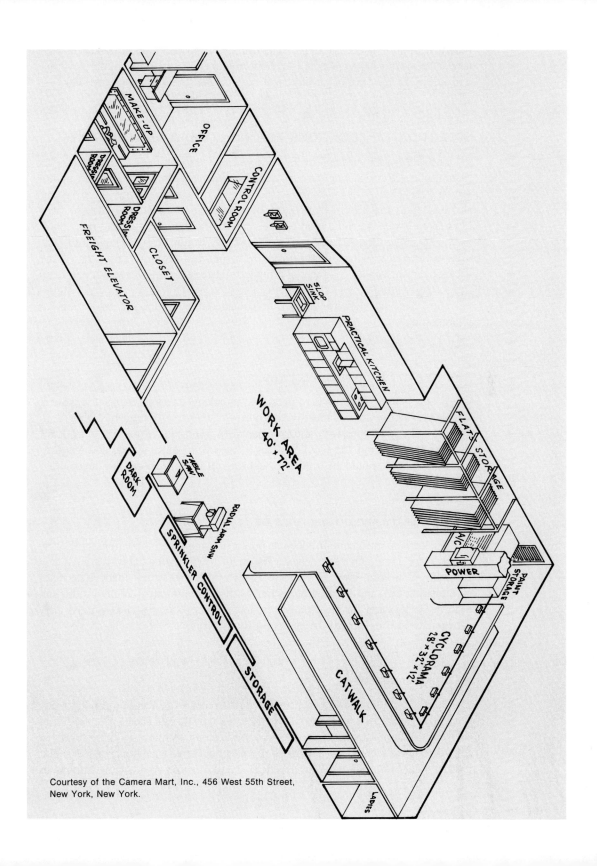

MAKE-UP

DRESSING ROOM

DRESSING ROOM

OFFICE

CONTROL ROOM

FREIGHT ELEVATOR

CLOSET

SLOP SINK

PRACTICAL KITCHEN

WORK AREA
40' × 72'

TABLE SAW

DARK ROOM

RADIAL ARM SAW

FLATS STORAGE

A/C

POWER

PAINT STORAGE

SPRINKLER CONTROL

STORAGE

CATWALK

CYCLORAMA
28' × 32' × 12'

LADIES

Courtesy of the Camera Mart, Inc., 456 West 55th Street,
New York, New York.

rented with crew and equipment. It is usually mandatory and advisable to have a crew member who represents the studio rental company. The studio crew man will know the location of all electrical outlets and standing props and flats.

SELECTION OF LOCATIONS FOR NONSTUDIO PHOTOGRAPHY

The selection of settings for on-location photography is much more complex than studio selection. The current trend in cinema is away from studio photography; the high costs of renting studios and building sets and the desperate slowness and anachronistic methods of studio production have driven many filmmakers away from the studios and into the field, and more and more films are being shot in natural settings. For example, Frank Perry's *David and Lisa*, a popular artistic success of the 1960s, was shot entirely on location in a large, vacant boarding school. The school provided all necessary interior sets at one-tenth the cost of a studio.

The following elements should be considered in evaluating a location for photography.

SUITABILITY OF EXTERIOR LOCATIONS

Although it is possible to re-dress and alter any interior setting, the general visual character of an area must be given careful scrutiny. A suburb of New York may be a cheap, cooperative, and convenient location, but it just won't work for shooting a film about the Civil War set in the deep South. Visual and environmental potential should be a primary consideration in selecting any location.

AVAILABILITY AND CONVENIENCE OF ACCOMMODATIONS

The location must contain adequate public housing accommodations and dining facilities for crew and cast. Many very small towns cannot absorb the sudden incursion of a large crew. This leads to delays at mealtimes, inadequate hotel accommodations, and eventually friction with the community. If the production is to be on location for an extended period of time, the area chosen must offer convenient and top-quality housing and food facilities.

SOUND PROBLEMS

Although dubbing (postsynchronous sound recording) is still a popular solution to on-location sound problems, it is not always an artistically satisfying solution. If the filmmaker wants to record sound on location (as is necessary in most documentary films), it is best to select an area free from major sound interference. For example, New Rochelle, New York, is an attractive suburb in

Westchester County with a great variety of potential filming locations, but it lies directly in the approach path of two major airports. This means that every thirty seconds between 8 and 10 AM and between 3 and 7 PM a jet plane is heard roaring in for landing, making synchronized sound recording impossible during six out of eleven working hours. Similarly, a house that seems to be ideal for interior sequences may be located near a major truck route or near a heavily trafficked intersection. Or the house may be so old that the floorboards creak when people walk on them. In both these situations sound recording will be impossible. All locations must be carefully examined *in advance* for sound problems. Unless postsynchronous dubbing is planned, sound problems may constitute the most serious drawback to on-location work.

COMMUNITY COOPERATION

For a film to be successfully produced wholly or in large part on location, the full cooperation of the immediate community must be enlisted. All community service groups must enthusiastically endorse the presence of the crew and cast. For example, police must be willing to provide crowd control and to suspend parking regulations for production vehicles. Unless such cooperation is obtained, the filmmaker is liable to spend all his time in conflict with the community, which would make successful production work impossible. Since the film and its crew and cast bring both prestige and economic gain to the community, the necessary support can usually be enlisted through early contact and continuous communication between the filmmaker and community leaders. Almost any kind of arrangement can be made with a community if conditions are anticipated and communication is established well in advance of actual filming. However, if there seems to be a feeling of hostility, either overt or covert, on the part of community members during the early phases of location planning, it would be well to seek out a different community, one that will enthusiastically accept the idea of a film production in its midst.

CLIMATE AND WEATHER CONDITIONS

Nothing can play havoc with a production schedule as much as weather. The location must be chosen with careful consideration given to the climate and general weather conditions prevalent during the time of year when filming is to be done. It is best not to go against the odds. Ketchikan, Alaska, which averages only 3 or 4 fully sunny days during the month of July, is obviously not a good choice for a great deal of exterior photography—unless, of course, gray, wet, overcast days are specified in the script. A review of the meteorological history of the area under consideration is a simple investment of time that can pay rich dividends. Factors such as time of sunrise and sunset, average number of sunny days in the month, general wind conditions (it is hard to shoot a quiet, gentle scene if the actors are being blown off their feet by gusts of wind), and the temperature range should all be investigated before a final decision is made.

These are but some of the factors that must be carefully considered in evaluating a possible location for photography. The best way to proceed is to analyze the essential visual elements indicated in the script and then determine the *ease* with which they can be obtained in a given location. It is wise to assume that everything will always be much harder to achieve during production than it appeared to be while scouting the location. If the location presents problems at the time of scouting, at the time of shooting it will be impossible. Two basic rules should be followed. First, *don't kid yourself.* Never assume that you can "work things out" during production. The location chosen must appear ideal in *all* respects if you are to have a reasonable chance for a catastrophe-free production. Second, *look under the carpet.* Examine the total area carefully and make a thorough check for any potential problems that might otherwise be overlooked. In your enthusiasm for a specific location—for example, a perfect house—it is easy to miss many negative elements a block away.

selection of foreign locations

The table on pages 113–14 is a brief *"Guide Michelin"* to areas of the world that offer a variety of interesting visual attractions for on-location photography. They are rated on a scale from 5 to 0 with regard to the following factors:

1. *Official cooperation*—ease with which filming in the area can be arranged and degree of freedom from interference.
2. *Studio and professional crews*—ease with which excellent professional film crews can be organized locally.
3. *Housing and food*—availability of good housing and food.
4. *Union cooperation*—willingness of local unions to provide assistance. (Countries not having any film unions receive a 0 rating.)
5. *Exterior and interior possibilities*—range of possibilities for exteriors and interiors.
6. *Transportation*—quality of transportation and ease of movement.
7. *Customs and internal travel regulations*—leniency of official regulations regarding bringing equipment into the country and transporting it from place to place within the country.
8. *Weather*—general quality of year-round weather conditions.
9. *Availability of equipment*—ease with which professional equipment can be obtained locally.

When shooting in any foreign country, the following procedures will greatly reduce the chance of costly delay, conflict with local officials, and more serious problems.

First, always write to the embassy, consulate, or other representative agency of the foreign government to request a meeting. At that meeting submit the *complete* script or screen treatment of the film you are making, even if only part of the film is being shot in the country in question. Describe in detail every area

LOCATION	OFFICIAL COOPERATION	STUDIO AND PROFESSIONAL CREWS	HOUSING AND FOOD	UNION COOPERATION	EXTERIOR AND INTERIOR POSSIBILITIES	TRANSPORTATION	CUSTOMS AND INTERIOR TRAVEL REGULATIONS	WEATHER	AVAILABILITY OF EQUIPMENT
Afghanistan	4	0	2	5	3	1	3	2	0
Africa, Central	3	0	1	5	2	2	2	1	0
Africa, East	4	0	5	5	5	4	4	5	0
Africa, Equatorial	2	0	1	5	3	1	2	1	0
Africa, Northeast	3	0	2	5	3	1	3	2	0
Africa, Northwest	2	0	2	5	3	1	3	2	0
Africa, West	2	0	3	5	3	2	3	2	0
Albania	0	0	1	5	3	1	1	1	0
Argentina	2	0	3	0	3	4	2	3	0
Arizona–New Mexico	5	3	5	5	5	5	5	5	3
Australia	4	4	5	5	5	5	5	5	3
Austria	5	3	5	5	5	5	5	3	3
Belgium	4	0	4	0	4	4	4	3	2
Brazil	2	0	2	0	3	4	1	3	0
Bulgaria	2	1	2	5	3	2	1	2	0
Burma	2	0	3	5	3	2	2	3	0
Cambodia	1	0	1	5	3	0	1	4	0
Canada	2	4	4	3	5	4	4	3	2
Caribbean Islands	4	2	5	3	4	4	3	5	0
Central America	4	0	3	5	3	2	3	3	0
Ceylon	2	0	3	5	3	2	1	3	0
Chicago	3	2	3	2	4	2	4	1	4
Chile	2	0	4	0	4	4	3	4	0
China	0	3	3	5	5	2	0	3	0
Colombia	2	0	3	0	4	3	2	3	0
Czechoslovakia	3	3	3	5	4	3	2	2	3
Denmark	5	2	5	5	4	4	5	2	3
Denver	5	0	4	5	4	5	5	4	1
Detroit	3	3	4	3	2	2	4	1	4
Ecuador	3	0	2	0	3	2	2	3	0
England–Wales	4	4	5	4	5	5	5	2	5
Finland	5	2	4	5	4	4	4	2	1
Florida	5	4	4	3	4	5	5	5	4
France	0	3	5	2	5	5	1	4	5
Germany, West	5	5	5	5	5	5	5	3	5
Greece	3	1	4	5	5	4	2	4	2
Hong Kong	5	3	5	5	5	5	5	5	2
Hungary	3	2	3	5	4	3	1	3	2
India	1	2	2	4	5	3	1	3	2
Iran	5	0	4	5	4	4	4	4	0
Iraq	0	0	1	5	2	1	1	3	0
Ireland, Republic of	5	0	3	0	4	3	3	1	1
Israel	4	3	5	4	4	5	5	4	4
Italy	4	5	5	3	5	4	4	4	5
Japan	4	5	5	4	5	5	4	3	5
Jordan	1	0	1	5	3	1	0	3	0
Korea, South	3	0	4	5	4	2	3	3	0

LOCATION	OFFICIAL COOPERATION	STUDIO AND PROFESSIONAL CREWS	HOUSING AND FOOD	UNION COOPERATION	EXTERIOR AND INTERIOR POSSIBILITIES	TRANSPORTATION	CUSTOMS AND INTERIOR TRAVEL REGULATIONS	WEATHER	AVAILABILITY OF EQUIPMENT
Laos	0	0	0	5	2	1	1	3	0
Lebanon	4	0	3	5	3	2	3	3	0
Libya	0	0	0	5	3	1	0	2	0
Los Angeles–Hollywood	5	5	5	4	4	4	5	5	5
Luxembourg	5	0	5	5	5	5	5	3	0
Malaysia	3	0	4	5	4	3	3	4	0
Mexico	3	3	5	2	5	3	2	4	3
Mongolia	1	0	2	5	3	0	2	1	0
Nepal	4	0	3	5	5	2	4	2	0
Netherlands	4	0	5	0	5	5	5	1	1
New York City	5	2	5	0	5	3	3	2	5
New Zealand	5	1	5	5	4	4	5	5	0
Norway	5	1	4	5	4	4	5	2	2
Pacific Islands	5	0	5	5	4	3	5	5	0
Pacific Northwest	5	2	4	4	5	5	5	1	2
Pakistan	0	0	1	5	3	2	1	3	0
Peru	3	0	2	0	5	3	1	3	0
Poland	4	3	2	5	3	2	2	1	2
Portugal	3	1	5	5	5	5	5	4	2
Rumania	3	1	3	5	4	3	2	3	1
Saudi Arabia	1	0	1	5	3	1	2	2	0
Scotland	4	0	3	0	4	4	5	1	1
South Africa	0	1	4	5	4	4	0	4	0
Spain	4	4	5	4	5	5	4	4	3
Surinam	3	0	2	0	3	2	2	2	0
Sweden	5	5	5	5	4	4	5	2	4
Switzerland	5	2	5	5	5	5	5	3	2
Syria	0	0	0	5	3	1	0	3	0
Taiwan	3	3	5	5	4	4	3	3	1
Thailand	4	0	5	5	5	3	3	5	0
Turkey	2	0	3	5	4	3	2	3	0
United Arab Republic	0	0	1	5	4	2	0	2	0
Uruguay	3	0	2	0	2	3	2	3	0
U.S.S.R.	2	4	3	5	5	4	1	2	5
Venezuela	4	0	4	5	4	4	3	4	0
Vietnam, South	0	0	0	5	1	0	1	3	0
Washington, D.C.	3	2	3	0	3	3	4	2	4
Yugoslavia	4	3	4	4	5	3	3	3	2

of the country you wish to travel and work in and submit a list of all the equipment you will want to import for the purpose of production. Include a full description of each piece of equipment, its value (market price both in U.S. dollars and in the currency of the country involved), its serial number, and its country of origin. (See the sample equipment list that follows.) Submit also the name of each member of the crew along with his age, nationality, and passport number.

Proposed List of Equipment to Be
Used for Filming in Korea and
the Philippines in October, 1970

All material in this listing will
be returned to the United States
of America upon completion of filming.

QUANTITY	DESCRIPTION OF ITEM	SERIAL #	COUNTRY OF ORIGIN
50	400-ft. rolls unexposed 16mm Commercial Ektachrome	7252	U.S.A.
20	400-ft. rolls unexposed 16mm Daylight High Speed Ektachrome	7241	U.S.A.
12	400-ft.rolls unexposed 16mm Tungsten High Speed Ektachrome	7242	U.S.A.
9	100-ft. rolls unexposed 16mm Commercial Ektachrome	7255	U.S.A.
6	100-ft. rolls unexposed 16mm Daylight High Speed Ektachrome	7241	U.S.A.
6	100-ft. rolls unexposed 16mm Tungsten High Speed Ektachrome	7242	U.S.A.
1	16mm Arriflex-S motion picture camera with constant speed motor, variable speed motor, matte box, assorted filters, 3 motor cables, take-up spool, filter holders, 4 magazines, 2 torque motors	16460 689 11711	West Germany
1	18mm Cooke Speed Panchro lens	601299	England
1	25mm Cooke Kinetal lens	601377	England
1	50mm Cooke Kinetal lens	615931	England
1	75mm Cooke Panchro lens	687128	England
1	90mm Makro Kilar lens	243/2300	West Germany
1	10mm Schneider-Kreunach lens	10113603	West Germany
1	280mm Telyt lens	1993492	Canada
1	5.7 Tegea lens	66670	France
1	400mm Leitz lens	1875597	West Germany
1	Belt battery for Arriflex camera	no number	U.S.A.
1	Standard battery for Arriflex camera	no number	U.S.A.
1	NCE Tripod and fluid head	no number	U.S.A.
1	Baby NCE tripod	no number	U.S.A.
1	Angénieux 12-120mm zoom lens with two motors	1239857	France
1	16mm Arriflex BL motion picture camera with 12-120mm Angénieux zoom lens, constant speed motor, 2 BL magazines, 1 changing bag, various filters in 85 series, accessories and cables	50999 (camera) 1186012 (lens)	West Germany France

QUANTITY	DESCRIPTION OF ITEM	SERIAL #	COUNTRY OF ORIGIN
2	Batteries for BL camera	no number	U.S.A.
1	Case containing two 400-ft. magazines for BL camera	no number	U.S.A.
1	Belt battery for BL camera	3274476	U.S.A.
1	Offset finder for BL camera	667	West Germany
1	Case containing various camera accessories and electrical accessories	no number	U.S.A.
4	Cases each containing: 2 Lowell quartz lights with stands, screens, dichroic filters, 2 25-ft. extension cables, 2 500-watt bulbs, 3 1000-watt bulbs, 2 750-watt bulbs, various electrical accessories	no number	U.S.A.
1	4 x 4 Lowell reflector	no number	U.S.A.
1	Nagra tape recorder, with	NP 64 4624	Switzerland
	4 lavalier microphones,	no number	U.S.A.
	1 set earphones,	DT 48	West Germany
	1 D24E AKG microphone and windscreen,	5725	Austria
	1 Sennheiser 404 microphone and windscreen and stand,	2132	West Germany
	various sync and microphone cables, sound accessories	no number	U.S.A.
18	5-inch rolls of 1/4" recording tape	190/9	U.S.A.
1	Sennheiser 804 microphone with windscreen, mount, and accessories	65375	West Germany
1	Stepdown transformer	no number	U.S.A.
18	Rolls Kodachrome II--36 exposure	no number	U.S.A.
10	Rolls Kodacolor X--36 exposure	no number	U.S.A.
3	Rolls Ektachrome EH--36 exposure	no number	U.S.A.
3	Rolls Ektachrome EHB--36 exposure	no number	U.S.A.
1	Set Sta-sets	no number	U.S.A.
1	Tool kit	no number	U.S.A.
1	Case containing 10 electrical extension cables and various electrical accessories	no number	U.S.A.

Second, always request from the country involved a *written official authorization* permitting you to produce the film or portion of the film in that country.

Third, obtain *written official approvals* from all departments and ministries that may be concerned with the production, such as information and education, travel and tourism, customs and immigration, and state and foreign affairs departments. Often each department acts as a law unto itself and refuses to accept any approvals other than its own. The departments of customs and immigration are of particular importance. You should request written approvals confirming your dates of arrival and departure, acknowledging your intent to produce a film, and affirming their agreement to permit you to enter the country for this purpose. A copy of your equipment list should be returned to you stamped and approved by customs. If there are special fees or other costs you must pay in order to import the equipment, they should be agreed on in advance. Often it is helpful to make arrangements with a local customs broker to post a bond guaranteeing the export of all the equipment. The bond will generally be between 10 percent and 20 percent of the value of the equipment and the broker will usually charge 10 percent of the bond. In some countries—India, for example—there is a special tax on each foot of film imported into the country and an additional tax on each foot of film exposed in the country.

All these special arrangements should be agreed to in writing before you enter the country. The necessity of obtaining written official authorization cannot be overemphasized. Many regulations are curiously elastic and may have a way of arising suddenly while you are at the airport trying to get your equipment and exposed film out of the country. Do not accept any verbal assurances of help, affirmation, and good will. It is a long way from New York to New Delhi, and the consular representative who assured you that there was no need for so much paperwork will be unavailable when your equipment is impounded and your costs skyrocket. Problems arise even with the best of advance preparation, and it is comforting to have a file of officially stamped documents and letters covering all departments and contingencies.

selection of the crew

The following table lists complete crews for three different types of production. Each crew, of course, is subject to variation depending on the size and complexity of the production. It is perfectly possible for a one-minute TV spot to use a larger crew than a simple, low-budget feature film.

For the filmmaker, no choice during the entire preproduction period is as crucial as the selection of those who will share with him the creative task of filmmaking. Although it is well worth trying to obtain the most skilled people available for each job, technical ability is not the only factor to be considered. Indeed, in most instances the evaluation of ability is relatively simple—an investigation of past work performance and personal references from other filmmakers who have worked with the individual should serve to establish both the level of professional competence and the quality of the individual as a person. More

THEATRICAL FEATURE	DOCUMENTARY	TV COMMERCIAL
Director	Director	Director
Assistant director	Assistant director	Assistant director
Unit manager		
Second assistant director (optional)		
Director of photography	Cameraman	Cameraman
Operating cameraman	Assistant cameraman	Assistant cameraman
Assistant cameraman		
Loader (optional)		
4 electricians	2 electricians	2 electricians
2 grips	1 grip	1 grip
3 props	1 prop	1 prop
Sound mixer	Sound mixer	Sound mixer
Recordist	Boom man	Boom man
Boom man		
Set designer		Scenic designer
4 scenic artists		2 scenic artists
Costume designer		Wardrobe supervisor
Wardrobe supervisor		
Make-up artist		Make-up artist

important than technical skill, however, is the essential element of *commitment.* This is far more difficult to ascertain in advance. Suffice it to say that the filmmaker must endeavor to surround himself with people who are committed to the project—the film at hand—and who will share the director's goals for the film. This inner circle usually consists of the assistant director, the cameraman, the sound mixer, and perhaps the chief electrician. In a large feature crew, the set designer and the unit manager might also be included.

Reliability, a *proven record of achievement,* and *pride in workmanship* are also highly desirable attributes for crew members. Far too many individuals who have worked in film for many years have lost both the desire to achieve excellence and the ability to relish the sheer delight of "making movies." In putting the crew together, it is worth taking the extra time to eliminate the hacks, the indifferent, and those whose records indicate that they cannot be relied on to arrive on time every day, to give 100 percent of their talent to the film, and to take personal pride in their work. No great film has ever been made without a great crew.

Crew members should be selected for their strengths, not their reputations. For example, although there are many highly skilled cameramen, each one has individual assets and liabilities, and each functions best with certain types of films. The cameraman whose strength is long-lens photography—romantic, beautifully posed images, soft focus, evocative scenes and colors (like Freddie Young, who worked on *Lawrence of Arabia, Dr. Zhivago,* and *Ryan's Daughter*)—would probably not be a good choice for a realistic, documentary-style film like *Midnight Cowboy.* However, the selection of Raoul Coutard to film Costa-Gavras' *The Confession* was an ideal wedding of the right cameraman to a specific film. *The*

Confession called for a convincing re-creation of an earlier time period; the film depends heavily on the audience's belief that they are watching events as they really happened. Since Coutard's strengths are brilliant use of the hand-held camera, great control over movement, and the ability to create a highly realistic atmosphere through the use of lighting, he was able to achieve exactly the effects needed to make *The Confession* the convincing, compelling film it is.

Another consideration in selecting crew members is union requirements. If the film is to be produced under union regulations, these rules should be examined in advance to see whether any deviation is possible. For example, the union day is generally eight hours long, beginning at 8 or 8:30 AM with an hour for lunch that must be given between 11:30 and 1:30. All work done outside of this time must be paid for at overtime rates. If a film requires a great deal of early-morning or late-night photography, it would be wise to check with the unions involved to see if they will modify or waive their regulations regarding overtime pay—many unions will do so if the request is made in advance. However, you must make certain beforehand that the crew is also willing to be flexible about union regulations. Other items covered by union regulations include weekly pay rates, holidays, seniority, lay-offs, discharges, and travel and living conditions.

summary

The importance of the preparatory phase of filmmaking cannot be overstated. The goal is always to achieve a smooth, efficient, economical operation, minimizing the chance of costly delay and error. Nothing should be taken for granted, as many instructions as possible should be put in writing, and a solid professional discipline must be established early. The assistant director generally is the central person during preproduction; this job requires a great attention to detail, a stable personality, and an ability to handle crises. The key word is "control." When shooting begins, all the work done during the preproduction planning begins to pay off.

part 2 the filming

EVERYTHING done in the preproduction phase of filmmaking points toward the moment when the film moves through the camera and the first image is recorded. The filming of a motion picture is built on three central pillars: directing, cinematography, and sound recording. For the finished film to be at all successful, each of these processes must be carried out with the highest degree of professional artistry and skill. No amount of clever editing can compensate for poor execution in the filming stage.

three **directing**

. . . a "good movie" is "taking the narrative out, taking the story out of it. The audience will sit and see the film and understand the movie's intention without being able to articulate it."

ROBERT ALTMAN, in
Aljean Harmetz, "The 15th Man
Who Was Asked to Direct 'M*A*S*H'
(and Did) Makes a Peculiar Western,"
New York Times Magazine,
June, 20, 1971, p. 47. © 1971 by
The New York Times Company.
Reprinted by permission.

The director's role in filmmaking has changed greatly over the years. In the past the director functioned more or less like a combination orchestra conductor and supervisory foreman. In his "orchestra conductor" role he interpreted the work of others (usually the screenwriter) and added his own stamp to the film. Thus we see in the work of the great directors of the '30s and '40s—Capra, Huston, La Cava, Dieterli, Litvak, Lubitsch and so on—a particular "personality" coming through all of their films. In his "supervisory foreman" role, the director of the past "ran the show" much like a military martinet and was responsible for "keeping things moving." Directors like Otto Preminger still work in this manner. Today the director is in effect the *total* filmmaker. One speaks of a "Bergman film" or a "Fellini film," using the director's name to describe both the creative style of the film and, in many cases, its content. The modern film director no longer merely takes a script handed to him by a studio and executes it, but rather is totally involved with the development of the script, the filming, and the editing. *A Clockwork Orange,* for example, a major film of 1972, represents a total artistic achievement of its director, Stanley Kubrick.

There are as many opinions on how best to direct a film as there are directors. The most effective approach for any director depends in large part on his personality and on his attitudes toward filmmaking. Examine the following statements on the art of directing by these excellent and successful filmmakers.

I am not a theoretician of the cinema. If you ask me what directing is, the first answer that comes into my head is: I don't know. The second: All my opinions on the subject are in my films. Among other things, I am an opponent of any separation of the various

phases of the work. Such separation has an exclusively practical value. It is valuable for all those who participate in the work—except for the director, if he happens to be both author and director at once.

—Michelangelo Antonioni[1]

Actually I don't separate the elements of film-making in such an abstract manner. For example, the directing of a film, to me, is simply an extension of the process of writing. . . . The most important element to me is always the idea that I'm trying to express, and everything technical is only a method to make the idea into clear form. I'm always working on the idea: whether I am writing, directing, choosing music or cutting. Everything must revert back to the idea; when it gets away from the idea it becomes a labyrinth of rococo. Occasionally one tends to forget the idea, but I have always had reason to regret this whenever it happened. Sometimes you fall in love with a shot, for example. Maybe it is a tour de force as a shot. This is one of the great dangers of directing: to let the camera take over. Audiences very often do not understand this danger, and it is not unusual that camera-work is appreciated in cases where it really has no business in the film, simply because it is decorative or in itself exhibitionistic. I would say that there are maybe half a dozen directors who really know their camera—how to move their camera. It's a pity that critics often do not appreciate this. On the other hand I think it's OK that audiences should not be aware of this. In fact, when the camera is in motion, in the best-directed scenes, the audiences should not be aware of what the camera is doing. They should be following the action and the road of the idea so closely that they shouldn't be aware of what's going on technically.

—John Huston[2]

I improvise, without doubt, but with material that dates from way back. One gathers, over the years, piles of things and then suddenly puts them in what one is doing. My first shorts had a lot of preparation and were shot very quickly. *Breathless* was started in this way. I had written the first scene (Jean Seberg on the Champs Elysées) and, for the rest, I had an enormous amount of notes corresponding to each scene. I said to myself, this is very distracting. I stopped everything. Then I reflected: in one day, if one knows what one is doing, one should be able to shoot a dozen sequences. Only, instead of having the material for a long time, I'll get it just before. When one knows where he is going, this must be possible. This is not improvisation, it's decision-making at the last minute. Obviously, you have to have and maintain a view of the ensemble; you can modify a certain part of it, but after the shooting starts keep the changes to a minimum—otherwise it's catastrophic.

—Jean-Luc Godard[3]

The long preparation for my films does not correspond to a desire I might have to be precise about each detail, to foresee very exactly and meticulously who the actors and actresses will be, to fix the architecture of a decor or the choice of a character. No. It's not that. For me, the principal effort is to create an atmosphere in which

[1] Michelangelo Antonioni, in Pierre Leprohon, *Michelangelo Antonioni: An Introduction* (New York: Simon and Schuster, 1963), p. 93. Eng. trans. copyright © 1963, by Simon and Schuster, Inc. Orig. Fr. Lang. © 1961 by Pierre Seghers, Ed. Reprinted by permission of the publisher.
[2] John Huston, from an interview with Gideon Bachmann. © 1965 by The Regents of the University of California. Reprinted from *Film Quarterly,* Volume XIX, Number 1, by permission of The Regents.
[3] Jean-Luc Godard, in *Cahiers du Cinema,* No. 138. Translation by Rose Kaplin for *New York Film Bulletin.*

the film can be born with the greatest spontaneity, without its being forced to remain within the limits or in the paths of the imagination that has given birth to it. I am accused of being an improvisor. It's not true. I should say, rather, that there is in me a constant openness to ideas, to changes, to improvements that may be born less out of myself than out of the situation that is created around the film and in which the film lives and takes form. For example, to remain faithful to ten pages of dialog written three months previous before anything was known about either the actors or the psychological atmosphere that will reign over the troupe, what does that signify, when one perceives on arriving on the set that some object or other, the color of a pillow or a shadow on a wall can perfectly replace these ten pages of dialog?

—Federico Fellini [4]

. . . The secret is the way in which the story is pieced together. With me, all the little bits of business and the situations must be planned and established before a camera rolls. Sometimes I plan as many as six hundred camera setups before I begin to shoot. If I ever tried to improvise a plot structure on the set, I couldn't get the effects or the reactions I want to get. . . .

There's practically no spare footage. . . . It's been said of my stories that they are so tightly knit that everything depends on everything else, and that if I ever made a change before the camera I might as well unravel the whole sweater. That's true too. Take a ready-made stage play like *Dial M For Murder*. As the director of that play in its filmed form, there was almost no work for me to do. The various bits and pieces had already been put together on the stage. I've often wondered why so many successful stage plays fail as movies. I think the reason is this: someone has decided to "open up" the stage play with added exteriors and turn it into a movie and, as a result, the tightness and tautness of the stage play is lost.

—Alfred Hitchcock [5]

Because there are so many different successful approaches to directing, it is difficult to set forth any explicit rules and recommendations to assist the beginning filmmaker. It is possible, however, to establish some guidelines or jumping-off points from which the young director can begin to fashion his own style. These guidelines can be divided into four basic areas: (1) the role of the director, (2) relationships with crew and cast, (3) building and directing the scene, and (4) general procedures.

the role of the director

Before production begins, it is essential that the director determine the role he will play during the filming and clearly establish his relationship to the cast and crew. The director is, and indeed must be, the absolute man in charge. A great deal happens during production. The shooting of a film is a highly charged emotional experience, often involving many people. The hours spent actually

[4]Federico Fellini, in *Cahiers du Cinema*, No. 164. Interview by Pierre Kast. English translation by Rose Kaplin.
[5]Alfred Hitchcock, in Harry M. Geduld, ed., *Film Makers on Film Making* (Bloomington: Indiana University Press, 1967), p. 132. Reprinted with permission from *The Saturday Evening Post*, ©1957 The Curtis Publishing Company.

filming, when the cameras are rolling, are only a small portion of the total time, and it is the director's prime function to exercise firm control over the entire process. Few if any films can be successfully made in a totally democratic environment or even in a "committee" setting. It does not matter how close or how productive the director's relationships with cast and crew have been prior to filming. The moment the cameras begin to roll he must make it clear that he is the single person in control. This does not preclude his taking advice from assistants and technicians, but all final decisions concerning the film must be his alone. Again, the way this position is established will vary, depending on the personality of the director.

An interesting case in point is that of the potentially superior but ultimately disappointing mid-1950s film *The Goddess,* written by Paddy Chayefsky and starring Kim Stanley. The filming began with high promise. Chayefsky's script was (and still is) one of the finest ever done for the American cinema. Kim Stanley, an outstanding actress, was ideally suited to her role. The cameraman, Arthur Ornitz, was also at the top of his profession. Ralph Cromwell, an experienced professional, was brought in from Hollywood to direct the film. Unfortunately, he was no match for Paddy Chayefsky, who had a very strong personal vision of how the film should be done; for a group of New York method actors led by Miss Stanley and Stephen Hill, who insisted on playing their roles in their own way; or for Arthur Ornitz, who felt that *he* should be directing the film. Cromwell completely failed to establish control as director. The production was characterized by dissension, tantrums, and endless arguments and discussions over just how each scene was to be played and shot. As a result, a potentially excellent and exciting film failed, and a fine script and many superior talents were wasted.

Another important aspect of the director's role is his ability to envision the *total* film. The cast, the cameraman, the soundman, and others will usually pursue excellence within the confines of a particular scene and will often lose sight of the total film early in the shooting. The director, on the other hand, must constantly remain aware of the relationships between characters, the effect of scene on scene, and the ultimate role each scene will play in the final film.

The director, then, must understand and accept his central role, not as democratic leader or committee chairman, but as *the* filmmaker. All final decisions must come from him. It is important that he remain, both on set and off, a creative artist with a clear vision of the film. He can listen to others, he can consult and discuss, but he must never relinquish his central control. Once this control is firmly established, he can function within a range of other relationships with crew and cast.

relationships with crew and cast

Whether the film is a large theatrical feature, a TV commercial, or a documentary involving a crew of three, the director has many different roles to play throughout the filming. Once production begins, he becomes a father figure, a policeman, a psychiatrist, a friend, and many other things to most of the cast and crew. He cannot divorce himself from the many emotional highs and lows, the labor

difficulties, or the numerous technical problems that normally occur during filming. Since everything that happens has a direct bearing on how smoothly the filming will go, the director must be involved and concerned with every aspect of the process.

The director must decide at the outset exactly how he wishes to relate to the crew and cast. The relationships he develops will reflect his personality and his approach to filmmaking. He may choose to be a martinet, behaving much like a general in command of troops (Otto Preminger), or he may assume the role of friend and counselor (Bob Rafelson). He may establish one type of relationship with the cast and an entirely different one with the crew. He may select a small group, an inner circle with whom he relates on an intimate, personal basis (most often, the director of photography, sound mixer, and assistant director), and totally avoid contact with the rest of the crew. The important thing is that the director establish firm relationships at the outset and make these relationships clear to cast and crew.

Today filmmaking is much more of a contributive art than ever before, and on most productions the intellectual and artistic resources of crew and cast are far superior to those of the past. Very large crews are seen less frequently; small, tight units are more often the rule. This suggests that the most successful directors are those who, while still clearly in command, establish a relationship of mutual respect and close personal contact with crew and cast.

Most good cameramen, for example, are highly skilled craftsmen who want to be more than mere technicians. They are not satisfied simply to execute the instructions of "the chief." They want to suggest variations, experiment with lenses, angles, and movement. The same pattern holds true for sound engineers and actors. The challenge for the director is to utilize this individual talent and desire to contribute without surrendering control. If an intelligent actor makes a suggestion that is clearly at variance with his own view, the director must use the greatest skill and diplomacy to reject the suggestion without incurring the actor's wrath and, more important, without blocking the flow of the actor's art and inspiration. In this type of situation it is a good idea for the director to use off time, evenings, or time when lighting or set changes are going on to discuss fully any reasonable suggestions that have been made by the cameraman, the sound engineer, or the actors. In these discussions the director can subtly maintain control by in effect "chairing" the meeting; at the same time, however, he must not only *honestly* consider the suggestions, but try to find out what problems motivated them. Often, the establishment of good interpersonal relations, so important to the effective functioning of any group enterprise, depends on the fulfillment of the need for ego-building and a sense of participation on the part of the group members. By holding a group discussion, the director is taking a significant step in helping to bring about that fulfillment. This, of course, does not mean that a true democracy or decision-by-committee is in action here, but it clearly indicates a leader who, although he favors a "one film, one director" approach, is secure enough to really listen to others.

The beginning filmmaker should also be aware that all productions go through emotional phases or cycles, which generally follow a pattern. In the initial phase,

usually the first few days of production, there is a great deal of energy, commitment, and enthusiasm propelling the filming. Members of the crew are getting acquainted or reacquainted, cast and crew are establishing relationships, and everyone is motivated by a high degree of faith in the film, in their fellow crew members, and in the director. During this period the director can accomplish a great deal—and he can be lulled into a false sense of security.

Following the "honeymoon" period there is usually a drop in morale. The work settles down into the day-to-day routine of making a film. Small rivalries and petty jealousies begin to surface, and the pace of production slows considerably. The director must take any action necessary to adjust the problems and to smooth over areas of dissension and difficulty. Any problems left unresolved during this period will reappear later in far more damaging form.

The following hypothetical situations will provide some further insight into the director's role in the filmmaking process.

1. After some five or six days of filming it has become obvious that the cameraman and the director have distinctly different ideas of how the film should look. The director feels that every scene is being "overlit" and the rushes show a stylized, unrealistic visual approach. Subtle pressure from the director has only engendered hostility and resistance from the director of photography, who feels that he is being pushed toward a style of work he is uncomfortable with. He feels that if he complies with the director's wishes, the film will look unlit and his reputation will be damaged. He resents the director's intrusion into what he feels is his own creative domain.

This type of situation indicates a lack of prior communication between director and cameraman, but there is no use looking backward—the production is in jeopardy. The director must immediately confer *privately*, off-set, with his director of photography. He must emphasize his high regard for his director of photography, which led him to choose him in the first place. He should clearly describe his own visual concept of the film and pose the photographic challenge as he sees it. The director must conclude his discussion by taking a strong, aggressive stance. In effect, he must remind his director of photography that the film can succeed only if there is but one director, and he does not intend to abdicate his position or delegate his powers. He should indicate a willingness to replace the director of photography immediately if a *modus operandi* cannot be reached. This is *direct* action.

2. After two weeks of filming, it is obvious that the lead actor is insecure and unable to come to grips with the director's concept of the part. He feels the director is not sympathetic enough and is paying too much attention to technical matters such as lighting and camera movement. Day by day, his performance is becoming more and more mechanical. The director, on the other hand, feels that the actor is doing a mediocre job and is not sure he can get any more from him. He is compensating for a disappointing performance by adding all kinds of innovative photography.

In this case, the director is making a mistake by not confronting the actor. No amount of technical virtuosity or clever camera work can compensate for an

unexciting performance. A better idea here would be for the director to invest a great deal of time and attention in the actor—he should encourage the actor to suggest other approaches and invest some time and film in trying them. Even if the actor's suggestions don't work, the knowledge that the director has confidence in him will surely improve his performance.

If the director can resolve the conflicts that arise during the early phase of production, filming will usually proceed on a more or less even keel for a while. Generally there is another serious drop in morale close to the end of the filming. All the small jealousies, resentments, and interpersonal difficulties that have been repressed throughout the filming tend to surface at once, and the pace of the filming slows. Every set-up seems more difficult to get under way and a team feeling is nonexistent. These fluctuations in morale usually occur no matter what the size of the production, and the director's ability to control them is critical to the success of the film. Often an emotional low or doldrum can so disrupt the filming unit that no really creative work is possible.

The importance of the quality of the director's relationships with crew and cast cannot be overstated. It is not enough for the director simply to be a talented filmmaker. He must also be able to create and control a working environment in which a group of very diverse people can work at their best. This is no small job, but it must be done.

building and directing the scene

Each director has his own methods of working. Some directors block out in advance every camera angle and every movement so that the filming itself proceeds in a mechanical, highly efficient way. Others treat the filming process improvisationally, working out movements, camera angles, and even dialogue as they go along. Some directors insist on elaborate and detailed rehearsals with crew and cast before a single foot of film is shot; others shoot their first rehearsal.

The "ideal" method for building and directing a scene is often determined not only by the director's personal approach, but by the style and content of the film. Films like *Husbands* and *Faces,* for example, were designed to be largely improvisations. The director, John Cassavetes, tried to re-create real-life experiences much in the manner of a documentary. The style and intent of both these films would have been destroyed by any kind of formal filmmaking. On the other hand, the films of David Lean (*Lawrence of Arabia, Dr. Zhivago, Ryan's Daughter*) depend primarily on an old-fashioned kind of storytelling. The *mise en scène* in each of Lean's films is massive and requires a great deal of formal control. Thus camera angles must be determined in advance, and every aspect of the scene must be carefully rehearsed and prepared. Between these two extremes the filmmaker is free to choose any variation or combination that suits his purpose.

In filming the scene the director must deal with three separate elements, joining them together into a single unit with a single purpose: (1) the setting or total environment in which the scene is to be played, (2) the cast, and (3) the crew.

THE SETTING OR TOTAL ENVIRONMENT

Whether the scene is to be filmed in the studio or on location, the director should, before filming begins, review every element contained in the physical environment and should consider each setting from all possible angles. Even if the setting is a real-life one, such as a hospital or a prison, it will probably need additions and subtractions before it will serve the purposes of the film. The director cannot assume that simply because the setting is real it will work without embellishments or changes. Often a hospital room is simply a bed and four walls. On film such a setting would appear barren and look like a cheap studio set.

Today the trend in filmmaking is away from the old Hollywood "L" set (the L-shaped corner of a room showing two walls and no ceiling) and toward complete, functional settings that are accurate in every detail. Plates 3–5 are settings from the village of Presbyterian Church, a fictional Western town built for Robert Altman's film *McCabe & Mrs. Miller*. The cast actually lived in the village and "weathered" it for several months. Every setting was so complete and every detail so authentic, that Altman was able to use his documentary camera style freely, choosing any angle or range he wanted. The settings contributed immeasurably to the excellent sense of place and time in this film.

In an interview regarding his first successful film, *Who's Afraid of Virginia Woolf?*, Mike Nichols made the following comment concerning the setting:

> I had in mind a couple that I'd known at the University of Chicago all along when we built the set, when we picked the books, when we chose the bookshelves made of planks and bricks and so forth. And the cups, those green mugs this guy had at the University of Chicago. It seemed to me that for the actors it would be useful to be at a real college, to smell it and walk around it. It's the kind of thing that's a gamble. You can't measure what you've gotten from it.[6]

When the film was released many critics remarked on the feeling of reality conveyed by the setting, which was after all no more complex than an average middle-class living room.

Often many of the small details contained in the setting are never seen or noticed on camera, but these details aid the actors in giving authentic performances by helping them to step into the time and place of the film. Robert Altman was acutely aware of this when he made *McCabe & Mrs. Miller*:

> For "McCabe & Mrs. Miller," Altman and Ericksen built the town of Presbyterian Church on a mountaintop in West Vancouver. The town cost $200,000. Everything in it was real. The town—all raw wood, foot-deep mud and piles of manure that steamed in the freezing winter air—was created by carpenters who lived in the cabins they were building and got drunk at night on whisky from the still they had also built.
>
> Life frozen upon a screen loses its spontaneity. The choices have been made forever. Altman tries harder than most directors to imply what lies below the two-dimensional surface of the screen. He stuffs his films with things that audiences cannot see yet of which he insists they are somehow aware. To pay for a quick call at Presbyterian

[6] In Joseph Gelmis, *The Film Director as Superstar* (Garden City, N.Y.: Doubleday, 1970), p. 279. Reprinted by permission of Doubleday & Company, Inc.

Church's whorehouse, the actors held real money in hands that were never seen by the camera. "If someone's playing a scene and they look down and they've got some crappy paper in their hand, they just don't play the scene as well," says Altman. "I want to be able to go onto a set and open a drawer and find things in there although that drawer will never be opened in a scene. But it adds validity because the actor knows the things are there and so do I."[7]

The director must develop each setting until he is completely satisfied that it realistically creates the kind of atmosphere he is seeking to achieve. Is it authentic? Does it look "lived in"? Is it right for *this* scene in *this* film? That the environment contributes an essential *texture* to the film can be seen in the atmosphere of a film like *Through a Glass Darkly* (Ingmar Bergman), in the reality of a film like *The Go-Between* (Joseph Losey), and in the impressionistic force of a suspense film like *Klute* (Alan Pakula).

THE CAST

The second major element the director must deal with as he films the scene is the cast. The problems are similar whether the actors are experienced or nonprofessionals, whether the film is a major studio production or a documentary. Just as there are an endless variety of directorial approaches, so there are a seemingly endless variety of actors and acting styles. The director must determine how to elicit from each actor the richest performance he can give. Michelangelo Antonioni has said that he never tells his actors anything about the entire film:

> I could give you many instances of occasions when I had to resolve serious problems in my relationships with actors. I should like at least to mention one of them in order to return to the question of intelligence in actors: the case of my relationship with Betsy Blair [who plays Elvia in *Il Grido*]. She is a very intelligent actress, who demands very elaborate explanations. I must confess that it was with her that I spent one of the most agonizing times in my career as a director; it occurred when she wanted to read the scenario of *Il Grido* with me. She wanted me to unveil the meaning behind every speech—which was, of course, impossible. Speeches are the fruit of the instinct; they are suggested by imagination, not by reason, and they often have no other reason for existing than the need felt by the author for just those words and no others. This is a perfectly natural fact, inherent in the nature of literary creation, and for that very reason often inexplicable. Thus I had to invent purely imaginary explanations for Betsy Blair, which corresponded in absolutely no way with what I meant to say in the film, and at the same time try to understand what *she* wanted to know. Only thus could I try to bring her to the point where she could play the character better than if I had explained it to her.
>
> With Steve Cochran [who plays Aldo] I had to use the opposite procedure. He had come to Italy thinking—who can say why?—that he might try to become a director, which was quite absurd. And so he refused from time to time to do something, the necessary motivation for which, so he said, he could not feel. Thus I was forced to

[7] Aljean Harmetz, "The 15th Man Who Was Asked to Direct 'M*A*S*H' (and Did) Makes a Peculiar Western," *New York Times Magazine,* June 20, 1971, p. 49. © 1971 by The New York Times Company. Reprinted by permission.

direct him with gimmicks, never letting him understand what I expected of him, but working with methods the existence of which he never suspected.[8]

In shaping and controlling an actor's performance, the director is trying to join the actor and the role into a single, indivisible unit. Since the director generally does his own casting, he naturally will have chosen the actors he feels are best suited to each particular role. As the actual filming proceeds, the director must come to understand the full range of each actor's talents. All actors have strengths and weaknesses, all of them have areas in which they just do not function well. Gene Hackman, for example, is essentially a low-key actor whose strength is underplaying. He is not blessed with a memorable face on which the camera might dwell nor with a distinctive voice of any great range. But because his directors worked within these limitations and did not try to turn Hackman into a different actor, Hackman was able to give brilliant performances in *Bonnie and Clyde, I Never Sang for My Father,* and *The French Connection.* If a director fails to really "know" his actor and forces him to work beyond his capabilities, conflict will arise and, more important, the performance will be placed in jeopardy. In *Cisco Pike,* for example, Hackman was forced to overplay and function like a completely different performer, so the entire film failed.

It is, of course, equally important to recognize the actor's strengths and work with them. Hackman's outstanding quality is an ability to communicate honest emotions to the audience. Thus a good director will encourage Hackman to pace his own speech and delivery and limit fussy and attention-diverting "business." This gives the actor a chance to build his performance around his depth and sincerity—Gene Hackman's hallmarks as an actor.

Once the director really understands just who the actor is and what he can do, directing becomes largely a matter of communication, of winning the actor's confidence so that he can fashion his performance in response to what the director wants. The director adjusts his goals to the actor's individual qualities and constantly tries to keep the actor moving toward those goals. It is essential that the director does not compromise. The director decides from what angle the actor is best filmed and how he should be lit for maximum impact and interest; he sets the standards for the performance. In fashioning the performance, the director must insist on being the only judge as to when a take is satisfactory. Too often, actors in film are poor judges of their own work. The memorable performances in contemporary film are without exception the result of close collaboration between actor and director—Ingmar Bergman and Max Von Sydow, Alain Resnais and Emmanuele Riva, Bernardo Bertolucci and Jean-Louis Trintignant, Vittorio De Sica and Dominique Sanda, Robert Altman and Warren Beatty, Stanley Kubrick and Malcolm McDowell, Federico Fellini and Anthony Quinn, and countless others.

The director must also assume control in building role relationships between characters. In the early days of Hollywood it was not uncommon to place two stars like Paul Muni and Bette Davis opposite each other and simply let the

[8] In Leprohon, *Michelangelo Antonioni,* pp. 104–05.

cameras roll. Generally these actors delivered their lines not to each other within the roles they were playing, but in their own individual styles, as if they were speaking only to the audience. Contemporary filmmaking is quite different. Today's audiences want a sense of realistic relationships between people. This means that the director must build and control the quality and character of every performance. Since the actor is usually the worst possible (because the least objective) judge of how well a scene has gone, the director must rely totally on his own perceptions. He must insist that every line of dialogue sound "true" to the scene—if the lines sound "read" or "performed" the film is doomed. Each director has his own techniques for achieving the sound of truth or reality. Some permit the actors to work it out among themselves within the setting, changing the words until the scene becomes something of an improvisation. Other directors keep the actors to the words of the script but continue rehearsing over and over again until a level of reality is reached. Cadences and rhythms of speech become very important. Silences and pauses, which re-create the patterns of real speech, tend to reduce the feeling of "spoken" lines.

A word about rehearsals. Among professional actors, some need long rehearsals and others prefer to move as quickly as possible to the actual filming. Many experienced actors build themselves to a peak through a series of rehearsals, arriving at the zenith just as the cameras begin to roll. Others, usually the younger "method" actors, prefer to use rehearsals simply to work out movements and coordination with the camera, saving their actual performance for the filming. A good general procedure is to conduct a series of basic rehearsals prior to the start of filming to establish role concepts and to acquaint the cast with the director's vision of the film. Then, during filming, specific scene rehearsals can be conducted off-set while lighting changes are being made and the set is being dressed. Final key rehearsals can be held on the actual sets just prior to filming.

When dealing with nonprofessionals, as in documentaries or other films in which actual occurrences are reenacted, the director must decide whether he can achieve any value from rehearsals or whether he is best advised simply to take his chances and film the action as it occurs. There are some guidelines here that can prove helpful. In general nonprofessionals do not benefit from rehearsals. Lacking an actor's training, they tend to become increasingly stiff and formal. In most cases, nonprofessional actors are used when a film calls for greater spontaneity or reality than one finds in "acted" films. Trying to make an actor out of a grocery clerk contradicts this aim. The best bet is to set up the technical equipment—camera, sound, and lighting—for maximum flexibility and to start shooting without rehearsals.

Whatever the type of production, the director must quickly ascertain the best method of working with his cast. When dealing with professionals it can be assumed that a certain amount of rehearsal is beneficial. Too many rehearsals, however, can destroy a sense of spontaneity and vitality and create artificial, mannered performances; too few rehearsals can result in amateurish chaos that is neither reality nor spontaneity. The director must listen carefully for the telltale signs of lines being read mechanically. This is a clear signal that a scene has been overrehearsed. It is always better to begin filming too early than too late. The

first rehearsal that begins to show hints of promise should be a sign to begin filming.

Because films are by nature fragmentary and can often be rebuilt in the editing room, the director can develop a false sense of security. "Oh well, we'll fix that in the editing" is an often heard comment. Although the very nature of the filmmaking art does give the director the opportunity to cut out the bad takes and to rearrange and hide his mistakes, it is unwise to become dependent on such tactics. At every stage of filmmaking the director should try to achieve perfection—solutions should never be put off until the next stage. This requires a certain measure of skill and sensitivity on the part of the director. For example, because it is difficult for actors to sustain a performance throughout endless takes and repeat filmings of the same scene, the director must determine just how many times he can safely reshoot the same material without wearing out his cast. He must make a compromise between the luxury of having endless camera set-ups to choose from in the editing room and the danger of his actors going stale. For the beginning director the following suggestions might prove helpful:

1. Avoid more than three or four takes of the same scene. If after four takes you haven't got it, assume that you won't get it and vary the lines and the camera set-up.
2. If, after three or four takes, the actor is not improving, call a coffee break and relax the entire atmosphere.
3. If technical problems are necessitating a great many retakes, change the shot or move on to another scene before the actors go stale. A stubborn director may achieve technical perfection after thirty takes, but in all likelihood it will be at the cost of the actor's inspiration. No actor can sustain a convincing performance through endless repetition.
4. Do not permit the scene to be performed the same way every time. Variety in performance offers choice in the editing and prevents staleness.
5. Encourage the actors to experiment—it is the only way greatness can be achieved.

THE CREW

The third element the director must deal with as he builds and films his scene is the crew. Without question, the most important individual on that crew is the cameraman. The director is responsible for the visual character of the film, but his instruments for achieving this are the creativity and technical skill of the cameraman. In most cases, the cameraman's level of artistry is equal or even superior to that of the director. Hence it is important for the director to establish an artistic partnership with the cameraman in designing the visual elements of the film.

At the outset the director should describe to the cameraman his own vision of how the film should look. For example, when Vittorio De Sica set out to make *The Garden of the Finzi-Continis*, he clearly wished the film to have a strange,

offbeat visual appearance—it was to be foggy, semireal, often bordering on the visually obscure. If his cameraman had not understood and completely shared this vision, the film could not have been successful. In addition, the director should examine the lenses being used and should view all movements through the camera while the scene is being rehearsed; he should also let the cameraman know the amount of coverage and the kind of composition he wants. The cameraman can and should make additional suggestions and even request other approaches—it is through such interchanges that a productive relationship is established. The long and highly successful partnerships between David Lean and Freddie Young (*Bridge over the River Kwai, Lawrence of Arabia, Dr. Zhivago, Ryan's Daughter*), Jean-Luc Godard and Raoul Coutard (*Au Bout de Souffle, Le Petit Soldat, Une Femme Est Une Femme, Vivre Sa Vie, Les Carabiniers*), and Ingmar Bergman and Sven Nykvist (*Through a Glass Darkly, Winter Light, The Silence, Persona, Shame, Cries and Whispers*) reflect the nature of the director-cameraman relationship.

The director is also well advised to create a close working relationship with the sound mixer (see Chapter 5), and of course he must establish an intimate partnership with his assistant director, who generally acts as the director's liaison with the crew. As the director "runs his set" during filming, as he rehearses and prepares his actors, and as he builds his total scene, he generally controls all the diverse elements of production by indicating what he wants to the various department heads (electrician, grips, props, set designer, and so on), often through his assistant director.

The assistant director's primary responsibilities are preparing the schedule, adjusting for changes in the schedule, controlling and supervising the crew, and often supervising rehearsals of one scene while the director is planning the camera movements and lighting for another. On a large production the assistant director often will do a great deal of preliminary work in preparing a scene for filming; during the filming itself he usually remains at the side of the director and sees that all elements are in place and working properly. Since the assistant director often functions as a second director and is in effect the director's alter ego, he too must fully share the director's vision.

The director's attention should be totally on the scene as it evolves. He cannot and should not be concerned with a thousand small technical matters. The director who becomes physically involved in technical details during filming dissipates his creative energies and is distracted from his prime function—directing the scene. If the director has chosen his crew wisely, he will have at every job a top professional who is entirely capable of handling all technical problems such as malfunctioning lights, improperly placed microphones, a noisy or inadequate camera, or make-up or wardrobe problems. The director is at the center of a vortex—he must insist that the entire crew function as one with a single goal: the successful filming of the scene in the manner he has envisioned.

In summary, the director must deal intensively with the setting, the cast, and the crew throughout the filming. He should be aware and in total control of everything that is happening. He should work toward a specific result, and, with the assistant director, determine time allocations and be prepared to change or adjust schedules and procedures. He is the sole arbiter of the *quality* of the filming.

When the director says "cut" the filming ends, and when he says "wrap" the day's work is over. No director should leave the scene until he has achieved exactly what he wants. Any compromises made during filming will haunt him for the entire course of production and beyond.

general procedures

PREPARATION AND SCHEDULING

The director should always prepare the day's shooting in advance. This does not imply a rigid schedule, but rather the opposite. The better prepared the director is, the more flexibility he will have during filming. He should review in advance the scene or scenes to be filmed that day; if he wishes, he can block out with his assistant the general approach to each scene, the camera angles to be used, and any specific problems or special elements involved. It is also helpful to set up a daily schedule indicating how much work is to be covered by, say, noon, 4 PM, and the end of the day. The director may also want to meet briefly with the cast in the evening to discuss the next day's filming.

This kind of preparation serves two purposes: it gives the director a clearly defined structure for the day's work, permitting him to use his time for actual filming, and it provides him with the time and the flexibility to vary any part of his prepared schedule. The director who decides to be totally spontaneous, to avoid any formal structure during filming, runs the risk of spending a great deal of time in on-set preparation while the crew and cast (who must nevertheless be paid) sit around waiting for him to get ready or to make up his mind. In addition, crew and cast are generally more secure when they feel the director knows exactly what he wants than when things are "made up" as the film progresses.

A word of caution here. In the past many Hollywood directors rigidly prepared each day's shooting in advance, blocking out each shot and listing every camera angle, and then proceeded to execute their own carefully prepared designs like mathematicians. Today this kind of approach is totally obsolete, for it destroys the spontaneity and flexibility essential to creative filmmaking. The director should be sufficiently prepared to know what he wants to do and how he wants to do it, but not so unyielding that he cannot easily and comfortably add shots, change ideas and scenes, and generally stay loose during filming.

CHOICE OF "PRINT" TAKES

It is the director's responsibility to select for printing those takes he wants the editor to consider. For example, if the director shoots a scene five times he may elect to print only takes 2 and 5. The editor would normally never see the other three takes. This is in effect a preediting or preselection process on the part of the director. Of course, if the editor does not like the takes selected, he can order a print of any or all of the other takes of the scene, but this is seldom done.

In choosing print takes the director must exercise creative judgment consistent with his vision of the finished film. His selections should be based on performance, camera movement (the cameraman is usually asked for his opinion about the visual aspects of each take), and the overall "feel" of the scene. A very confident director will often print only one take of a scene rather than permit the editor a choice.

STRUCTURING THE DAY

Every shooting day has its own structure, its own series of ups and downs. As part of general procedure, it is wise for the director to maintain control of the working day. He can begin slowly, and when he senses that crew and cast have moved into high gear, he can apply forward pressure. He can relax the pace if he feels any resistance or staleness, pick up again in midafternoon, and so on. If he feels the day's shooting is going badly he can break for lunch early, or break later if it is going very well. Of course, if he has a full union crew he is somewhat limited by union rules governing lunch hour, and other breaks, but even these can be varied by mutual agreement. The key factor is that the director must remain sensitive to the rise and fall of tensions and creative achievement on the part of the crew and cast and structure the day's filming accordingly. Often a break taken at exactly the right moment can turn a slow, unproductive day into a successful one by refreshing the cast's creative vitality. The forward motion of the day's filming must never be left to chance, nor can it be controlled by the actors or crew. The director must determine and control the structure of the filming day by day.

VIEWING THE RUSHES

On feature films and often on television commercials, it is a general practice for the director to see "rushes" or "dailies" every day. These are prints of the scenes shot during the day. In documentary filming, where the locations are often far from the laboratory and production is in 16mm, which takes longer to process and print, this is usually not possible. On most feature films, television films, and commercials, all film shot during the day is unloaded and sent by special messenger to the laboratory at the end of the day's shooting (usually by 7 PM). In the major film centers such as New York and Hollywood, the labs are set up to develop and print the film overnight so the rushes are ready for screening early the next morning. If the location is within a day's flight of the lab, the film can be placed aboard a plane, picked up by the lab, and processed and returned to the location within 24 hours.

By viewing the rushes as soon as possible, the director can examine the results of his work and decide whether he wants to alter or adjust his approach or reshoot scenes that do not look as promising as he had hoped. The decision as to who views these rushes with him is largely a matter of personal preference. Some directors permit no one to join them in the viewing; others invite everyone. As

a general rule it is wise for the director to have at least the cameraman view the rushes with him. Actors, however, may or may not benefit from seeing the rushes. Some actors react very badly to viewing their own performances and tend to overcompensate for real or imagined failures on screen. The director can lose control of a performance if the actor, after seeing the rushes, disagrees with the director's evaluation of his work. On the other hand, many actors are quite capable of intelligently and constructively viewing the rushes and can improve their performance as a result of having seen themselves on screen. The director should by this time be familiar enough with his cast and crew to know who will benefit from this experience and who will not.

THE REVIEW OF EACH DAY'S WORK

As part of the preparation for the next day, the director should review and analyze each day's work with his assistant. They should examine how they stand with regard to schedule, how they feel the work is proceeding, and what changes in procedure might be advisable. A daily review of this kind helps the director keep up with his film and insures that changes will be made when they are needed. If any problems that develop are left unattended even for a day, they will almost certainly be compounded and ultimately seriously damage the film. For example, if an actor is not responding to the demands of his role, the director should confront the problem immediately. If the cameraman is working too slowly and the production is behind schedule after the first two days, it can be assumed that things will get worse before they get better. The director must immediately ascertain whether the schedule should be changed to fit the cameraman's pace or the cameraman prodded to speed up his performance. In any case, the sooner a problem is understood and steps are taken to solve it, the better.

directing—an approach

1. Develop a single, unified concept of the entire film and enforce that concept at every stage of the filmmaking.
2. Be flexible enough to vary that concept as it appears necessary, but *know* when you are making essential changes.
3. Be receptive to suggestions from all key members of crew and cast and be secure enough to accept some and reject others. The final choice belongs to the director.
4. Be aware and in control of everything that is going on at all times. The word "director" should mean exactly what it says. Nothing should be allowed to "just happen." *The director is the filmmaker.*
5. *Never* accept anything less than *exactly* what you want. Whether in performance, camera work, or sound, anything less than perfection will return to haunt you.
6. No film was ever made by one person alone (including *Citizen Kane*). One

of the most important functions of the director-filmmaker is to elicit the absolute best from everyone concerned with the film.

7. The *momentum* of the filmmaking process must be maintained, and only the director can do this. The forward drive and the emotional enthusiasm that helps create a first-rate film must initiate from the director.

It is impossible to overstate the importance of the director's role. In most cases he is the creative author of the final film. He must also be the spirit of the filming, the motivating force, and the central point of control for every element in the filming process.

suggested reading

AMERICAN FILM INSTITUTE, *Dialogues on Film.* Beverly Hills: American Film Institute, 1972.

DONNER, JÖRN, *The Personal Vision of Ingmar Bergman.* Bloomington: Indiana University Press, 1964.

KAEL, PAULINE, FRANK MANKIEWICZ, and ORSON WELLES, *The Citizen Kane Book.* Boston: Atlantic-Little, Brown, 1971.

KYROU, ADO, *Luis Buñuel: An Introduction.* New York: Simon and Schuster, 1963.

LEPROHON, PIERRE, *Michelangelo Antonioni.* New York: Simon and Schuster, 1963.

MILNE, TOM, ed., *Losey on Losey.* Garden City: Doubleday, 1968.

ROUD, RICHARD, *Jean-Luc Godard.* Garden City: Doubleday, 1968.

TALBOT, DANIEL, ed., *Film: An Anthology.* Berkeley and Los Angeles: University of California Press, 1966.

WALKER, ALEXANDER, *Stanley Kubrick Directs.* New York: Harcourt Brace Jovanovich, 1971.

suggested viewing

Citizen Kane (1941), Orson Welles
The Conformist (1970), Bernardo Bertolucci
Cries and Whispers (1972), Ingmar Bergman
8½ (1963), Federico Fellini
The French Connection (1971), William Friedkin
The Garden of the Finzi-Continis (1971), Vittorio De Sica
The Godfather (1972), Francis Ford Coppola
Hiroshima, Mon Amour (1959), Alain Resnais
Jules and Jim (1961), François Truffaut
The Last Tango in Paris (1972), Bernardo Bertolucci
Persona (1966), Ingmar Bergman
The Servant (1964), Joseph Losey
Shame (1968), Ingmar Bergman
2001: A Space Odyssey (1968), Stanley Kubrick

four cinematography: photographing the motion picture

Nothing upsets me quite as much as the fellow who congratulates me on my "beautiful photography." That's about the last thing I want to hear. There was a time perhaps, in the beginning, when I did try to make every shot beautiful. That seemed to be the purpose of good photography and it was also what was expected of me. Today, I am far more concerned with the most intelligent and effective use of natural light to live up to the expectations of the director and the script. Light is a passion for me. I think we all have a great deal still to learn about it and its potential uses. It's not just good exposure that counts. I am quite prepared to go to the limits of over or under-exposure if that achieves the desired effect and builds the right kind of atmosphere. As the years pass I have come to believe more and more that the simplest, most natural approach to motion picture lighting is best and gives us our greatest opportunity to do artistic justice to our subjects.

I see a great many films and I have come to the conclusion that a large number of pictures today are over-lit. Technical perfection in terms of cameras and lenses seems to have been matched by a desire to fill the screen with lots of perfectly placed and calculated light. I just don't go along with this and I have Ingmar Bergman to thank for letting me experiment with a kind of cinematography which, by utilizing true light where possible, seems to me to do greater justice to the medium.

Of course, Bergman is unique. I have had the privilege of working with him since 1951 and, through him, have learned to better understand the ultimate possibilities of cinematography. Because he had worked in the theatre, he was intensely interested in light and its uses and how it can be applied to creating a given atmosphere. Bergman has been making pictures for so many years and he knows everything about the camera as a technical instrument. He has a mind and an imagination that takes in not only the

SVEN NYKVIST, in "A Passion for Light." Reprinted by permission from *American Cinematographer*, April 1972.

limits of poetic imagery but—equally—the scientific aspects of filmmaking. He has done away with "nice" photography and has shown us how to find truth in camera movement and in lighting.

Times are changing in the film industry, and I am all in favor of it. We are being permitted to come a little closer to the truth in the way we light sets and people. Not every face has to be beautifully lit. Shadows are a part of our visual life. The Nouvelle Vague in France did a lot for the cinema because of their disregard for convention. We should carry on along those same lines by not being afraid of anything as long as we consider it to be the truth.

the role of the cameraman

The prime responsibility of the cameraman is, of course, recording the visual image on film. This is perhaps the most important element in the creation of a motion picture. The composition of that image, its texture and character, the movement within the frame—all these determine what we "feel" about the film. The cameraman—or as he is sometimes called, the director of photography—assumes full responsibility for the visual image. Working closely with the director, and understanding and sharing the director's vision of the finished work, he must decide what the photographic style of the film will be and how best to achieve that style. As each scene is prepared for filming, it is the cameraman who determines the general light level or intensity for the scene, directs the placement of each light, and suggests the angle from which the scene is to be shot. The cameraman also supervises the position and speed of any camera movement within the scene. He selects and determines composition, suggesting to the director the placement of all elements within the frame. Of course, final approval must come from the director, but the cameraman makes the initial suggestions and decisions and is thus a major influence on the visual aspects of the finished film.

One recent motion picture that clearly demonstrates the impact of the cameraman on the finished film is Robert Altman's *McCabe & Mrs. Miller*. Altman envisioned a special kind of atmosphere—obscure, hazy images set in a frontier town. The cameraman, Vilmos Zigismond, used prefogged and postfogged film, long lenses, highly diffused lighting, and strange elliptical compositions to create some of the most beautiful and unusual visual images ever seen in cinema. These images lent the film a sense of romance and nostalgia, which became even more poignant when coupled with the harsh reality of the setting and the story. The visual quality is one of the major factors in the tremendous artistic success of this film. (See Plates 3-5.)

The cameraman, then, is second in importance only to the director in the creation of the film. He is assisted by his camera crew, which takes its instructions from him and is usually directly under his control. On a large feature film or TV commercial, the crew generally consists of a camera operator, who operates

the camera and is responsible for smoothness of motion and perfect execution of the cameraman's compositions, and an assistant cameraman, who loads the camera, makes any necessary changes in the focus mechanism during a shot, and is generally responsible for the "care and feeding" of the camera. Occasionally, a large feature film will have a second assistant cameraman, who loads magazines while the filming takes place. On a documentary film or a low-budget feature, the director of photography usually operates the camera himself with the aid of an assistant cameraman.

The basic tools used by the cameraman in the recording of the visual image are the film (raw stock), the camera and mounting devices, lenses and lens accessories, and lights and lighting accessories.

the film (raw stock)

The film—the raw stock on which the visual image is recorded—consists of a strip of celluloid (cellulose acetate) coated with an emulsion that is sensitive to light and capable of receiving and retaining images. The *emulsion* side of the film, on which the image is recorded, is dull; the *base* side is shiny. The film is perforated at regular intervals on one or both edges and is generally designated by its width (8mm, 16mm, 35mm, etc.). As shown in Table 4-1, the wider the film, the greater the number of perforations per frame and hence the more stable the film when it is run through camera, editing machine, or projector. The width of the raw stock also determines the size of the visual image and the sound speed when the film is projected. A 35mm frame is $2\frac{1}{2}$ times as large as a 16mm frame; a 70mm (wide-screen) image is 4 times as large as a 35mm image. The larger the area on which the image appears, the smaller the difference between the size of the filmed image and the screened image, and therefore, the better the quality of the projected image. There is less grain and greater clarity and resolution with the larger film sizes. (*Resolution* refers to the measurable sharpness and differentiation of fine detail within an image.) In addition, since the larger film has a greater track area, sound fidelity is also considerably better.

Table 4-1

	16mm	35mm	70mm
Perforations per frame	1	4	5
Frames per foot	40	16	$12\frac{4}{5}$
Sound speed, feet per minute	36	90	90

All raw stock (unexposed film) is given a numerical rating that indicates the film's relative sensitivity to light. This number is called the *ASA rating*. The higher the ASA rating, the greater the film's sensitivity to light. A film stock that has a very great sensitivity to light is described as a fast film; film that has a low

sensitivity to light is referred to as a slow film. A fast color film, such as 35mm Eastman Negative color stock #5254 (ASA 100) requires relatively little light to obtain a normally exposed image. On the other hand, 16mm Eastman Reversal color stock #7252 (ASA 25) requires four times the amount of light to obtain the same image. The faster the film, the higher its grain content. *Grain* refers to the film's clarity and accuracy in reproducing images—the higher the grain content, the fuzzier the picture. Very fast film, such as that used for TV news coverage, has a high degree of grain (see Figure 8), whereas film used in theatrical productions is slower but provides a much higher-quality image (Figure 9).

In the past, the cameraman had a wide range of choices in both 16mm and 35mm raw stock. Today, because of the demands and commercial realities of television and theatrical distribution, black-and-white film is virtually obsolete. There is no TV market for black-and-white films, and most filmmakers do not want to eliminate this lucrative distribution potential. Although the success of Peter Bogdanovich's *The Last Picture Show* may result in some black-and-white feature films, the influence of television will keep color predominant. In addition, the two raw stocks in widest use today (16mm EK 7252 and 35mm EK 5254) are so versatile and capable of reproducing such a wide range of images that most

FIGURE 8 ▼

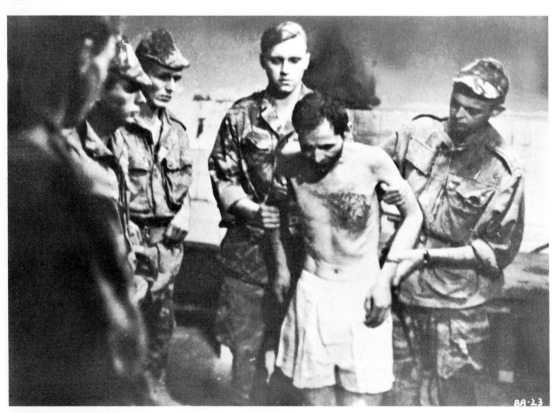

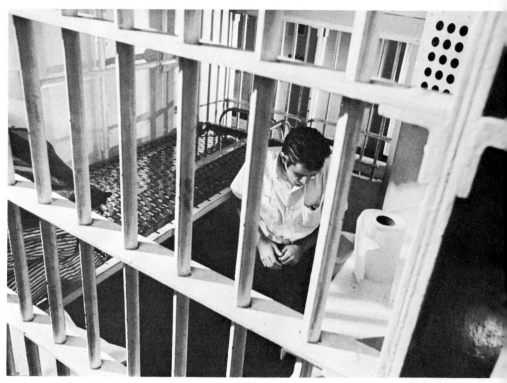

FIGURE 9 ▲

other raw stocks are not needed. The only exceptions are those instances when there is so little light (either natural or artificial) that no exposure is possible with normal film; in such a case, if 16mm film is being used, a high-speed film such as EK 7241 Daylight or 7242 Tungsten can be used. It is also possible, through forced developing, to increase the speed of both 16mm EK 7252 and 35 mm EK 5254 by adding one or possibly two lens stops. Forced developing entails leaving the film in the developer under carefully controlled conditions for a period of time beyond the manufacturer's normal specifications. This increases the emulsion's density and the film's ASA rating and its sensitivity to light. The cameraman, knowing in advance that the film will be processed in this manner, can assume the higher ASA rating and use less light at the time of photography. To "push one stop" would be to change the ASA rating from 25 to 50. Currently Eastman Kodak is placing on the market two new film stocks that will provide in 16mm and 35mm a faster speed with even less grain and higher resolution. They will be in 35mm 5247 negative, and finally a 16mm negative stock 5257.

A word about the relative values of 16mm and 35mm film. Traditionally, the great majority of feature films have been photographed in 35mm. This is because the 16mm frame loses too much quality when projected on a large theater screen. Most TV films and commercials are also photographed in 35mm since TV broadcasting equipment obtains better results with a larger initial image size.

However, as a result of recent advances in optical printing equipment, it is now possible to enlarge a 16mm negative to 35mm and retain a relatively high degree of quality. *Woodstock*, for example, was photographed entirely in 16mm and then enlarged to 35mm for theatrical distribution. The advantage of this technique lies in its economy. It is far less expensive to shoot a film in 16mm color (20 cents per 16mm foot, including raw stock, developing, and work-printing; a work print is a cheap, low-quality duplication of the original film made for editing purposes) than in 35mm color (37 cents per 35mm foot). The additional per-foot cost *plus* the fact that in 35mm $2\frac{1}{2}$ much times as much footage is used accounts for a substantial cost differential. Though the cost of enlarging the finished film is approximately 80 cents per foot, the saving of 17 cents per foot on all *shooting* footage plus the smaller amount of film used in 16mm more than compensates for this expense (see Table 4-2). It must be remembered, however, that while the quality of a 16mm film enlarged to 35mm is quite good, it is not equal to a print made from an original 35mm negative.

Table 4-2

Note: 20,000 feet of 16mm film is equivalent in running time to 50,000 feet of 35mm film.

	EXPOSED FOOTAGE (Shooting ratio of 20:1)	COST (per foot) OF RAW STOCK, DEVELOPING, AND WORK-PRINTING	TOTAL
35mm	50,000	$0.37	$18,500
16mm	20,000	0.20	4,000
Blow-up of the finished 30-minute film from 16mm to 35mm	2,700 (35mm footage)	0.80	2,160
		Total savings:	$12,340

the camera

The motion picture camera is actually a very simple mechanical device. In principle, it has changed very little since the development of the first box camera. The film is transported from the chamber (magazine) into the body of the camera, a totally light-free environment. As the film passes in front of the aperture of the camera, it stops for a fraction of a second (usually 1/50 of a second), the shutter opens, the image is recorded on a single frame just as in a still camera, and the shutter closes. The film moves forward until the next frame is in position, the shutter opens again, and the next frame is recorded. Because all this occurs

so rapidly—usually at a rate of 24 frames per second—there are only minute, almost imperceptible changes from frame to frame (see Figure 10). However, when these images are run through a projector, the illusion of motion is achieved.

The cameraman views the action either directly through the lens by means of a complex prism of rotating mirrors (as in the Arriflex and Eclair cameras) or through a side parallax viewing system that duplicates the image received by the lens.

LOADING THE CAMERA

In most cameras made for professional use, the film is loaded into a magazine that is separate from the body of the camera (see Figure 11). One exception is the Eclair magazine, which contains a transport mechanism. In this magazine the film is fed from one side and is taken up on the reverse side (see Figures 12a and 12b). In all cases the film must be loaded in complete darkness, either in a photographic darkroom or in a *changing bag*, a specially designed cloth bag containing an inner sack that completely seals off light. The person loading the camera puts the magazine and the cans of unexposed film inside the bag and zips shut the inner and outer sacks. He then places his hands inside the bag through sleeves that fit tightly around his arms and loads the magazine. Since the entire operation is performed either in the changing bag or in a darkroom, the loader must work totally by touch. An experienced person can load a magazine in about 15 seconds. Once loaded, the magazine is mounted on the camera and the film is threaded through the camera's geared mechanism. The camera is then closed and ready for use. Of course, each camera will be loaded differently, but the basic principle is the same for all. Figure 13 shows the threading of the film through a 16mm Arriflex BL.

◀ FIGURE 10

FIGURE 11 ▲

FIGURE 12a ▼

FIGURE 12b ▶

FIGURE 13 ▶

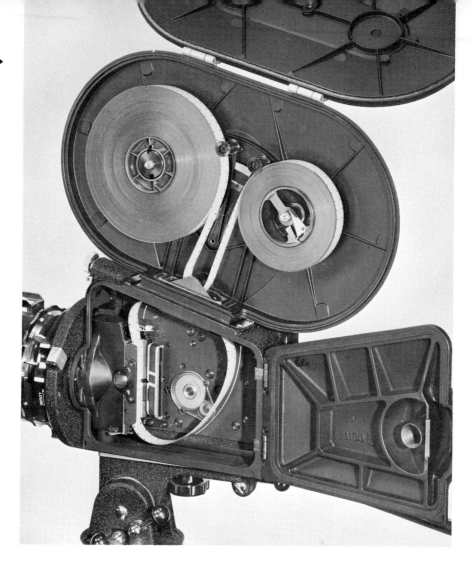

TRANSPORTING THE FILM THROUGH THE CAMERA

Most professional cameras are powered by batteries or by standard electrical current and are also equipped with two types of interchangeable motors—a constant speed motor that transports the film past the aperture at a steady 24 frames per second, or a variable speed motor that can be adjusted to provide from 4 to 60 or more frames per second. The variable speed motor permits both slow- and fast-motion photography as well as the subtler adjustments that are necessary in certain situations. For example, when shooting from a moving vehicle it is wise to speed up the transport a little to increase smoothness—32 frames as opposed to the normal speed of 24 frames per second is common for moving shots. The increased shooting speed does not noticeably affect the visible movement, but slows it down just enough to make the camera action appear smoother.

FIGURE 14 ▲

 If a scene is to appear on screen exactly as it was filmed, it must be projected at the same speed at which it was photographed. The movement in a scene photographed at 16 frames per second (home movie speed) and then projected at 24 frames per second will appear speeded up, unnatural, and jerky. A scene shot at 90 frames per second and projected at 24 frames will be in slow motion. (For extreme slow motion effects, widely used in TV commercials as well as in some feature films, special high-speed cameras operating at up to 1,000 frames per second are available.) Since the standard speed for sound film projectors is 24 frames per second, any variance from this speed will produce *sound* distortion; thus 24 frames must be the standard for filming images to be used with synchronous sound. Most professional cameras are equipped with a *tachometer,* an instrument that shows the exact speed at which the camera is operating.

 On many cameras it is possible to change the speed with which the shutter opens and closes, thus varying the amount of light reaching the film. The faster the shutter opens and closes, the less light reaches the film. In addition, on some cameras the size of the aperture (the opening through which light reaches the film) can be widened or narrowed to vary the amount of light reaching the film. These techniques are valuable when there is too little light available for the lens

selected for the scene. By slowing down the shutter speed or enlarging the aperture, the cameraman can photograph without compromising his choice of lens.

MOUNTING THE CAMERA

Since movement is a central factor in the art of the motion picture, it is important to be able to move the camera with the highest degree of ease and proficiency. The simplest form of camera mount is the tripod, but there are a variety of mechanical devices, known as *heads* (Figure 14), that fit between the tripod and the camera to facilitate smooth, effortless camera movement. The camera is mounted on the head, which is in turn mounted on the tripod. Fluid heads such as the O'Connor and the Miller, and geared heads such as the Worrell help make possible smooth lateral movement (*pans*) and vertical movement (*tilts*).

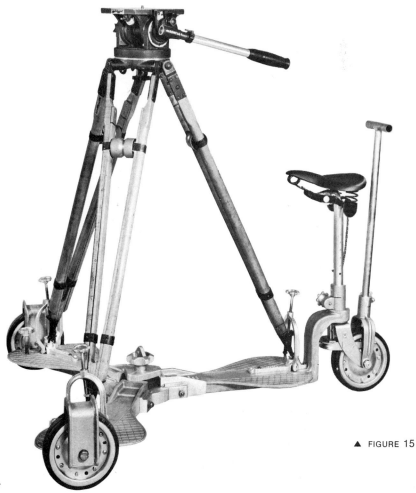

▲ FIGURE 15

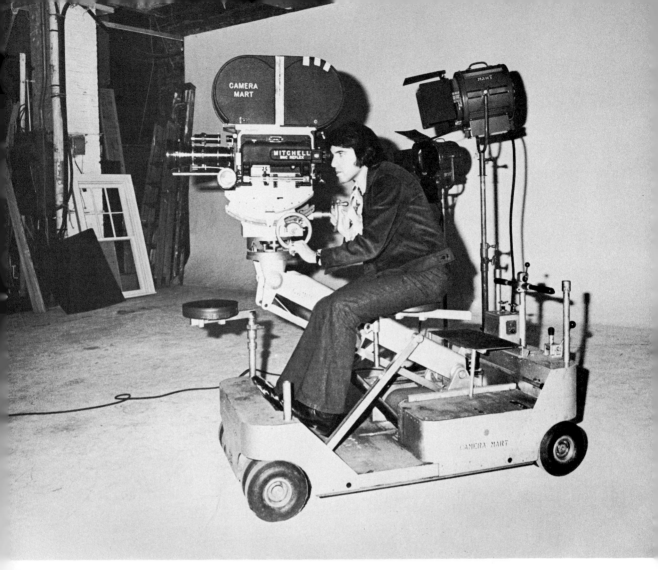

FIGURE 16 ▲

Dollies are used to move the camera itself. These range from the *bicycle dolly* (Figure 15), for straight-line forward and backward movement with only minor variations, to the versatile *crab dolly* (Figure 16), which can provide just about any type of movement desired.

The choice of camera mount must be related to the kind of camera movement desired. A complex studio dolly is hardly necessary for simple straight-line movement, while a rising 360-degree turn ending in a spectacular overhead view of an entire set cannot be accomplished with any smaller, less versatile piece of equipment than a complex electronic crane dolly.

An important rule to keep in mind is that *all movement should be justified*. It often takes a great deal of restraint on the part of the filmmaker to frame and compose the scene and then let it play without moving the camera at all. However,

the judicious and creative use of camera movement is a major factor in the filmmaking process. Each time the camera moves, even slightly, the image changes, and it is this evolving imagery that, if properly employed, can arrest and hold the viewer's attention.

THE HAND-HELD CAMERA

Jean-Luc Godard, in his first major film, *Breathless* (1959), is among those credited with freeing the camera from its artificial pedestal, the tripod. Since then, the hand-held camera has assumed major importance in contemporary filmmaking. The vitality, naturalness, and improvisational quality imparted to the image through the use of a free camera cannot be overemphasized. However, like all creative innovations, the hand-held camera has tended to be overused and abused; it has often been employed in an attempt to cover up directorial inadequacy or amateurish filmmaking. The subject material should determine whether or not a hand-held camera should be used. When a controlled reality or an immediacy of action is sought, as in *cinéma vérité*, use of the hand-held camera is justified. Haskell Wexler used the hand-held camera to fine advantage in his film *Medium Cool*. In the final scenes of riot, revolution, and violence, the camera, freed from its locked-down observer role, was able to plunge into the action and really involve the audience.

It takes a tremendous amount of skill, both artistic and mechanical, to employ a hand-held camera successfully. The cameraman must be able to make all his own focus adjustments very quickly, since the distance between the lens and the subject is constantly changing, and he must be able to hold his camera absolutely steady when necessary. When a hand-held camera is used, the assistant who ordinarily makes focus changes cannot help, and the cameraman is on his own. This type of filming, therefore, requires a high degree of mechanical dexterity on the part of the cameraman. There is nothing more distracting than the constant, pointless jiggling of a camera during a scene. The camera can move freely when there is a reason for it to do so, but it must also stop frequently within the same scene. Such controlled movement takes a great deal of practice and discipline, and few cameramen really master this technique. However, the hand-held camera is and will continue to be a major creative tool of the modern filmmaker.

the lens

The lens is the "eye" of the camera, through which the visual image is seen. Since the lens determines not only the size of the image but also its texture and quality, the selection of the right lens for a particular scene is a critical choice, one of the most important to be made in the filming process. Every lens is different from every other lens and each will impart to the scene unique characteristics that strongly affect the end result. (See Figure 17.)

In simplest terms, the photographic lens consists of several pieces of finely ground optical glass arranged in a series of planes and curved so as to direct and

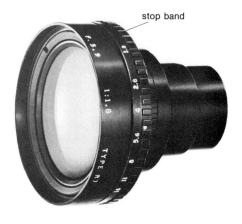

stop band

FIGURE 17 ▲ FIGURE 18 ▲

bend the rays of light from outside the camera onto the film. All professional photographic lenses are equipped with a *stop band*, which opens and closes the "iris" of the lens, thus controlling the amount of light passing through it (see Figure 18). Adjusting the iris is commonly termed "opening" and "closing" the lens. The stop band is calibrated with a series of numbers called "f stops" and/or "t stops."

The amount of light falling on the subject is measured by means of a *light meter* (see p. 171). Judging on the basis of the ASA rating of the film (the film's sensitivity to light), the cameraman determines exactly how much light should be permitted to reach the film to achieve a perfect exposure. The correct lens setting is then made by rotating the stop band until the setting indicated on the light meter is opposite the dot or marker. If the scene is dimly lit, the lens must be opened to permit as much light as possible to reach the film. If the lens is not opened sufficiently, the scene will be underexposed, or too dark. Figures 19a–19c show the same frame measured for an f4 setting and photographed with the lens set at f2.8, f4, and f5.6. Similarly, if the scene is exceptionally bright, as on a sunlit beach, the lens should be closed down to prevent too much light from reaching the film and overexposing the scene. The important point to note here is that there is only one perfect exposure for any scene and any deviation from that setting will result in underexposure or overexposure. Although the laboratory can often compensate in developing and printing for errors in measuring the light levels of the scene or errors in setting the lens, the cameraman should always strive for perfection during filming. As Figure 19a demonstrates, an overexposed scene, even if overexposed by only a fraction, results in a loss of detail, a distortion of color values, and a "washing out" of general quality; an

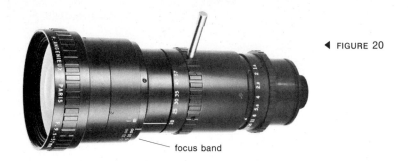

focus band

underexposed scene submerges detail in shadows and "plugs up" the scene: the dark areas go completely black, and the visual texture we normally get from shadowed areas is lost. It is easier, however, to salvage an underexposed scene by increasing the printing light to bring out detail (which, although obscured, will usually still be present) than to save an overexposed scene by underexposing the negative. Overexposure washes out detail, and you cannot put back what is not there.

All lenses are equipped with a *focus band* (Figure 20), which adjusts the focus of the lens. This band is marked with numbers indicating in feet or meters (or both) the distance between the film and the subject. Usually the focus is set first by eye. Looking through the viewfinder, the cameraman adjusts the band until

FIGURE 21a ▼

the subject looks perfectly clear. When this is done, the actual distance between the subject and the film should coincide exactly with the figure opposite the lens marker. If the distance indicated does not coincide exactly with the actual distance between subject and film, either the lens is out of calibration or the cameraman has failed to set the focus accurately. When the figures conflict, eye focus is usually more reliable.

As noted earlier, every lens has its own characteristics and produces a different effect from that of every other lens. The three most important features to consider in determining which is the right lens to use for a particular scene are the focal length of the lens (this determines image size); the range of the aperture, or lens opening (this determines the ability of the new lens to admit or shut out light); and the depth of field (this determines the soft-focus/sharp-focus elements within the frame).

FOCAL LENGTH

All lenses are identified by focal length (10mm, 18mm, 100mm, etc.); this figure represents the distance from the lens to the aperture of the camera. Wide-angle lenses (those between 5.7mm and 15mm[1]) are closer to the aperture and thus give a wider, more inclusive image. "Normal" lenses are so called because they transmit to the film an image most like the range of normal vision (Figure 21a). They include all lenses between 18mm and 75mm. "Long," or telephoto, lenses give a telescopic image (Figure 21b) and include all lenses 100mm or longer.

[1] All lens sizes given in this section are for 16mm cameras.

RANGE OF APERTURE

The second key characteristic of a lens is the range of its aperture from its smallest to largest opening. The ability of a lens to admit or shut out light determines both its usefulness under particular lighting conditions and the character of the image. For example, most long lenses do not have apertures that open beyond f3.5. Thus if shooting is to take place outdoors without the aid of artificial light, and if there is not sufficient illumination for an f3.5 reading on the light meter (as at dusk or twilight), a long lens cannot be used. Of course, if other adjustments are made, such as fast developing ("pushing") of the film to increase its speed, or slowing down the motor speed of the camera so more light reaches each frame, it is possible to use a long lens. Similarly, some wide-angle lenses cannot be used for shooting in very bright sunlight, since the lens cannot be closed sufficiently to provide a properly exposed image. Generally speaking, the larger the range of aperture, the more useful the lens.

DEPTH OF FIELD

The depth of field of a lens is defined as the range of acceptable sharpness in front of and behind a place of focus obtained in the final screened image. This factor more than any other gives the lens its "character" and determines the kind of image it will produce.

Generally, wide-angle lenses provide a greater depth of field and long lenses give a more restricted depth of field. However, factors other than the focal length affect the depth of field of the lens. For example, the wider the lens aperture used, the narrower the depth of field. If a cameraman elects to shoot a dimly lit interior scene with an f3.5 lens opening, he will have far less depth than if he used lighting for an f5.6 opening with the same lens.

In recent years the depth of field of lenses has grown in importance. The scene in which every element is equally sharp has gone out of favor and been replaced by the "soft focus" scene, in which the illusion of depth is created by having a large portion of the frame obscured by soft-focus foreground elements and leaving only a small portion of the image sharp. One of the more recent films to utilize this technique effectively was the Swedish film *Elvira Madigan*. The director, Bo Widerberg, used long lenses to photograph most of the film, creating a soft, romantic aura entirely appropriate to the subject.

THE ZOOM LENS

With the zoom lens the cameraman can, with a single instrument, obtain the wide variety of image sizes that could ordinarily be had only through the use of many different lenses. Zoom lenses like the 12mm-to-120mm Angénieux permit the cameraman to change image size *during* a shot or to adjust image size instantly without changing lenses. The zoom also permits visual movement toward or away from the subject without actual movement of the camera. Because of its speed and versatility, the zoom lens has become a very valuable tool for the contemporary filmmaker.

FIGURE 23 ▲

THE EFFECT OF THE LENS ON THE IMAGE

Every element of the image, not simply the image size, is affected by the lens. For example, different image sizes can be achieved by moving the camera toward or away from the subject, but this does not create the same effect as a change of lenses. Figures 22a and 22b show the effect on a scene when the camera is simply moved closer to the subject and the lens remains the same. In Figure 23 the camera remained stationary, but a longer lens was used to provide the close-up view. Note the entirely different *character* of Figures 22b and 23. The image size is almost identical, but the relationships within each frame are entirely different. Figure 22b was photographed with a normal 25mm lens. The depth of field is fairly extensive, with the background figure almost as sharp as the foreground setting. In Figure 23, however, the use of a longer lens (100mm) has greatly restricted the depth of field. The foreground figure is quite soft and all the attention is on the background. In this type of frame, the foreground serves mainly to create mood and texture to support the background, and an entirely different feeling is created.

In general, wide-angle lenses hold all elements within the frame in focus. The wider the lens, the greater the linear distortion (see Figure 24). Linear distortion refers to the vertical bending of the image caused by the wide-angle lens. Since the lens, although short, encompasses a wide image, it must bend the light rays as they pass through the lens. Wide-angle lenses are often used for dramatic effect, as in dream or fantasy sequences, since immense foreground figures and tiny

background figures can all be held in relatively sharp focus without the blurring of distant objects that occurs in normal vision. An early and famous use of wide angle lens distortion was by Gregg Toland in *Citizen Kane*. The death of Kane, with its highly distorted foreground images (head of Kane, glass of water, glass paperweight) and its distant background images (the nurse entering the room) with all images sharp, is one of the most important single scenes in the history of film.

Movement or the illusion of movement is also affected by the lens. When figures or objects move toward or away from the camera, use of a wide-angle lens will cause the movement to appear speeded up, while a long lens will make it seem much slower, since a long lens tends to foreshorten the background-foreground relationship. Often with very long lenses (240–400mm) a subject running directly toward the camera will appear to be moving in place; the same figure photographed with a wide-angle lens will appear to be moving toward the camera much more quickly than he actually is.

FIGURE 24 ▶

LENS ACCESSORIES

There are a wide variety of lens accessories that can further alter the character and quality of the visual image. These include:

1. *Density filters,* which reduce the amount of light reaching the film if the lens's smallest opening is not small enough.
2. *Color filters,* which can be used to impart any desired color or mood characteristic to a scene. For example, if an exterior scene is being shot in the early morning, when the light is blue in tone, magenta or red filters can be used to add greater warmth to the scene.
3. *Polaroid or haze filters,* which help to clarify or sharpen an image by filtering out atmospheric haze, often present on warm summer days or at midday, when the sun is high overhead and heat has built up to obscure the landscape.
4. *Sky filters,* which can be used to reduce wide exposure differences between a bright sky and a landscape in shadow. Normally it is impossible to properly expose a scene in which the sky reads f16 on the light meter and the land reads f5. If the lens were set at the proper exposure for the land, the sky would be seriously overexposed, if set for the sky, the land would be impossibly underexposed. The sky filter helps to compensate for this difference. The filter consists of a neutral density glass coated at the top to reduce the amount of light entering the lens from the sky area. Since the line where the coating ends must always be matched with the horizon, no vertical camera movements can be made when this filter is on the lens.

Other lens filters that offer a variety of special effects include *prismatic filters,* which multiply the image, and *proxars,* which allow the lens to focus closer to the object than is normally possible.

Filters are available in either glass or gelatin. The glass filter fits over the front of the lens, either in a ring as part of the lens itself, or in a matte box that is part of the camera. The matte box shields the lens from random light as well as holding the filters in position in front of the lens. Glass filters are manufactured in a variety of sizes for every type of lens and are keyed by series numbers. Generally, each filter will fit only one lens size. Thus a 120mm telephoto lens may require a series 9 filter; a 75mm lens may require a series 7 filter. Gelatin filters are available in sheets that must be cut to size and fixed to the back of the lens. Because they are mounted closer to the rear element of the lens, they tend to interfere less with the sharpness of the image than glass filters and cannot cast light reflections on the lens. The difference in the image obtained, however, is very slight and does not always compensate for the difficulty of mounting and removing the gelatin each time it is used. For this reason, glass filters are usually preferred over gelatins.

It is important to note that any glass or gelatin filter changes the amount of light passing through the lens and affects the image in a variety of ways. No filter or lens accessory should be used without a thorough investigation of the total effect it will have on exposure, color, and general quality of the image. Prior to

filming, all lenses and accessories should be carefully checked out on the camera and a test film should be run. The zoom lens should be reviewed in all positions and checked for in and out movements. A *test card,* available from any film laboratory, can be used for this preliminary checkout. The best procedure is to photograph the card with each lens at three sample exposures. These samples will demonstrate the color resolution, the overall sharpness of the frame, and the accuracy of each lens aperture calibration and focus calibration. If the light meter gives an f5.6 reading and the lens is set at f5.6, the test film should be perfectly exposed. If the subject is measured at 7 feet 6 inches away from the aperture of the camera and the image looks sharp when the lens is set at 7.6, the film should be perfectly sharp. Anything less indicates a malfunction of lens, camera, or light meter that must be investigated and remedied immediately. During filming, it is wise to keep a careful record of the lens and exposure used for each shot, so that if a malfunction does occur it will be easy to identify the lens at fault.

illumination

Another essential element in creative cinematography is illumination. Lighting, more than any other single factor, gives the scene its visual texture. In the early days of filmmaking, when film stock was extremely slow (insensitive to light), lighting was largely a pragmatic affair. An interior scene was lit at the level that would best register on the film. The films of Hollywood's "golden age" are characterized by artificial, "stagey" lighting. In Figures 25a and 25b, note the "halo" effect around the heads of the principals, the heavy black-and-white shadows, and the extreme contrasts. The viewer is continually aware of the artificial play of light and shadow. This high-intensity illumination, often combined with garish color photography, became a trademark of the pre-World War II Hollywood film. Too often it created an obvious, dramatic effect far removed from either art or reality.

Over the years, however, lighting has evolved into a highly creative field. Contemporary cinematography is a much more subtle blend of art and life. The current trend in filmmaking is to create a "perceived" reality heightened by artistic visual effects. The basic approach to illumination is far more subtle and realistic, with artificial lighting used primarily to augment or "touch up" the realistic light sources present in the scene. The use of harsh, artificial contrasts and high-angled lighting has largely been replaced by diffused, softer light accented by touches of intense illumination. In addition, current film stocks are quite sensitive to light, making possible far lower light levels when illuminating a scene. The viewer is almost totally unaware of the presence of any lighting at all.

◀ FIGURE 26

LIGHTING EQUIPMENT

BULBS AND ACCESSORIES

The basic tools the cameraman uses to light the scene are a series of incandescent fixtures (spotlights and floodlights) and arc lights in a wide range of sizes and intensities. The spotlight contains an incandescent bulb covered with a Fresnel glass lens and encased in a metal shell (Figure 26). This light casts a beam that can be focused to cover a small area with harsh, high-intensity light, or a wide area with low-intensity light. The *floodlight* (Figure 27) consists of an incandescent bulb encased in a shell lined with a white or silver reflective surface and open in front. The floodlight casts a gentle, diffuse light that falls at random over a wide area. In addition to these incandescent fixtures there are *arc lights* (Figure 28), which consist of a burning carbon arc that emits a very high-intensity illumination. Because these high-intensity arc lights emit a far greater amount of illumination than spots or floods, they can be used to light large areas. High-intensity arc lights are often used during on-location color filming in order to balance sunlight. The advent of the crystal *quartz bulb* (Figure 29), however, has revolutionized the art of film lighting. These relatively small lamps emit light equal in intensity to that of the larger, conventional incandescent bulbs and provide the filmmaker with a small, mobile lighting unit capable of achieving a full range of lighting effects in any studio or on-location setting.

FIGURE 27 ▶

FIGURE 29 ▶

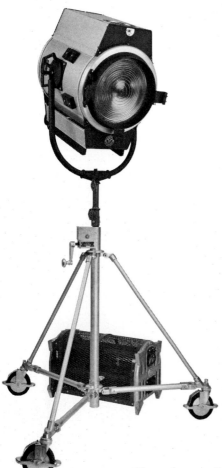

FIGURE 28 ▲

Since the art of illumination relies primarily on the quality and character of light rather than on its quantity, the artificial lighting added to a scene must be broken up into patterns, softened, partially blocked, or diffused. This can be accomplished through the use of a variety of lighting accessories.

BARNDOORS

Lights are usually equipped with a set of *barndoors* (Figure 30), a frame with four opaque black shutters that can be made to swivel in front of the lamp, enabling the cameraman to block off the light falling on any portion of the scene and to cast heavy, controlled shadows.

When the light emitted by a particular lamp is too harsh or intense, a *diffuser*—either a piece of spun glass or a copper or wire screen or a polyester spun mat (called Rosco tough spun)—can be used to soften the effect (see Figures 31a and 31b). The diffuser is placed in front of the lamp and can be used to cover the entire light or simply a portion of it; an alternative method is to bounce the light off diffusing material, thus softening its quality.

Careful and judicious use of diffusers can also enable the cameraman to control color values. For example, a red object, illuminated directly with high-intensity light reflects a sharp, garish red. But when the light is diffused (made softer), a less intense light hits the red object and it thus reflects a softer color value.

FIGURE 30 ▼

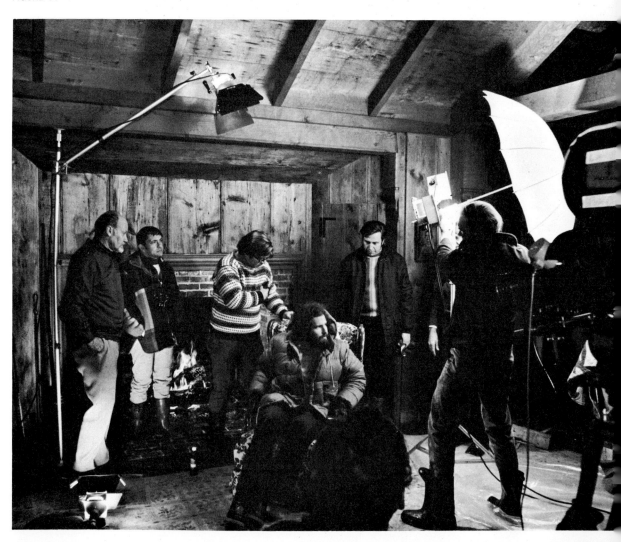

FIGURE 31a ▲

FIGURE 31b ▼

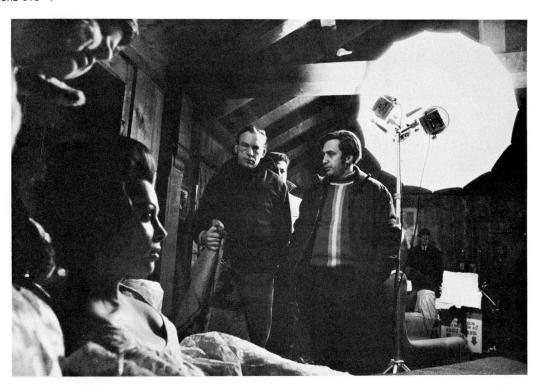

Since the barndoor is directly in front of the lamp, it can only cast heavy shadows or cut off the light completely from a portion of the frame. If the cameraman wishes to subtly shade an area or reduce the light intensity of the background only, he must use a *gobo*, a framed black opaque cloth (Figure 32a). This cloth is placed in front of the lamp and casts a shadow over a part of the scene (Figure 32b). The closer it is to the light, the darker the shadow. Because the position of the gobo is totally flexible (it is not attached to the light), it can shade any portion or area of the frame.

COLOR FILTERS

Color gelatins are often placed in front of lights to lend a specific color value to the scene—perhaps the yellow-gold of firelight or the cold blue of ice and snow reflected through windows. These filters are fireproof and are available in a wide variety of colors.

Some special effects currently in vogue are achieved by pre-flashing or post-fogging the film (exposing it to light before or after exposure but prior to developing) under carefully controlled conditions in the laboratory. This mutes the colors and softens the image without materially detracting from sharpness or resolution. In prefogging, the film is run through the printing machine with the

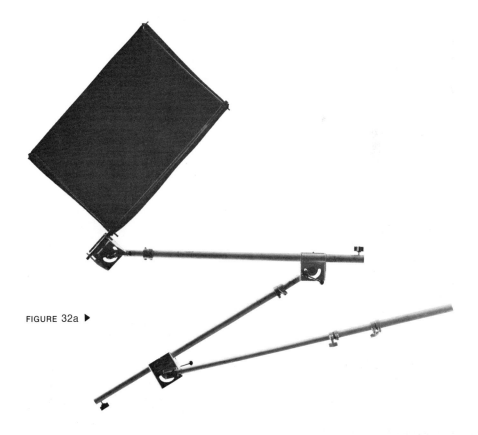

FIGURE 32a ▶

FIGURE 32b ▲

aperture open, using the size of the aperture and the speed at which the film is moving as the control. This exposure to light prior to filming reduces the contrast of the image. The following excerpt from an article in the *New York Times Magazine* explains how one director used this process.

> The peculiarities of "McCabe & Mrs. Miller" begin with the look of the film. Of the many attempts by directors to use color to comment on the picture they are making (Antonioni's "Red Desert," George Roy Hill's "Butch Cassidy and the Sundance Kid," John Huston's "Moulin Rouge"), "McCabe & Mrs. Miller" is closest—both technically and emotionally—to Huston's grim use of color in "Moby Dick." The faded quality of the color is Altman's deliberate attempt—by methods known as flashing and fogging—to create the archaic feel of an old photograph left for too many years in somebody's attic album.
>
> Except for the snow sequence at the end of the film where he wanted to increase the reality of "the moment of truth" with as harsh a black-and-white effect as possible, Altman used fog filters throughout the picture. Then before the negative was developed, the film was put on a printer and re-exposed to light. According to Altman, "adding more yellow than normal not only threw the print toward yellow but made the look of the film more extreme. Adding more blue did the same thing." Altman's intention was "to complement the period, the set, and the look of the people, to make the audience see the film as more real." To him the blue and yellow suggested the faded printed material of the period—old magazines and bottle labels, aging and yellowed newspapers.[2]

[2] Aljean Harmetz, "The 15th Man Who Was Asked to Direct 'M*A*S*H' (and Did) Makes a Peculiar Western," *New York Times Magazine,* June 20, 1971, pp. 46–47.

THE LIGHT METER

The intensity of the light entering the lens from any portion of the frame is measured by means of a *light meter,* or exposure meter, a photoelectric cell that measures the intensity of the light and indicates which lens opening should be used (see Figure 33). The procedure is very simple. A light screen, labeled to correspond with the film speed (ASA rating) and containing a series of small holes that will permit a specific amount of light to reach the photoelectric cell, is inserted into a slot in the meter. The meter is then held close to the subject with the white bulb, or photosphere, facing the lens. (The photosphere is a part of incident light meters that simulates a three-dimensional object.) Since the bulb contains the photoelectric cell (Figure 34) that is measuring the direct (incident) light falling on the subject, the bulb should be on a straight line with the lens. The reading on the face of the meter indicates the proper lens opening. Before production, it is wise to check out the light meter by shooting a test run of film at various readings to make sure that the exposures indicated are accurate. A faulty light meter can lead to disaster in any film.

In determining the lighting levels to use for any scene, the cameraman should first measure the intensity of the light in the portion of the frame that he has established as his basic center. He should then check the relative intensities in all other portions of the frame and set up acceptable ranges of exposure between light and dark to achieve the effect he desires. The acceptable range will vary depending on many elements, such as whether the film is for television (which has a narrower range) or theater projection, and, of course, what kind of effect is desired. The greater the contrast range, the moodier and more dramatic the film. For example, in Figure 35 the face of the subject would comprise the central exposure— let us say f4. The area around the lamp will be about 25 percent brighter and should read f4.5, and the background will be about 30 percent darker, reading f3.2. If the cameraman finds an area that is two or three stops brighter than the basic center, he will want to tone down the light reaching that area to avoid overexposure; if he finds an area two or three stops darker, he will increase the light in that portion so that it will not appear completely dark in the finished film.

FIGURE 33 ▶

FIGURE 34 ▲

FIGURE 35 ▼

THE CONTRAST GLASS

The *contrast glass* is a small ring of darkened optical glass that, when held to the eye, allows the viewer to see only the relative contrast of light and dark. Whereas the light meter gives a direct measurement of the relative light intensities in various portions of the frame, the contrast glass permits the cameraman to view the entire scene solely in terms of the light and dark relationships. He can then make further adjustments for areas that are too bright or too dark.

LIGHTING THE SCENE

The type of lighting used and the position of each light are, of course, the factors that determine how the scene will look. Getting an exposure is easy, but placing lights to achieve a desired effect—the essence of artistic lighting—is more difficult. The following is a brief guide to the art of illuminating interior and exterior scenes.

INTERIORS

When lighting an interior setting, the filmmaker should first view the setting in its natural light, keeping in mind the mood called for in the script. Is it a gay scene, a sad one, a mysterious one? What is the "reality" the film is trying to achieve? If the film is not a fantasy or a deliberate distortion of reality such as *A Clockwork Orange,* all light added to the interior should be kept consistent in mood and tone with the realistic sources of light (windows, lamps, candles, etc.) present in the scene. Every type of light has a distinctive character and quality. Light entering an interior from a window creates very different effects on sunny days and rainy days. A candle casts an entirely different light from that of a fireplace or an electric lamp. It is not necessary, however, for the cameraman to be bound only by realism. It is quite possible, even desirable, to begin from a realistic base and go on to create an artistic effect that is larger than life; but it is wise to remain consistent to the tone of the realistic light source.

An excellent example of effective lighting is the naked wrestling scene in Ken Russell's *Women in Love.* Although the cameraman used a single source of light, the fireplace, he enhanced it by adding red and orange filters as well as by varying the amount of light falling in different parts of the frame. No fireplace could possibly have cast such an intense, golden light, nor could the firelight have illuminated the bodies of the men from so many angles. However, a sense of realism is achieved because the added illumination is true to the basic type of light the fireplace would cast, and artistry is added through variations in light intensity and angle.

The bathing sequence in *McCabe & Mrs. Miller* is another excellent example of the creative use of lighting. The sequence takes place in a primitive frontier town building, and the realistic light sources are a few kerosene lamps. Again, there is a basic yellow-gold quality to the scene. To this the cameraman added huge quantities of steam from the hot baths—far more than would normally be created. The light filtered through the steam, creating a play of shadows within

the scene (see Plate 4). The result was a skillful blending of the artistic (in mood and effect) and the real (in consistency of light).

In recent years no single film has revealed the crucial importance of lighting in color photography as has *The Godfather*. Gordon Willis was able to evoke an entire era largely through the use of very low-intensity lighting, the effects of which he enhanced through a great deal of laboratory manipulation. The film was used at a much higher ASA rating than it carried under normal conditions. By

FIGURE 36a ▲

postfogging the film, Willis not only gave himself the advantage of the increased speed, which enabled him to use very little light, but he also added a "period" character to the color. It was this character, far more than the costumes, old cars, props, and make-up, that created the reality level that made the film so effective. With the very low light level, the lenses were used at "open" stops (f2.8 and f3.5). This reduced the depth of field and permitted backgrounds to go very soft and fuzzy. The tremendous difference in sharpness between foreground and background, a result of the lighting approach, also contributed to the "period" effect. One interesting point of reference to this type of lighting is the work of the "little Dutch masters" such as Vermeer, who refined the art of painting through the use of light and specific, controlled levels of color that were not "real" but lent a feeling of reality that was the artist's own creation. Scenes from *The Godfather* and *McCabe & Mrs. Miller* (Plates 1–5) elicit a similar response.

The proper use of each light for its own intensity and character is an essential aspect of creative cinematography. Since it is crucial to obtain an illusion of depth within the frame, the control of varying light intensities is of great importance. *No light should be allowed to fall at random.* The cameraman must control the lighting effects in even the smallest segment of the frame. Lights must be properly positioned to achieve specific effects. A light placed in front of a subject at eye level (see Figure 36a) simply gives illumination. Side lighting tends to edge-light the subject and separate it from the background (see Figure 36b), while back lighting tends to add depth and interest (see Figure 36c). A combination of all

three types of lighting within a scene generally gives the most effective results. Lights must also be positioned so that they are out of the range of the camera and do not reflect light directly into the lens. Any reflection on the lens will halate the scene and wash it out. To avoid this, lights are usually placed over the set or, on occasion, below camera level.

The angle of lighting is another important factor in determining the character and mood of the scene. The sharper the angle from above or below, the more distinct the shadows created and the more dramatic the effect (see Figure 37). Thus musicals, comedies, and light, romantic scenes are generally lit from minimal angles with diffused light, while dramatic or emotional scenes are lit from sharper, more oblique angles.

Although there is no absolute formula as to the relative light values to use for background and foreground elements, the cameraman should always keep in mind the effect of the intensity of the light on the depth of field. The more light used, the more the lens must be shut down and the greater the depth of field. Thus, to photograph a scene in which a large portion of the frame is out of focus, with the subject highlighted and clearly separated from the background, a very low level of lighting must be used. In lighting any interior, the illusion of depth is essential. Motion and planes of focus help to create depth, but in the final analysis it is the lighting that is most critical. If all illumination is from the front, the result will be flat and one-dimensional. By varying the light intensities throughout the frame and by separating figures from the background through variations in the intensity, angle, and character of the light, the cameraman can achieve the illusion of depth.

The predominant trend in contemporary cinematography is toward lowering light levels. The faster (more sensitive to light) the raw stock, the easier it is to work with very low levels of illumination. This has several important advantages: (1) more areas within the frame fall into subtle shadows, and a greater degree of reality is achieved; (2) the fewer lights used the faster it is possible to work; (3) the fewer lights used the cooler the set, making it easier to work; and (4) the fewer lights used the more flexible the camera, since the camera can change angles without pointing directly into a light. The films of Vilmos Zigismond (*McCabe & Mrs. Miller, Deliverance*), Conrad Hall (*Fat City*), and Gordon Willis (*The Godfather*) demonstrate the advantages of using very low light levels when mixing indoor and outdoor light without filters.

It is important to note that commercials and films produced for television require a much lower contrast ratio within the frame than those produced for theatrical release. The contrast ratio is the relationship between the intensity of the brightest and darkest elements in the frame. Television films are often lit on a 3:1 or 4:1 ratio, while films for theatrical release can go as high as 8:1 or 10:1, or even higher.

When both sunlight and artificial light are present in a scene (for example, when a window in the interior opens onto daylight), the cameraman must balance and control the different intensities and color values of these two sources of light. As noted earlier, all raw stock is manufactured for use with a specific type of light, either natural or artificial. Thus if both types of light are present in a scene,

FIGURE 37 ▶

one or the other will lack realistic color unless filters are used or one of the light sources is removed. Also, daylight tends to be far brighter than artificial light. Thus if the interior is lit at f3.5 and the light coming through the window gives a reading of f8, the daylight will completely halate and overexpose the scene. This can be avoided either by raising the intensity of the artificial light closer to that of the daylight or by covering the window with a shade or blind. The color values

◀ FIGURE 38

of the light sources can be balanced by placing a number 85 gelatin filter (this adds the missing magenta color tone) over the window to match the color quality of the artificial light. Sheets of 85 gelatin filters combined with neutral density materials that will reduce the intensity of the light are available for this purpose. As part of the new realism in film lighting, however, cameramen often do permit window daylight to overexpose and retain its blue characteristic.

EXTERIORS

The problems of exterior photography are largely concerned with the control of natural elements. The sun, the primary source of illumination, is constantly moving, changing not only the angle, but the intensity and quality of natural light. Morning light is blue in tone and evening light is red. Because a scene often takes many hours to complete, it is absolutely necessary to retain control over the light so that the color values it imparts to the scene will not change during the shooting. This can be done by using color correction filters over the lens. As the daylight becomes redder, a blue filter is added to retain the original color values present when filming began in the morning. It is also often necessary to supplement the daylight with artificial light if, for example, a sunny day turns cloudy during filming and the director does not want to change

PLATE 1 From the motion picture *The Godfather,* copyright © 1972 by Paramount Pictures Corporation.
All Rights Reserved.

PLATE 2
From the motion picture *The Godfather*, copyright © 1972 by Paramount Pictures Corporation. All Rights Reserved.

PLATE 3 From the motion picture *McCabe & Mrs. Miller.* Photo by Steve Schapiro. Courtesy of PLAYBOY Magazine, copyright © 1972.

PLATE 4 From the motion picture *McCabe & Mrs. Miller*. Photo by Steve Schapiro. Courtesy of PLAYBOY Magazine, copyright ©️ 1972.

PLATE 5 From the motion picture *McCabe & Mrs. Miller,* copyright © 1970 by Warner Bros., Inc.

the character of the light within a scene. In such a case, spotlights are needed to retain the original sharp contrast and shadows. In the opposite case, that of a cloudy day that suddenly erupts into bright, harsh sunlight, artificial fill light is needed to fill in the newly created shadows. Such a mixture of artificial and natural light also makes it difficult to maintain consistent color character. The pervading light is, of course, daylight, which is bluer in color quality than artificial light. *Dichroic filters* must be placed in front of all the artificial lights being used so that they will give off a light exactly matching daylight in color. (These filters, however, reduce the intensity of the artificial light by about 30 percent.) *Silk filters* (Figure 38), placed in front of the artificial lights or in the path of direct sunlight, can change a harsh, sharp light into a soft, diffused light. By always being lit through silk, many aging female stars are protected from having the camera reveal the ravages of time. *Reflectors* can direct sunlight so that it can be used just like artificial light.

Until recently cameramen avoided shooting directly into the sun, but now the "sunspot," or halated image, has become almost a cliché in modern film. Scenes photographed in early morning or late evening produce long shadows and tend to create greater visual interest. Scenes shot in the middle of the day, when the sun is high overhead, are flatter and have less shape and dimension. Scenes shot on cloudy or hazy days or in rain contain softer, more muted colors and are often moody and intriguing. It is important to note that the entire character of sunlight can be altered simply by changing the angle from which the scene is being shot. Thus a hand-held camera rotating 360 degrees around a scene will produce a series of images whose basic lighting quality is constantly changing. With today's lenses, raw stock, and lighting equipment it is possible to shoot exteriors under any lighting conditions. *McCabe & Mrs. Miller,* photographed almost entirely in rain and snow, included some of the most creative and beautiful scenes ever achieved on film.

ELECTRICITY IN THE UNITED STATES AND OVERSEAS

In most areas of the United States electrical power is supplied by 110-volt AC current, and the standard wall outlet is a flat fixture designed to accommodate a two-pronged plug. In other parts of the world, however, things are not so simple. Currents vary, and it is not unusual to find 220-volt or even 360-volt lines, which render a 110-volt bulb useless. The same holds true for electrical outlets. It is wise, before shooting abroad, to carefully analyze the electrical situation so that you can come equipped with the proper bulbs and extensions and any adapters that may be necessary. For example, a Siamese cable can be used with 220-volt electrical current. This adapter splits the line at the source so that two 110-volt lamps can be plugged into the 220-volt outlet. Since it is quite common to encounter DC current overseas, it is wise to purchase DC power inverters and then regulate to correct voltage.

The key to effective and artistic cinematography is artistic lighting. Because the interrelationships between light and shadow create the texture of the perceived

image and contrast ratios and color values contribute a great deal to the visual impact of the scene, control over lighting effects must be absolute. In the final analysis, it is the filmmaker who sets the standard. The scene, when ready for filming, should reflect the filmmaker's conception of how it is to look and feel and what values the image is to impart.

composition

Once the camera, lens, and mount are chosen, the filmmaker must face one of the most important creative decisions in the filming process—how to compose each scene of the film. The goal of all film composition is to capture the eye of the audience. In a successful film, the viewers are always watching exactly what the filmmaker wants them to watch. Their eyes never wander, nor does their interest or attention waver. This is the result of the effective and creative composition of each frame in the film.

Composition is essentially a matter of relationships. The filmmaker must enclose the action within an artificial frame. His goal is to create a sense of action beyond that frame and an illusion of depth on a flat surface. The objective is to carry the viewers beyond the surface and into the frame itself, so that for the time they sit in the darkened theater they will suspend disbelief and accept the reality of the people and events that appear on screen. If the frame is all-enclosing, it takes on the contrived quality of a theatrical stage setting. There is no life beyond what is seen and heard. Thus an *extended* frame, which suggests action beyond what is actually seen, provides a more dynamic composition. Figure 39a is a far more interesting scene than Figure 39b, yet the only difference is that some of the visual elements have been permitted to extend beyond the borders of the frame.

The relative position of every element within each individual frame determines the visual interest of the image. In contemporary filmmaking the partially obscured frame is very popular and is certainly in many ways esthetically satisfying. Precisely because the viewer must search beyond the obscuring elements for the main point of interest, the eye is drawn deeply into the frame. Often the obscuring elements also surround the central figure with "atmosphere" and heighten the mood of the scene. Oblique and unexpected compositions also tend to heighten drama, pace, and interest. For example, through the use of a wide-angle lens it is possible to fill 90 percent of the frame with a large hand in the foreground and through the fingers see a full figure deep within the frame that occupies only 10 percent of the total image. In general, lateral composition, where two figures stand on either side of the frame commanding equal attention, is not as interesting as "in-depth" composition, where a foreground figure faces another figure in the background.

Another way of composing an effective and striking image is to surround the characters with inanimate objects whose shapes, forms, and color patterns add emotional content to the frame. For example, if two lovers are placed in a dramatic confrontation far from the camera and the entire action is viewed through the

bars of an iron fence, the content of the dialogue will be affected. The face of a character barely glimpsed through the iris of a partially broken window is not only far more dramatic than a straight close-up of the same face, but also literally "pulls" the eye of the viewer deep into the frame. It is possible to heighten any mood through the composition of a scene; at key moments during the scene the mood can be altered simply by changing the composition. Tension can be increased by placing people or objects in odd or unexpected parts of the frame, as Stanley Kubrick does throughout *A Clockwork Orange*. The frames shown in Figures 40a and 40b should be examined for the effect of the composition on the "tone" or dramatic value of the scene.

There are few, if any, actual "rules" of composition that can be set down and strictly followed. The filmmaker must develop the esthetic judgment necessary to make every image in the film interesting and "right" for its own purpose in the overall film. A frame or a scene that doesn't contain its own built-in interest or excitement has no place in a motion picture.

FIGURE 40a ▼

FIGURE 40b ▶

MOVEMENT

The single factor that separates cinema from all other visual art forms is *motion*. The painting is forever frozen, and the theater provides motion only within a fixed frame. Film, however, is centered about the concept of moving images—movement within a frame and movement of the frame itself. The creative use of motion is an essential element in the filmmaker's art. Some filmmakers never learn to use movement intelligently and creatively. Others master it and become great because of it.

Every frame in a finished film is different in some way from every other frame. If the camera changes angles in the middle of a scene, everything within the frame also changes. Within the frame a subject can move suddenly toward or away from the camera, dramatically changing relationships. The camera itself can move smoothly or abruptly, quickly or slowly, and can switch toward or away from the center of a scene. It can pan left or right to suddenly include elements unseen before. The free movement and rapid changes of angle possible with the hand-held camera have become a trademark of the contemporary film. When used judiciously, a highly mobile camera can add impact and reality to a scene. In addition, cameras can be mounted on cars or planes to plunge the audience into a first-person view of the action, as in the chase sequence in *The French Connection.*

All camera movements must be carefully considered, planned, and executed, for without the creative use of motion, film returns to its own simple beginnings and becomes sterile and lifeless, like a photographed stage play. To be sure, there are many times when the absence of camera movement is essential—for example, it is often necessary to have the camera view a scene from an absolutely static

position so as not to distract from the action—but only when motion has been properly used will the contrast of static scenes be effective.

Here are a few important points with regard to camera movement that the beginning filmmaker should keep in mind:

1. The character of light changes radically with the smallest change in camera angle.
2. Jerky movement of a hand-held camera, unless used for a specific effect, distracts the audience and is the mark of an amateur. It takes a great deal of practice to use a hand-held camera effectively.
3. The longer the lens the more difficult it is to achieve smooth motion with a hand-held camera. It is best to stay with the wider-angle lenses, which minimize rough movements.
4. When the camera moves toward or away from a subject, the focus changes and the lens must be adjusted during the shot (unless a wide-angle lens is being used).
5. Pans (horizontal movements) and tilts (vertical movements) should always be used for a specific reason. One characteristic feature of amateur photography is the constant panning right and left to include the widest possible view. This is not good filmmaking.
6. The zoom lens must be used with great care. It creates an obvious, artificial effect that can be very annoying if not used with taste and judgment. It is often helpful to combine a slight pan with the zoom. This adds a dimension that tempers the artificiality of the zoom.

PLANES OF FOCUS

The illusion of depth so vital to the creation of artistic and interesting images depends largely on the cameraman's use of varying planes of focus. If all elements within the frame are equally sharp, the eye tends to wander aimlessly and interest is soon lost. One of the major characteristics of the contemporary film is the use of uneven planes of focus—that is, soft-focus foreground with sharp-focus background, and vice versa. The patterns of light and color created by soft focus are often very pleasing and add to the total artistic effect of the frame. Focus can be shifted from one plane to another during dramatic action, in order to add to the impact of a scene. It is important for the creative filmmaker to establish specific planes of focus and to maintain absolute control of what is "soft" and what is "sharp" in every shot. In Figures 41a and 41b, note how the shifting focus determines where the eye tends to fall.

THE EFFECTIVE IMAGE

If all movement takes place from left to right, if all elements are equally sharp, and if all visual relationships within the frame are of equal importance, the image will have no real feeling of depth and little or no visual interest. The eye has no place to go; it wanders haphazardly over the scene searching for something of interest. The objective is to compose a scene that will create its own excitement

and interest. When movement takes place both toward and away from the camera as well as horizontally across the frame, when focus points shift with new backgrounds, when foreground relationships are established and portions of the frame are obscured by soft-focus images, the image takes on a life and vitality of its own and we have a true motion picture scene. The eye and the mind of the audience leap past the artificial, one-dimensional surface and move into the scene to seek out those elements that are important to the filmmaker. The illusion of depth, created through movement (both of the camera and of objects within the scene) and variations of focus, is essential to successful composition.

To create an effective visual image, the filmmaker must view every scene through the camera and determine whether or not he has an exciting and valid composition for the scene at hand. He should have an immediate visceral or "gut" reaction to what he sees. If he does not, the scene should probably not be filmed. No focus relationship should be allowed to just "happen." However free or spontaneous the end result may look, the key word is *control*. The filmmaker must retain command over every element within the frame. Size relationships, the changing image as the camera moves, the various vantage points from which the scene is to be viewed, the changing focus points that subtly alter the entire scene—these are but a few of the important factors the filmmaker must consider and control.

cinematography—an approach

1. Conceive in your mind's eye how the entire film should look and then create each image to be entirely consistent with that concept.
2. Choose the right equipment for the job and be sure every piece of equipment is in perfect working order.
3. Strive for subtle rather than obvious effects in lighting and movement.
4. In general, use the lowest possible light levels.
5. View each scene through the lens before you shoot it. Don't trust the cameraman alone. Trust your own eye.
6. Make no compromise with the visual image. It is, in effect, the film. A set of mediocre images can never make a great film.
7. There is only one "right" lens for a scene. Be sure the lens you use will give you the image you want. Learn as much as possible about lenses, and experiment with each type of lens before shooting.
8. The more the camera moves with the style and rhythm of the scene, the more vital the result. The camera that remains riveted to its mount, viewing the scene from afar, usually produces a static and sterile film.
9. Vary the vantage point from which the action is filmed and try to achieve effects beyond those which the eye would normally perceive. The camera's-eye view should be a combination of the artistic and the real.
10. Keep in mind that the camera, lens, and lights are simply mechanical tools for capturing the visual image. The filmmaker is the creative force that controls them. Too often they tyrannize the filmmaker and dictate the filmmaking process.

11. Don't be afraid to take a chance—the cameraman or filmmaker who won't gamble is in the wrong business.

On any production, film is the cheapest single item, so experimentation poses no financial problems. The filmmaker who continues to press for a more creative, more interesting image is the one with the greatest chance of success. Learn the rules of the game thoroughly and then develop a style and approach of your own.

suggested reading

CLARKE, CHARLES G., *Professional Cinematography*. Hollywood: American Society of Cinematographers, 1964.

DONNER, JÖRN, *The Personal Vision of Ingmar Bergman*. Bloomington: Indiana University Press, 1964.

KINSTLER, EVERETT R., *Painting Portraits*. New York: Watson-Guptill Publications, 1971.

MILLER, ARTHUR C., and WALTER STRENGE, *American Cinematographer Handbook*. Hollywood: American Society of Cinematographers, 1966.

NYKVIST, SVEN, "A Passion for Light," *American Cinematographer,* April 1972.

SIMON, JOHN, *Ingmar Bergman Directs*. New York: Harcourt Brace Jovanovich, 1972.

WALKER, ALEXANDER, *Stanley Kubrick Directs*. New York: Harcourt Brace Jovanovich, 1971.

suggested viewing

FILM	CINEMATOGRAPHER
Citizen Kane (1941)	Gregg Toland/Orson Welles
Cries and Whispers (1972)	Sven Nykvist
Elvira Madigan (1967)	Bo Widerberg
Fat City (1972)	Conrad Hall
The Godfather (1972)	Gordon Willis
Images (1972)	Vilmos Zigismond
Lawrence of Arabia (1962)	Fredderick Young
McCabe & Mrs. Miller (1971)	Vilmos Zigismond
The Seventh Seal (1956)	Gunnar Fischer
Through A Glass Darkly (1962)	Sven Nykvist
Weekend (1967)	Raoul Coutard

five **sound recording**

Sound recording has traditionally been the reason why people have thought it necessary to work within the soundproof walls of a film studio. But sound technology has advanced more strikingly than any other technical side of filmmaking. Aside from lightweight portable sound recorders which can be slung over a shoulder (formerly a sound truck with a man inside served the same purpose), there is a diverse range of microphones which allow excellent recordings to be made under the worst conditions. We had a scene in *A Clockwork Orange* that took place under the Albert Bridge. The traffic noise was so loud that you had to raise your voice just to be heard in a conversation, but with the aid of a Sennheiser Mk. 12 microphone no larger than a paper clip, stuck into an actor's lapel, it was possible to produce a sound track which had only a very pleasant hum of activity in the background.

STANLEY KUBRICK, in Alexander Walker, *Stanley Kubrick Directs*. New York: Harcourt Brace Jovanovich, Inc., and Davis-Poynter, Ltd., 1971, pp. 52–53.

The recording of sound during the making of a film is not simply a technical operation but a highly complex creative task that significantly affects the quality of the finished motion picture. Over the last decade advances in sound recording equipment have made possible richly varied sound tracks that rival the most original of visual images for inventiveness and creativity. The intelligent use of this highly sophisticated equipment, combined with a truly imaginative approach to sound, has become a hallmark of contemporary filmmaking.

the role of the sound mixer

Whether the film is a lavish studio production with a three-man sound crew (mixer, recordist, and boom man) or, as is often the case, an on-location documentary with one man performing all three jobs, the role of the sound mixer is critical to the success of the film. Deciding what equipment to use, obtaining the highest-quality sound possible, and evaluating the sound as recorded are all the

responsibility of the sound mixer. In addition to possessing these technical skills, the mixer must be an aural artist. A great deal of esthetic judgment, for which there are no clearly defined rules, is required in his work. A large portion of what he does involves the creative evaluation of the quality and character of what he hears in relationship to the scene.

Recording the human voice without losing the timbre and nuances that give it character and individuality is never simple. Anyone, of course, can record sound by placing a microphone in front of an actor and turning on a tape recorder. The *art* of sound recording, however, depends on the ability of the sound mixer to capture, through strategic placement of microphones and use of the best equipment available, the full range of the human voice—with distortion and extraneous, unwanted sounds eliminated and foreground and background sound relationships carefully balanced. Studio and location sound each pose their own particular problems and present a different set of challenges. Within the confines of a studio, sound recording is much simpler and easier than on location, where there may be a great deal of sound interference. In each case, it is the content of the material to be filmed and the director's requirements that dictate what the sound mixer must do.

Since the quality of the sound is every bit as important as the quality of the visual image, the sound mixer assumes major importance in the filmmaking process. In selecting the sound mixer, the director should exercise just as much care and discretion as he does in selecting a cameraman. Among the criteria for selection are experience with the type of film being made, ability to work rapidly with no compromise of quality, knowledge of highly complex equipment, and an innate sense of drama that enables the mixer to evaluate the sound quality from an esthetic as well as a technical viewpoint. The mixer must really know sound (a very complicated subject), and he must be able to adjust to, compensate for, and solve a great number of problems that arise during the making of a film.

The other sound crew members should also possess a high degree of ability (this is far harder to obtain than one might think). The *recordist* (who is becoming obsolete as equipment becomes lighter and simpler) should really know his equipment and be able to take over for the mixer in emergencies. The *boom man*, the third member of the crew, must have a great deal of technical skill and manual dexterity since he must continually keep the microphone in an optimum position, usually under difficult circumstances. An inadequate or clumsy boom man will negate all the skill of the mixer and seriously slow down the pace of production.

equipment

THE TAPE RECORDER

Since all sound is recorded initially on magnetic tape, the tape recorder is the most important piece of sound equipment in filmmaking. In the past, most feature film productions and TV commercials employed sprocketed optical film and, more recently, sprocketed magnetic tape for sound recording. However, the development of reliable synchronizing systems has led to the almost universal use of lightweight magnetic recorders which employ nonsprocketed quarter-inch tape.

FIGURE 42 ▶

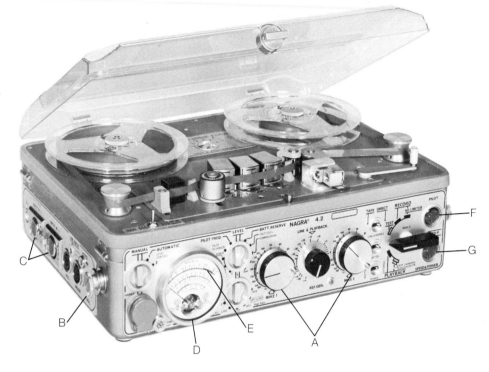

The use of sprocketed tape is now confined to "second-generation" sound tracks used for editing, since it is easier to handle with current editing equipment.

The quarter-inch tape recorders such as the Nagra (Figure 42) are popular with filmmakers because they are highly mobile (about the same size and weight as portable typewriters), completely dependable, and relatively trouble-free. The basic model (the Nagra IV) provides two input channels. Additional channels can be obtained through the use of a small mixer or an external preamplifier. (With the use of the preamplifier, three channels can be recorded simultaneously. With the use of a mixer, up to six, seven, or even more channels can be recorded simultaneously.) In addition, the Nagra is very durable and extremely simple to operate. As shown in Figure 42, it has controls to adjust recording volume (A) and to adjust playback volume (B). The input channels are located on the left side of the machine (C) and a Modulometer (a sound modulation meter) provides a visual check on the volume level of the sound being recorded (D). When the volume is carefully monitored, the needle should not be permitted to stray too often over 0 decibels (E). The Nagra is also equipped with a device for checking the integrity of its synchronous recording system. When the sync signal emanating from the camera motor (see below) is received on the tape during recording, a white cross appears in the round window marked Pilot (F). A white cross also appears in the window marked Speed and Power (G) if these functions are operating properly. The Nagra 4 provides operating speeds of 15 i.p.s. (inches per second), $7\frac{1}{2}$ i.p.s., or $3\frac{3}{4}$ i.p.s. It can go forward or reverse at high speed and contains many other valuable features for high-quality professional synchronous sound recording.

Most 35mm tape recorders require a standard 120-volt, 60-cycle electrical current and can therefore be used only when wall outlets or portable generators are available. The Nagra, however, can be operated by a dozen standard flashlight batteries when no electrical current is available. This is a tremendous advantage, since so many contemporary films are shot out of the studio and therefore require equipment that is highly mobile. A 16mm Arriflex BL or Eclair camera used in combination with the Nagra sound unit provides the filmmaker with a basic set of equipment capable of filming any type of motion picture in any setting.

The development of a system for recording synchronous sound on quarter-inch tape has been one of the most significant technical advances in recent years. The major problem in the development of such a system was the fact that since quarter-inch tape has no sprocket holes, it could not be locked into a fixed speed for perfect synchronization with the camera. A method had to be devised which, during the filming of sync sound, would provide for the synchronizing of both picture and tape together for future playback. Briefly and simply, the current practice is to record a reference signal onto the tape that will reflect any changes or variations of the camera drive so that both recording speed and filming speed can be monitored for synchronization and adjustments made when necessary. There are three basic ways to provide a reference signal:

1. If the camera has a synchronous motor and is powered by A.C. current from main lines, then the line voltage can be much reduced (to 1 volt) and can be used as a reference signal and recorded on tape. Provision to do this is built into the Nagra AC power supply (ATN).

2. If the camera is driven by a battery-operated motor that can fluctuate in speed, a generator can be built into the camera so that a synchronizing signal can be taken from the camera and reflect any variations in camera speed. This method requires a cable between camera and recorder.

3. If neither of the above methods is used, then very precise frequency-controlled generators can be used on both the camera and recorder as long as the frequency of the two generators does not deviate more than minutely from 60 cycles. Minute deviation from 60 cycles will produce only negligible distortion of the synchronization. With this system the recorder and camera operate as if they were connected to a common source of power and there need be no connection between the two.

The Nagra and other quarter-inch tape recorders utilize a 60N signal derived from the same power source as the camera. The signal used for the Nagra neo-pilot system is recorded on a very narrow band in the center of the tape as a push-pull track. Since the two halves of the track are out of phase no sound from this track is reproduced by the playback head. A special third head is used to pick up this signal and feed it to the motor control circuits for synchronous playback. Since most editing machines use a sprocket-driven mechanism, all sound recorded onto quarter-inch tape—both synchronous and nonsynchronous—must be transferred to either 16mm or 35mm tape. The playback machine, however, uses the 60-cycle signal as a guide for reestablishing synchronization. That is, when the tape is played back so the sync signal is running at 60 cycles, the exact speed of the original recording is maintained.

FIGURE 43 ▶

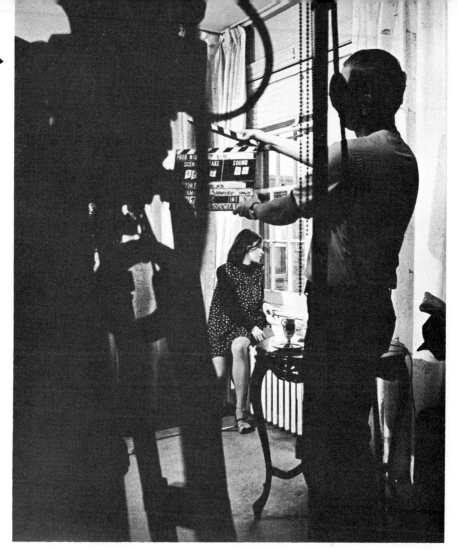

Before each scene is shot, a precise relationship must be established between film and tape. This procedure is known as *marking sync.* The tape recorder is run first to get "up to speed"; then the camera is turned on. When the camera reaches operating speed, a *clapstick* is held in front of the camera (Figure 43). The clapstick consists of a blackboard on which are written the scene, take, and sound numbers and any other important data. On top of the slate are two flat boards joined by a hinge. The assistant cameraman announces the scene, take, and sound numbers and slaps the boards together, producing a sharp noise. Later, in the editing room, the film editor aligns the exact frame of film on which the two striped boards first come together with the exact frame on the tape where the sound of the boards coming together is first heard (see Figure 44a). The scene is now "synced up" for the purposes of editing.

Most cameras are now equipped with an electronic slating system that operates as follows. The sound recorder is turned on; when the recorder is up to speed

sync frame

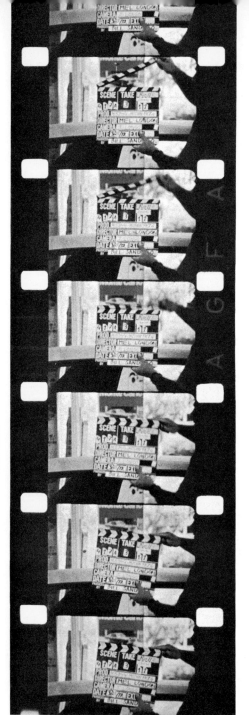

FIGURE 44a ▲

FIGURE 44b ▼

sync frame

the camera is turned on. At the moment the camera reaches speed, a light in the aperture fogs the frame and at the same time an oscillator in the Nagra is activated and a tone is recorded on the tape. This system generally only works where there is a physical connection between camera and recorder via the sync cable. It does not work with camera and recorder on crystal control unless the slating device includes a radio transmitter and receiver. It does not work with camera and recorder run on AC unless the sync cable is connected or a wireless link is used. Figure 44b shows the point at which the film was fogged. The frame indicated will be lined up with the sound on the tape, providing perfect synchronization.

If anything alters the speed of either camera or recorder during filming, serious problems can occur. The problem is usually a slowing down of speed or a loss of synchronizing signal. If the camera and recorder are connected with a sync cable so that the camera is the source of the signal then the reference signal will reflect the change in speed and the sound will remain "in sync" with the picture. However, as the tape playback speed must be speeded up to maintain synchronization, the pitch and quality of the sound will change. A 1 or 2 percent deviation is not noticeable, but a low battery may drop camera speed off by 20 percent and everyone suddenly becomes soprano-voiced. It is important, therefore, to check camera speed either on the tachometer or at the recorder on the pilot signal frequency meter. Another type of problem can occur where camera and recorder are run from a common power source, such as AC or crystal-controlled units. Under these conditions either unit can change speed. If this occurs, the picture and track will no longer run together and there will be no synchronization between the two. This problem can also be caused by loss of sync signal.

It is essential, then, that during filming the assistant cameraman carefully and continually check the tachometer on the rear of the camera to make sure that the speed of 24 frames per second is being maintained. In addition, the sound mixer must carefully monitor both his sync-signal indicator and his frequency meter to verify the speed of his recorder.

Crystal units are now available to provide a totally cordless setup between the camera and the quarter-inch recorder. This type of operation permits maximum mobility for filming over a fairly wide area and enables sound and camera to be widely separated. This system is quite reliable.

THE MICROPHONE

The microphone plays a major role in determining the character and quality of recorded sound. A wide range of microphones are now available to fit almost any requirement and to solve almost any filming problem. There are multidirectional microphones, which pick up sound in a wide circular pattern, and unidirectional, or "cardioid," microphones, which pick up only those sounds that are directed in a straight line at the instrument, eliminating most peripheral sounds. In addition, there are "shotgun" microphones that can be used for sound pickups from long distances.

In general, the microphone should be of good quality and should offer smooth response, since this is what affects the sound at its introduction into the recording system. Any initial distortion will be compounded as it goes further on in the filmmaking process. A useful recording accessory is a *high-pass filter,* which will remove low-frequency rumble and noise such as traffic, wind, and the like.

The best way to select the proper microphones is to first analyze the kind of sound recording required by the scene and the amount of control possible. If the situation allows a close microphone, a smaller, less directional mike can be used. However, if requirements dictate that the microphone must be further away from the speaker, then the more sensitive *condenser microphones* should be used, with the surrounding noise determining how directional the mike should be. A more directional mike can cut down extraneous noise, but its positioning is more crucial; people moving will go out of its pickup pattern more quickly. Under difficult conditions a *lavalier microphone* may be the answer, since it can be placed closer to the speaker's mouth than other kinds of mikes. However, it must be mounted in such a way as to minimize rubbing from clothing. Cotton wrapped around the mike, or tape made into a loop with the sticky side out will help.

THE BOOM

The final important piece of sound equipment is the mike boom. Essentially, the boom is an aluminum rod that can be extended and contracted. By attaching the microphone to the boom, the sound engineer can "reach" into any scene, placing the mike in the best possible position for recording the sound *and* for following a speaker during the course of the scene. The boom should always be placed as close as possible to the speaker yet far enough away so that it will be out of the camera range and will not cast shadows on the scene.

The choice of boom depends on the degree of mobility required and the amount of control present during the filming. The more complex mike booms are the Mole Richardson and the Fisher booms, which are mounted on a wheeled tripod and equipped with a system of pulleys and levers that enable them to be noiselessly and smoothly moved about during the scene. The Mole Richardson and Fisher booms, however, are strictly studio equipment, for they are far too large and cumbersome for location use. On location lighter, more mobile "fishpole" booms are used.

recording the sound

MOBILITY AND MIKE PLACEMENT

The placement of the microphone is of critical importance in determining the quality and accuracy of the sound produced. A microphone placed too close to the subject can result in overmodulation and distortion. A microphone that is too far away can create an echo or reverberation and pick up too much background

noise. If the microphone is not placed at the proper angle in relation to the source of the sound, sibilance (the oversounding of *s*) will occur. Unfortunately, there are no charts, diagrams, or rules to serve as guides for mike placement, but the general goal is to have the microphone in a position where the mixer can hear the voice as free from any distortion as possible and at the same time eliminate as much extraneous background noise as possible. The exact angle and position at which this can be achieved depends on the type of microphone used as well as on the setting (amount of background noise present) in which the sound is being recorded.

Within the confines of almost any interior setting, the microphone, when placed on a boom, can usually follow any physical movement, no matter how sudden or complex. A skilled boom man can follow the actors' movements, keeping the microphone out of camera range but close enough to the subject or subjects to obtain top-quality sound. Occasionally, if the area is too small to permit a boom to operate and if the floor is not included in the frame, lavalier microphones can be used. These microphones are hidden under the clothing of the actors, with wires running down through the clothes and along the floor to the recorder. However, the wires and cables will restrict the movements of the actors, so lavaliers cannot be used when a great deal of mobility is required.

In settings where wide shots and movements of broad latitude occur, it is generally not possible to place microphones near the speakers. The solution other than postproduction dubbing (see Chapter 7) is to employ a shotgun microphone and have the boom man and entire sound crew physically follow the action as closely as possible or to use radio transmitters and lavaliers on the individual actors.

There are, of course, times when it will be impossible to obtain top-quality sound during shooting. In such cases, on-set microphones should be used simply to record the dialogue without regard for quality; this recording can later be used as a cue track for postproduction dubbing.

SOUND PERSPECTIVES

The sound as recorded must bear a direct relationship to the images being filmed. For example, if a scene is a wide-angle shot, with the actors far from the camera, the sound must reflect this distance. Few things are more disturbing than watching two people far away from the camera, small within frame, and hearing their voices as loud and clear as if they were standing nearby. Scenes of this type—in which the actors and the camera are far apart—pose many problems. If the filmmaker wishes to avoid postproduction dubbing, or if dubbing is impossible (as is the case with many documentary films), the sound as recorded must mesh perfectly with the image. The microphone must be placed close enough to the actors to get audible, intelligible sound and yet not so close that the amount of "presence" in the sound will be unrealistic in relation to the scene. When the actors move, the sound perspective should change too. A scene may begin with an actor on full-screen close-up. At this point his sound should be rich and full

of "presence." If he moves away from the camera the quality of his voice should become mixed with the environmental sound and change to accommodate the visual change.

SOUND RELATIONSHIPS

Another critical matter in sound recording is sound relationships. Careful sound balance, as dictated by dramatic relationships within the scene, is critical. In the work of Robert Altman (*McCabe & Mrs. Miller, M*A*S*H*) and Bernardo Bertolucci (*The Conformist*) the various levels of obscure or inaudible sound often contribute to the sense of reality and to the poetic quality of the work. Sometimes permitting the background sound to dominate the track contributes to tension and drama in a scene. The ceaseless noises of the battlefield operating rooms in *M*A*S*H,* with the babble of voices only occasionally becoming clear enough to be understood, were an important element in the film's success.

The basic relationships the sound mixer must deal with are:

1. The quality of voice recording in relation to the actors' relative positions on the screen.
2. The relationship between direct dialogue and background sound.
3. The relative level of voice projection. For example, in intimate scenes the actors are usually encouraged by the director to keep their voice projection to a minimum. This complicates things for the sound recordist, since the level of the voices will be very close to the level of all background noise and thus hard to separate.

These balances are achieved by judicious mike placement, use of the right equipment for the situation, and the careful monitoring of the sound as it is being recorded.

OVERLAPPING SOUND

The trend in current filmmaking is to avoid dull, stagy dialogue—people talking in an orderly fashion, one after another. Today overlapping sound—two or more people talking at once from different parts of the frame—is a common technique for adding reality and vitality to a scene. In this kind of scene it is impossible for the mike boom to be in all places at the same time. In determining where to position the boom, the sound mixer must decide on the relative importance of sound relationships, consistent not only with the visual image but with the film's intent.

There are two possible methods for recording overlapping dialogue by several speakers. First, during rehearsal the boom man identifies the key players in the scene and keeps the microphone in a good position to pick up the key dialogue. By using a multidirectional microphone he will also pick up (at slightly reduced quality) all other dialogue in the area. The dialogue of the less important speakers is recorded separately as a "wild" track. Later, in the editing room, this wild track

can be combined with the sync-sound track to give total value to all the voices as they overlap and speak together. If all the speakers are present in the scene, the fact that the wild track is not in sync will not matter because the audience cannot watch all the actors at once. If the scene shows only a portion of the speakers, the wild tracks can be used for those who are offscreen. This is the technique Robert Altman used so successfully in the operating room sequences in *M*A*S*H*. He was helped, of course, by the fact that the speakers were wearing surgical masks, thus hiding their lip movements from the audience and making synchronization unnecessary.

The other solution for this type of problem is to put lavalier microphones, hidden mikes, or radio mikes on half the speakers and use the boom for the other half. This cuts down the number of people the boom has to follow, but, as noted earlier, it may restrict other movement because of cables or fixed positions.

A word of caution here: it is not always wise to mix types of microphones within a scene, since the quality of the sound may vary. Often a microphone that will do a great job recording the primary dialogue may create other problems that make it impossible to use in the scene. For example, it may seem desirable to use a multidirectional microphone during an outdoor barbecue sequence in order to pick up as many voices as possible. However, if the level of background noise at the location is very high, this mike will also pick up that background and may obscure the most important sounds. The desired effect of overlapping sound is almost always embellished by postsynchronous dubbing.

BACKGROUND NOISE

If the sound recording is done in an area where there is a great deal of unwanted background noise or interference, a unidirectional microphone must be used. This type of microphone picks up sound from one direction only, thus eliminating a great deal of random or extraneous noise. Of course, there will still be some background sounds, but since the visual image will show a wide or busy area, these sounds will be realistic and desirable, provided they do not overpower or obscure the dialogue. If the background noise is too great, postproduction dubbing will be necessary. Background noise can be removed to a limited extent by noise reduction and filtering in the transfer studio. One rule of thumb is to put as high a level of voice as possible on the tape, even if the background seems louder. The transfer engineer can make more corrections with high levels than with low levels.

SOUND EFFECTS AND BACKGROUND LOOPS

If sound levels are set for spoken dialogue during the filming, many of the peripheral sounds are often too low to be heard. Therefore, the sound crew should record as many sound effects as possible during filming for later use by the editor.

In particular, key sounds not always audible during the take—doors closing, motors starting, footsteps, and any other sounds that add character to a scene—should be recorded separately, perhaps while silent shooting (nonsync sound) is going on. Although there are many excellent sound-effects libraries where special-effects recordings can be purchased or created, the more sound that can be picked up in the locale of the filming, the better.

An often overlooked but very important sound element is the background sound loop. Every room, every environment, has a basic background sound. That is, when everything is totally quiet, there is still a "tone," a sound, to the area. After all the dialogue has been recorded in a given place, the sound crew should record about a minute of this basic "room tone." The editor can then use this background sound loop to even out his cuts, so that the level of background noise will remain constant in the scene. Without this sound loop he would have to use either dead (totally silent) track or background sound from another environment, and the tonal differences from shot to shot would be noticeable on the sound track.

sound recording—an approach

Sound recording is as important as illumination or photography to the artistic success of a film. It is far more than a mere technical task. The great soundmen of today, like Don Mathews of Detroit and Dave Blumgart and Chris Newman of New York and Hollywood, have all made important contributions to the many films they have worked on. The following is a brief guide to assist the filmmaker in achieving a technically and artistically satisfying sound track during filming, one that the film editor can use and expand on as he assembles the final motion picture.

1. Select a sound mixer who, in addition to being a first-rate engineer, really knows something about the esthetics of sound. Ideally he should own his own equipment and be able to take it apart and repair it if necessary.
2. Familiarize the entire sound crew with the script and with your approach to the film.
3. Let the sound mixer determine what equipment is necessary on the basis of his understanding of the film. *Talk to your sound mixer,* just as you talk to your cameraman.
4. During filming, try to obtain perfect sound every time. Don't depend on dubbing. It is well worth the time and expense needed to get good sound on location. Live dialogue recorded during filming will always be better in performance quality than dubbed sound.
5. Don't overrehearse sound takes. Film is the cheapest item on a production budget. By shooting a scene early, you keep the actors fresh and involved and get the best sound takes.
6. Don't compromise picture for sound or sound for picture. Always assume that all problems can be solved, and get the cameraman and sound mixer to work together to solve them. Once the director has indicated a willingness

to give up a great shot to achieve technical perfection, everyone on the set will slack off a bit. The result will be a pretty picture and "clean" sound without any vitality or originality.

7. Record all possible background sounds in every location. When the camera is shooting silent shots, the sound crew should be working on wild sound.

The past decade has seen tremendous technical advances in sound, and more recently there has been a new recognition of the *artistic* role sound can play in the art of filmmaking. The director now works with his sound mixer just as he does with his cameraman, and sound men themselves are growing more artistically adventurous. This artistic renaissance, coupled with the great technical freedom afforded by the new equipment, promises an even more vital role for sound in contemporary filmmaking.

suggested reading

HAPPÉ, L. BERNARD, *Basic Motion Picture Technology.* New York: Hastings House, 1971.

LIPTON, LENNY, *Independent Filmmaking.* San Francisco: Straight Arrow Books, 1972.

NISBETT, ALEC, *The Technique of the Sound Studio.* New York: Hastings House, 1970.

PINCUS, EDWARD, *Guide to Filmmaking.* New York: Signet, 1969.

ROBERTS, KENNETH H., and WIN SHARPLES, JR., *A Primer for Film-making.* New York: Pegasus Books, 1971.

TREMAINE, HOWARD M., *Audio Cyclopedia.* Indianapolis: Howard M. Sams, 1969.

suggested viewing

Citizen Kane (1941) Orson Welles
A Clockwork Orange (1971) Stanley Kubrick
The Conformist (1970) Bernardo Bertolucci
The French Connection (1971) William Friedkin
The Hospital (1971) Arthur Hiller/Paddy Chayefsky
Images (1972) Robert Altman
*M*A*S*H* (1970) Robert Altman
McCabe & Mrs. Miller (1971) Robert Altman
Murmur of the Heart (1971) Louis Malle
2001: A Space Odyssey (1969) Stanley Kubrick

part 3 **after the filming**

ONE of the things that makes film unique among the arts is that a film is in fact created anew three distinct and separate times. The first time is when the initial concept is written as a script; the second is when it is translated from words on paper to images and sound on film; and the third and final time is when what was filmed is subjected to the creative mercies of the film editor.

In contemporary filmmaking, director and editor together rework the filmed material, changing the order of things, adding new ideas and in general completing the artistic process known as filmmaking. The artistic importance of this final phase of the making of a film should not be underestimated.

six editing

There is a law in psychology that says if an emotion gives birth to a certain movement, by imitation of this movement the corresponding emotion can be called forth. If the scenarist can effect in even rhythm the transference of interest of the intent spectator, if he can so construct the elements of increasing interest that the question, "What is happening at the other place?" arises and at the same moment the spectator is transferred whither he wishes to go, then the editing thus created can really excite the spectator. One must learn to understand that editing is in actual fact a compulsory and deliberate guidance of the thoughts and associations of the spectator. If the editing be merely an uncontrolled combination of the various pieces, the spectator will understand (apprehend) nothing from it; but if it be coordinated according to a definitely selected course of events or conceptual line, either agitated or calm, it will either excite or soothe the spectator.

V. I. PUDOVKIN, in
Daniel Talbot, ed.,
Film: An Anthology.
Berkeley: University of California
Press, 1966, p. 193. Originally published
by the University of California Press;
reprinted by permission of
The Regents of the University
of California.

the role of the editor

The film editor generally uses the script and the director's stated intentions as guides for the film he will assemble. Within this framework the editor can, through his cutting and his choice of visual and aural elements, exercise a major influence over the artistic quality of the finished film. Indeed, in some cases the editor will command such total control over the pace, mood, and rhythm of the film that he becomes in effect a filmmaker in his own right.

The film editor's work is also highly personal and introspective, much like that of the painter. The editor works in isolation, surrounded by the tools of his craft. The director is often far away, perhaps at work on another film, by the time the film reaches the editing stage. But the editor must continually rework the film in his mind, reconstructing the order of events and compensating for poor technical execution and for errors of commission and omission.

In larger commercial operations, where editing is done on a tight time schedule,

the editor often acts as a law unto himself, rarely consulting the director. In most cases, however, the success of the film depends on a close working relationship, based on mutual respect, between editor and director. The wise filmmaker establishes the same kind of relationship with his editor that he has with his cameraman. Although the final decisions always lie with the director, the creative editor should be allowed the widest possible latitude in arriving at the first cut.

On most productions the editing crew operates as a small, closely knit unit under the direction and control of the editor. The editor is responsible for all creative decisions in assembling the film and usually marks all cuts himself. He handles the film and sound tracks and operates the editing machines. The *assistant editor* is primarily responsible for cataloguing the film and tapes into individual units and numbering the scenes and tracks and identifying their content. Generally he makes most of the actual splices, writes up the optical and sound cue sheets, and does a great deal of the physical and record-keeping work. On occasion, the assistant also matches the final negative (that is, he cuts the original negative to conform with the editor's working copy), but usually a specialized negative matcher is hired for this job. The *apprentice editor,* found on most feature film productions, does the remainder of the work, including storing and retrieving film, some splicing, and some cataloguing of the material. Occasionally he will be permitted to synchronize the rushes.

the editing process

PREPARING THE RUSHES FOR EDITING

After the film has been developed by the laboratory and the director has screened the rushes, the editor's work begins. Since the film will be run in the editing machines many times during editing and may be scratched or otherwise damaged in the process, a *work print* is prepared for this purpose. This duplicate print of the original camera negative serves as the editor's working copy. *Work tracks,* or copies of the sound tracks as recorded during filming, are also prepared for the editor's use. These tracks can be on either 16mm or 35mm magnetic tape, depending solely on the preference of the editor. In general, 35mm tape is easier to handle, but it is more expensive.

The editor's first task in preparing the rushes is to synchronize the work print, the work tracks, and the original film negative. The work print and the work tracks are aligned by the method described in Chapter 5. For each scene with synchronized sound the editor marks an X in crayon on the exact frame where the wooden clap sticks come together and another X on the section of tape where the sound of the clap sticks is first heard. The original negative and work print are easily aligned by matching the code numbers on the edge of the film with the duplicate set of numbers reproduced on the work print (Figure 45). Original, work print, and work track are then sent to an edge-numbering laboratory, where a master set of code numbers is put at corresponding intervals on each element. Print, tracks, and negative are now in sync for the purposes of editing. From this point on the editor can work freely with his picture and his tracks, assured that he will

FIGURE 45 ▲

always be able to reestablish the synchronous relationship. The original negative is returned to safe storage and is not used again until the editing is completed and the film is ready for printing.

In the next stage in the preparation of the film for editing, the work print and sound tracks are screened on the editing machine. Currently there are two basic editing machines in wide use. The *moviola* (Figure 46) has been for many years the most popular editing machine in the United States. It consists of a series of up to 6 separate channels on which the editor can run picture and sound either synchronously or separately. The picture channel projects the film on a small viewer. The editor operates the moviola by means of switches or foot pedals, which propel the film and tape for-

FIGURE 46 ▼

FIGURE 47 ▲

ward or backward at a variety of speeds. An interlocking gear system enables the editor to operate all separate channels synchronously at 24 frames per second.

Recently the European *table-top editing machines* such as the Steenbeck and the Kem (Figure 47) have become quite popular with American filmmakers. These machines can run as many as four separate rolls of either film or tape and project the film on a large screen in the center of the table. The major advantage of this type of machine is the ease and speed of its operation. When using the moviola, the editor must himself wind and rewind each roll of film many times. The table-top machine rewinds film at very high speeds at the touch of a button, thus freeing the editor to give his full attention to creative matters. They do far less damage to the work print and work tracks than a moviola, and, in addition, machines like the Kem and Steenbeck enable the editor to view all the film available on one screen while simultaneously reviewing the edited version on another (Figure 48). The table-top devices are, however, much more expensive ($15,000 to $20,000, as compared with $4,000).

Usually, if the director is available, he and the editor will review the film and sound tracks together. At this point the director should communicate to the editor his evaluation of each scene and his opinion of how each piece of film should be used. It is *essential* that the editor fully understand what the director has in

mind and how he feels the film should be cut. This is the point of departure from which the editor can proceed. How far he chooses to move on his own depends entirely on the editor and his relationship with the director. But unless the editor fully understands all the artistic elements that have gone into the film, he runs the risk of fragmenting or even destroying the essential unity of the finished work. As noted earlier, the editor should always enjoy a wide creative latitude, but he should never fall prey to the illusion that he is creating a new film from scratch. His primary purpose is to bring to completion an artistic work already in progress.

Once all the available film and sound have been previewed, the editor physically prepares the material for editing. If the moviola is being used, each scene and its corresponding sound track must be separated and catalogued. The larger rolls of film are cut apart and each scene is rolled up, together with its sound track, on a film core. The scenes are numbered in the general order of the script, and the content of each scene, together with its beginning and end code numbers, is noted in a breakdown catalogue for later reference. If a Kem or a Steenbeck is being used, it is not necessary to break down each scene, since a large roll of film can be projected and rewound in a few seconds. In addition, all nonsynchro-

FIGURE 48 ▼

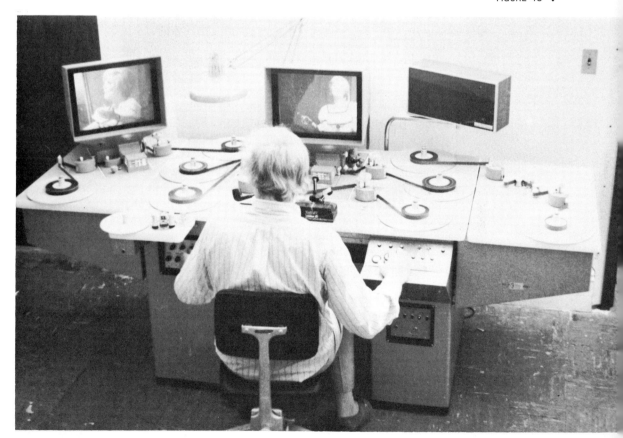

nous sound (voice-overs, sound effects, etc.) must be carefully catalogued so that the editor knows exactly what wild sound he has to work with. The wild sound tracks should be numbered and a list of their contents prepared.

THE ROUGH CUT

Following the review of all rushes and his conference with the director, the editor assembles the film into a *rough cut,* or first draft of the finished film. At this stage of his work the editor is primarily concerned with the basic sound and picture only.

ASSEMBLING THE SEQUENCE

Generally it is best to assemble the sequences of the film in script order, but this is by no means essential. Many film editors prefer to begin with the more difficult or complex sequences. Whatever method he chooses, the editor must first decide on the *tone* of the sequence he is cutting. Some questions he may ask at this point are: Is this a fast or a slow-paced sequence? What purpose does it serve in the larger design of the film? Most important, what kind of emotional effect should the sequence convey? As he develops a feeling for the sequence, the editor will select those takes or portions of takes that best serve his purpose. He will usually need to review all the visual and aural elements available for the sequence several times. His evaluation of these elements is crucial, since he may well disagree with the director and use a take or scene that the director was not happy with. At this point, however, it is essential that the editor satisfy only himself and remain constant to his conception of the sequence.

In evaluating each take the editor must determine such things as quality of acting performance, impact of camera angle, and effectiveness of movement, whether internal (within the frame) or external (camera movement). He must be able to judge negative as well as positive values within the shot, marking off sections of dialogue or picture that are unconvincing or that detract from the desired effect. If a particular scene has many rich elements but is flawed by some false action or dialogue, the editor can try to strengthen the scene through intercuts. If he is seeking to establish a slow, romantic mood, he can eliminate sudden zooms or lines delivered too harshly or too quickly. If the sequence is climactic in the film, the editor can isolate the visual images with the greatest emotional power.

The more confidence the editor has in his own abilities, the more quickly he will discard the bulk of the film and work only with those takes that he feels come closest to his vision of each sequence. It is important to note that *no decision made during the editing process is irrevocable.* A discarded take or segment of a shot can easily be retrieved later and reintroduced into the film. Editing is basically a trial-and-error process.

After the editor has evaluated his materials, he makes a rough plan of how he will cut the sequence, determining the number of shots and scenes to be included, where he will make his cuts, and how much sound overlap he wants

to use. The editor then assembles the sequence as follows. He inserts his choice for the first scene into the editing machine, runs it until he wants to cut to a different angle, and stops the machine at that point, marking in crayon the exact frame he wishes to cut on. If he is cutting to another sound track on the same frame he must also mark the sound track at the appropriate point. Next the editor runs the second scene and its sound track through the editing machine, selecting the frame he wants to begin with and marking both picture and track. He then splices the second scene on to the marked frames from the first scene. The editor can now run the edited version of scenes 1 and 2 to see if his cutting works.

The editor continues in this fashion until he has assembled the entire sequence. All of his cuts, of course, will not be "straight across." Perhaps he will want the sound track from scene 1 to carry over into scene 2 and not pick up the second sound track until later in the scene. Or he may wish to reverse the procedure and allow the sound track of scene 2 to be heard before scene 1 is complete. Once he has assembled the sequence in rough form, he reevaluates the material and determines the best order in which the selected scenes should appear. This order is crucial, for the linear character of the film as created by the editor determines much of its total effect.

MATCHED ACTION CUTS

Within a single sequence, where action is happening consecutively in the same setting, the editing process must be as invisible as possible. Assume, for example, that the editor is cutting a series of shots of someone descending a flight of stairs. The shots are of different image sizes and were photographed from different camera angles. As the scene shifts from angle to angle, the editor's matched action cuts must be so skillful as to be almost unnoticeable. This effect is achieved by making sure that the action from scene to scene is uninterrupted. Assume that in a long shot of the scene, the subject has his left foot forward and is ready to place his right foot on the lower step. If the editor simply cuts to a closer view of the subject in the same position, the effect will be one of repeat action. A frame or two must be eliminated to allow for the shift in scene so that the viewer will have the feeling that a normal amount of time has elapsed. (This illusion of elapsed time is a key concept in editing and one that many film editors fail to understand.) There is a built-in rhythm to the walker's descent, which should not be interrupted. This rhythm must be carried through by the position of the subject in the incoming shot, so that the transition between the two shots will be smooth and the cut will be virtually invisible. A little farther into the second scene the subject appears in a position farther down the steps. At this point the editor may elect to make a matched cut to the third shot. Again the editor must select a slightly later moment in the action to make his cut.

When the angle of the scene shifts radically, the editor has more leeway in his choice of where to join the scene to the next scene because the audience, distracted by the change of angle, cannot really follow the position anyway. A sense of continuity should still be maintained, but if the editor wishes he can actually jump the action. A good rule to remember is the greater the change of

angle, the less critical the matching of action. Of course, if the editor cuts to an entirely different scene and then returns to the original subject, he must rejoin the action at a point that accounts for the time spent on the "cutaway" scene. If the cutaway took five seconds, the next shot could well find the subject at the bottom of the steps, depending on the pace established in the first view of the action.

The key to action cuts is to keep movement flowing smoothly and call as little attention as possible to the editing process. Often the best edited films are those that seem the least edited. Of course there are many times when the editor will deliberately disregard matched action, striving instead for shock effects, large gaps in action, or sudden changes of position and angle. This too is an integral part of the editing process. However, when a continuous flow of action is desired, the editor's ability to obtain a perfect matched cut is important.

Another element that must be considered in the matching of action is the sound track. Often an editor finds to his chagrin that it is impossible to make a certain picture cut because the dialogue doesn't match at that point. For example, assume there is a long shot in which the subject has his right hand outstretched as he says "How do you do." At this point the editor may wish to cut to a medium shot as the subject continues ". . . Paul, old friend." However, in the medium shot available to the editor the subject has already withdrawn his hand to his side. The editor must then either make the cut at an earlier point in the dialogue when the positions match, use the dialogue from the long shot as dubbed dialogue in the medium shot, or not make the cut at all.

Although technical perfection in achieving smooth cutting transitions from scene to scene is always desirable, it should never become a case of the tail wagging the dog. The editor who sacrifices desired visual or aural effects simply to get perfectly matched cuts is mistaking his creative priorities. Matched cuts are desirable when possible, but they must never be allowed to dictate the pace and quality of the film.

SILENT FOOTAGE

Many documentary films and even theatrical features contain scenes and sequences that are shot without sound; these scenes are accompanied in the finished film by music, narration, voice-over comments, or sound effects. There are several ways to approach the rough cutting of this type of footage. (1) The footage can be edited by itself with no guide to pace and rhythm other than its own content. This means that the editor creates his own order and length as he goes along. Later music, narration, or sound effects will be added to accompany the footage, and at that time the editing can be revised to provide a better "fit." (2) The silent footage can be cut to words—either narrative or voice-over comments—with the verbal pacing and content serving as a guide. (3) The editor can cut the silent footage to music, using the pace and rhythm of the music as a guide. As will be noted later, cutting to music usually insures a better mesh between film and sound.

THE FINE CUT

After the rough cut has been approved by the editor and director, the editor proceeds to the most critical aspect of his work, preparing the *fine cut,* a revision of the rough cut, with refinements and corrections. At this point in the editing the pace and logic of the film should come under careful scrutiny. Each scene and sequence must be examined to make sure that the maximum value has been extracted from the footage available. In preparing the fine cut the editor must coordinate many different visual and aural elements, and editorial control at this stage is imperative. For example, it is not at all unusual for a completed sequence to contain the following elements: (1) visual images—a two-minute sequence can consist of as many as twenty or thirty separate cuts; (2) dialogue tracks—a single sequence can contain as many as six or eight separate dialogue tracks; (3) narration or voice-over tracks; (4) music tracks; (5) sound effects tracks; and (6) optical effects.

Essentially, the preparation of the fine cut consists of adding layers of creative elements to the initial structure of the film. In this process the editor goes back over the entire film several times—refining every cut, experimenting with different orders, adding multiple-track elements, and substituting or eliminating scenes. Optical transitions and special effects are also indicated at this time. For example, the editor may wish to join two successive scenes by a *dissolve,* a blending together of the end of one scene and the beginning of the next. To do this, he draws a diagonal line in crayon from the frame where the outgoing scene will begin to fade out and the incoming scene begin to fade in to the point where both scenes have equal visual value. At this point, the center of the dissolve, he cuts the outgoing scene and splices on the incoming scene. He then draws another diagonal line from the point of the splice to the frame where, on the final composite print, the outgoing scene will disappear entirely. More complicated optical effects such as *multiscreen images* (several different images appearing simultaneously within the same frame), *wipes* (wherein the incoming scene appears horizontally across the frame, replacing the outgoing scene—in effect pushing it off the screen), and *superimpositions* (two scenes simultaneously occupying the full frame) are usually indicated separately on white leader (white film) for preparation by an optical laboratory.

Usually the director and the editor will review the fine cut together and decide on all the finishing touches for the film. If it is to have an original music score, the mood and tone of that music are established for each sequence. In addition, the style and character of the titles are sketched out, sequences that need dubbing are indicated, and a few more minor editing revisions are made.

It should be noted that the preparation of the fine cut is a most important aspect of the film editor's work. It is at this point that the editor can make the most significant and innovative improvements in the film and can stamp his personal touch on the finished work. In this process the editor must always be willing to gamble, to experiment. Modern filmmaking techniques like flash-cutting (subliminal use of a few frames at a time), overlapping sound, and fragmented (jigsaw-puzzle) structures have all been developed in the editing room by editors

who were willing to make radical departures from the familiar or the obvious. One of the things that makes film editing so interesting is that it lends itself to so much experimentation. Since the editor is dealing with duplicate materials, nothing he does is irreversible, and daring innovations can be attempted at virtually no cost. If something doesn't work, it is relatively simple to tear it apart and begin again. If the work print becomes damaged, the scene can easily be reprinted and the tracks retransferred.

the art of film editing

Up to this point we have been concerned primarily with the mechanics of film editing—the basic procedure by which the editor cuts and assembles the finished film. As noted earlier, however, film editing is also a highly creative process, requiring a high degree of taste and judgment as well as technical skill. The best film editors are those who begin with a clear understanding of the director's intent, the theme and structure of the script, and the moods and ideas contained within the visual images, and then use every element at their disposal to create the finished film.

Joseph Losey's fine film *The Go-Between* provides a clear example of the editor's artistic contribution to the film as conceived by the director. Based on a novel by L. P. Hartley, the film deals primarily with boyhood memories and with growing up. The novel and script are written from the vantage point of a middle-aged man remembering a traumatic event of his childhood. Although the film as photographed followed a direct linear course, the editor decided to introduce flash cuts throughout. These cuts were scenes of the protagonist returning after almost fifty years to the scene of the film's primary action. The cuts are introduced into the course of the action swiftly and without warning, so that the audience at first has no way of knowing what is happening. However, as the film proceeds and the cuts grow slightly longer, they build a counterpoint to the "remembered" action and their purpose becomes clear. The final sequence of the film—the protagonist's visit to a very old woman (the heroine of the film's primary action)—is set entirely in the present. The decision of the editor to use flash cuts to prepare the audience for this ending strengthens the theme of the film and adds to its visual interest. Thus the editor materially affected the character and quality of the film while greatly strengthening and supporting the original concept.

Let us now consider some of the techniques by which the editor exerts artistic influence over the film he is cutting.

POINT OF VIEW

The editing process has often been compared to a carnival shell game—a sleight of hand procedure designed to distract and control the attention of the audience. In assembling a sequence, the editor usually has available shots of the same action viewed from several different vantage points. The point of view he chooses to

present will determine the audience's emotional response to the action. Assume, for example, that the editor is cutting a scene showing two people playing chess. The director may have covered the action from three basic positions: the points of view of the two players and the point of view of the audience. The editor can choose to play the scene from any one of these points of view or from a combination of the three. If the editor decides to approach the scene from the point of view of one of the players, the emotions of the audience will be transferred to that player. The editor must then remain consistent to that viewpoint unless he wishes to dilute the effect. In other words, if the audience is to share fully in the emotions of one of the players, the editor should not cut in shots of the two men as seen from a third-person viewpoint.

The use of a "wandering" point of view, or sudden shifts in viewpoint, however, can sometimes create dramatic effects. In Robert Redford's fine sports film *Downhill Racer,* the audience is frequently given a first-person view of the skiing, beginning at the top of the hill, and is not returned to a more comfortable "observer" point of view until the race is over. An abrupt change from a third-person or "observer" viewpoint to the point of view of one of the participants often adds emotional impact to a scene.

The entire question of point of view is one of the most critical with regard to the art of editing. Since most directors provide camera coverage that permits a fairly flexible editing approach, the burden falls on the editor to think through his artistic choice with regard to the vantage point from which the scene is to be viewed. While it may be desirable from a standpoint of impact or drama to cut the sequence from the viewpoint of one of the characters it may also be false to the intent of the "whole" film.

PACE AND RHYTHM

The editor can immediately determine from the action within a scene—the speed of the actors' movements, the style of the dialogue, and the nature of camera movements—what type of pace has been established. He can then, through his cutting, create the effect he desires by maintaining, heightening, or altering that pace. For example, a slow pan over a seashore establishes a dreamy, romantic mood and a slow, heavy pace. The editor may simply decide to use the shot in its entirety without interruption, thus maintaining the established pace. Or he can extend the slowness of the pace by adding long dissolves to shots of waves pounding the shore. Or the editor can cut sharply to many short shots of sun, sky, birds, and surf, creating a swift pace and completely altering the original mood.

The editor's decision as to the length of each shot greatly affects the rhythm and tempo of the film. The more shots used (i.e., the shorter the cuts), the faster the pace. Often an editor will alternate a single long shot with several short cuts, creating a mixed rhythm designed to upset the audience and keep it off balance. There are absolutely no limits regarding the length of a single scene. It can be permitted to run for several minutes without a single interrupting cut (as in the

opening of Orson Welles' *Touch of Evil*), or it can be as short as one frame. A thirty-minute film can have as few as one hundred scenes in it, and a one-minute TV commercial can conceivably have as many as three hundred scenes in it.

A significant advance that has affected film editing in recent years is the knowledge that the human mind is capable of retaining images on a subliminal basis and of sorting out and making sense of endless numbers of images, each lasting only a fraction of a second, flashed in succession. Despite the brevity of these cuts, the viewers' subconscious minds retain a progression in which nothing is forgotten. The use of these very short flash cuts is a major factor in contemporary dramatic editing. Films that have used this technique to excellent advantage include the classic *Hiroshima, Mon Amour* and, more recently, *The Go-Between*, *A Clockwork Orange*, and *Cabaret*. A recent three-minute film produced by Vision Associates for the U.S. Information Agency compressed the history of totalitarianism into three minutes of film containing almost one thousand separate images. On the next page is a section of the editor's log for this film, showing the length of each cut in 35mm footage. You will note that a 6-frame scene in 35mm runs for $\frac{1}{4}$ of a second.

Another key element in establishing pace is the number and character of *interrupting cuts.* If a scene proceeds logically and sequentially, with cuts made only with elements contained within the primary action, the scene will appear ordered and moderately paced. However, if a dozen cuts from another time and place are added to the scene at various points, the pace will be greatly accelerated. The more bizarre and illogical the intercut fragments, the quicker the tempo of the scene, because the audience is propelled unexpectedly back and forth. The result is that the audience constantly feels the need to keep up with the action, and an illusion of speed is created.

Sharp cuts, sudden changes in the logical order of visual images, unexpected shifts in point of view and location, the abrupt beginning or ending of a sound track, sudden changes in sound volume—all these contribute to a fast-paced sequence. The slow sequence is created by long pans and dollies, lengthy scenes enacted without intercuts, unchanging sound volume, and a logical progression of motivated cuts.

TIME

It is the special quality of film to be able to expand and contract elapsed time. These effects are created in large part on the editing table, and perceived time is perhaps the element over which the editor can exercise the greatest control.

In its simplest form, the control of time is exercised by intercutting visual elements into the continuity of a single action, thereby diverting attention from the primary action. If after each cut the editor returns to the basic scene at the same point he left it, the sense of time will be expanded. If he returns to the primary action at a much later point, the time sequence will be contracted. Thus a simple act such as a man descending a flight of stairs can take five seconds or twenty-five seconds, depending on the number and length of intercuts.

Scene#			
300 – Emaciated Body Prisoner in Grade M.S. (B/W – Blue)		5 FR. ✓	⎫
301 " " " " " "		7 FR ✓	⎬ 1-Shot
302 " " " " " "		2 FR ✓	⎭
303 Hitler on Podium Swastika - L.S. (B/W)		21⁺ R.S.	⎫
304 " " " " " "			⎬
305 " " " " " "			⎭
306 Prisoner w/Guard - MS Zoom-In C.U. - (B/W-Bl)		3 FR.	
307 " " " " "		12 FR.	
308 " " " " "		6 FR.	
309 Hitler as in sc. 303-305 M/S (B/W)		11 FR. ✓	
310 Swastika on Podium - sc. 309 C/U-(B/W)		12 FR. ✓	
311 Hitler Youth Marching Group (B/W)		6 FR. ✓	
312 Hitler in Car-Parade-Arm Salute " (B/W)		5 FR. ✓	
313 " " " sc. 312 M.S. (B/W)		6 FR. ✓	
314 Athletes w/Nazi Banners-Girls Group (B/W-Red)		6 FR. ✓	
315 Nazi Soldiers w/Parade Drums Group (B/W-Red)		11 FR. ✓	
316 " " w/Shovels-Rear Shot (B/W-Red)		12 FR. ✓	
317 " Celebration-Massed Soldiers E.L.S. (B/W)		11 FR. ✓	
318 " Sailors F.S. (B/W-Bl.)		6 FR. ✓	
319 Stadium-Nazi Rally-Masses E.L.S. (B/W-Red)		18 FR. ✓	
✱ 320 Mussolini w/Feathered Hat MS/B/W-Live (C-0680 OPT.#10		12 FR. ✓	
320A Building, German E.L.S. (B/W)		2 FR. ✓	
320B Marching Men Group Shot (Color)		3 FR. ✓	
320C Hitler in Car Salute M.S. (B/W)		3 FR. ✓	
320D Women Marching Group (B/W?)		2 FR. ✓	
320E Statue-Man on Horseback F.S. (B/W-Bl.)		3 FR. ✓	

The film editor, of course, can also control time in many more complex ways. Through a variety of devices such as flash-cutting, scenes and sequences arranged out of normal time order, and the intercutting into a sequence of fragments of events that occur in another time and place, the editor can freely move forward and backward in time. One of the most popular techniques in modern film editing is the *jigsaw-puzzle effect,* in which a basic sequence of events in logical and chronological order is fragmented into very short segments and scattered throughout the film. Generally sequences containing straightforward, continuous action—for example, a man getting out of bed, dressing, and having breakfast—are edited in a more or less normal time flow. However, if the editor chooses, he can scatter the sequence over the entire film, flashing back to events of the previous day and ahead to a fate that awaits the character. Thus although the simple acts of rising, dressing, and eating are drawn out over a time span of two hours, the expanded time, under the editor's control, seems totally acceptable.

The editor's ability to expand and contract time at will has almost no limitation. The more he succeeds in disorienting his audience, the easier it becomes for him to continue to set up his own time patterns. It is not necessary for the audience always to understand what is happening on screen. Indeed, many times the editor will deliberately try to disorient the audience so that they cannot identify the place and character of fragmented intercuts. This type of cutting, however, should never be done at random or simply for its own sake. Only when used to further the basic intent of the film is it a valid and effective technique.

The following are a few basic guidelines for the beginning filmmaker or film editor with regard to the subject of time:

1. A succession of short cuts tends to speed up time.
2. If the intercuts are inserted in such a way as to allow the primary action to seem to continue uninterrupted at its normal pace, the sense of time will be unaffected. If the primary action is halted to allow for the intercuts, the sense of elapsed time will be expanded.
3. If intercuts project forward or backward in time, the time sequence will be expanded. If the intercuts show concurrent action taking place elsewhere, the sense of time will be contracted or speeded up.
4. If the intercuts are unmotivated either visually or through dialogue, time will be speeded up or contracted. If a verbal or visual cue announces the intercut, time will be slowed down or expanded.

Since no rules in filmmaking are absolute, there will of course be situations where the above generalizations will not hold true, but as basic guidelines they usually prove helpful.

TRANSITIONS

For the editor the creation of transitions—forward motion from one scene or one sequence to another—is a crucial factor in structuring the film. The simplest optical transitions are the dissolve and the fade. In traditional editing the fade

in and fade out are used to announce the beginning and end of a scene or sequence. They are, so to speak, a period ending one thought and a capital letter beginning another. The dissolve—a subtle blending of one scene into another—provides a smoother transition between visual elements and is effective for maintaining the flow of action when time and place are changing.

Fades and dissolves are, however, essentially artificial devices for moving from scene to scene. Today editors are relying more and more on the direct cut, motivated by some visual or aural stimulus, to achieve smooth transitions between scenes. Unlike the fade and the dissolve, which provide external, optical cues, the direct cut signals a transition through relationships between elements *within* the action. Making such transitions requires a high degree of creative editorial thinking and careful selection and matching of cuts. The editor must select the precise frame in the outgoing scene at which a direct cut will cue a time or place transition and the exact frame in the incoming scene that will make the transition work. For example, assume that a scene ends with a room being plunged into total darkness. At the exact frame where the room goes black the editor can cut to a shot in a dark tunnel a split second before a train emerges into daylight. The audience is propelled along in the action without any sense of interruption.

Once again *The Go-Between* provides an excellent example. The action in the early part of the film takes place entirely in the past—sometime in the early 1900s. In one sequence, the principal character, Leo, then a young boy, has been taken to town by Marian, a girl of nineteen whom he idolizes. Marian asks Leo to amuse himself by going to visit the great cathedral so that she can be free to meet her lover. A long shot shows Leo moving toward the cathedral, and suddenly, without warning, a direct cut is made to the same setting in an obviously different time; the scene ends with a view of a modern Rolls Royce standing in front of the church. The cut is cued by the shot of the cathedral, and continuity is maintained by the similarity of camera angle in both shots. Although it lasts for only a few seconds, the audience accepts the cut and is alerted to what will be the central editorial device for making time transitions in the film.

VISUAL AND AURAL RELATIONSHIPS

IMAGE TO IMAGE

Since films are essentially structured about the relationship from shot to shot and image to image, the establishment of these relationships lies at the core of the editing art. The editor must be able to sense all of the values inherent in a particular set of images and then cut them in a succession so that their interaction with each other adds up to the total desired effect for the sequence. No editor should ever let two scenes appear in succession without knowing exactly what effect he is creating and why. Every scene is influenced by the scene that follows. A direct cut from a wide-angle shot to an extreme close-up will affect the impact of both scenes. Since editing is essentially a storytelling art, with the visual images serving as words, the creative editor attempts to construct interesting relationships

between successive images, avoiding the obvious. If the audience can predict the order of the images, it soon becomes bored and restless. For example, consider the following three images: (1) long shot—countryside; (2) medium shot—brook; (3) closeup—pretty girl. If they are placed in this conventional, logical order, the result will be predictable and dull. However, the interest level can be considerably heightened if they are placed in a less "logical," more unusual order; each becomes richer and more interesting individually. Thus, when the initial long shot of the landscape is followed by a sharp cut to an extreme close-up of the girl, the landscape tends to linger in memory and the girl immediately becomes a part of her environment. The viewer is immediately propelled into a special world, and the medium shot of the brook that follows draws him into the mood of the sequence.

Successive images can also be used to work against each other, to contradict each other, and even to cancel each other out. A soft, gentle, romantic image followed directly by a harsh, abrasive image communicates to the audience a sense that "something is wrong" and prompts the audience to try and reach for the real sense of the sequence. The idyllic images of Leo's youth in *The Go-Between* were continually interrupted by fragmentary flash cuts that were gloomy, gray, and depressing. These images tended to cast doubt over the future of the main characters and to disturb the quiet beauty of the action. This type of image-to-image relationship is also effective in propelling the main action forward, for when one image is followed by another that is so different in mood and style, the audience cannot help but be rushed forward into the action. This technique has been used in several excellent "thriller" films like *Bullitt* and *The French Connection*.

IMAGE TO SOUND

The film editor must also be able to create effective relationships between picture and sound tracks. Like the visual images, the dialogue tracks have a pace and rhythm of their own. The way the editor employs these synchronous sound tracks often determines just how good an editor he is. If he is content to deal with the spoken dialogue as an adjunct to the picture on a one-to-one basis, the film will be rather monochromatic. In *Citizen Kane* (1941), Orson Welles opened up an entirely new world of sound-picture relationships by using overlapping dialogue—several voices speaking simultaneously and interrupting one another—and dialogue delivered by off-screen speakers. Today the creative modern film editor uses tracks as freely as he uses pictures. He knows that aural cues can be as effective and provocative as visual cues, and he makes good use of this knowledge.

The key point here is that the synchronous dialogue track is not irrevocably locked to its matching picture. By introducing cutaways and nonsynchronous sound into the scene, the editor can free the dialogue track so that it becomes an independent creative element in structuring the film. Once he has eliminated the image of the speaker, the editor can open up the track, tighten it, or run it

alongside extraneous and unrelated images. He can double up on the tracks to create several layers of sound, and he can overlap dialogue so that cuts do not take place in a predictable manner, at the same point in picture and track.

Sound cuts can be made at any point in the dialogue tracks, and often the dialogue from one shot can be laid over another shot of the same scene and still appear to be in sync. Assume, for example, that the editor is cutting a conversation between two men. He begins with shot 1—a view over the shoulder of A looking directly at B. At some point in the dialogue, the editor wishes to reverse the angle and look over B's shoulder at A. However, he feels that the dialogue performance from the first shot is superior. In many cases the dialogue track from the first shot can be made to appear in sync with the visual image of shot 2. Since B's lips are not seen in shot 2, his dialogue from the first shot can easily be used. This is a simple example of how dialogue tracks can be handled separately to get the most effective results.

Another popular editing technique is the use of synchronous dialogue tracks as voice-over tracks accompanying visual images ranging far afield from the scene the dialogue originally accompanied. For example, in the scene above the two speakers may be arguing about the future of the wife of A. After a few minutes of conversation to establish the subject, the editor may cut to a shot of the wife going about a routine chore in some other time or place. The dialogue track from the original scene continues exactly as recorded, but the intercuts add a note of irony and give the audience a vantage point unshared by the participants in the drama. Thus the sync-sound track takes on a life and a vitality of its own; most important, it can be edited freely without regard to the visual images with which it was recorded.

This same type of freedom applies to all supportive sound elements in the film. In preparing his background sound tracks, the editor works both with wild sound recorded during the filming and with sound effects he makes or buys to add to the film. It is essential that the editor realize that every visual image can benefit from the conscious, creative use of supportive sound elements. For example, the opening sequence of David Lean's film *Ryan's Daughter* consists of simple scenes of Rosie Ryan walking on a deserted beach on the coast of Ireland. The background noises of sea and surf, the cries of birds echoing the loneliness of the girl, and the almost inaudible sound of her feet on the sand all combine to communicate more clearly than words the emptiness of her life, which is a motivating factor in the film.

Supportive elements that are totally unrelated to the picture can also be used by the editor. One of the outstanding thrillers of recent years, William Friedkin's *The French Connection,* owes much of its tremendous impact to the use of unreal and unmotivated sound effects. For example, during a chase sequence in an abandoned building, the editor echoed the voices of the men far beyond reality and added a variety of extraneous sounds such as water dripping, doors slamming, and glass breaking to heighten the suspense. The creative use of sound effects to further cement the relationship between sound and picture is unlimited and gives the editor an opportunity to do some truly original editorial thinking.

STRENGTHENING PERFORMANCE AND THEME

The film editor exerts a strong influence over the quality of performance in any film. By the judicious use of cutaways the editor can eliminate bad takes or unconvincing dialogue, and by the effective intercutting of close-ups and long shots he can add power and impact to an ordinary or even substandard performance. In most dramatic films this is one of the most important factors in the editing. For example, Irving Oshman's editing of *David and Lisa* not only camouflaged Frank Perry's stagy and uneven direction, but greatly aided the somewhat amateurish performances of Keir Dullea and Janet Margolin. By separating the good takes from the bad, salvaging sections of sentences, and eliminating poorly delivered phrases—all the while maintaining a sense of cohesion—a good editor can be the final salvation of the film actor.

Similarly, the creative film editor structures his work so that the theme and flow of the film are strengthened and supported. Every film has a structure and an intended flow—from idea to idea, from sequence to sequence. It is the editor who controls that movement and who must, through his choice of scenes and transitions and use of track and supportive elements, sustain it. The thematic structure of Peter Bogdanovich's nostalgic and evocative film *The Last Picture Show* was greatly aided by the editor's emphasis on long shots and camera angles that kept the physical setting continually in view. Through his choice of visual elements the editor can reinforce the film's intent or lose it completely. The flow of a romantic film like David Lean's *Dr. Zhivago* depends entirely on the smoothness of the cuts and pacing; the film would have been destroyed by wild intercutting or sudden jarring transitions. On the other hand, the impact of John Schlesinger's *Sunday Bloody Sunday* relies almost exclusively on the dialogue tracks; any attempt to structure the film around its nondescript visual images would have destroyed the desired effect.

The structure and flow of a film are determined by its script and by the filmmaker's intent. The editor must remain constant to this intent or he will edit a different film from that which the director has photographed. This leads only to disaster.

THE ELEMENT OF SURPRISE

Modern film editing relies heavily on the element of surprise. When Alain Resnais made his first flash cut in *Hiroshima, Mon Amour* (1959), he opened the door to an entirely new world of film editing. Currently just about anything goes in the art of editing if it succeeds in capturing and sustaining the attention of the audience. Rapid changes of time and place within a single scene or sequence, brief cuts designed to reach the audience on a subliminal level, sudden switches in pace and rhythm—all these have become trademarks of contemporary film editing. Most good editors are now aware that there are virtually no restrictions as to what scenes can be joined to other scenes or how sound tracks can be used in relation to picture. The criterion is "Does it work?"

The primary aim in the use of surprise elements is to keep an *uneven* rhythm going so that cuts and pacing are not telegraphed to the audience. If the audience can sense in advance what to expect from scene to scene or where sound cuts are coming with respect to the visual images, the film soon becomes boring.

Surprise can be achieved by any sudden, unexpected shift in sequence of shots, by the introduction of extraneous elements not immediately recognizable by the audience, or by the combination of unrelated materials (e.g., sound tracks from one scene overlapping into another scene). There are endless ways in which the editor can jolt the audience. It is worth noting, however, that there is a real danger of overusing these techniques until they become meaningless clichés. The flash cut, for example, is already so common that audiences are reacting to it with boredom. The best rule to follow is to save the surprise effect for a point at which it will make a vital and valid contribution to the film.

editing—an approach

The following brief guide to proven editorial procedure is designed to help the beginning filmmaker avoid problems and to achieve in the editing room a finished work consistent with his original vision of the film.

1. Meticulous record-keeping is an essential element of film editing. In the final stages of editing it is often imperative to locate material from the original filming. If at the very beginning of editing all film and sound are carefully catalogued and stored, it will be much easier to locate needed materials later.

2. Save all trims and outtakes. In the haste and tension of editing, it is easy to throw away short pieces of film not being used (trims) or to lose track of scenes discarded in the early stages of editing (outtakes). It is wise to take the extra time to catalogue these pieces and return them to their place on the shelf. It is impossible to say with certainty that a piece of film or sound will *never* be needed. Rummaging through the film barrel later on can be a frustrating, time-consuming, and costly process.

3. Review the work print and all sound tracks carefully in the beginning for technical problems. Sometimes minute technical imperfections are not caught, and a damaged scene or sound track is cut into the film. These flaws may not show up again until the answer print and at that stage repair is costly. Be sure that every piece of work print and track used is technically perfect.

4. Make all markings clear and precise from the beginning. All optical transitions and special effects should be marked precisely and accurately the first time. If this is not done, it is easy to overlook these elements later. Again, the result will be costly repairs in the optical laboratory.

5. Set a schedule for the entire editing period in the beginning and do not let it slip. The editor should know from the beginning how much film is to be edited in how much time and should prepare a balanced schedule accordingly. For example, if a thirty-minute film must be edited in five weeks (to rough cut) the editor should try to cut six minutes per week. A master schedule should be prepared at the outset, providing target dates for rough cut, fine cut, optical effects,

narration, mix, matching, and answer print. This enables the editor to remain in control of his work and to stay on schedule. Too many film editors simply work on one element at a time and are forced to rush the final stages of their work as a result of lack of planning. In addition, if overtime work is necessary to meet the film's deadline, it is best to schedule it evenly throughout the editing period rather than letting it pile up at the end, when everyone will have to work around the clock, leading to minimum creativity and technical efficiency.

6. Do not underestimate the need for technical dexterity in film editing. Almost without exception, the most creative film editors are also the most technically proficient. The higher the degree of technical skill, the freer the editor is to experiment creatively. An editor who cannot operate his machines, keep his materials in sync, or control a multiplicity of elements spends all his time and energy fighting his tools and has none left for creative editing.

7. Never lose sight of the fact that editing is not simply a mechanical process but is a valid art in itself. This means that if the film editor is to serve the cause of the film, he must be willing to innovate and experiment. The less the editor is bound by traditional rules and restrictions, the better the result. Since the editor is dealing with work print and work track, no cut is final; the editor who will not try something new and interesting is simply a mechanic.

8. The key elements of editing are the control over elapsed time, the linear structure of the film, and the selection of the vantage point from which the action is viewed. The editor must constantly be in command of these basic elements, letting nothing happen by accident.

9. Don't let any single element (sound, picture, an actor's performance) lock you in or dictate how you edit the film. Probably, the editor can be the freest artist in the entire filmmaking process if he wants to be.

10. Learn to work *with* the director. The editing process is not a contest of wills or egos. The best, most creative editor is the one who makes a major contribution toward helping the director achieve his vision of the film and adds his own art to that vision.

Editing requires both the total technical mastery of machines and film, and a highly creative imagination capable of giving full and equal attention to every element in structuring the film. The best rule of thumb is "Anything can be made to work on the editing table." This is why the editor plays so important a role in the filmmaking process.

suggested reading

MILNE, TOM, ed., *Losey on Losey*. Garden City: Doubleday, 1968.

WALKER, ALEXANDER, *Stanley Kubrick Directs*. New York: Harcourt Brace Jovanovich, 1971.

WARD, JOHN, *Alain Resnais and the Theme of Time*. Garden City: Doubleday, 1968.

suggested viewing

Bullitt (1968) Peter Yates/Philip D'Antoni (time)

Cabaret (1971) Bob Fosse (flash cutting)

Carnal Knowledge (1971) Mike Nichols (dialogue cutting)

A Clockwork Orange (1971) Stanley Kubrick (style)

David and Lisa (1963) Frank Perry/Irving Oshman (effect on performance)

The French Connection (1971) William Friedkin/Philip D'Antoni (action and pace)

The Go-Between (1971) Joseph Losey (time)

Hiroshima, Mon Amour (1959) Alain Resnais (time)

Murmur of the Heart (1971) Louis Malle (dialogue cutting)

Taking Off (1971) Milos Forman/Janos Kadar (pace and rhythm of singing sequence)

seven postproduction sound

I take it one is ready to admit the principle that we must make our sound help the mute rather than reproduce it. Sometimes it is useful, of course, to hear what people are saying and see their lips move, but we may take it as a principal guide that wherever we can make the sound add to the general effect we should. Our rule should be to have the mute strip and the sound complementary to each other, helping each other along. That is what Pudovkin means when he talks about asynchronistic sound. He talks of the mute and the sound following each a separate rhythm, as instruments in an orchestra follow their separate parts to the end of creating together a larger result.

Sound can obviously bring a rich contribution to the manifold of the film—so rich a contribution in fact that the double art becomes a new art altogether. We have power of speech, power of music, power of natural sound, power of commentary, power of chorus, power even of manufacturing sound which has never been heard before. These different elements can all be used to give atmosphere, to give drama, to give poetic reference to the subject in hand. And when you remember that you can cut sound as you cut film and that you can, by re-recording, orchestrate any or all of these elements together in exact timing with the mute, the possibilities become enormous.

JOHN GRIERSON, in Forsyth Hardy, ed., *Grierson on Documentary.* Originally published by the University of California Press; reprinted by permission of The Regents of the University of California.

Once the fine cut has been completed to the satisfaction of both director and editor, the editor can proceed to polish the visual editing and to add all postproduction sound. During the basic editing, he dealt only with sound that was recorded at the time of shooting—dialogue, on-location sound effects, and perhaps some voice-over commentary by the leading characters. Now the editor adds other sound elements, including *dubbed dialogue, voice-over* and *narration* (if needed), *additional sound effects,* and *music.* These supportive sound elements are usually

recorded first on quarter-inch magnetic tape and then transferred to 16mm or 35mm magnetic tape for editing. Music should always be transferred to 35mm tape because the larger area makes it easier to disguise cuts and to achieve smooth musical transitions. With 16mm tape, a splice can be made only between two perforations, one on either side of the frame; 35mm tape has four perforations, giving the editor a wider choice of where to make his cut. This option is especially critical when dealing with music.

dialogue dubbing

Often the director or editor will decide that certain scenes or sequences as edited need a better-quality dialogue track. This may be the result of a variety of factors, including poor acting performance, faulty sound recording (too much background noise), or the need for foreign-language dialogue. Most often only segments of the dialogue are dubbed—rarely is an entire film or part of a film dubbed unless it is being translated into another language.

All dialogue dubbing is done in a sound recording studio. The basic process is quite simple. Each scene to be dubbed is "looped" by the editor. That is, the film containing the scene to be dubbed is set up in a circle—spliced head to tail in short sections of 50 to 100 feet—so that it can be run through a projector continuously. The original sound tracks are played synchronously with the picture, and the actor doing the dubbing watches from a control booth and listens to the dialogue through a set of earphones. He speaks the dubbed lines into a microphone, repeating segments as needed until a perfect match is made. This procedure assures that the new sound tracks will be in perfect sync and free of distracting noises. In addition, the actor has a chance to improve his performance. Background sounds, perspectives, and other elements are added later to give the new dialogue track reality.

When dialogue is being dubbed into a foreign language several additional factors enter the picture. Recently there has been an increase in cooperative film productions between nations, many of which have proven successful and profitable. In this type of production the cast is usually made up of actors from most of the countries in which the film will be distributed. During the shooting of sync-dialogue scenes, each actor delivers his lines in his native language. If the actor is multilingual, his scenes are shot in several languages. Later, the dialogue tracks for the remaining actors are dubbed into the other languages.

One of the most important factors in foreign language dubbing is the quality and accuracy of the translation. The dialogue must be translated not only to preserve the sense of the original words but also to keep the translated version as close as possible in sound formation to the original. For example, although the word "yes" and the French equivalent "oui" are both only one syllable in length, the lip movements needed to form them are quite different. Thus "oui" will never quite appear in sync with "yes" if it is dubbed into the sound track. Another word more closely matching "oui" in lip movements but with the same meaning would have to be found. If, however, a German film were being dubbed

into English, the German "ja" could be replaced by "yes" and appear in perfect sync, since the lip movements for both words are almost identical.

With phrases and sentences, these translation problems are of course compounded. In addition, the length of the translation in relation to the length of the original speech becomes an important factor. Generally, the length of each translated sentence cannot vary by more than a frame or two from the original. With longer speeches this can be a very difficult problem. For example, suppose the original sentence is: "But we had a date." The German translation would be: "Aber wir haben eine Verabredung gehabt." In this instance the translator would have to experiment with various paraphrases of the original until he found a version that could be stated concisely in German and at the same time remain relatively close phonetically to the original English. Because the translation itself is a crucial factor in dubbing, the importance of finding skilled and imaginative translators cannot be overstated. Such individuals can be found in the language departments of major universities and through the United Nations. Their command of both English and the foreign language involved must be extraordinary.

Another major problem in foreign language dubbing is matching the quality of the foreign actor's voice to the physical appearance of the actor on screen. Dialogue dubbing is an unusual skill that few actors possess, so the choice is somewhat limited. Radio actors tend to have very good voices for dubbing because they are accustomed to acting with voice alone. Careful consideration must be given to the size, character, and quality of the dubbed voice. No matter how good technically the dubbing is, any mismatch between voice and picture will make the performance seem artificial and "out of balance" and will seriously detract from the film. The English-dubbed version of Serge Bondarchuk's Russian masterpiece *War and Peace* was only partially successful for these reasons. Translation difficulties and mismatched voices greatly reduced the quality of performances. In a situation like this, the use of subtitles is generally preferable.

If the director and editor know in advance that the film is to be dubbed in a foreign language, they should shoot and edit the film with as many short scenes, shifts of angle, and cutaways as possible. This will prevent the audience from watching a speaker from any one camera position for too long, which would only emphasize any dubbing inadequacies. In addition, physical movement on the part of the actor helps distract the viewer's attention from any imperfections in dubbing.

Recent advances in sound recording technology have made possible vast improvements in both the speed and the accuracy of electronic dubbing. Until recently it was not unusual to spend several hours dubbing a page of dialogue and several weeks dubbing an entire film. Today a full-length film can be dubbed in a few days.

The dubbing of dialogue can improve a film technically and in some instances can strengthen a weak or inadequate acting performance. However, it is a serious mistake to assume that dubbing is the total answer to any sound problem incurred during filming. It is nearly always preferable to get the best on-location sound possible. Often a little patience and effort will quickly solve what appears to be an insurmountable sync-recording problem. Despite the technical improvements in dialogue dubbing, postsynchronous dialogue often tends to sound mechanical

and artificial, lacking the vitality and spontaneity of a synchronous performance. With today's emphasis on realism, every filmmaker should strive for as much sync-dialogue recording and as little dubbing as possible.

voice-over

Often the filmmaker or the editor decides that the film as edited needs additional voice-over lines or segments of voice-over commentary. The voice can be that of a third-person observer or that of one or more of the actors in the film. The addition of a voice-over sound track can make a major artistic contribution to the finished film. Voice-over can be used (1) to heighten an effect (the use of Dylan Thomas' poetry to accompany the Welsh landscapes at the opening of the short film *Dylan*), (2) to strengthen the theme of the film (the narration in the classic film *How Green Was My Valley,* which was spoken from the vantage point of many years after the action and which stated the themes of love and of the beauty of the harsh life of the Welsh miner), (3) to clarify a point of view (most of Alex's first-person narration in *A Clockwork Orange*), (4) to convey necessary information not contained in the visual elements (the voice-over track of the minister in Bill Jersey's classic documentary *A Time For Burning,* in which the image shows merely the minister writing a letter but his own voice-over conveys the content of the letter), and (5) to provide a dramatic counterpoint to the visual images (the humor conveyed in Alex's voice-over in *A Clockwork Orange* as it plays against scenes of dreadful violence). At the beginning and end of Joseph Losey's *The Go-Between* the main character makes a brief voice-over comment. The opening line, taken from L. P. Hartley's novel, is spoken by Michael Redgrave, who plays the leading character, Leo, as a middle-aged man. We *hear* Redgrave's voice as we *see* the eleven-year-old Leo riding in a carriage to the house where he will spend the summer. He says simply, "The past is a foreign country; they do things differently there." This brief comment sets the mood for the action and establishes the relationship between past and present, which is a major theme in the film.

Of course, in TV commercials and most documentary films voice-over usually conveys specific information that cannot be contained in spontaneous and natural dialogues. Usually all voice-over material is written in advance and is recorded either at the time of production or when the editing is complete. The voice-over is recorded in a sound studio, and the editor places the words exactly where they will be most effective in relation to the visual image.

NARRATION

Few if any good filmmakers today use narration in the dull, expository manner of the didactic films of the 1930s through the 1950s. The use of narration in the past was so stultifying that it created a desire on the part of filmmakers of the 1960s never to use narration. Now, however, a more realistic and measured

response has emerged. In many films, narration, if creatively conceived and skillfully written, can make a positive contribution to the film as a whole: it can enrich the texture of what is seen; it can provide a specific vantage point from which to approach the film; and it can provide its own dramatic force and excitement.

It is generally best to use as little narration or voice-over as possible. It is, after all, an artificial technique carried over from radio, and it tends to be overused. It also provides the director with a crutch with which he can prop up inadequate live sound sequences. It is usually used to hide parts of the film that were not thoroughly thought through in the initial development of the script. Often it is only on viewing the final cut that director and editor turn to voice-over narration to save or clarify some part of the film that isn't working. Unfortunately, too many documentary films rely on direct, didactic narration to communicate a message. This kind of narration merely tells the audience what it is already seeing. John Huston relied too heavily on this type of "telling" in his otherwise excellent *Moby Dick,* and it hurt the film. On the other hand, Ingmar Bergman's classic film *Through a Glass Darkly* uses voice-over very effectively to help the silent taciturn characters express feelings and emotions. It is very sparingly used and does help, but too often this is not the case. Alex's wheedling, personal narrative in *A Clockwork Orange* creates a direct line of communication between an unpleasant antihero and the audience and thus serves a purpose beyond mere accompaniment of the images. This use of narration is a strong addition to the film's sound track.

PREPARING THE NARRATION

Although methods vary, the following is a fairly common and effective procedure for writing narration. When the script is first written, a narration is also written with careful attention paid to the "tone and texture" of the language. Simplicity and a subtle poetic cadence are often desirable, but overripe, "fancy" writing usually brings disastrous results. After the editing has been finalized, the narration is "read" against the picture to measure its effectiveness and length. It is then finally revised and recorded.

Prior to recording, the narrative script must be cued against the edited film. The director or editor runs the film through an editing machine at standard sound speed and reads the narration aloud to make sure that the words fit the scenes in length and create the effect he desires. Adjustments in the length or tone of the narration should be made at this point, and the script should be marked to guide the actor-narrator in his reading.

In rehearsing the narrative script, the director should first establish the "sound" he wants the actor's voice to have. This is done by having the sound recordist experiment with various microphone positions. A microphone placed too close to the actor results in too much presence and too many mouth noises and breath sounds; if the mike is too far away, there is too little presence and too much "room" echo. If the microphone is too directly in line with the mouth, excessive sibilance can result. If the angle is too sharp, the fullness of the voice may be adversely affected. Once the proper microphone position and sound have been established,

the director should communicate to the actor the "tone" of the entire narration— romantic, poetic, driving, ironic, and so on. Finally, he must establish with the actor a rhythm or pace for the entire narration and for individual sections. There may be parts calling for a faster, more powerful reading. The narration should be rehearsed just like a part in the film until the director is satisfied that he has the reading he wants.

RECORDING THE NARRATION

Almost all narration is recorded in a sound studio. The narrator works in a soundproof room, and the director and engineer monitor the voice through speakers. Some directors prefer to have the narrator narrate the film to the picture, watching the film as he speaks the words. Although this assures a perfect technical fit, it is less than ideal from an artistic viewpoint. No matter how experienced the narrator is, he is forced to divide his time and attention between the words he is speaking and the images those words support. Thus he compromises his delivery in favor of "making it fit." Another approach is simply to screen the film for the narrator prior to the recording so that he will be familiar in a general way with the image flow. This too has its dangers. The narrator, instead of concentrating fully on his own delivery will try to recall the image he has seen. In the long run, the best approach is to treat the narration as a self-contained unit and to try to obtain from the narrator the best possible reading, regardless of timing. Ideally, the actor should simply "perform" the narration as though there were no accompanying visual images. He must attempt to create the total effect solely through the words he is reading. Later on the editor can easily adjust the tape or even eliminate words, phrases, and sentences if absolutely necessary. Where timing is essential, as with most TV commercials, a stopwatch can be employed to ensure that the narration will fit. Most narration is recorded on quarter-inch tape and a half-hour film can usually be narrated in about two hours.

Generally, it is a good idea to let the actor read through the narration without interruption during the first recording, because if he is constantly interrupted he loses his rhythm and pace. If he misses a line or is dissatisfied with the reading of a particular section, he can stop, go back a full paragraph, and continue. When the first reading is completed, the director should make comments and corrections and discuss the overall performance with the actor. During the second recording the director can interrupt and ask for retakes on specific paragraphs or pages. If necessary, the director can then record pick-up sections of the narration that he is still not satisfied with. It is very important to get a perfect reading of the entire narrative as early in the recording session as possible. Even the best actors will begin to "go stale" after two or three performances, and no amount of prodding can recapture the initial freshness and vitality. A sentence spoken too many times loses its meaning to the speaker.

Many filmmakers tend to forget that at this stage of production the film is still flexible. In most cases it is quite easy to extend a scene in length if the narration as performed runs longer than the narration as cued by the director or editor. An experienced film editor will usually allow for this, knowing that an

NARRATOR

Now the long road from the safety of sketches and specifications to the reality of flight must be traveled.

The calculations . . . the tests . . . all say it can be done.

Now the building of an airplane begins.

From England came the engines . . .
from Ireland—the engine pods . . .
from Tennessee—the wings . . .
from California—the flight control system . . .
from Texas—the underwing pylons . . .
from Canada—the fuselage subassemblies . . .
from Japan—the fuselage doors . . .
from Illinois—the hydraulic systems . . .
from Ohio—wheels, tires, brakes . . .
from Arizona—gyroscopes.

From the hands and hearts and minds of hundreds of thousands of human beings . . . separated by the seas, and the prairies, and the mountains . . . joined now in common cause.

actor, in projecting his lines, tends to read at a slightly slower pace than normal speech. Sometimes, of course, there will be critical sections of film where the narration must fit between two segments of live dialogue that cannot be recut or extended. In such cases the director must alert the actor beforehand so that he will time his reading to fit within those segments of the film.

MARKING THE SCRIPT AS RECORDED

Since the recording of narration normally requires several takes and retakes, it is essential that the director mark the narrative script for the editor to show precisely what occurred during recording and to indicate his preferences. Above is an example of a page of narration as marked during recording for a half-hour documentary film on the building of the L-1011 aircraft. The takes (T) are numbered consecutively; each vertical line shows how far that take ran, and each jagged line indicates where the actor stopped and went back to repeat a phrase. The letters RT stand for retake, a section rerecorded after a full reading was completed (thus the gap in numbers), and the circled takes represent the filmmaker's preferences.

After the narration is recorded, it is transferred to 16mm or 35mm magnetic tape for editing. Although many filmmakers transfer only the takes they have selected, it is a good idea to rerecord the entire narration. The use of magnetic tape enables the editor to make fine, subtle adjustments in the narrative track—he can isolate sentences and phrases, eliminate or juxtapose words and even parts of words, and expand or contract pauses. For this reason the best takes for the purposes of editing cannot always be anticipated, and the editor should be given the greatest possible freedom in assembling the narrative track.

The editor lays in the narration to fit the film on a single sound track, placing each sentence or phrase alongside the visual images it is intended to support. This is a very critical procedure. The decision as to where each word will fall with relation to both the picture and the other dialogue tracks is one of the most important the editor will make. He must decide whether the words should precede or follow the image, or whether picture and words should be run simultaneously. It is very difficult to generalize regarding exactly how best to lay narration in, but a good course to follow is:

1. If the narration is explanatory—giving information—it should slightly precede the on-screen images.
2. If the narration is evocative—supporting or creating a mood—it is best to run it either simultaneously or slightly trailing the images to which it refers.
3. If the narration is a counterpoint to the visual elements, it should precede or run simultaneously.

It is important never to let the narrator drone on in a fixed pattern of cadences. The rhythm of the narration as it is laid in should be varied so that the audience is not "cued" as to when to expect the voice. In addition, the general rhythms of the film should determine the rhythmic pattern of the narration.

One final word regarding the narration track—nothing will destroy a good film more quickly than an excess of narration. An average thirty-minute documentary film can rarely sustain more than a maximum of eight to ten minutes of narration. Film is primarily a visual art, and there is a definite limit as to how much spoken narration the audience can absorb. The best narration makes effective use of long periods of silence, when the narrator, having made a point or evoked a mood, ceases talking for at least three times as long as he has just spoken.

sound effects

In addition to the wild sounds recorded during filming it is often desirable to add sound effects in the final phase of editing. These include dramatic effects (a dog barking offscreen during the preamble to a gunfight), realistic sounds (a plane's wheels touching ground during a landing), and, most important, a variety of *offscreen* sounds to heighten a sense of place or to add mood or atmosphere to

the film. In real life many of our emotional and subconscious reactions to our environment are stimulated by sounds whose sources we never see. We rarely experience total silence. Thus the careful addition of key background sounds, well recorded and perfectly adjusted to the picture, can make a major contribution to the film. Peter Bogdanovich's fine film *The Last Picture Show* owes much of its sense of place and time (a small Texas town in the early 1950s) to its use of background sounds—the constant revving of motors on old cars, the sound of the wind whistling through half-deserted streets, wooden doors opening and closing. In addition, Bogdanovich added a constant cacophony of recorded music— country and Western songs and pop songs of the early 1950s. This music, whether visually motivated or not, contributed enormously to the general sense of time and place so vital to the film's success.

In assembling his background sound tracks the editor has two choices. He can go to a sound effects library and purchase prerecorded sounds, or he can hire a sound recordist to create exactly the effects he wants. The library offers satisfactory effects for very general sounds (wind, rain, dogs barking, etc.) and for specific sounds that come from indeterminate offscreen sources. However, when the quality or authenticity of an aural effect is important or when the sound source is seen, it is far more satisfactory to record the effect specifically for the film. There is a difference between the sound of an old pickup truck and a new car, and that difference is important.

The sound effects are prepared on a separate FX (sound effects) track, in much the same way as narration or voice-over. Effects that accompany on-screen images must be laid in to approximate a synchronous effect. For example, if a dog is *seen* barking or windshield wipers are *seen* on a car, the sound effect must appear to be in sync with the picture. If the sound effect is from an unseen source, the editor can cut it as he wishes, striving only for maximum dramatic effectiveness. At the *final mix* (when all sound elements are blended), these postsynchronous sounds are given perspective, and their quality is adjusted by volume, echo (reverberation), and presence to perfectly fit their visual sources, ensuring completely realistic effects.

For a long time the importance of the sound effects track as an independent creative element in the film was either overlooked or ignored. Sound effects were considered merely an adjunct to the voice and music tracks of the film. In fact, however, the best films of recent years have all had highly complex, carefully edited sound effects tracks that have made invaluable contributions to the films. The justly famous auto chase sequence in *The French Connection* was photographed without synchronous sound and the total sound was completely edited from postsynchronous sound effects.

music

In the linear development of the film, music is usually the last element to be added. Recently, however, with the advent of flashcutting and the use of *montage* (rapid successions of juxtaposed images), many editors have found it effective to reverse

the traditional procedure, obtaining their basic music at the outset and editing the film to the music. There are two major advantages to this technique. First, film is actually far more malleable than music. It is easier to cut and adjust images for length and position than it is to break up or reorganize a unified piece of music. Second, when scenes are cut to music they tend to appear far more cohesive and integrated with the music than when the music is scored to an edited film.

In general, music has two main functions in relation to the visual images. The first is to create or support the general mood of the scene or sequences; the second is to support or create a desired pace of action that moves the film forward. Music can also be used to bridge gaps of time and space between sequences.

There are two basic approaches to the final music scoring of the film. The filmmaker or editor can commission a composer to create an original score—this is the general procedure for most feature films, many TV commercials, and some documentary films. The second alternative is to purchase a score from a film music library, which will normally have on tape thousands of prerecorded musical selections designed specifically for film. In most cases a score composed for the film is superior to precomposed and recorded music, because the music is composed specifically to relate to each scene or sequence. It is also easier to create a definite mood with a totally originally composed music score than with many separate library pieces. A good example is Michel Legrand's beautiful and simple score for Joseph Losey's *The Go-Between*. Based on a single melodic theme, played on the piano, the thematic variations gave the film a continuity that would have been almost impossible with library music.

When an original score is commissioned, the procedure is as follows. The composer views the edited film and notes the length (to the frame) and content of each sequence for which music is required. He then composes his music, usually in the form of a piano or a guitar arrangement, to fit the footage. Once the music has been approved by the filmmaker and editor, it is scored for orchestra and recorded in a studio on quarter-inch tape. At this session the composer keeps a footage or time clock running to make sure that each segment of music fits the scene it is to accompany. The editor then transfers the music to 35mm tape and edits it to the film. If the recording job is done properly, the track will lay in perfectly, with only minor adjustments needed.

When a library score is being used, the editor must make a number of adjustments in the track to ensure a perfect relationship between music and picture. The editing of film music is highly complex and requires a technical knowledge of music as well as editing skill. Since a piece of music is itself an artistic whole, it cannot simply be cut at any point to fit the film. The editor must cut and blend the tracks carefully, hiding the cuts as much as possible within the music itself. This can be done by cutting the music in a highly percussive section, or in a section that has many sharp staccato changes of rhythm. If the cut is made so that it falls under narration or other sounds, it is easier to hide.

Most music tracks are set up on two separate rolls of 35mm tape called the A and B tracks. Thus instead of having to cut sharply from one piece of music to another, the overlap of the end of one piece with the beginning of another allows the sound mixer to blend the two pieces gradually in a subtle changeover

without any sharp or jarring cuts. If transitions are skillfully made they will be completely unnoticed by the audience. Rhythmic, fast-paced music is generally easier to edit than slow-moving, romantic music. Rock music, for example, is often very easy to cut because it usually has an upbeat tempo and many changes of pace. The editor can cut such a rock track in virtually any fashion that will suit his purposes.

All film music should be used sparingly and should always be motivated by the mood and content of the film. All too often music tracks are used as a crutch to disguise inadequate directing, acting, or editing. This is not an ideal or productive use of music. The editor can, by his selection of music and by the way he lays in his tracks, do a great deal to ensure that the music is properly used in the film. For example, in *Through a Glass Darkly,* Ingmar Bergman used a small segment of Bach's B-minor Cello Suite six times. This was the only music in the film, and its effectiveness can scarcely be measured. *Woodstock,* of course, derived its score directly from the content of the film; but the highly skilled editing of the music tracks gave the film much of its drive and pace and dictated the order of the visual images. The "feel" of the music suggested the order of the scenes and determined their length.

Music for film has an endless number of variations, ranging from a single instrument playing throughout a full-length film (Michel Legrand's piano score for *The Go-Between*) to the London Philharmonic playing Strauss' *Also Spracht Zarathustra* for a one-minute TV commercial (Eastern Airlines' *Wings of Man*). The scoring of film music is a highly specialized field, requiring more than skill or accomplishment as a composer. The essential qualities of a good composer of music for film are a knowledge of what instruments are reproduced best on optical tracks, an appreciation of the internal rhythms present in all visual images, and, most important, the ability to create a *unified* score for an entire film. In other words, the final score cannot be merely a collection of separate pieces but must have a single musical line.

the sound mix

When all the sound tracks have been edited and cleaned and the film finally approved, the final creative task—the sound mix—begins. The mix is the skillful and artistic blending of all sound tracks into a single track. It is usually done in a special sound recording studio equipped to run many separate sound tracks synchronously with the projected picture. The sound mixer sits at a large console with controls that enable him to adjust the volume and quality of each track. Most modern sound mixing studios are also equipped with a "back-up" system, which enables the mixer to stop and reverse tracks and picture simultaneously. In assembling the final sound track, the mixer works from a set of *cue sheets* prepared by the editor; these sheets tell him exactly what sound elements he has and when (in 35mm footages) each element is to be heard in the film. Cue sheets notations are made in 35mm footages whether the film is in 16mm or 35mm because they are more accurate and permit a greater division for measurement. Since many different sound tracks are often run synchronously, adjustment of their rela-

tionships to one another is a complex and demanding task, and therein lies the art of mixing.

On the next page is a portion of a cue sheet prepared by the editor for the final sound mix of a 1½-minute sequence of a thirty-minute documentary film. All films are mixed one reel at a time, and since each reel is ten minutes long, the full cue sheet for the first reel of the film ran slightly more than six such sheets. The first sound to be heard is music, appearing on the A music track at 6 feet 20 frames. Later in the sequence this track is to be blended with another piece of music on the B track, a technique known as a *music crossover*. Although the blend is to be made at 25 feet 4 frames, the first music track extends to 27 feet, and the incoming track begins at 23 feet. This leeway is necessary to give the mixer time to make the crossover and create a smooth transition. (The dotted lines indicate how much of the total music is available on the track.) The B music track runs to 46 feet 4 frames and is then faded out, ending at 51 feet. At 8 feet a sound effects loop begins and runs continuously through the scene, providing the sound of wind. As the absence of dotted lines indicates, this loop will cut sharply in at 8 feet and sharply out at 52 feet. At 10 feet 20 frames the narration begins and runs to 30 feet. At 26 feet 4 frames the sound effects of a rainstorm are heard; this track is to be faded out at 46 feet 4 frames. At 33 feet the first segment of lip-sync dialogue begins, running until 40 feet, and another dialogue track overlaps it at 38 feet, running until 50 feet.

As this example illustrates, a single sequence can contain six or eight different sound elements, many of which are heard simultaneously. When working with a large number of elements, the sound mixer often makes one or more *premixes* to reduce the total number of tracks to be handled in the final mix.

As he lays in the final sound track, the mixer adjusts relative volume levels, keeping the music strong when it is playing alone and lowering the volume just before the narration or dialogue begins. He equalizes all voices, adjusting the highs and lows to achieve the best quality possible. Often the same actor recorded in separate locations or at different times will sound like two different people. His dialogue tracks must also be equalized. Finally, the mixer adds special effects such as echoes and filters (for telephone voices), provides noise suppression on the dialogue tracks when necessary, and adds perspective to all voice and sound effects tracks.

The length of time required for the final mix depends, of course, on the number and quality of the tracks used. An average three-reel picture (thirty minutes) takes three to five hours to mix, but it can, if it is complex, take all day. A one-minute TV commercial can take four hours to mix, and a feature film often takes a week or two. The final mix will normally be scheduled after all picture and sound elements have been approved and about one or two weeks prior to receiving the answer print.

It is important to note that the sound mixer's job is not simply a technical task. Relationships between dialogue, narration, music, and sound effects are delicate. Although the editor sets the guidelines in preparing the cue sheets, much of the mixer's work must be done by ear, and the mixer must often make esthetic judgments as to the relative values of the sounds to be heard in each scene.

Vision Associates, Inc.

CUE SHEET

Prod. No._____ Title_____

NARR	'A' DIALOGUE	'B' DIALOGUE	'A' MUSIC	'B' MUSIC	FX	FX LOOPS

6^{20}

8
WIND

10^{20}

23

25^4 25^4

26^4

27

30

33

38

40

46^4 46^4

FADE

50

51

52

suggested reading

HAPPÉ, L. BERNARD, *Basic Motion Picture Technology*. New York: Hastings House, 1971.

LIPTON, LENNY, *Independent Filmmaking*. San Francisco: Straight Arrow Books, 1972.

PINCUS, EDWARD, *Guide to Filmmaking*. New York: Signet, 1969.

ROBERTS, KENNETH H., and WIN SHARPLES, JR., *A Primer for Film-making*. New York: Pegasus Books, 1971.

suggested viewing

A Clockwork Orange (1971) Stanley Kubrick (use of classical music)
The Conformist (1970) Bernardo Bertolucci (dubbing)
The French Connection (1971) William Friedkin (sound effects in chase sequence)
Hiroshima, Mon Amour (1959) Alain Resnais (dubbing and original music)

eight the laboratory

To the laboratory the filmmaker entrusts all the work of months, even years. The final preparation of the film and the sound track by the laboratory must be a labor of love—carefully executed, perfectly done. Anything less is inexcusable.

IRVING L. OSHMAN, Film Editor, *David and Lisa*.

preparing the film for the laboratory

The preparation of the film for the laboratory is the final stage in the filmmaking process. Up to this point all editing work has been done on a low-cost duplicate print (work print) of the original film. With the exception of adding special optical effects, that original has not been touched. Now, in preparation for release printing, the original film is made to conform with the edited work print. This process is called *negative matching* and is usually done by either the assistant editor or, more often, by a specialist, a negative matcher.

At the completion of the editing process the work print is a single strand of film, consisting of sections of scenes spliced to one another. All optical effects have been indicated on the work print in crayon, and any damaged or destroyed sections have been replaced by leader (white, yellow, or black opaque film stock used only as filler). On each strip of leader, called a *slug,* the editor has indicated in crayon exactly what segment of film is missing. Figure 49 shows a section of a 16mm work print ready for negative matching. Some of the tools used by the editor, including his splicer and marking implements, are shown in Figure 50, and Figure 51 is a diagram of how a work print is marked for the negative matcher, indicating how he should match the original.

As noted in Chapter 6, at the outset of the editing process the camera original and the work print are imprinted with a matching set of edge numbers. All raw stock is manufactured with latent image code numbers; these numbers appear every 16 frames in 35mm film and every 20 frames in 16mm. However, with 16mm film these identifying numbers are generally too small to be seen clearly by the editor, so the film was sent to an edge-numbering laboratory, where a larger and clearer set of edge numbers were printed on the original, the work print, and, in case of synchronous sound, the magnetic work track. Since scenes are cut up

◀ FIGURE 49

FIGURE 50 ▶

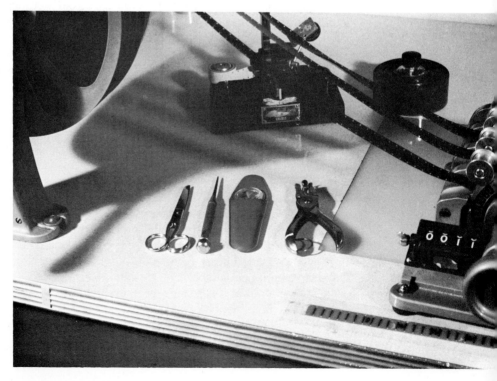

FIGURE 51 ▼

Method of marking work prints to indicate effects

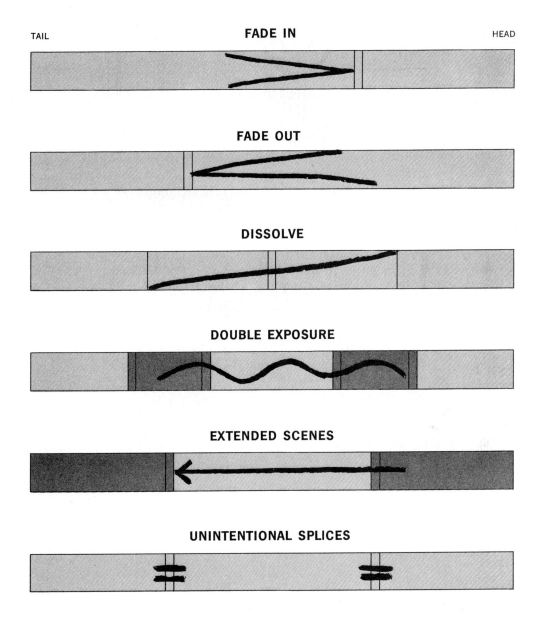

TAIL **FADE IN** HEAD

FADE OUT

DISSOLVE

DOUBLE EXPOSURE

EXTENDED SCENES

UNINTENTIONAL SPLICES

Courtesy of Deluxe General, Inc. © 1970.

into hundreds of small pieces during the editing and are scattered throughout the work print, these edge numbers provide the only source of identification for the negative matcher.

BREAKDOWN

The first step in preparing the film for the laboratory is the breaking down of the original footage. The negative matcher compiles a breakdown sheet like the one shown opposite, listing each scene in the *edited* film in the order of its appearance and noting the first and last edge numbers of the scene. Since the edge numbers appear every 16 frames, there will of course be many scenes that start a few frames before the first edge number or that end several frames beyond the final edge number; but only the first and last edge numbers that appear on the scene are indicated on the breakdown sheet. If a cut has been made in the middle of an edge number, the next full edge number is used for identification purposes. In addition, if flash cuts have been introduced in the editing, there may be several fragments of scenes that show no edge numbers. In this case, the editor must identify the fragments by eye and mark them by putting a very thin strip of tape on the edge of the workprint over the perforations on the side that will not affect the passage of the film through an editing machine and synchronizer. The editor then puts an identifying number on this tape so that the negative matcher will be able to find the corresponding frames in the original footage. (If the editor had foresight during his cutting, he will have made some preliminary identifying marks on these unnumbered frames.) Some cuts may have resulted in one- or two-frame shots; these may be too close together to run through the laboratory's optical printer or printing machine because the film cannot bend smoothly within a few frames and the splices tend to open. Also, the printer cannot respond to timing changes within so few frames. Different laboratories set different minimums for the length of shot which they will print, time, or balance. The editor should determine the laboratory's limitations and inform the negative matcher about them before he begins his work. The informed negative matcher will then extract any shots which are shorter than the laboratory's specifications and send them out to an optical house, where they can be rephotographed in a one-piece reproduction called an *optical master.* The negative matcher later splices the optical master into the original film.

Following the preparation of the breakdown sheets, the negative matcher removes from the original film the complete footage of each scene that appears in whole or in part in the work print. *He does not at this point make any cuts within the scene.* Thus, even if only three frames of a 200-foot take have been used, the negative matcher removes the *entire* take, from camera start to camera finish. Often three or four segments of a single camera take appear in the edited work print as separate, nonconsecutive scenes. Again, the negative matcher does not at this time cut up the original take. He simply rolls up the entire take and wraps the roll in a strip of paper, marking on the paper which scene numbers

VISION ASSOCIATES, INC. TITLE A.T.&T.-"All Kinds of People". PPCD. # 442......

PAGE I

CODE or EDGE NUMBER LCG
OF EDITED VERSION

16 FR. F.I		
1 CD-6725-6735	16 CA-7036-7040 WITH SC. 18	31 CA-5775-5785
2 CC-3827-3832	17 CA-6090-6096	48 XX 48 XX 32 CA-4913-4930
3 CC-5469-5474	18 CA-7048-7054 WITH SC. 16	48 XX 48 XX 33 CA-6284-6290
4 CB-8014-8016	19 CA-6097-6106	48 XX 48 XX 34 CA-6301-6308
5 CB-4441-4445	32 XX 32 XX 20 CD-7301-7317	35 CA-6365-6373
6 CB-4619-4623	21 CD-7342-7349	36 CA-6407-6410
7 CC-5881-5896	22 CD-7379-7387	37 CA-6425-6429
8 CC-7079-7084	23 CF-0320-0328	38 CA-6381-6387
9 CF-1110-1117	24 CF-0345-0350 WITH SC. 23	39 CA-6725-6731 WITH SC. 36
10 CF-2335-2345	25 CF-0355-0371 WITH SC. 24	40 CA-6734-6737
11 JI 36-72999-73024 OPTICAL MAIN TITLE	26 CA-3566-3576	41 CA-6789-6797
12 CA-6902-6918	27 CA-3405-3410	42 CB-0203-0219
13 CA-6143-6152	28 CA-3423-3434 WITH SC. 27	43 CB-0194-0196
14 CA-7016-7027 WITH SC. 12	29 CA-5239-5246	44 CB-0245-0251
15 CA-7121-7128	30 CA-5185-5191	45 CB-0227-0235

are contained within it. The rolled-up film is then stored in the order of its first scene (see Figure 52). When every scene on the breakdown sheet has been accounted for, the matching of original to work print can begin.

NEGATIVE MATCHING

For the purposes of illustration, the matching process described below will be given in terms of 16mm reversal color film. The process is essentially the same for all types of raw stock, and any significant variations between 16mm and 35mm will be noted within the discussion. Reversal color stock is a film stock that develops as a positive image instead of a negative image, and therefore all matching is done with black opaque leader. In 35mm, which is a negative color stock, the

FIGURE 52 ▲

matching also uses black opaque leader, except where there are fades and dissolves—then a clear color negative is used. Individual laboratories may have their own preferences as to how the original should be marked and laid out for printing, but the same basic principles are involved and the differences from lab to lab are not significant.

During the negative matching, the original film is divided into two sections, called the A and B rolls. The matching is done on a 16mm multiple-gang synchronizer (Figure 53a). The negative matcher must view the scene by eye since a viewer might scratch the original film. Normally the workprint is placed in the first gang, the A roll in the second gang, and the B roll in the third gang, farthest away from the editor (Figure 53b).

There are several reasons for laying the original film out for printing on two rolls instead of in a single strand. First, if the original were spliced scene to scene as in the work print, it would be impossible to dissolve or blend scenes into one another. The dissolve involves superimposing the fading out of one scene on the fading in of the next scene, and sections of both scenes must overlap for the length of the dissolve. Overlaps cannot, of course, be made if a single strand of film is used. Second, by alternating successive scenes on two rolls of film, direct

◀ FIGURE 53a

▼ FIGURE 53b

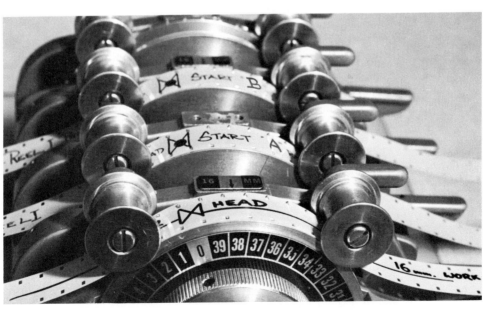

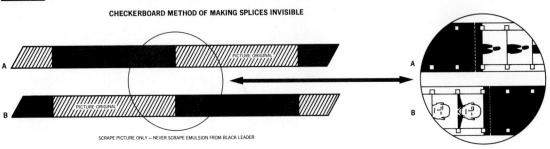

CHECKERBOARD METHOD OF MAKING SPLICES INVISIBLE

SCRAPE PICTURE ONLY — NEVER SCRAPE EMULSION FROM BLACK LEADER

FIGURE 54 ▲ Courtesy of General Film Laboratories, 1546 North Argyle, Hollywood, Calif. © 1970.

scene-to-scene splicing is avoided and the "feel" or "look" of the splice is eliminated. When two pieces of film are spliced together the minute portion where one piece of film overlaps another is wider than a frame line; the line of the splice will show up in standard laboratory printing. In the A and B roll setup, however, the negative matcher always splices image to leader or leader to image, keeping the leader on the *right* side of the splicing machine. This procedure ensures that the splice line will always be on the opaque leader, never cutting across the image frame, and thus the jumpy quality of direct scene-to-scene splicing is eliminated during printing (see Figure 54).

In 35mm film most optical effects are made in an optical house. If all opticals (special effects as well as dissolves and fades) are prepared in this way, there is no need for an A and B layout and the original can be conformed to the work print in a single strand, with each scene spliced directly to the next. (Splices do not show in 35mm because of the larger size of the frame line.)

At the start of the negative matching process, the matcher prepares identifying *head leaders* for the A and B rolls. These usually tell the title of the film; the name of the producer or producing organization; the roll (A or B); the *printer's start frame*, identifying the "head" of the roll (usually indicated by a punched hole outlined in ink); and any other information that the editor feels is important (Figure 55). Following the identifying leaders, the matcher attaches the SMPTE Universal leader to the front of each roll (Figure 56). This leader serves to cue the projectionist when changing from reel to reel and is also used for synchronization purposes in the editing room and the laboratory. The printer's start frame is always marked at a fixed distance from the first frame of picture—4 feet 32 frames in 16mm and 12 feet in 35mm. The SMPTE Universal leader is cut to exactly this length and is placed on the A and B rolls, corresponding to the white leader at the beginning of the work print. At the end of the matching process the matcher will attach *tail leaders* to the A and B rolls, containing additional information for the laboratory and indicating the printer's end frame.

After the head leaders have been prepared for both the A and B rolls, the negative matcher locks them into the synchronizer with the work print and rolls

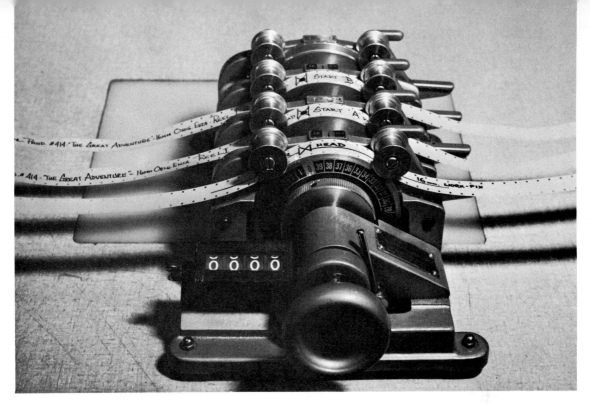

FIGURE 55 ▲

FIGURE 56 ▼

segment 1

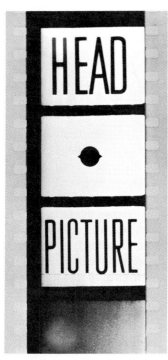

segment 2

segment 3

FIGURE 57 ▲

FIGURE 58 ▲

all three rolls forward (locked together in perfect synchronization) until he reaches the first frame of the first scene on the work print. Let us assume that the editor has indicated in crayon that he wants scene 1 to fade in over a span of 48 frames. Let us say for purposes of illustration that the first edge number on the work print of scene 1 appears from the seventh to the ninth frame and is 52 28073. You will note that the printed edge number is clearer than the latent image code number (Figure 57). The negative matcher next removes the entire scene from the shelf and locates the first edge number. He places the scene in the synchronizer in the gang containing the B roll, lining up the frame containing the *first figure* of the edge number with the corresponding frame in the work print. He then closes the synchronizer, locking in both pieces of film. The matcher rolls the film backward in the synchronizer until he reaches the point in the work print (7 frames earlier) where the scene begins. He marks the beginning frame on the original film with a metal scribe, an instrument resembling a miniature metal ice pick (Figure 58). Then, with a scissors, he cuts off the unused portion of the front of the scene.

The negative matcher then splices scene 1 onto the opaque leader on the B roll in the third gang of the synchronizer. Figure 59a shows laboratory instructions for the correct preparation of 16mm original reversal A and B rolls. Figure 59b shows the same instructions for 35mm film. In the first gang (the A roll) the matcher splices opaque leader onto the Universal leader at the same frame. With the scribe he makes two small parallel marks next to the perforations on the edge of the first frame of scene 1 on the original film to indicate a 48-frame fade-in as per the editor's instructions on the work print. (He also prepares a written cue sheet for fades.)

The negative matcher then runs the three rolls—the work print, scene 1 on roll B, and opaque leader on roll A—through the synchronizer, double-checking the matching edge numbers as they go by until he reaches the point on the work print where scene 1 cuts directly to scene 2. Repeating the earlier matching process, he cuts off the end of scene 1 on the B roll and cuts the opaque leader on the A roll at the same point. The matcher then splices opaque leader onto the end of scene 1 on roll B and splices scene 2 to the opaque leader on roll A. The three rolls are now run forward in the synchronizer until the end of scene 2 is reached. Assume that at this point the editor wants scene 2 to dissolve into scene 3 over a span of 48 frames. The editor has indicated this on the work print by marking in crayon a 24-frame diagonal line at the end of scene 2 and another 24-frame line at the beginning of scene 3. To set up the original so that the laboratory can print this effect, the negative matcher splices scene 3 (the incoming scene) onto the opaque leader on roll B twenty-four frames ahead of the frames on the work print where scenes 2 and 3 are spliced together. Twenty-four frames beyond the work print splice the matcher cuts off the remaining portion of scene (the outgoing scene) on the A roll and splices opaque leader to it. In a dissolve of this kind there is only one place where the incoming and outgoing scenes appear on screen with equal value—at the center of the dissolve, the place on the work print where scene 2 was spliced to scene 3.

FIGURE 59a ▼

Courtesy of General Film Laboratories, 1546 North Argyle, Hollywood, Calif. © 1970.

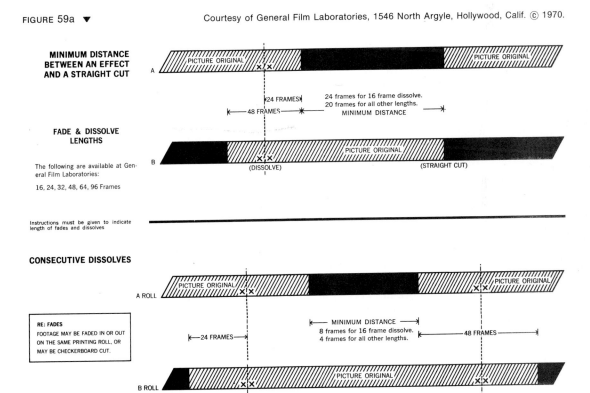

MINIMUM DISTANCE BETWEEN AN EFFECT AND A STRAIGHT CUT

FADE & DISSOLVE LENGTHS

The following are available at General Film Laboratories:

16, 24, 32, 48, 64, 96 Frames

Instructions must be given to indicate length of fades and dissolves

CONSECUTIVE DISSOLVES

RE: FADES
FOOTAGE MAY BE FADED IN OR OUT ON THE SAME PRINTING ROLL, OR MAY BE CHECKERBOARD CUT.

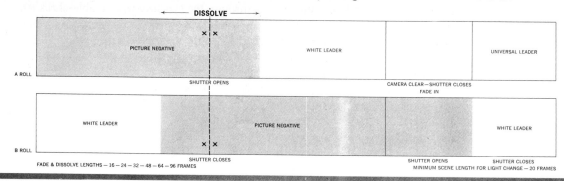

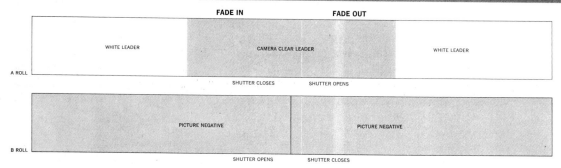

FIGURE 59b ▲ Courtesy of General Film Laboratories, 1546 North Argyle, Hollywood, Calif. © 1970.

The negative matching proceeds in this manner until the entire film has been conformed to the work print. Special optical effects that cannot be made in the printing laboratory (wipes, superimpositions, multiscreen opticals, etc.) are prepared by an optical house. The new print—the optical master—is then cut into the A and B rolls instead of the camera original. Most laboratories are currently equipped to make dissolves and fades of 16, 24, 32, 64, and 96 frames. Dissolves and fades of any other length must be treated as special effects and prepared in an optical house.

At the end of the matching process the A and B rolls appear in a kind of "checkerboard pattern." At this point it is important to emphasize the extreme care and precision with which the negative matcher must work. During editing, scenes that are damaged on the work print can be reprinted from the original any number of times. The original film, however, *cannot* be duplicated. It is relatively fragile, coated with a soft emulsion that is easily subject to scratches and abrasions. The simple act of winding it onto a core during the breakdown can leave horizontal cinch marks that will damage the film beyond repair. A misread edge number can result in a scissor cut made in the wrong place. This type of error *cannot* be undone. It is essential, then, that negative matching be carried out in a setting not unlike that of an operating room. The matcher must

at all times wear editing gloves and must not allow himself to become distracted by conversation or anything else during his work. It is wise to take several breaks during the matching to relieve the tension caused by the demands of the work. If a serious error is made, it must be reported to the film editor immediately. He may be able to supply an equally good duplicate take, or offer a valid editorial alternative. This is the only time during the editing that the original film is actually cut, so extreme care and attention must be given to every move.

THE SOUND TRACK

After the preparation of the film is completed, the negative matcher lines up the optical sound track (a photographic representation of the sound modulations) with the work print and the A and B rolls in the fourth gang of the synchronizer. The optical track is a transfer onto optical film from the quarter-inch or 35mm magnetic tape used in the mix. As noted in Chapter 7, during the sound mix an audible tone or "bleep" is added to the sound track to facilitate the alignment process. This tone is placed on the sound track between the head start frame and the place at which the first frame of picture appears, and it is "visible" on the optical track. When this frame is lined up with the corresponding frame on the work print leader, the picture and sound are properly synchronized.

At this point the track negative is said to be in "editorial sync." That is, it is in an exact frame-to-frame relationship with the picture. However, on all film projectors the picture gate (the place where the film passes in front of the light source) is separated from the sound head, so the sound track must be placed in "projection sync" before printing. On 16mm projectors the sound head is separated from the picture gate by exactly 26 frames. The film moving through the projector first reaches the picture gate and then 26 frames later reaches the sound head. Thus the sound track must be advanced by 26 frames ahead of its corresponding picture frame. In 35mm the track must be advanced 20 frames. Once this has been done, the film is ready for the laboratory.

laboratory printing

TIMING THE FILM

After receiving the film, the laboratory makes its own preparations prior to printing. During printing, the A and B rolls will be run through a printing machine and automatic controls will change the light intensity for each scene. The printing shutter will also gradually open and close automatically as fade-ins, fade-outs, and dissolves are made. The timer, a highly trained technician, must evaluate each scene by eye or with the aid of an electronic timer and assign a light intensity to it. If a scene is underexposed on the original film, the timer will give it a stronger printing light. If the original scene is overexposed, the timer will try to "under-print" it by allowing less light, although this is more difficult. (In 35mm, where

the original is negative, these procedures are reversed.) Color filters can also be added during the printing to alter or improve color values. For example, if a scene seems excessively blue, a compensating magenta or even a red or yellow filter can be added to give warmth.

It is important to note that tremendous improvements in the film can be made during laboratory printing; in some cases scenes previously discarded as "unusable" are not only salvaged but actually made excellent by the laboratory. However, it would be less than wise to assume that the lab can always correct for sloppy or inadequate photography. Despite the ability to make adjustments, there is always the danger of a loss in quality. In the years ahead more and more basic laboratory work will be computerized, and eventually computers will be programed to control the entire printing process.

THE RELEASE PRINT

In 16mm color the original film, a positive reversal stock, is printed directly onto a positive stock. In 35mm, the original film is negative, and prints are made on positive duplicating stock. In 16mm, since the original film is positive (reversal) prints can either be made directly on a positive reversal stock (which is very expensive), or an *internegative* can be made, from which subsequent positive prints are struck (the best way). The first sample print that satisfies the laboratory is submitted to the director for changes and suggestions. This is called the *answer print*. Since all color and intensity corrections are made on the basis of this print, the quality of the sample is crucial. It should be perfect or close to it. When corrections have been made and the filmmaker is completely satisfied with the answer print, the laboratory proceeds with preparations for the *release print*. With 16mm film, all release prints are made from the internegative, and, depending on the number of prints required, other internegatives will be made. It is possible to print approximately fifty to seventy-five prints from each internegative before dirt and abrasions make it unusable.

Until recently, the preparation of release prints in 35mm was a little more complicated and expensive, since interpositives had to be made before internegatives could be prepared. (Internegatives are needed in 35mm to protect the original negative.) However, through a new process called CRI (color reversal interruptive) the laboratory can now make internegatives directly from the original 35mm negative. Blow-ups from 16mm to 35mm and reduction from 35mm to 16mm are easily done in the lab or optical house with minimal loss of quality.

There are, of course, many more technical aspects of laboratory work that demand skilled control, including color dyes, bath temperatures, speed of developing, grain, and color filtering. These and other items can be studied in technical manuals such as the handbook *Recommended Standards and Procedures for Motion Picture Laboratory Services* published by the Association of Cinema Laboratories, 901 North Washington Street, Alexandria, Virginia. For the beginning filmmaker it is most important to understand how to prepare the film for a specific laboratory and how to help the lab give the very best possible printing and developing.

The key to choosing the best laboratory for a particular printing job lies

essentially in the evaluation of lab personnel. The lab manager is the central figure; the timer is also a critical part of the team. Unfortunately, most labs promise far more than they deliver. The best way to choose is to gather recommendations from other filmmakers.

suggested reading

HAPPÉ, L. BERNARD, *Basic Motion Picture Technology.* New York: Hastings House, 1971.

LEVITAN, ELI, *An Alphabetical Guide to Motion Picture, Television, and Videotape Production.* New York: McGraw-Hill, 1970.

QUICK, JOHN and TOM LABAU, *Handbook of Film Production.* New York: Macmillan, 1972.

SPOTTISWOODE, RAYMOND, ed., *The Focal Encyclopedia of Film and Television Techniques.* New York: Hastings House, 1969.

nine distributing the film

The final step in the long road that brings film from idea to audience is distribution. Filmmaking is an art, and as such it is also a form of communication. No matter how much talent and work have gone into the production, no film can achieve its purpose unless it is seen, and it is the process of distribution that makes possible an audience for the motion picture.

Until the moment the film is complete and ready for distribution, the filmmaker's primary task has been to create the motion picture. In most cases he is the director of the film. In most theatrical feature films the producer (either a company such as Paramount or MGM, or an individual who has raised the money for the film and supervises its spending) hires the director. Usually the producer leaves all artistic decisions in the hands of his director-filmmaker. The director will be paid a fee plus a percentage of the gross revenue. In documentary and sponsored films the producer is usually a company specializing in this type of film, and the company hires the filmmaker. With TV commercials, the advertising agency is responsible for the business and creative aspects of making the commercial; they hire a production company to produce the spot according to the storyboard they have created. The production company assigns the director-filmmaker.

In most cases, however, arranging the distribution is the responsibility of the producer. Only in rare instances where the director-filmmaker is also the producer will he exert any major influence over distribution.

Every type of film has an established channel through which it is distributed. It is a tremendous advantage, almost a necessity, for the filmmaker to establish in advance what kind of audiences the film is to reach. The film will have a much greater chance for success if these factors are taken into account when major filmmaking decisions are made. For example, in making a full-length feature, the filmmaker cannot ignore the realities of theatrical distribution, with its rating system and its strong financial pressures. Decisions regarding such items as the handling of sex, the choice of locations, the use of name actors, and the treatment of controversial material all depend on the eventual distribution goals for the film.

distribution channels

THE THEATRICAL FEATURE FILM

The overwhelming majority of theatrical feature films are distributed by large, established organizations such as MGM, Paramount, and United Artists. These large companies produce their own films (and sometimes distribute them, despite federal antitrust pressure); provide money for independent producers, thereby acquiring an interest in the films they do not directly produce; and acquire for distribution films that have been produced by others. The distribution companies maintain continuous contact with film exhibitors (theaters and theater-chain owners) throughout the world and provide a network of distribution essential to the film's financial success.

It is virtually impossible for the independent feature film producer to arrange for his film's distribution without the aid of the large theatrical distributors. There are two major reasons for this. First, it is far too expensive and time-consuming for the producer to approach each theater or theater-chain owner on his own. Second, the competition from the large distributors, who offer theater owners a continuous supply of films, is just too great. In addition, the ability of the large distributor to offer films by filmmakers with an established record of successes, featuring stars who "draw" at the box office, puts the smaller independent producer at a disadvantage.

The normal method of distribution for the independent theatrical film producer is to have the potential distributor see the film as soon after the first answer print is made as possible. Then, hopefully, they will negotiate a contract for distribution. Unfortunately for the independent producer, it is the distributor who is in control and who usually gets the best part of the bargain. The producer, knowing that he will be unable to earn any income from his film unless he can arrange distribution for it, is generally forced to accept the best deal he can get. This usually ranges from 30 to 50 percent of the gross earned income, depending on how much the distributor wants the film. The gross earned income of the film is all monies paid to the distributor as a result of the film's exhibition. In addition, a percentage of each dollar paid for the theater tickets goes to the theater owners. Generally the producer receives very little from his first film, but if it is successful he is in a much better position to negotiate a more favorable contract for his next film. The theatrical distributor is responsible for arranging theatrical bookings for the film and for all advertising and promotion. He also makes and pays for all distribution prints of the film.

The complex nature of feature film distribution can be seen at a glance in a breakdown of figures for the highly successful film *David and Lisa,* produced independently by Paul Heller and Frank Perry in association with Vision Associates of New York. The film, produced for $189,000, was an extremely "low budget" feature. A distribution contract was signed by the producers with Continental Pictures, a relatively small distributor. Basically, the contract called for the producer to receive 36 percent of all gross revenues up to the first $400,000 and then, on a sliding scale, between 40 and 60 percent of all monies over that. Considering the circumstances, this was an unusually favorable contract for the

producers—the film was a low budget product by a director who had no record of success and no box office name. By December 1971, the film had grossed nearly six million dollars at the box office. Allowing for deductions for advertising and other items covered by the contract, the distributor received $2.8 million, of which $1.2 million was paid to the producers.

THE THEATRICAL SHORT

Theatrical shorts are almost always produced independently, either by film-makers who wish to use the film as a showcase for their talents (such as John and Faith Hubley's animated shorts or "art" shorts such as the 1972 Academy Award winner *Sentinels of Silence*), or by organizations who wish to promote their activities (such as the shorts produced by the Bell Telephone System). The films usually run ten to fourteen minutes in length, must be exhibited in 35mm (they can be produced in 16mm and enlarged), and are given either to theatrical distributors or to companies like Modern Talking Picture Service and Association-Sterling, who for a fee (generally $10.00 per nine-day booking) will distribute 100 prints of a film, guaranteeing one thousand theatrical bookings per year. If the film is totally noncommercial (e.g., a cartoon, travelogue, or nature film), a distributor might conceivably buy it outright for several thousand dollars, but such procedure is exceptional. Because of the promotional nature of many theatrical shorts, they are generally offered to distributors without charge. Hence there is little or no financial return for producers in this market.

THE NONTHEATRICAL FILM

Nontheatrical films include documentaries, educational films, industrial and other sponsored films, training films, and any films designed to be distributed to audiences outside theatrical or commercial television programing. Since most nontheatrical films are sponsored by a company, foundation, government agency, or some other group with a message or a specific purpose other than entertainment, the sponsor usually arranges for distribution. Some sponsors of films, particularly large companies or companies using the film for purposes strictly within their organization, handle their own distribution. Generally, however, the sponsor purchases the prints and hires a commercial distributor to provide distribution for a fee. This distributing company will guarantee $1\frac{1}{2}$ to 2 showings per month for each print given them. They will arrange bookings with appropriate groups such as service clubs, schools and colleges, and women's clubs; mail the prints; inspect each print when it returns; and, if necessary, repair the print before the next showing. The distributor will also notify the sponsor prior to each showing in case the sponsor wishes to arrange any special publicity. In addition, commercial distributors will arrange public service television showings for nontheatrical films that are primarily educational rather than commercial in nature. Such films are often booked on nonprime-time TV (early morning, daytime, or late night) as

fill-in material. The distributor usually charges about $5.00 for each nontheatrical booking and $8.00 for each TV showing.

The development of table-top projection units and videotape cassettes has opened another significant avenue of distribution for nontheatrical films—the private or institutional showing. For example, a fund-raising film can be shown to two or three executives in an office setting, or a teaching film may be shown to a small group of nurses in a hospital office. This method of distribution is generally confined to special merchandising programs and training situations, but the near future should see expansion into much broader areas. Large institutions such as universities and hospitals will certainly be using film teaching units, and nontheatrical films, particularly documentary films, seem ideal for home cartridges and cable TV. Very few nontheatrical films will be made in the next few years without careful consideration given to this new and important channel of distribution.

THE TV COMMERCIAL AND PUBLIC SERVICE SPOT

Since the television commercial is produced solely for the purpose of selling a product or communicating a message via television, its distribution is relatively simple. The commercial is produced by or for an advertising agency, which then buys time on either a TV network or an individual station for the spot. The costs of time are directly dependent on the number of stations involved (in the case of the network) and the time of day at which the spot is to be run.

Some organizations in the public service field, such as the Save the Children Federation, the American Cancer Society, and Boys' Clubs of America, use TV spots to raise funds, attract public participation, or encourage volunteers. These organizations produce the spots and prepare prints to mail to every TV station in the country. Each station is required by the FCC to give a fixed percentage of air time to public service messages and to run the spots without cost.

legal and technical matters

It would be impossible in this text to cover all legal and technical problems encountered in producing and distributing a film. Needless to say, a good attorney and a good accountant are almost as important to a film as a good cameraman and a good editor. The following guidelines may prove helpful.

CONTRACT TERMS

Contracts for filmmaking and film distribution are of paramount and vital importance. Too many inexperienced filmmakers, in their desire to make a film as quickly as possible, fail to protect their rights.

The following elements must be considered, agreed on, and carefully spelled out in all production and distribution contracts.

1. The responsibilities of each party to the agreement. Such questions as artistic control (who has final approval or "last cut"), schedules, money control, casting and hiring—all must be covered.

2. The rights to all material covered by the contract (the script, the film itself, original music, etc.). Generally the producer or producing company owns the rights to the film, and the others involved get a percentage of gross or net income. The producer then grants exclusive distribution rights to a distributor, who in turn pays him (or the production company) a percentage of all incomes received from the distribution of the film. With documentary or sponsored films or TV commercials, the sponsor usually owns *all* rights and pays for the distribution of the film. The producer of the film should, of course, seek to retain as many residual and subsidiary rights as he can, as well as some measure of control over advertising and distribution.

3. Other matters to be covered include ownership of the negative (very important), contingencies such as acts of God or illness, flow of cash, advertising, rights of termination (under what specific conditions can the contract be terminated by either party), and, in the case of documentary or sponsored films, methods of payment (usually one-third on signing, one-third on script approval, and one-third on completion).

In nontheatrical films the *initial agreement* or contract between the producer and his sponsor is the most important document related to the production. It should cover such things as the financial arrangements, the responsibilities of each party to the contract, the ownership of the negative and of the rights to the film, and the disposition of subsidiary rights (such as music, and so on). The agreement should provide for a wide range of contingency events. On pages 262–68 is a sample contract covering the production of a sponsored documentary film.

The producer and the distributor should draw up a *written* agreement specifying all arrangements made regarding fees, the ownership of all rights to the material developed under the agreement, methods of payment, and, most important, rights of approval. It is of utmost importance, once the film enters distribution, that there be no ambiguous or unclear articles that might permit, say, an actor or a musician to litigate against the producer. Such court actions can hold up distribution, often long enough to destroy the film's chances for financial success. The more that is spelled out in writing, the safer the future of the film.

During the production of any film, anyone appearing in the film who is not covered by a professional actor's contract must sign a written release. A good form for such a release is shown on page 270. To insure the legality of this release, a $1.00 fee should be paid by check to each nonprofessional and a record of such payment should be kept. An invasion-of-privacy lawsuit can be very costly, even if it is won by the producer. The goal of a well-run production is not to win litigation but to prevent it. Recently, a random shot of a sidewalk cafe in Rome

AGREEMENT, dated _____ between Vision

Associates, Inc., with offices located at 680 Fifth Avenue,

New York, New York, hereinafter referred to as "PRODUCER,"

and (the client) having offices at _____

hereinafter referred to as "CLIENT."

WITNESSETH:

That, in consideration of the mutual covenants and

agreements hereincontained, and for other good and valuable

considerations, the parties hereto have mutually agreed to

and hereby mutually agree as follows:

ARTICLE 1

The PRODUCER agrees to furnish one (1) sound motion

picture, photographed in 16mm Commercial Ektachrome color,

having a playing time of 28 1/2 minutes, and one (1) sound

motion picture, photographed in 16mm Commercial Ektachrome

color but released in 35mm, having a playing time of 10 to 13

minutes. The subject of these motion pictures will be _____

ARTICLE 2

The PRODUCER agrees to furnish and deliver at its expense

in first class condition without scratches or injury and in

accordance with accepted professional standards relating to photography, sound recording, editing, and art work of the motion picture industry, the items hereinafter set out, subject to the approval of CLIENT as hereinafter provided:

 (a) Recording script on all narration and dialogue

 (b) Work prints

 (c) Answer prints

ARTICLE 3

The PRODUCER agrees to keep the motion pictures produced hereunder, and all negative films, positive films, sound tracks and other materials used in connection therewith, insured at full insurable risks with a reputable and financially responsible insurance company.

ARTICLE 4

The PRODUCER agrees that on completion of production the following materials will become the property of CLIENT:

 (a) All picture negatives

 (b) All sound negatives

 (c) One (1) 16mm answer print from the original A & B rolls of the 28 1/2-minute film, and one (1) 35mm answer print blown up from the 16mm A & B rolls of the 10- to 13-minute film

 (d) All artwork produced in connection with the picture

ARTICLE 5

The PRODUCER agrees to defray all costs and expenses incurred in connection with the production of all services and materials specified in this agreement.

ARTICLE 6

The PRODUCER agrees that all performances, appearances, and services, and all of the literary, dramatic, and other material furnished by PRODUCER and used and rendered in connection with the motion picture shall have been fully paid by PRODUCER and that said motion picture shall be free and clear of all encumbrances, liens, hypothecations, customs, duties and claims.

ARTICLE 7

CLIENT agrees to pay the PRODUCER a contract price of

payable as follows:

one-third upon signing of contract;

one-third upon commencement of live major photography;

one-sixth upon approval of interlock;

one-sixth upon delivery of answer prints of both the 28 1/2-minute film and the 10- to 13-minute film.

ARTICLE 8

CLIENT shall have the right of cancellation without prejudice at any stage of this contract and be liable for all direct costs, labor and materials, incurred by the PRODUCER to date of cancellation, plus twenty-five percent (25%) for profit and overhead. Should such sum be less than the amount already paid the PRODUCER in progress payments, the PRODUCER agrees to refund the difference within one week of receipt of termination notice from the client.

ARTICLE 9

The PRODUCER undertakes to obtain such rights in respect of music, dramatic, literary, and artistic works as may be necessary for the production of the film, and the PRODUCER shall and does hereby indemnify, without additional cost to the CLIENT, CLIENT, against all action, claims or demands in respect of the use of said works as herein set forth.

ARTICLE 10

The PRODUCER shall secure comprehensive written consents and authorizations from any person whose name, likeness, or voice is used in any part of this production.

ARTICLE 11

The PRODUCER warrants that this production shall not violate or infringe any copyright or patent right, nor shall it constitute actionable violation of the rights of any person, living or dead, and the PRODUCER agrees to hold CLIENT harmless from and to assume the defense, at its own expense, of any and all claims, actions or causes of action which are or may be asserted by reason of any claim, copyright, patent right or defamation arising out of this production.

ARTICLE 12

The contract price includes World Royalties payable by the PRODUCER for use of the sound system employed in the film. It also includes the fees payable by the PRODUCER for the rights referred to in Article 9 on the basis that the film will be used, distributed, or released nontheatrically or theatrically throughout the world and for television purposes in the United States and Canada.

ARTICLE 13

The sound track produced for use with this film shall not be used, distributed, or released except in conjunction with the showing of the film. CLIENT agrees to provide, at its expense, technical supervision by a person or persons qualified

and empowered to make the necessary decision or decisions relating to the approval of the film for accuracy of detail and other matters.

ARTICLE 14

The PRODUCER warrants and agrees that in all transactions relating to the production, he is an independent contractor and that all contracts and arrangements including those of employment shall be made by him as principal and not as agent for CLIENT, and that he will assume any and all liability arising thereunder and will indemnify and defend CLIENT against any and all claims arising in the course of this production.

ARTICLE 15

The PRODUCER agrees to comply with all applicable provisions of all rules and regulations now existing or as hereafter promulgated and amended, of any Union having jurisdiction in the premises, with respect to the production of the aforesaid motion picture, and PRODUCER further agrees that so long as it shall not be unlawful so to do, he shall engage such persons who shall be members in good standing of Unions having jurisdiction in the premises.

ARTICLE 16

It is agreed by the parties hereto that neither party shall be held responsible for any losses resulting if the fulfillment

of any terms or provisions thereof shall be delayed or prevented

by revolution, or other disorders, wars, acts of enemies, strikes,

fires, floods, acts of God, or without limiting the foregoing,

by any other cause not within the control of the party whose

performance is interfered with, and which by the exercise of

reasonable diligence, said party is unable to prevent whether

of the class of causes hereinbefore enumerated or not.

ARTICLE 17

The PRODUCER agrees, in addition to those matters falling

within Article 9, to indemnify CLIENT against all actions, claims,

or demands which may arise in respect of any of the processes

used by the PRODUCER and/or apparatus of any kind supplied by

the PRODUCER in connection with the production of the completed

film.

ARTICLE 18

This AGREEMENT embodies the entire understanding between

PRODUCER and CLIENT, with respect to the subject matter thereof.

No waiver, modification, or addition to this AGREEMENT shall be

valid unless in writing signed by PRODUCER and CLIENT.

CLIENT VISION ASSOCIATES, INC.

By: _____ By: _____

 Lee R. Bobker
 President

PERSONAL RELEASE

I, _____ , for

just and sufficient consideration, receipt of which is hereby

acknowledged, hereby irrevocably grant to Vision Associates,

Inc., your successors and assignees the right to record my

likeness and/or voice on film, to edit such film at your

discretion, to incorporate the same into a motion picture film,

tentatively titled _____ , and to use

or authorize the use of such film or any portion thereof in any

manner or media at any time or times throughout the world in

perpetuity and to use my name, likeness, voice and biographical

and other information concerning me in connection therewith,

including promotion in all media but not for the endorsement

of any product or service.

I hereby release you and anyone using said film or

other material from any and all claims, damages, liabilities,

costs and expenses which I now have or may hereafter have by

reason of any use thereof.

Signature: _____

Address: _____

Date: _____

Production No. _____

appeared in a travel film, revealing a well-known personality embracing a woman who was not his wife. That brief, unauthorized appearance cost the producer $25,000, and it might well have cost him more, since the film was used in the divorce proceedings. A good rule is: when in doubt, get a release.

In all distribution contracts and agreements it is a good idea to retain some control over what is spent for advertising and when and where the film is to be distributed. Because of the negotiating power of the distributor of theatrical films, this may not always be possible, but it is worth fighting for.

Be sure that you have adequate insurance coverage for (1) the negative (insurance against damage to the film during and after filming), (2) libel and slander, and (3) workman's compensation. Both during production and after distribution there will be many times when the producer is particularly vulnerable to a lawsuit. The knowledge that he has a carefully thought-out, comprehensive insurance policy is very comforting to a producer. There are brokers who specialize in film insurance and can design specific policies to fit the type of film being produced.

Conduct all transactions in writing and confirm all important conversations in writing. Keep careful and full financial records of all production expenses.

In nontheatrical distribution, retain the right to terminate any distribution contract within ninety days written notice. This prevents you from being tied for too long to a distributor who is doing a poor job, and it has the salutary effect of keeping the distributor on his toes.

Effective distribution is essential to any film's success. Film distribution is a highly competitive business, and a producer must constantly fight for his share of the market. There are many subtle factors involved in distribution that can often make or break a film. For example, a decision by the distributor to permit Paddy Chayefsky's fine film *The Hospital* to open the same week as Stanley Kubrick's blockbuster *A Clockwork Orange* cost the former a great deal of money at the box office. Every filmmaker should be as creative and demanding in making his distribution arrangements as he is in the making of the film itself. All films are made to be shown to audiences—if the distributor fails to deliver the desired audience, the film, however fine, also fails.

ten careers in filmmaking

The question most commonly asked by those seeking to enter the field of filmmaking is "How do I get a job in film?" A more productive and interesting question, however, would be "How can I have a rewarding career in filmmaking?" This involves far more than simply getting a job. It raises questions like what *kind* of job one should seek, what sort of company one should work for, and, most important, what career one should pursue in order to achieve a specific goal in film.

Despite pessimistic reports to the contrary, it is far from impossible to enter the filmmaking field. Indeed, the current need for creative young talent is extreme. For young men and women today, filmmaking offers a wide variety of job possibilities and unique career opportunities. Film is a fascinating, always stimulating art form; it is technically complex and invites talent from many other creative areas (writers, musicians, artists). In addition to the obviously glamorous positions of director, producer, and cameraman, jobs such as editor, unit manager, assistant director, script clerk, production assistant, and art coordinator are available, not to mention laboratory, art, and animation work. All these make film a very fertile field for the building of both a career and a way of life.

preparation and training

There are three basic ways to prepare and train for a career in filmmaking: university study, on-the-job apprenticeship, and independent filmmaking. Each of these approaches has assets and liabilities that are worth exploring.

UNIVERSITY STUDY

For the high-school graduate who would like to make filmmaking his career, there are a number of excellent universities offering an undergraduate major in filmmaking, and in some cases a program of graduate study leading to an M.A. or Ph.D. degree. Other universities offer a variety of film courses which the student can take in conjunction with a liberal arts major in a related subject such as English, fine arts, or journalism. Currently there are 427 universities and colleges with

fully operating programs in film scholarship and filmmaker-training; 96 of these offer a major in film, and 47 offer an undergraduate degree in film.[1] In fact, at the current rate of growth it is likely that by 1980 every university or college will include in its curriculum some courses in filmmaking.

It is essential that the student interested in filmmaking select a college or university that offers film courses of the highest quality. All too often, colleges and universities provide a few film courses that simply pay lip service to this modern art but provide little real support for or recognition of film as an independent curriculum. Other major institutions of higher learning accept film as a coequal art and place film courses on a par with literature and the sciences. A clue to the quality of a university's film curriculum can be found in the number of film courses listed in its catalogue (the more the better) and the credentials of its film instructors. It is wise to look into the background of those teaching film. Are they "part-time" instructors whose major background is in literature or other areas? Or are they men and women whose credentials indicate a genuine interest and involvement in film? The titles of the courses offered provide another index to the quality of film education in a university. Generally, it is best to avoid overly specialized or esoteric-sounding courses such as "The Male Myth in the Films of Andy Warhol" or "The Use of the Dissolve in the Later Films of D. W. Griffith." Look for courses whose names have a pragmatic ring to them and whose value can be recognized from their titles: "The History of Film," "Film Production," "Film Editing," "Music for Film," and so on. These courses may sound less exciting and may seem to provide little material for cocktail party conversation, but they represent the core of what the filmmaker will need to know to pursue a career. In addition, a truly comprehensive program in film should include courses in the financial matters related to film production; these provide essential knowledge, without which the fledgling producer would probably fail to complete a film.

For the aspiring filmmaker the university approach offers the following positive values: First, it gives the student a chance to establish a solid *technical* base in filmmaking. Just as a premedical program lays a foundation in biology, anatomy, and the physical sciences necessary for a career in medicine, so a four-year undergraduate program with a major in filmmaking provides the minimal technical skills and knowledge needed to make films. As has been indicated throughout this book, filmmaking is a combination of craft and art, requiring a high degree of technical skill and knowledge as well as tremendous sensitivity in esthetic and artistic matters. Second, the university affords the student the opportunity to study and practice the art and craft of film in a secure, protective environment. The university student can work at making films without the financial and other pressures so common to the motion picture field. Third, within the university setting the aspiring filmmaker can acquire a knowledge and appreciation of related arts such as literature, music, and the fine arts, including painting, graphics, design, and still photography. Perhaps no other creative field demands of the artist so

[1] Data obtained from *The American Film Institute's Guide to College Film Courses, 1971–72.*

wide a knowledge of arts other than filmmaking. On a day-to-day basis, the art of film calls for visual perception, a knowledge of history, literature and languages, music and art, and many other skills and disciplines that are best learned in college. Fourth, the university approach offers the filmmaker a chance to become familiar with and skilled in handling technical equipment—cameras, tape recorders, editing machines, and so on. This knowledge is almost impossible to obtain elsewhere. Filmmaking equipment is too costly to rent over a long period of time, and equipment used on the job cannot be set aside for teaching and training purposes. Finally, the college program affords the student a rare opportunity for experimentation. Out in the field most film crews are too busy doing what they are being paid for to allow the amateur time to "play around," even though most professionals recognize that it is through such experimentation that the art grows. In contrast, most universities encourage students to experiment with new ideas and enable them to test their own technical and creative innovations. Upon graduation, the young filmmaker offers a prospective employer a basic technical knowledge that could otherwise be gained only through a major investment of time and money on the employer's part, and a background of creative experimentation out of which something of real value for the employer may emerge. If the filmmaker wishes to proceed immediately to producing his own film, he will certainly be better prepared as a result of his academic work.

The limitations of the university approach should also be noted. There is no question that filmmaking as taught in the university is far removed from the reality of professional work in the field. Technical standards are generally quite low, and since film is a relatively young art creative values tend to fall into an "anything goes" category. Such an atmosphere does not really prepare the filmmaker for the harsher realities of filmmaking "on the outside." After graduation the filmmaker is liable to have difficulty bridging the gap between the university and the job. In addition, since filmmaking equipment is so expensive and becomes obsolete so rapidly, the university student may enter the field having never worked with up-to-date professional equipment. For example, most universities edit on moviolas and still others, less well endowed, use viewers and synchronizers only. As noted in Chapter 6, most professional editing facilities are converting to the single-unit tabletop machine (Kem or Steenbeck). Finally, one of the major advantages the university offers—an atmosphere in which creative experimentation is encouraged—may ultimately prove to be a liability. The student who is accustomed to working in such an ideal setting may find on-the-job success difficult to attain. It would be dishonest to understate the commercial realities that motivate professional filmmakers. Time and procedure are critical when translated into profit and loss. The college filmmaker, emerging from four years of "creating" films with no one to answer to but himself, his teachers, and a few classmates, must face an employer who all too often will compromise technical quality and creative inspiration for on-time delivery and on-budget performance. Unless the student filmmaker understands this reality, his career is endangered. This is not to suggest that the college graduate should shut off forever his willingness to experiment. Without this, there would be no art. It is simply to suggest that it

is important to be prepared for the differences between the two environments and to find ways of working creatively and well despite the many practical pressures that exist in the field.

ON-THE-JOB APPRENTICESHIP

A second approach to entering film is to learn filmmaking on the job. The major advantage of this approach is that the learning process is always accelerated when one learns by doing. The pressures and pace of commercial filmmaking are so great that learning takes place by a kind of sink-or-swim shortcut. Although there is little time spent in the discussion of theory or esthetics, it is possible to achieve technical proficiency at a very rapid rate.

It is vital to recognize that there are two distinct paths to a filmmaking career that on-the-job training offers: directing and editing. Since these two paths are usually mutually exclusive, it is wise for the aspiring filmmaker to make an early decision as to his final goal. For the filmmaker who wants ultimately to write, direct, or produce his own films, the initial job should be related to production. The editing room should be avoided at all costs. In the early stages of a career it is highly unlikely that an employer will switch an apprentice editor over to production or vice versa. Once a person begins in the editing room, promotions generally propel him toward being a full-fledged film editor. As a matter of fact, the better and more promising he is as an editor, the less likely he is to be offered a job in production. Few, if any, successful filmmakers began as editors. (Robert Wise, who cut *Citizen Kane,* is an exception.) Thus even a successful career in editing will not help the aspiring filmmaker whose real goal is directing or producing. For this reason a basic choice should be made early. And once made, it should be thought of as permanent. Of course, this does not mean that the director-oriented filmmaker should not learn as much as he can about editing. All the great filmmakers of today strongly influence the editing of their films, and most are quite conversant with both the art of editing and the technical skills involved. The director who does not understand all the technical and creative facets of editing puts himself at the mercy of the film editor and jeopardizes his film's chances of success.

Once a specific career line is chosen, the apprentice must be prepared to accept the struggle of learning on the job. The drive to learn quickly and thoroughly must motivate the apprentice so that he is willing, indeed anxious, to remain after hours, to ask questions, and to try to understand the work while doing the best possible job at the more menial tasks assigned him. The apprentice film editor, for example, spends much of his time carrying film to and from the laboratory or making splices in work prints. If he is smart, he will use the trip to the laboratory to learn something about lab operation, and while splicing he will try to understand what kind of film he is handling and how the scenes have been put together. The apprentice on a production crew is kept quite busy getting coffee, carrying equipment, and doing errands that are not always related to filmmaking. But the simple experience of being on set during filming is in itself extremely

valuable: the production apprentice can familiarize himself with equipment, note the responsibilities of each job, and acquire a basic knowledge of procedures and techniques. This kind of on-the-job training has the unique advantage of providing both instruction and firsthand experience—there is no better or quicker way to learn and understand the mechanics of filmmaking.

On-the-job apprenticeship, like all approaches, presents certain disadvantages to the aspiring filmmaker. First, the apprentice is often kept so busy doing routine, dull jobs that the opportunities to understand artistic motivation and to evaluate artistic decisions—topics that can be examined and discussed at leisure in the university—are virtually nonexistent. This important aspect of the filmmaking process can only be investigated after working hours through informal talks with more experienced filmmakers. Second, forging a career solely through on-the-job training tends to make the individual very parochial. Whereas in the university setting it is possible, even imperative, to expand one's intellectual horizons to embrace the other arts and sciences, the day-to-day demands of a real job make it difficult to keep learning about things other than film. The aspiring filmmaker who chooses to begin his career directly on the job tends to suffer far greater intellectual and artistic limitations than his university-educated peer.

INDEPENDENT FILMMAKING

The third approach—making a film on one's own—is both the most interesting and the most risky way of entering the field. The obvious advantage to actually making one's own film is that it provides direct experience in *all* aspects of filmmaking—formation of the initial concept, writing, administration, camera work, editing, hiring, and bookkeeping. The filmmaker has the opportunity to really control his own project from start to finish, to test his own artistic and technical skills, and to learn rapidly. Realistically, however, it is probably true that without the careful preparation of college study or the high-pressure approach of on-the-job training, the odds against a successful first effort, or even a productive one, are very high. One can of course point out exceptions, such as Stanley Kubrick, whose first film, *Day of the Fight,* was made with little preparation and enjoyed moderate success. To be sure, Kubrick learned a great deal from the experience. Nonetheless, the overwhelming majority of first efforts made without concrete training or academic preparation are disappointing and do not teach the filmmaker as much as he can otherwise learn.

Perhaps the ideal solution is to combine all three approaches. The filmmaker who can afford to spend some time studying film in a university should do so. At the same time, he can, if possible, try to get valuable summer or part-time work in the film industry. After graduation, he should choose one of two basic career goals (editor or director) and begin on-the-job training. During his first two or three years of work he can use vacations and spare time to experiment with making a short film. This "combination" approach offers the best of all possible worlds and the best chance of success.

finding a job

The first step toward finding a job in the film industry is securing a job interview. Unfortunately for the beginner, the traditional methods of seeking employment offer little hope for success in the filmmaking field. For example, sending résumés to prospective employers is almost always worthless. They are seldom read or even seen by the person to whom they are addressed. A receptionist or a secretary usually files them or throws them out. A busy film executive simply does not browse through incoming résumés accompanied by letters of application. On the rare occasion that a résumé might reach the addressee, it almost never gets the attention required to elicit a positive response. Of course, the few remaining large Hollywood producers can be written to because they usually have a personnel office set up expressly to interview young talent, but by and large the applicant's goal is to reach the people who are engaged in actual filmmaking. Telephone calls are also a poor way to secure a job interview. Unless the path has been cleared by someone who has influence with the prospective employer, it is too easy for the receptionist or the secretary to politely deny access to the boss via the telephone.

The most effective way to get a job interview is also the hardest and the most ego deflating. It involves compiling a list of all the film-producing companies for whom you might like to work and calling on them personally. Generally, it is best to prepare a *brief* (one page if possible) statement of background and qualifications, including educational background and whatever specific skills you have in film. If you have produced your own film, even a short film in high school or college, this should be indicated on the background fact sheet. Then you should choose, on the basis of organizational size, types of films produced, and location, the companies that seem to offer the kind of work environment that fits your goals.

Once a list of potential employers is prepared, you should make calls in person. Accept the fact that in most cases you will not get past the receptionist the first time around; but persistence does pay off. One thing is in your favor. Film producers desperately need young talent and will usually reward the persistent caller with an interview. If you make a favorable impression, many producers, if they have no immediate job openings themselves, will suggest other companies and even open a door or two.

During the interview itself it is best to try to be yourself. State your case as briefly and forcefully as possible. Don't apologize for a lack of experience. No intelligent employer expects someone seeking entry to a field to have a long list of credentials. Try to convey a sense of dedication to filmmaking and a passion for what you want to do. If you have any ideas on filmmaking or films, talk about them. If you have made your own film, bring it along. Remember you may have only ten or fifteen minutes to separate yourself from all the others whom this employer has seen and will see.

The final step in applying for a job is following through. Every time you receive a personal interview, you should follow it up with a courteous letter of thanks and periodic inquiries over the next few months. Don't sit back and wait

for the job to come to you. Again, it can be effective to employ a combination approach by sending out a letter and résumé, following up with a call, and then paying a personal visit. But your chances for success depend almost entirely on the personal call.

working in the field

UNION MEMBERSHIP

One of the great barriers to getting a good job in film is the trade union situation. The film industry developed as a craft guild, and during the growth of film from its infancy to a big business the unions served a vital function in protecting employees from exploitation by greedy film moguls. However, in the past decade the unions have failed to grow with a changing industry. The new technology, which has made equipment easier to operate and far more mobile, has also made it possible for independent filmmakers to make films with very small crews. The unions, seeking to protect their members in a declining job market, have tried to discourage new applicants and thus have forced many young filmmakers to work outside the organized industry.

Though union control of jobs has declined markedly in the past few years, it is still essential, at least in the theatrical film and TV fields, to apply for union membership. Most feature films and TV-commercial production companies are closed shops—that is, everyone working for the company must belong to the union having jurisdiction in his particular craft. Thus the beginning filmmaker is advised to apply as soon as possible to an appropriate union for apprentice membership. One can apply for membership before having a firm job offer or after getting a job, since under the Taft-Hartley Law the union must either accept the application or permit the individual to work. The more effective method is to apply after a job has been secured. On the following pages are samples of applications for union membership.

Every union has different requirements for membership. Some unions, such as Motion Picture Film Editors and the Directors Guild of America, which covers production assistants, will offer no problem in processing the applications. The more rigid and difficult unions that continue to practice a policy of protectionism, such as Local 644 (cameramen, New York) and Local 52 (stagehands, New York), will probably ignore the application the first few times. However, under the terms of the Taft-Hartley Law any union employer can hire an applicant in any capacity whether or not union acceptance has come through; the prospective employee must simply have shown a willingness to join the union. All employees, whether or not they are union members, must be hired under terms and conditions covered in the current union contract. Thus the union barrier to employment is far weaker than it seems, and over the next decade it will weaken still further.

The documentary field is consistently more open to job applicants because of the variety of producers operating within it. Many documentary film production companies are highly successful nonunion shops and afford the beginning filmmaker an opportunity to work at many jobs, unrestricted by the craft guilds.

Application for Membership

I do this date_____ , hereby make application for membership in the International Photographers of the Motion Picture Industries, Local No. 644, I. A. T. S. E. and M. P. M. O. I further agree that if any of the statements made herein are found to be false I am automatically considered suspended from this Local.

————————o————————

Name in full_____

Address _____ City _____

State _____ Phone _____

I do further agree that I will accept and fully observe the Constitution and By-Laws or any other laws or rules of Local No. 644, I. A. T. S. E. and M. P. M. O. if I am elected to membership.

Signed_____

————————o————————

The undersigned members of Local No. 644, I. A. T. S. E. vouch for and recommend the above named applicant for membership:

————————o————————

Initiation Fee $_____ Amount Paid with Application $ _____

Balance Due $_____

Date of Election_____ Official Rating _____

PERSONAL HISTORY STATEMENT

1. (a) When Born_____ Where _____
 Month Day Year

 (b) Are you a citizen of the United States?_____ (Attach Copy of Birth Certificate)_____

 (c) If Foreign Born, Indicate When and Where You Were Naturalized_____
 Year

 _____ (Attach copy of Naturalization Certificate)
 Date of Naturalization

 (d) Father's Name_____ Father's Birthplace _____

 Mother's Maiden Name_____ Mother's Birthplace_____

 Wife's Maiden Name_____ Wife's Birthplace _____

 (e) Marital Status: Single_____Married _____ Divorced _____ Separated _____ Widowed _____

2. Education (Includes military service schools): Number of years and dates attended:

3. (a) Have you ever been convicted of a crime? Yes () No ()

 If so, give the date and circumstances_____

 (b) Has a judgment been rendered against you in any court of law? Yes () No ()

4. No person shall be eligible to become or remain a member or to hold any elective or appointive position in Local 644 who now or hereafter belongs to, joins, affiliates with, adheres to, sponsors, promotes, advocates, supports or aids, directly or indirectly, any principle, doctrine, purpose, aim, program, action or deed of the Nazi, Fascist or Communist Party or any of its sponsored or affiliated organizations, associations, groups, bodies, conferences or councils, whose principles, doctrines, purposes, aims, programs, actions or deeds are at variance with or hostile to those of the United States of America, the Dominion of Canada or of the I. A. T. S. E. and M. P. M. O. of the United States and Canada.

 Do you adhere to this principle? Yes () No ()

5. Do you swear allegiance to the American Flag without reservations? Yes () No ()

Requested Rating _____

Now Working as _____

Where Working _____

Applicant must state his experience in full:

®
PRINTED IN U.S.A.
◆ 44

Application Blank of Local Union No. 644 of the International Alliance of Theatrical Stage Employes and Moving Picture Machine Operators of the United States and Canada.

I have the honor to make application for membership in Local No. _____ of the International Alliance of Theatrical Stage Employes and Moving Picture Machine Operators of the United States and Canada. I have authorized, designated and chosen said labor organization to negotiate, bargain collectively, present and discuss grievances with my employer, as my representative and my sole and exclusive collective bargaining agency, and I do hereby confirm the same in all respects. If elected to membership, I shall abide by the Constitution, By-Laws, decisions, rules, regulations and working conditions of Local No. _____ and of the International Alliance of Theatrical Stage Employes and Moving Picture Machine Operators of the United States and Canada. I base my application for membership on the following facts, which I affirm to be true:

I, _____, was born on _____;
 (Print or Type Name) (Day) (Month) (Year)

now residing at _____, have
 (Street) (City) (State) (Zip)

been a resident of _____ for _____ years. I am by
 (City and State)

occupation a _____ and have worked
at the following:

Theatres _____

Laboratories _____

Studios _____

Elsewhere in the theatrical, television or moving picture industries (specify) _____

a total of _____ years. My Social Security Number is _____

I am now employed by _____ at _____

as a _____
 (Specify Occupation)

Have you ever applied for membership in any Local of this Alliance? _____

Date of Previous Application, if any _____ Made to Local No. _____

Was Application rejected? _____

Signature of Applicant _____

Dated at _____, 19____

Initiation Fee _____ Amount Paid _____ Balance Due _____

Is this application for journeyman _____ or apprentice _____? (check one)

(LOCAL SEAL HERE)

The undersigned (must be three members of this Alliance in good standing) vouch for and recommend the above-named applicant for membership:

_____ Local No. _____

_____ Local No. _____

_____ Local No. _____

THIS APPLICATION MUST BE COMPLETED IN DUPLICATE WITH SIGNATURES OF APPLICANT AND THOSE VOUCHING ON BOTH COPIES.

This is to certify that _____ has on this _____

day of _____, 19____, been admitted to membership in Local No. _____
having fully complied with the requirements as set forth in the Constitution and By-Laws of said local organization and of the International Alliance of Theatrical Stage Employes and Moving Picture Machine Operators of the United States and Canada.

_____, President

_____, Secretary

(LOCAL SEAL HERE)

☞**THIS STUB TO BE FILLED IN AND RETURNED TO GENERAL OFFICE IMMEDIATELY FOLLOWING APPLICANT'S ADMISSION TO MEMBERSHIP.**

Member's Social Security Number _____

```
┌─────────────────────────────────────────┐
│                                         │
│     DIRECTORS GUILD OF AMERICA-          │
│     PRODUCER TRAINING PROGRAM            │
│                                         │
└─────────────────────────────────────────┘
```

DESCRIPTION

A training program for second assistant directors was created in
April 1969 pursuant to provisions contained in the collective
bargaining agreement of 1968 between the Directors Guild of
America, Inc. and the Film Producers Association of New York,
Inc. The program is designed to emphasize the administrative and
managerial functions characteristic of Assistant Directors and
to familiarize the trainees with the paper work and proper
maintenance of records, including the preparation of call sheets,
production reports and requisitions; to acquaint them with the
working conditions of the collective bargaining agreements of
industry guilds and unions; and to give them a basic knowledge
of the administrative procedures in motion picture production,
including production and some post-production operations.

During their training, trainees will have the opportunity to
improve their skills in the handling of people, learn how to call
actors, extras and other personnel, how to assist in the staging
of background action and the giving of cues to actors, how to
determine compensation adjustments for extras and stunts, how to
make arrangements for facilities and rental equipment, how to
break down scripts, and how to schedule and budget pictures. They
will be able to acquire some knowledge of looping, recording
wild lines, characteristics of camera lenses and matching of
angles for editing.

The program will include both on-the-job and off-the-job training.
On-the-job training encompasses a minimum period of 400 work days
during a two year program. Employment will be subject to all
applicable collective bargaining agreements and studio or producer
rules and regulations. Consistent with the collective bargaining
agreement referred to above and the Trust Indenture under which
this program operates, trainees are employed and paid by signatory
producers. Upon satisfactory completion of the program, the
trainee will be accepted into the Directors Guild of America as
a Second Assistant Director.

RATES OF PAY

The wage scale of trainees will be at the rate of $135 - $165 per week

SEMINARS

Trainees must participate in a seminar program consisting of a course of study usually conducted one evening every six weeks. This off-the-job training is not compensable. The seminars cover a wide area of subject matter and are conducted by directors, assistant directors, producers and union officials.

LAY-OFF PERIODS

Acceptance into the program does not represent a guarantee of continuous employment. All trainees should be prepared to cope with periods of unemployment. Trainee employment is dependent upon the general employment and production status of the entire industry, and is contingent on the cooperation of producers who are the trainees' employers.

ENTRANCE REQUIREMENTS

To be eligible to apply to the Directors Guild of America-Producer Training Program, an applicant must meet ALL of the following basic minimum qualifications:

1. Evidence by a birth certificate or other authentic proof of age, applicant must have passed his 21st birthday and not yet reached his 31st birthday as of May 1st, except that extra time for a period of not exceeding three (3) years shall be allowed beyond such 31st birthday to compensate for any time during which applicant has been on active full-time duty in the regular Armed Forces of the United States, whether or not in time of war.

2. Graduation from an accredited four-year college or university or suitable equivalent in experience derived from employment in the motion picture industry, or suitable equivalent in satisfactory attendance in accredited technical training schools related to the film industry. Each one year of work experience or attendance in accredited technical training schools will be counted as the equivalent of one year college level education.

 Evidence of employment in the motion picture industry subsequent to applicant's eighteenth birthday must show the occupations and dates for each job so that the time that you were employed in any one occupation can be clearly determined.

3. At least two (2) letters of reference from motion picture or related industry employers or the person to whom you directly reported. These letters should include comments on such qualities as:
 (a) Excellence of performance
 (b) Organizational experiences and ability
 (c) Your capacity to give orders and also to accept and execute orders
 (d) Administrative ability (planning, scheduling, etc.)
 (e) Skills in dealing with people
 (f) Consistency of behavior
 (g) Versatility
 (h) Ability to work effectively under pressure

4. United States citizenship or permanent resident status in the United States.

5. Good health and character.

TESTING

Applicants who meet the basic qualifications will be evaluated by an objective rating system in which such data as experience, education, references, etc. will be weighed. These applicants will then be selected for testing. All applicants will be notified of preliminary selection or rejection.

The selected applicants will then be given written tests administered by Princeton Associates for Human Resources, Inc.

Those applicants who have received the highest test ratings will then be asked to participate in a series of interactional, behavioral processes. Applicants will be rated by Princeton Associates for Human Resources, Inc. against certain behavioral criteria related to the work requirements of Assistant Directors. Through progressive screening and selection, a group of applicants will be finally selected for participation in the two year Directors Guild of America-Producer Training Program.

You will be notified as to whether you have qualified for the testing phase of our pre-training selection. If you have qualified, you will have several weeks notice prior to commencement of testing.

SELECTION AND PLACEMENT OF TRAINEES

Each year the Directors Guild of America-Producer Training Program Board of Trustees accepts a limited number of applicants into the training program. That number depends to some extent upon the employment outlook for the coming year in the motion picture industry. Once the trainees have been selected, they are eligible for employment. Trainees will be dispatched in the order in which they were selected by Princeton Associates for Human Resources, Inc.

FILING DATES

Applications including all supporting documents must be received before June 30th of the calendar year. Aptitude and interactional testing takes place during the month of July. Announcement of selection of trainees is in August.

FOR APPLICATIONS OR FURTHER INFORMATION ON THE PROGRAM PLEASE COMMUNICATE BY MAIL, TELEPHONE OR IN PERSON TO:

MR. HAROLD KLEIN

ADMINISTRATIVE TRUSTEE

DIRECTORS GUILD OF AMERICA-
PRODUCERS TRAINING TRUST FUND

165 WEST 46TH STREET

NEW YORK, N.Y. 10036

TELEPHONE: (212) CI 5-2819 or CI 5-2545

GEOGRAPHICAL LOCATION

It is unfortunately true that to forge a successful career in filmmaking you have to be where the action is. Feature film production is still centered in Hollywood and New York. There is no way to build a successful career in this area of filmmaking in Chicago, Detroit, or Brownsville, Texas. Production units are formed in Hollywood and New York, hiring takes place there, and it is necessary to be on the spot. In Europe, London, Paris, and Rome are the big cinema centers, but because of local unions and national work laws it is very difficult for Americans to get work in foreign productions.

TV commercials are also centered in Hollywood and New York, with the latter having the edge because the large advertising agencies are located there. However, there is a fair amount of TV commercial production being done in Detroit and Chicago. Documentary and educational film production is widely scattered, and here it is possible to make a successful career in a variety of places such as New York, Chicago, Detroit, Atlanta, Dallas, Detroit, San Francisco, and Los Angeles.

SUCCESS ON THE JOB

Perhaps the most important key to success in the filmmaking field is the ability to combine genuine artistic talent with a solid technical background early in a career. This requires enough self-motivation to learn a great deal of technical material as quickly as possible.

At every job, at every stage, the most important aspect of a developing filmmaking career is the learning process. This applies to the simplest and most menial jobs, because these jobs make up the base on which a career will be structured. The old cliché "Do it right" applies tenfold in film. Mistakes are unbelievably costly, and most filmmakers live a financially marginal existence until they establish themselves in the field. Accept the facts of life. Filmmaking is usually carried out in an atmosphere of frantic hysteria. It is an environment that invites error; thus the battle for care and attention requires double the effort.

When a job ceases to provide stimulation, education, and opportunity for advancement, it is time to leave. Too many talented filmmakers become trapped in dead-end jobs long after the job has given them all the value it can give, and they have contributed all they can to the job. The following job progressions offer the best opportunity to build skills and prepare for further advancement.

1. Apprentice editor, assistant editor, editor, supervising editor, management.
2. Production assistant, unit manager, assistant director, executive producer.
3. Production assistant, unit manager, assistant director, director, executive producer.

Filmmaking can be an extraordinarily rewarding career. In all its aspects it challenges the individual's artistic, intellectual, and technical abilities in a wholly unique way. It demands a willingness to work intensely and a passion and com-

mitment to the art, and it calls for the development of a wide range of complex skills. It affords the individual a chance to travel, to associate with interesting and diverse people, and to come in contact with many of the forces that are shaping our society. Since it is the central art form of our times, it is varied, consistently interesting, and never lacking in emotional and physical excitement. No other field offers such a wide opportunity for a practical continuing education. The filmmaker works with all the arts—literature, the theater, music, and the visual arts. Today more than ever, the aspiring filmmaker has a really broad opportunity to work and advance in film.

As with any art form, the mastery of technique coupled with a truly creative spirit are a guarantee not only of success, but of a rewarding and interesting life.

index

index

Camera lens (*continued*)

test card, 164

wide-angle, 157, 158, 160, 161, 180, 184

zoom, 162

Camera original, *see* Original camera negative

Cameraman

basic tools, 143

creative role, 127

crew members, 118, 142–43, 193, 195

director of photography (head cameraman), 118, 127, 128, 134–35, 138, 142–43

selection of, 118–19

union membership, 277–80

wages and hours, 74–75, 97, 103

Carabiniers, Les, 135

Cardioid microphone (unidirectional), 195

Careers in filmmaking

Directors Guild of America Producer Training Program, 282–85

editing, 274, 286

independent filmmaking, 275

job hunting, 276–77, 286

job progressions, 286

on-the-job training, 274–75

production, 274–75, 286

rewards of, 286–87

union membership, 277–81

university study, 271–75

writing, 274

Cassavettes, John, 8, 129

Cast

accommodations on location, 110, 112–14

casting, 105–07

crowd scenes, 73

extras, 72

fees and salaries, 96

nonprofessionals, 133

optimizing performances, 77–78, 132–34, 138, 222, 228

rehearsals, 129, 133–34

relationship with director, 126–29, 131–32

sickness, 83, 103

travel and subsistence costs, 102

Changing bag, 147

Characters

described in screen treatment, 16

dialogue for revelation of character, 8, 38–46

fitting actor and role, 106

Chayefsky, Paddy, 38–45, 126

Cinéma vérité, 17, 153

Cinematography

background-foreground relationships, 158, 160–61, 174, 175, 176, 180, 184–86

camera mounts, 151–52

camera parts and operation, 146–51

camera placement and movement, 149, 151–53, 179, 183–84, 186

color control, 162, 167, 169, 170, 173, 174, 177–79, 254

composition of scenes, 180–86

contrast, 170, 173, 176

exposure problems and techniques, 143–45, 154–56, 169–70, 253–54

exterior photography, 83, 158, 162, 178–79

film stock, 143–46, 164, 176–77

filters, 162, 178–79

focusing problems and effects, 156–61, 184–86

hand-held camera, 153, 179, 184

illusion of depth, 158, 160–61, 174, 175, 176, 180, 184–86

image size, 158–60, 162

interior photography, 173–78

lenses and adjustments, 153–61

light measurements, 154, 164, 171

lighting equipment and effects, 164–73

linear distortion, 160–61

low-intensity lighting, 164, 167, 174, 176

movement of images, 161, 183

shooting speed, 149–51

special effects, 160–61, 169–70, 173–74, 180, 182, 183, 184

Citizen Kane, 161, 220

Clapsticks, 193, 206

Clarke, Arthur C., 10

Climate of foreign locations, 112–14

Clockwork Orange, A, 8, 123, 173, 182, 216, 230, 231, 270

Color filters, 162, 169, 173, 177–78, 254

illustration acknowledgments

Pages 15 and 25: Courtesy of Eastern Airlines.

Pages 26 and 27: Stanart Studios, producer, for IBM World Trade Corporation.

Pages 34 and 35: Courtesy of Eastern Airlines.

Page 109: Courtesy of Stage 54 West, Inc., a division of Camera Mart Stages, Inc.

Page 144: From the film *The Battle of Algiers,* an Allied Artists release.

Page 145: From the film *The Price of a Life.* Director, Lee Bobker; cameraman, Herbert Raditschnig.

Page 147: Photo supplied by author.

Page 148: TOP — Courtesy of Mitchell Camera Corporation. CENTER AND BOTTOM — Eclair Corporation of America.

Page 149: Courtesy of Arriflex Company of America, New York and California.

Page 150: Courtesy of Camera Mart, Inc.

Page 151: National Cine Equipment, Inc., New York, New York.

Page 152: Courtesy of Camera Mart, Inc.

Page 154: Courtesy of Angénieux Corporation of America.

Page 155: Photos supplied by author.

Page 156: TOP — Courtesy of Angénieux Corporation of America. BOTTOM — From the film *The Revolving Door.* Director, Lee Bobker; cameraman, George Silano.

Page 157: From the film *The Revolving Door.* Director, Lee Bobker; cameraman, George Silano.

Page 159: From the film *The Road.* Director, Lee Bobker; cameraman, Arthur Filmore.

Pages 160 and 161: From the film *The Odds Against.* Director, Lee Bobker; cameraman, Ray Long.

Page 163: TOP — From the film *Stella Dallas.* ©1936 by United Artists Corporation. BOTTOM — From the film *Craig's Wife.* Originally released by Columbia Pictures.

Page 164: Courtesy of Mole-Richardson Company, Hollywood, California, U.S.A.

Page 165: Courtesy of Lowel-Light Photo Engineering Company, New York, New York.

Page 166: Courtesy of Mole-Richardson Company, Hollywood, California, U.S.A.

Pages 167–69: Courtesy of Lowel-Light Photo Engineering Company, New York, New York.

Page 170: Photo supplied by author.

Page 171: Courtesy of Photo Research, Inc., Burbank, California, manufacturer; Scopus, Inc., New York, New York, distributor.

Page 172: TOP—Photo supplied by author. BOTTOM—Photo by Herbert Raditschnig.

Pages 174 and 175: Photos by Herbert Raditschnig.

Page 177: Photo supplied by author.

Page 178: Courtesy of Camera Mart, Inc.

Page 181: From the film *The Road*. Director, Lee Bobker; cameraman, Arthur Filmore.

Page 182: From the film *The Revolving Door*. Director, Lee Bobker; cameraman, George Silano.

Page 183: From the film *The Road*. Director, Lee Bobker; cameraman, Arthur Filmore.

Page 185: Photos by Herbert Raditschnig.

Page 191: Courtesy of Nagra Magnetic Recorders, Inc., New York, New York.

Pages 193 and 194: Photos supplied by author.

Page 207: LEFT—Photo supplied by author. RIGHT—Courtesy of Magnasync Moviola Company.

Pages 208 and 209: Courtesy of Kem Electronic Mechanic Corporation.

Pages 242, 246, 249, and 250: Photos supplied by author.